for Suzanne,
Larry,
Elaine,

all good things,

Samuel

In Character

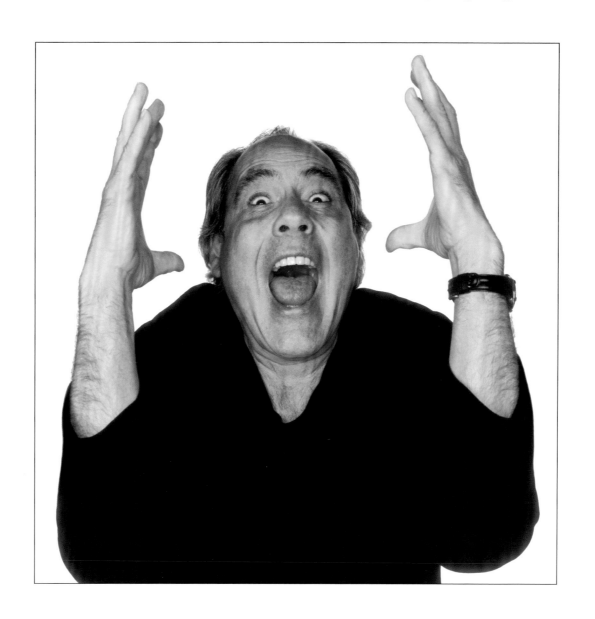

Actors Acting

In Character

Actors Acting

Directed and Photographed by

Howard Schatz

Project Director / Senior Editor

Beverly J. Ornstein

Foreword by

Roger Ebert

BULFINCH PRESS

New York • Boston

Bulfinch Press

Time Warner Book Group

1271 Avenue of the Americas, New York, NY 10020

Visit our Web site at www.bulfinchpress.com

First Edition: April 2006

Library of Congress Cataloging-in-Publication Data

Schatz, Howard, 1940 –

In character : actors acting / directed and photographed by Howard Schatz ;

project director / senior editor, Beverly J. Ornstein ; foreword by Roger Ebert. — 1st ed.

p. cm.

Includes index.

ISBN 0-8212-2907-9

1. Stage photography. 2. Celebrities — Portraits. 3. Actors — Portraits. 4. Portrait photography.

5. Schatz, Howard, 1940 – I. Ornstein, Beverly J. II. Title.

TR817.S33 2005

779'.9792028 — dc22 2004018527

Book design by Howard Schatz

Printed in Singapore

following page: CHRISTOPHER LLOYD

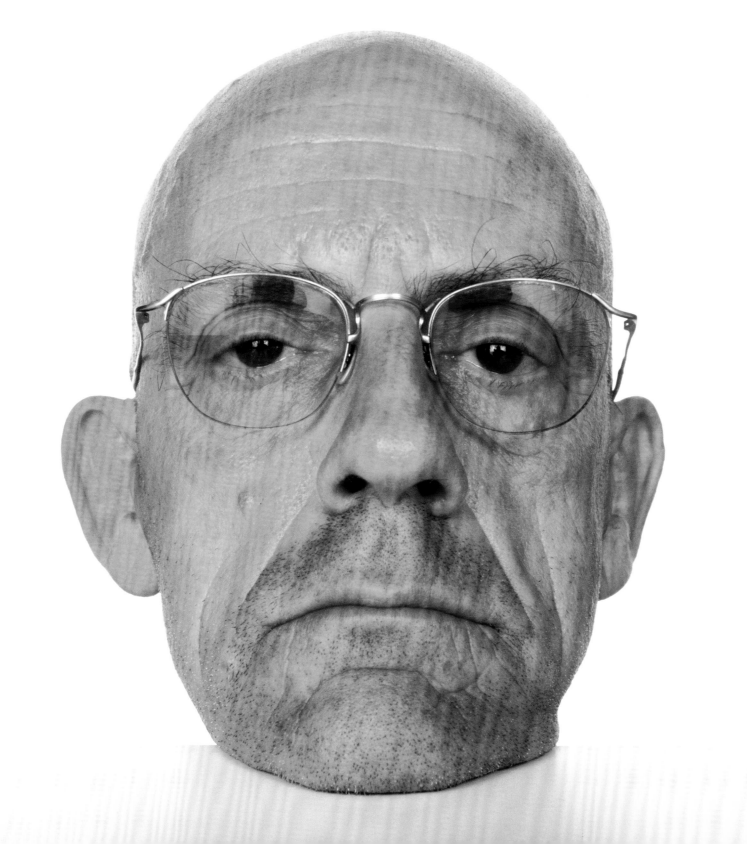

Other books by

Howard Schatz and Beverly J. Ornstein

Botanica
2005

Athlete
2002

Rare Creatures
2002

Nude Body Nude
2000

Body Knots
2000

The Virtuoso by Ken Carbone, with photographs by Howard Schatz
1999

Pool Light
1998

Passion & Line
1997

The Princess of the Spring and the Queen of the Sea
1996

Body Type: An Intimate Alphabet
1996

Newborn
1996

Waterdance
1995, 1998

Homeless: Portraits of Americans in Hard Times
1993

Seeing Red: The Rapture of Redheads
1993

Gifted Woman
1992

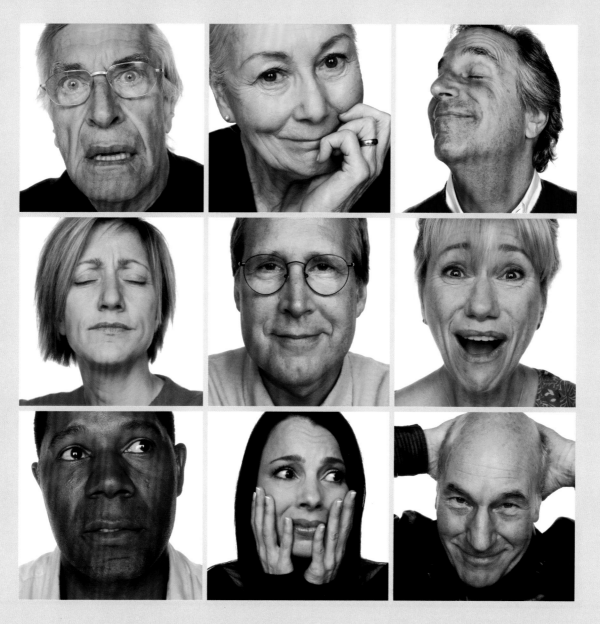

Each actor was given a direction, a character to play, a scene, and, at times, even dialogue.
Photographs were made as each actor creatively developed the part.
Looking through this book, the reader might find it interesting and challenging to view the photographs
before reading the direction, in an attempt to imagine what the direction might have been.

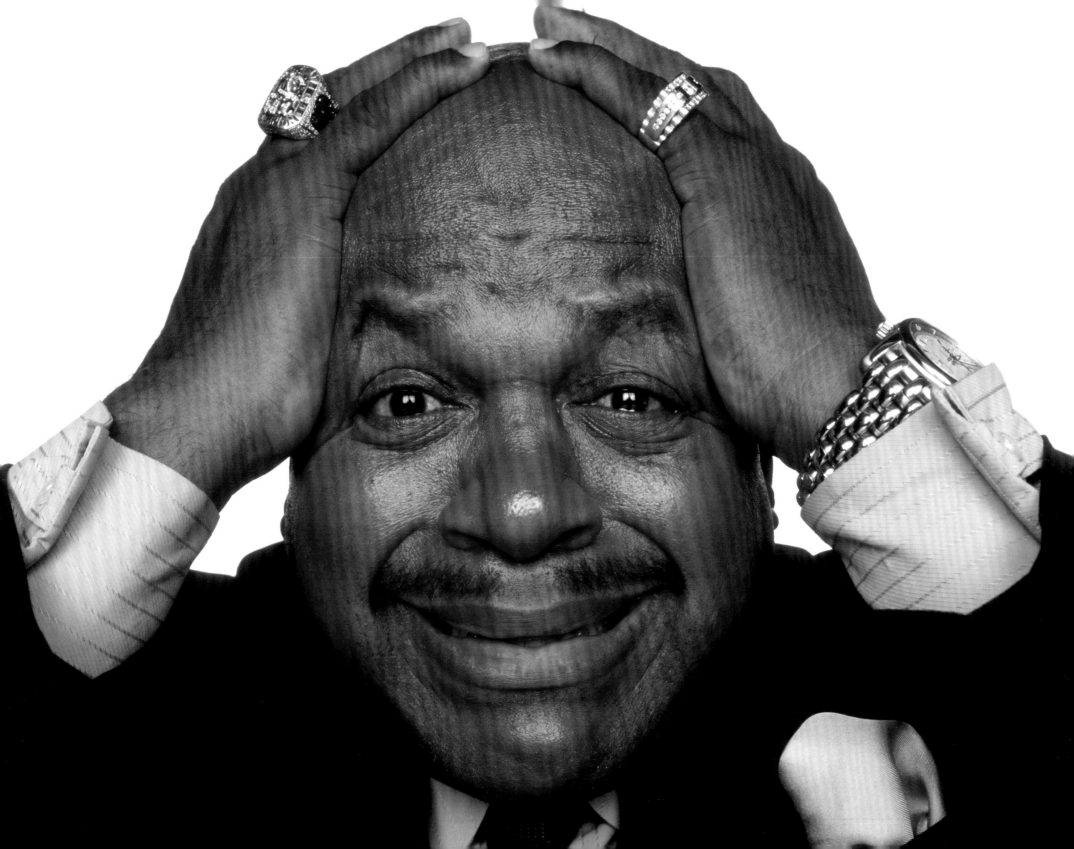

Foreword

BY ROGER EBERT

One of the most famous experiments in the history of the movies was conducted by Lev Kuleshov of Russia in the early 1920s. He wanted to prove that audiences did not see each shot separately but rather added them up to produce an effect. He photographed a bowl of soup, an attractive girl, a teddy bear, and the coffin of a child. Then he matched each image with identical shots of an actor named Mozhukhin. Audiences said the actor's face reflected hunger, lust, tenderness, and sorrow.

This experiment is always interpreted as proving that the actor was not acting – that the audience, inspired by the effect of montage, brought the emotion to the screen. I disagree. Mozhukhin was by definition acting even if he wasn't consciously doing anything, because the mechanism of the film was providing the audience with the effect of emotion – and the effect, not the means by which it is created, is the point of acting.

What the experiment did not ask was, what happens next? The simpleminded response to Kuleshov was that he proved acting did not matter, that montage was everything. But an actor cannot go emotionless throughout a film, cannot always exhibit a poker face (although Jean Gabin, in movies like *Pépé le Moko* and *Touchez Pas au Grisbi*, came close). There are speeches to make, longer scenes to negotiate, subtler emotions than hunger or lust. Kuleshov's simple montages were level one, and while they prove something basic, they leave everything else to speculation. They ignore the need for actors to carry emotion far greater distances.

As I read *In Character* and experienced the photographs by Howard Schatz, I began to understand how some of that distance is traveled. This is a wonderful book for reasons beyond its obvious appeal. It is not just actors "making faces," but actors extending themselves into imaginary situations as if, for a moment, they are real. To journey through the book and see familiar faces was to realize how much, during a career of looking at movies, I have come to love actors, to appreciate the gifts they bring.

First I looked at the pictures. I tried to guess the emotions, and while in a broad sense I was always right – love does not look like terror – I found that when I read the scenarios, dialogue, and emotions directed by Schatz, I noticed greater exactness of detail. Was this because I had been nudged by the prose or was it really there? I paused at Robert Loggia (p. 227) ("You are a veteran Chicago detective hearing an inconsistency in an over-confident suspect's alibi after a six-hour interrogation"). The first detail I noticed was the smile; not a happy smile, but one with a certain weary contentment. After reading the instruction, I looked more carefully at the eyes, and I found knowledge in them; he had just seen something that changed everything. Acting was happening.

You can see that over and over again in this book. These actors know what they're doing (a few overdo it, but you can decide that for yourselves). And they are playing to the medium: they know they are in close-up for a still camera, and they try to modulate the emotion for the medium and the distance.

In their comments, which are often revealing and filled with lore, they speak again and again of the differences between their media. What surprised me was how consistently they respect the stage and love it, how they feel limited by film, and how for the most part they dismiss television. "You don't feel important in

facing page: CHARLES S. DUTTON

the movies," says Philip Bosco, whose movie performances I have often admired. Sydney Pollack, who is after all a movie director, says, "There was something magical about getting up in front of the audience," and you realize that when he speaks of acting he unconsciously thinks of stage acting. Charles S. Dutton sees the stage as a fight ring: "I look at the other people on stage as opponents." Kate Burton discovers, "Oh, my God; it's all about collaboration." They are both thinking of the same thing: theater.

What they do and how they do it remains a mystery to them. Scott Glenn wonders, "How do you combine at the same time 100 percent concentration with 100 percent relaxation?" If the actors don't know, the audience certainly doesn't, and I sense what Dutton means when he says, "Not one single fan can look you in the eye and tell you something that can really make you say, 'Ah, they know.'"

Ellen Burstyn talks of the "communion" between the actor and the live audience. Hal Holbrook talks of "that great heart-throbbing thing going on out there that you can't see." Marianne Jean-Baptiste, nominated for an Oscar says, "If theater paid well, I'd never, ever do anything else." "Film, for me, is a director's medium," says Natasha Richardson, "it's not an actor's medium." And Bosco says, "I don't really believe you need to act in movies."

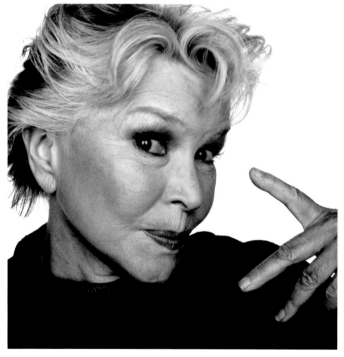

I was a little stunned by the time I reached the end of the book. As a film critic, was I living in a fool's paradise? In praising film acting, was I actually praising direction, technical excellence, or a kind of illusion using the actor like paint or clay? I don't think so. I think I understand that so many of the actors love the stage because what they accomplish there is all their own; they have an independence and self-sufficiency that floats free of machines and editors and montage. But in the movies, all of those other crafts allow us to get closer to them – too close for comfort, maybe, so that sometimes we sense not their technique but their very essence. Film gives them less satisfaction, takes more from them, and manipulates that essence in their absence. But I feel it gives the audience more. It looks into their eyes and souls and shows us not only what they can control of their presentation, but, crucially, what they cannot.

Maybe the Native Americans were right, and the camera steals the soul. Certainly Howard Schatz has looked deeply into the actors in this book, and they have deeply looked back. There is something curiously intimate about what actors do on these pages. As a reader, I began to feel like the mirror in their dressing room. I wasn't looking at them. They were looking at themselves.

above: ELLEN BURSTYN *facing page:* HAL HOLBROOK

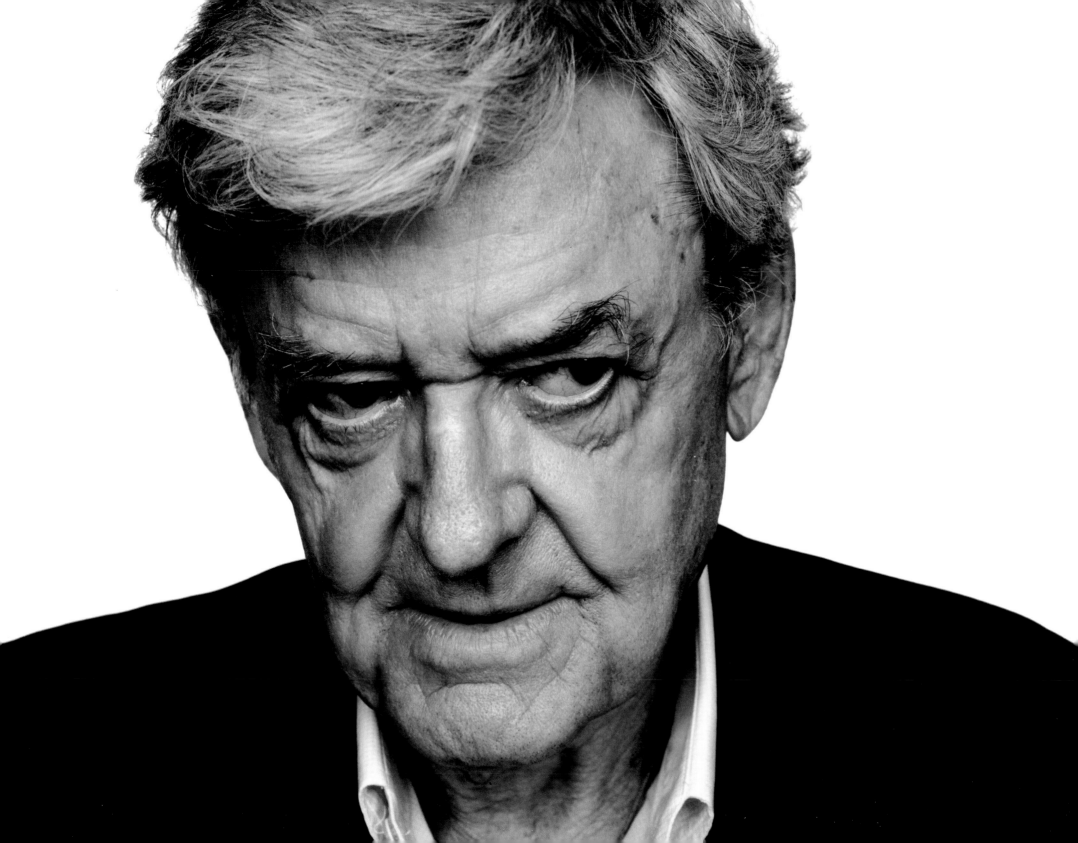

Act I

The Players

PETER FALK

RICHARD DREYFUSS

EDIE FALCO

NESTOR SERRANO

ROBERT VAUGHN

MICHAEL YORK

FRED WILLARD

GIANCARLO ESPOSITO

RICHARD SCHIFF

STEVE GUTTENBERG

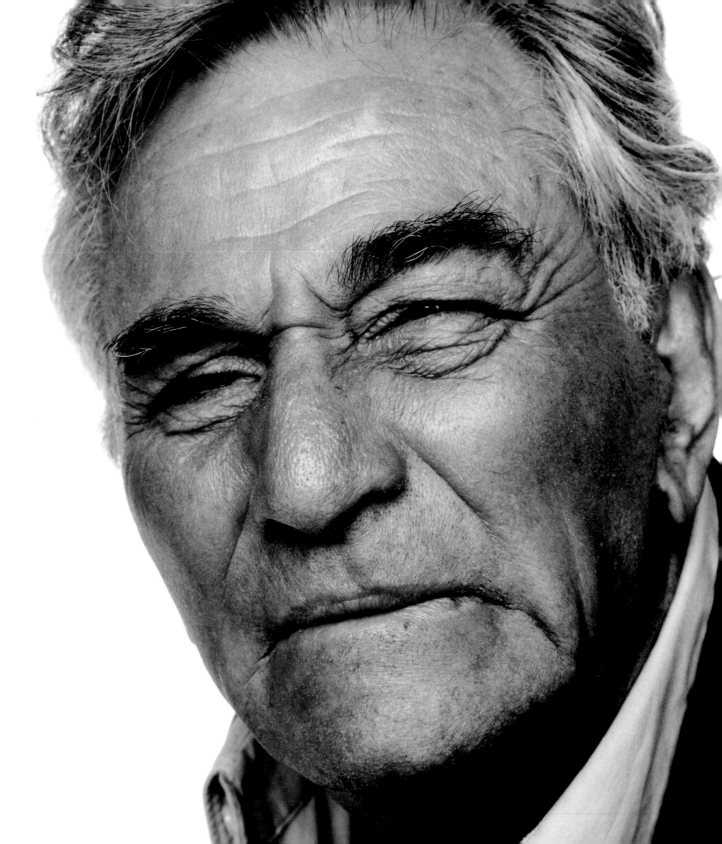

PETER FALK

1. You are…a grandfather
at a museum
with your granddaughter,
reacting to the sight
of a cow
cut in half
and displayed as art.

2. …a tough, impatient
homicide detective
telling a suspect,
"You lie to me
one more time…"

14

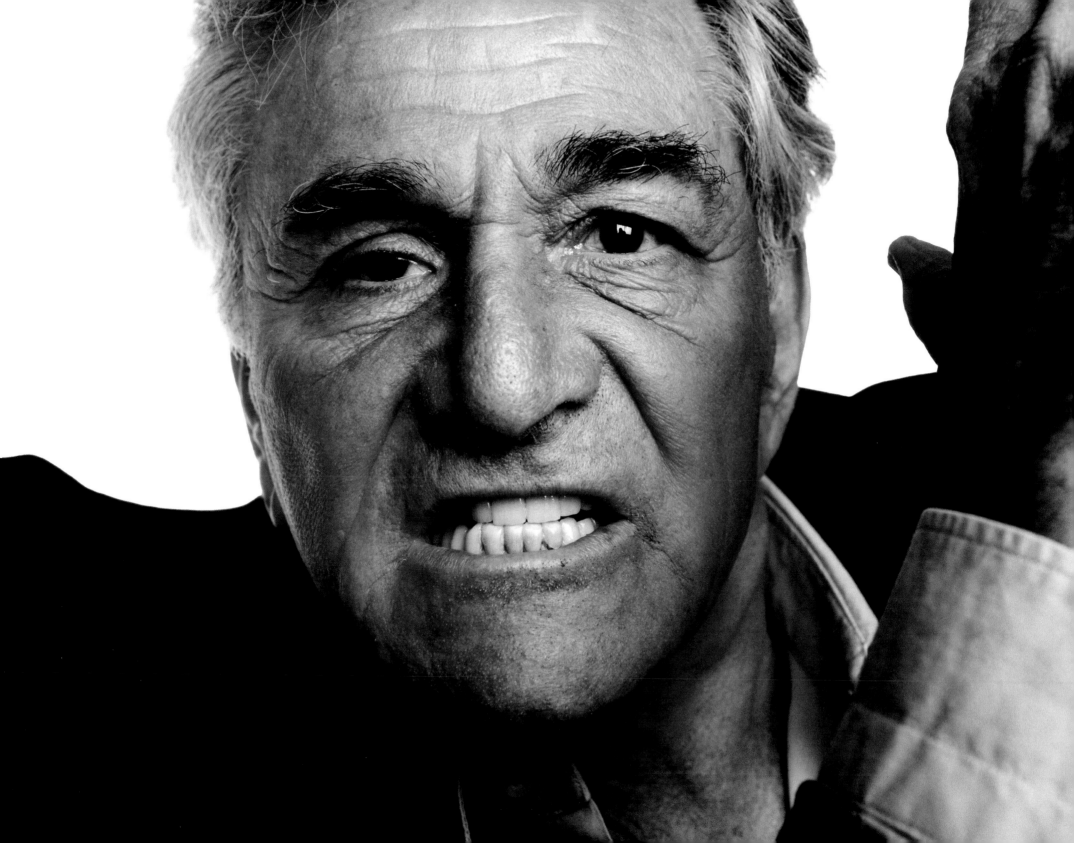

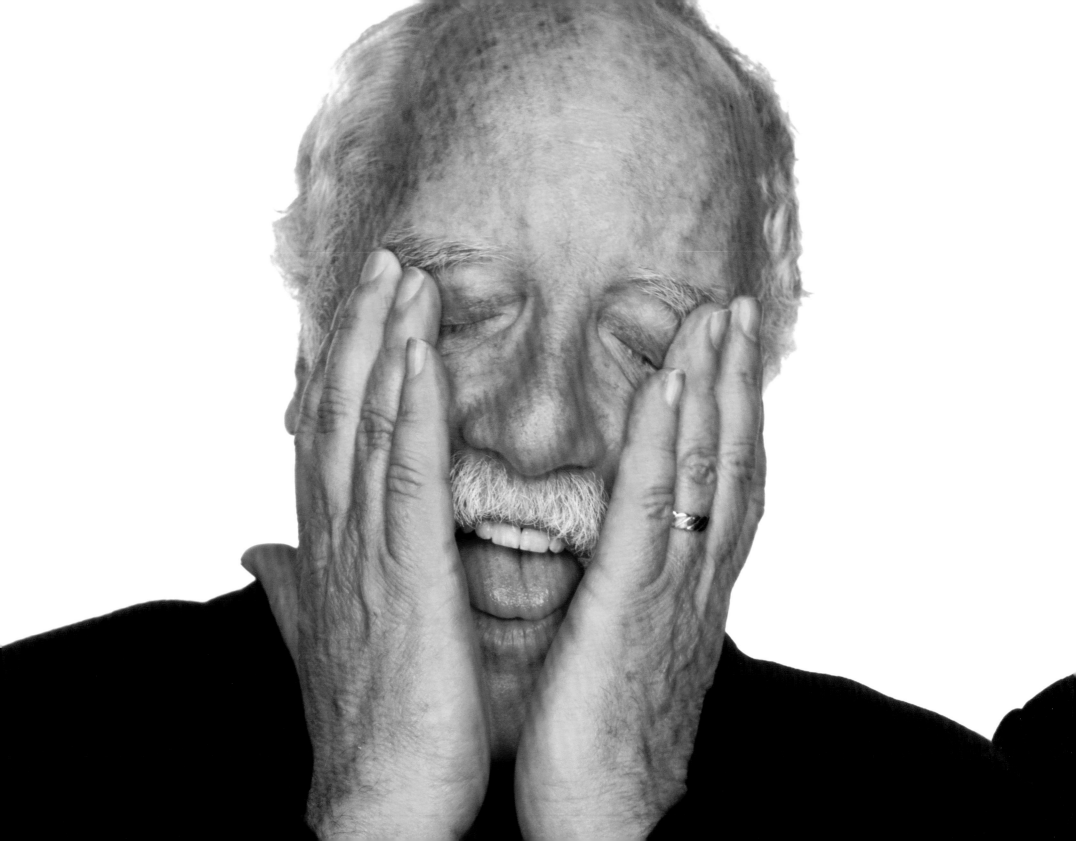

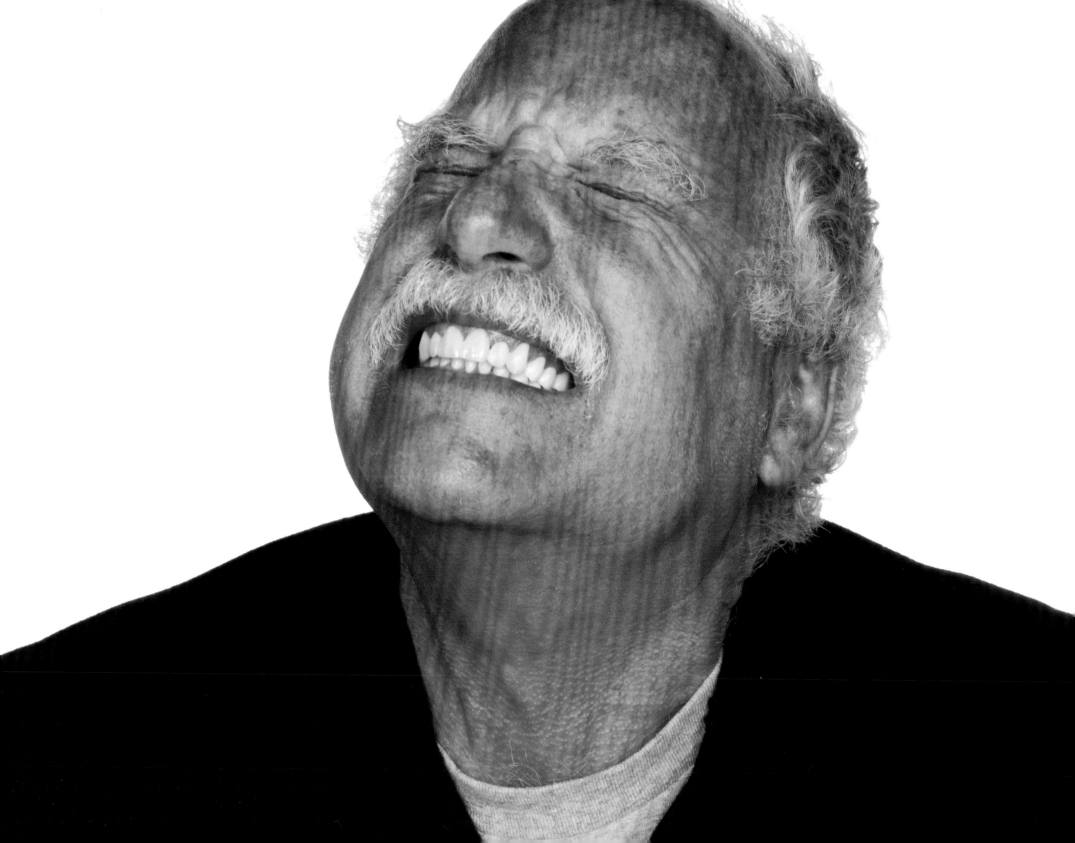

RICHARD DREYFUSS

1. You are…responding to a very dirty joke.

2. …an earthquake survivor

trying to lift a huge beam

off your screaming wife.

People say, "Well, you actors, you just say these words. They're not yours." That's true. But the genius of Shakespeare could not be felt or understood without the actor saying those words. And no matter how much you read them on the page, the acting is going to make them into something else. And that is a noble calling. An actor never says to himself, "These are mine. I wrote them." He knows that he is the mechanism, the Rube Goldberg device – the thing that is the connective tissue between understanding and appreciation and that genius.

You move people in drama and you can feel them on your face as you walk across the stage. You can feel them on you. You know. You don't have to look. They're on you. And they're not on you to say, "Isn't he Richard Dreyfuss?" They're on you because you're Hamlet. They're on you because they understand. They're on you because they have to be. Because they're caught up in that thing. There's huge visceral pleasure, sensual pleasure, out of that experience.

EDIE FALCO

1. You are…a mother

thinking about how to tell your children

that you're leaving their father.

2. …a little girl telling your mother

that your twin brother

said a dirty word.

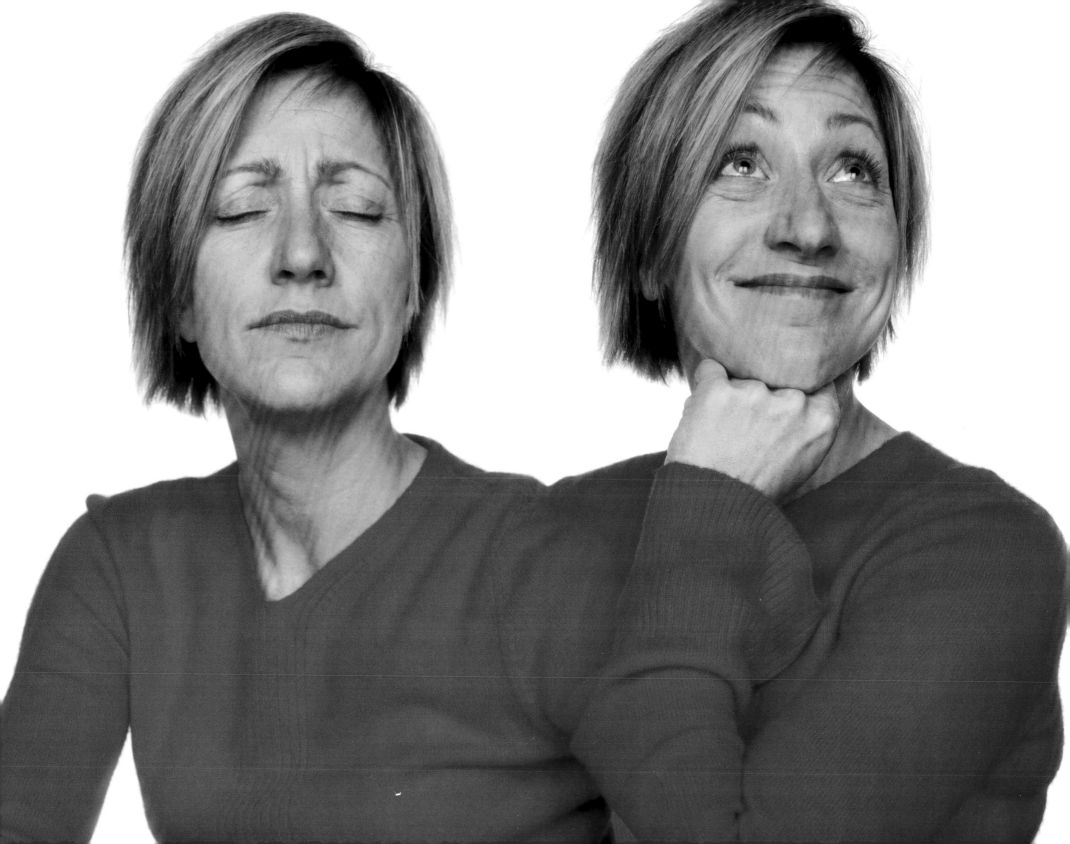

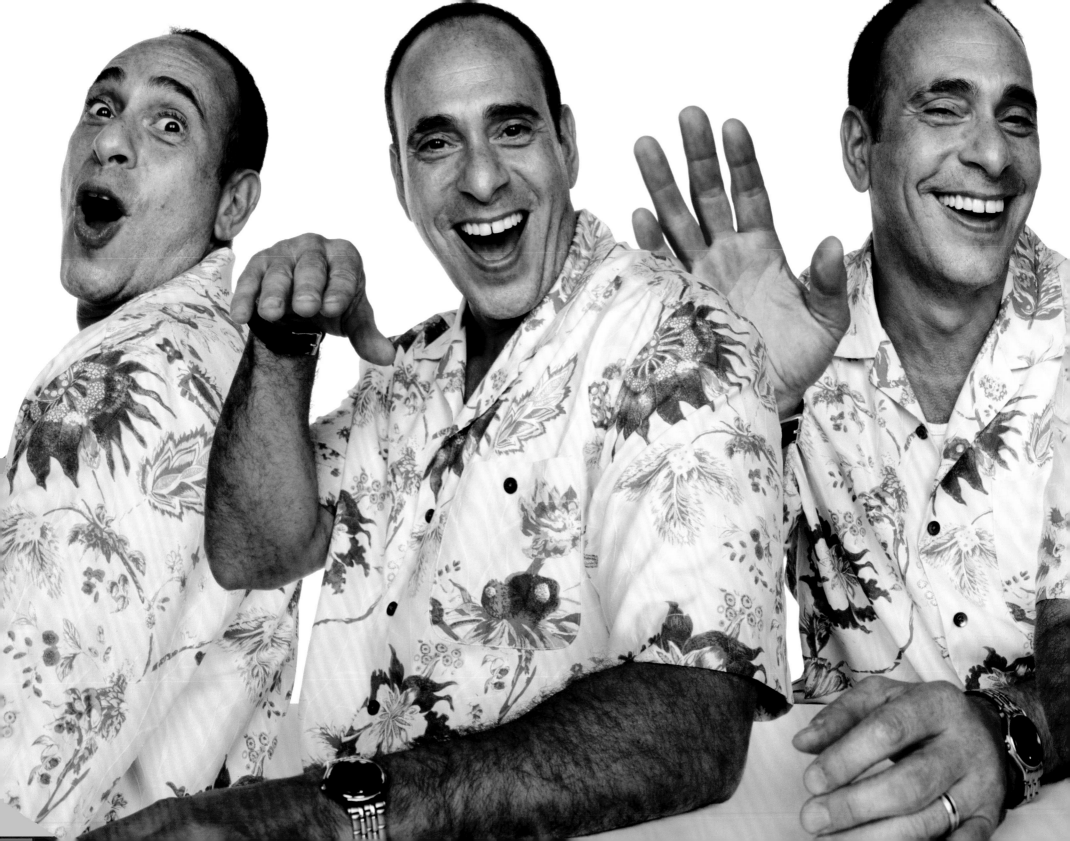

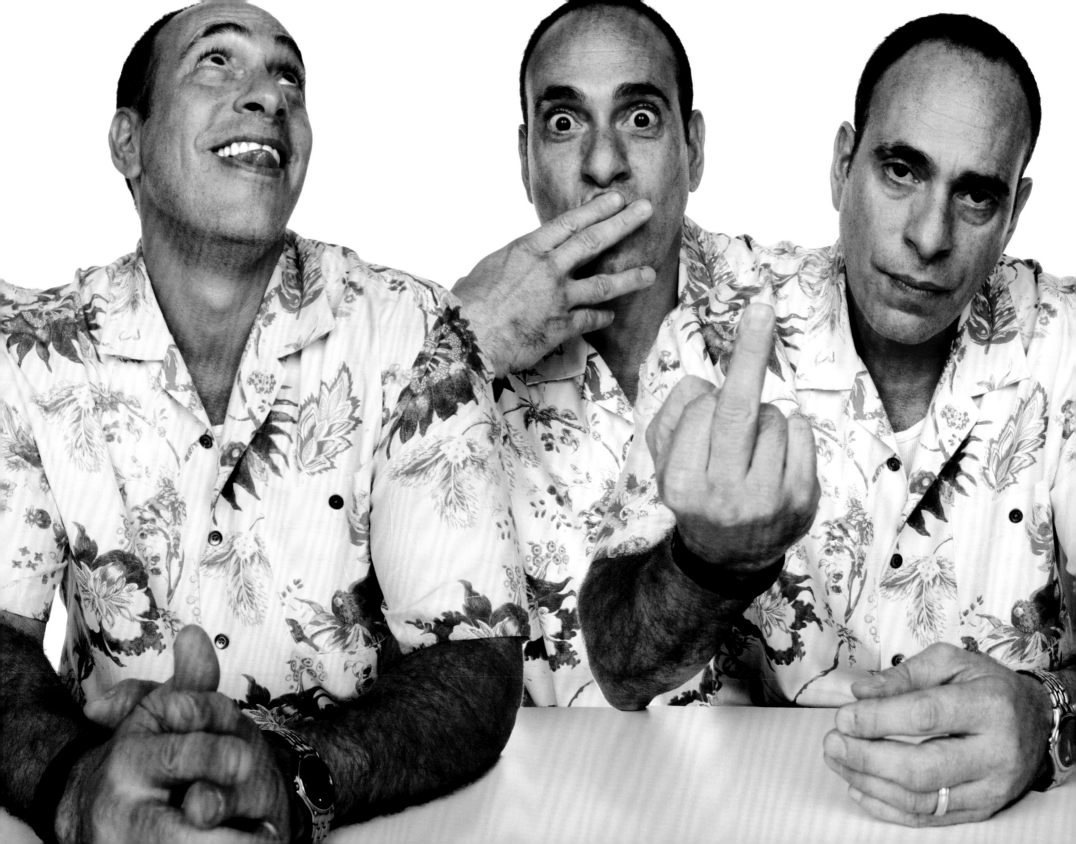

NESTOR SERRANO

You are at a gay bar,

gossiping with a cute guy at the bar

about fashion at the Oscars,

then reacting to your jealous boyfriend.

ROBERT VAUGHN

1. You are…a pediatrician

with a bright five-year-old cancer patient

who is making up an intriguing fairy tale.

2. …a senior senator

giving a speech

on the glory of the American way.

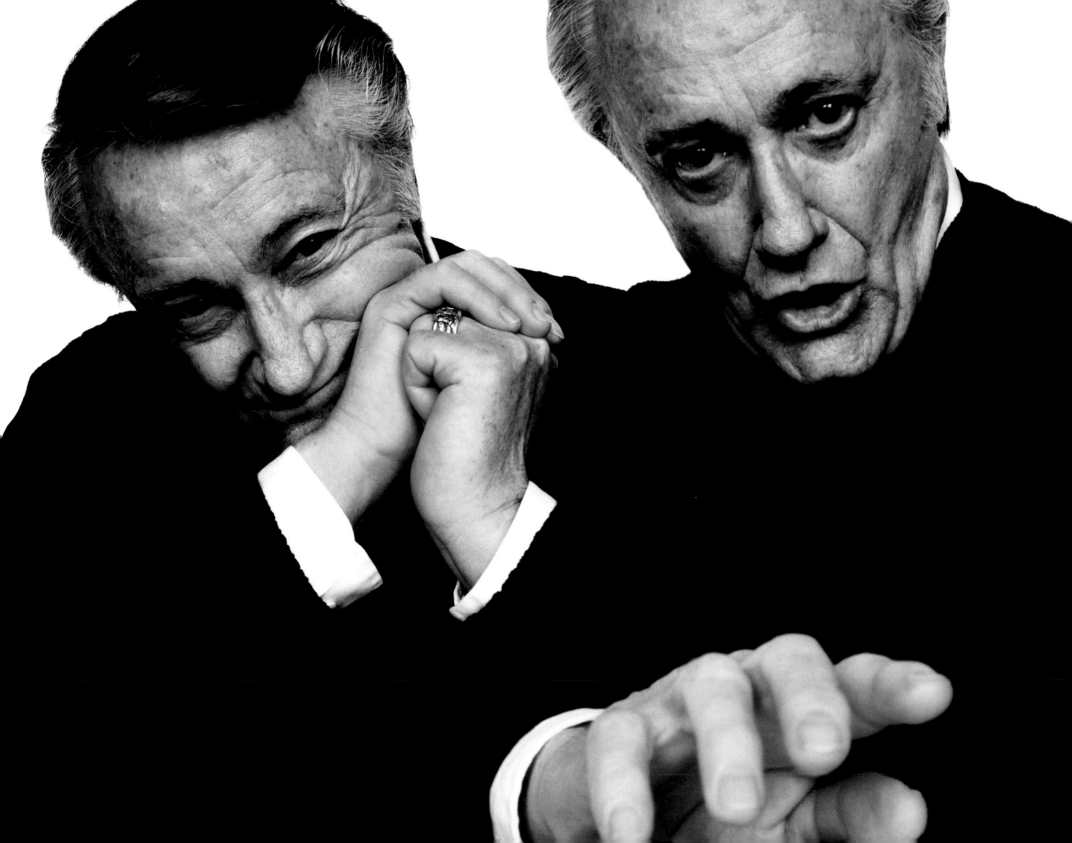

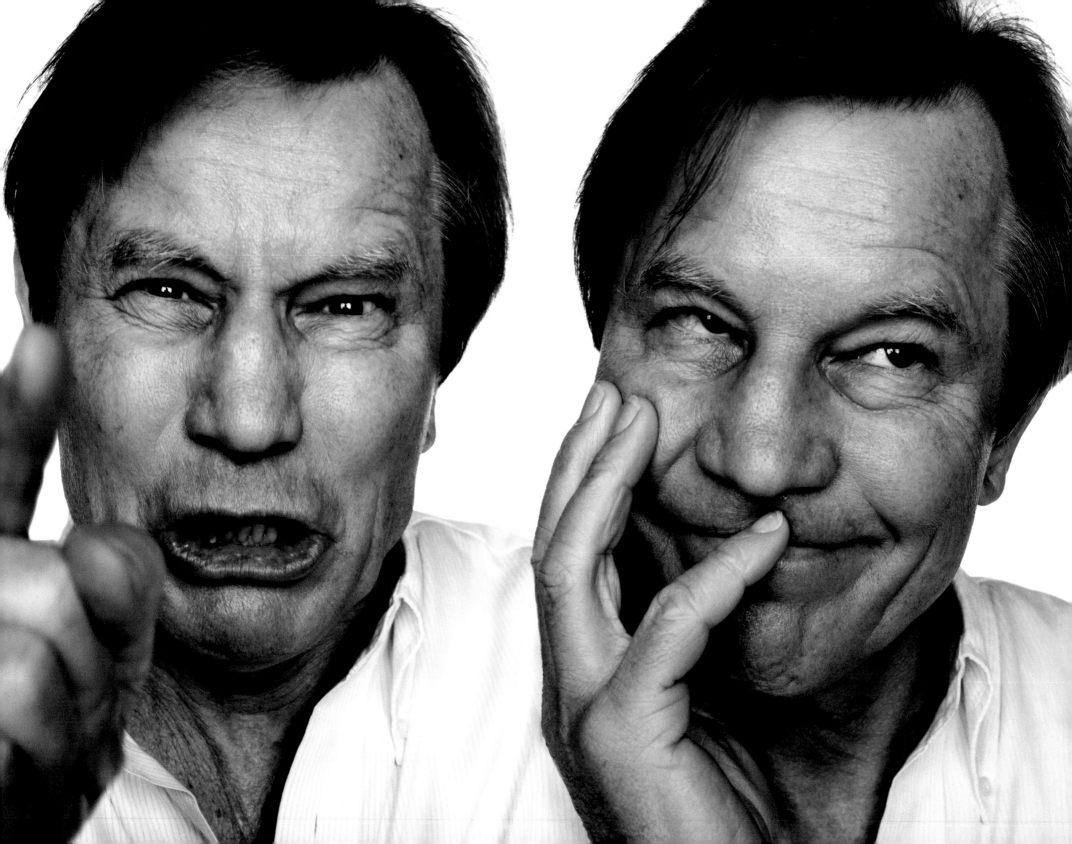

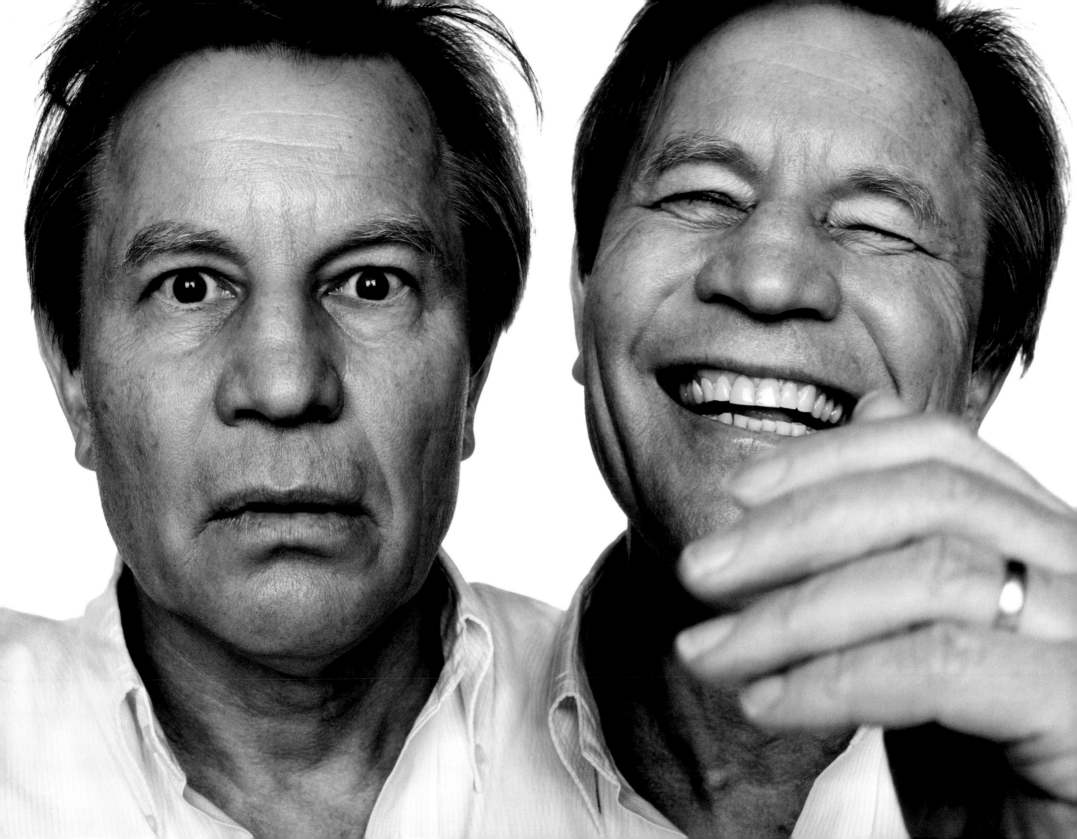

MICHAEL YORK

1. You are…a demented elderly woman

whose children are trying

to put you in a nursing home.

2. …being introduced at a gathering;

embarrassed by excessive flattery.

3. …a train commuter

alone at midnight

retrieving your car from a deserted lot,

seeing a man brandishing a butcher knife.

4. …a fraternity fellow

laughing with your "brothers"

about sexual exploits.

I think it's all imagination –
it's an extension of what we
do as children when we play
make-believe, but maybe with
a more serious purpose. The
great thing about this job is
that there's no cutoff point –
as your age changes, so your
range increases.

FRED WILLARD

1. You are…a maximum-security prison warden

hearing that there's a riot in C Block –

two guards killed, four held hostage,

the ringleader, a multiple murderer,

serving four consecutive life sentences.

2. …a desperate real estate agent

watching a buyer about to sign a contract

for an overpriced white elephant:

"Sign, don't read; sign, don't read…"

I love acting because when it's
time to speak everyone else has
to shut up before your cue.

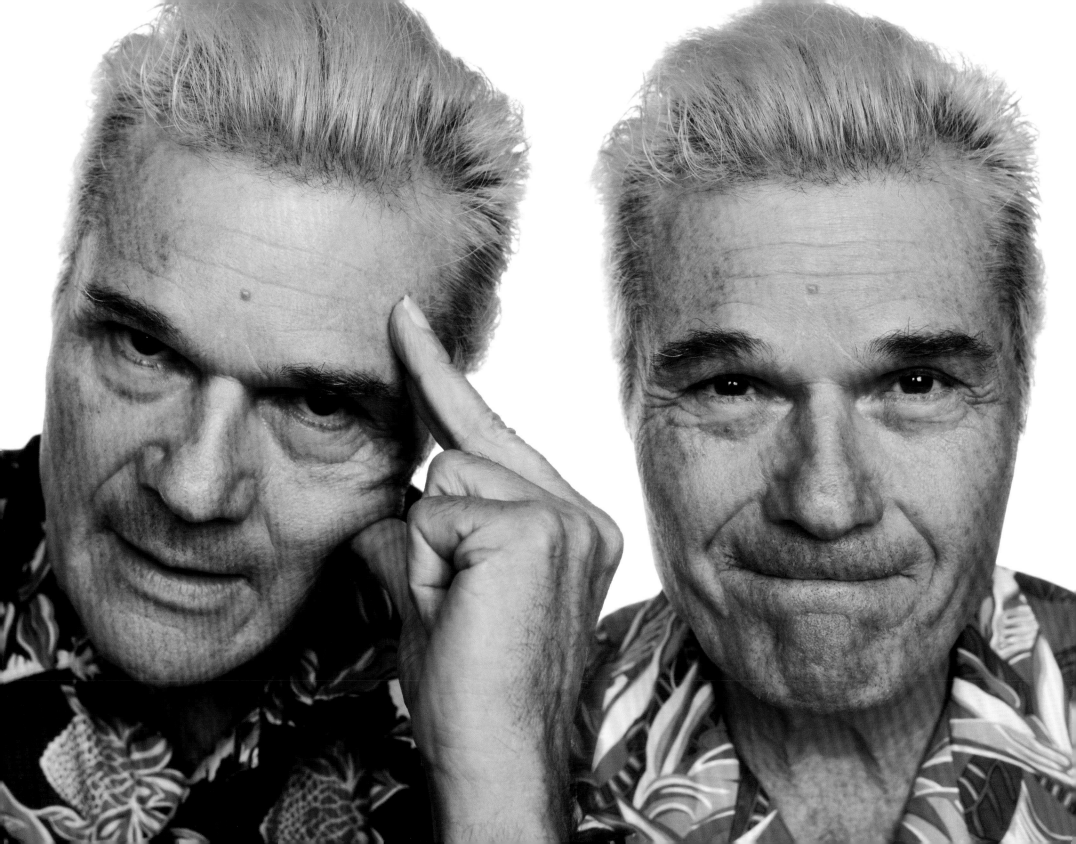

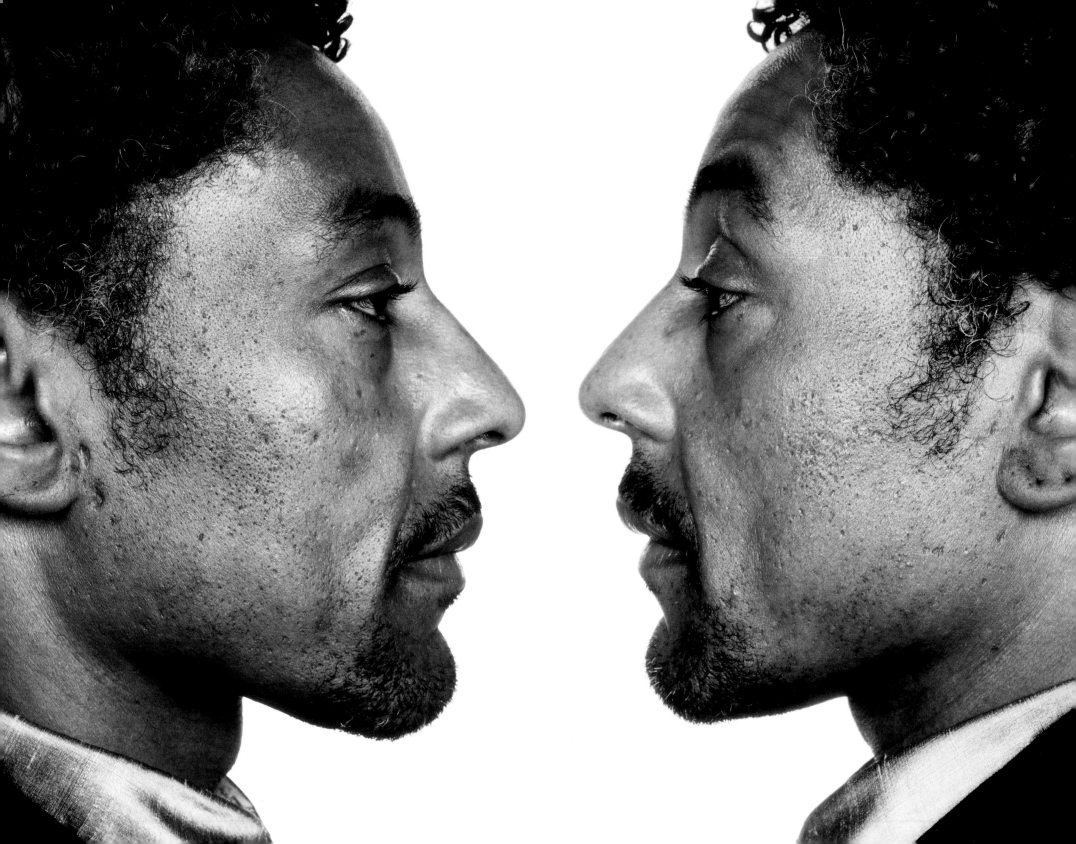

GIANCARLO ESPOSITO

following pages

RICHARD SCHIFF

You are two gang leaders

in a standoff.

1. You are…the host of a dinner, and a guest

has had too much to drink:

"You come into my house and come on to my wife,

and act this way?

What's the matter with you?!"

2. …a law professor putting a wiseass student on the spot:

"And now what would you say to the judge,

Mr. Sullivan?"

3. …an ace relief pitcher

reacting to a batter whiffing on an inside fast ball

for the last out of the last game in the World Series.

Sometimes it is just one little item that will start to give me insight into what a character is. Deciding upon what kind of overcoat the character would wear or what kind of shoes. If I don't know a lot about the origins or the background of this particular character, it might start with what he does.

I start very, very slowly and give myself a chance to incorporate some of who I am into the character so that they become a blend. I look for similarities and things that are very different as well. I decide should I play against certain moments or should I play into them? For example, if the character I just made has some kind of disability, do I want him to hide that disability and not make it seem so pronounced because I'm embarrassed by it? Or do I want to make that disability seen and do I want to elicit some kind of pity from the audience or any other characters I might come into?

I was so scared of being on stage that I literally had to get to the theater at twelve, and I'd start doing warm-up exercises and meditation and vocal work and go through the script, take a break and eat, and do it all over again, so that I was ready by eight to begin this journey. I'm like the athlete who's running a hundred-yard dash fifty times before he runs.

It's like building a ski ramp, so that at eight o'clock, when the lights are up, you can just shoot through the gates, come out, and just fly. That part felt great. But I didn't want to see anyone afterward. I didn't want to see anyone's faces. I just wanted to bury myself.

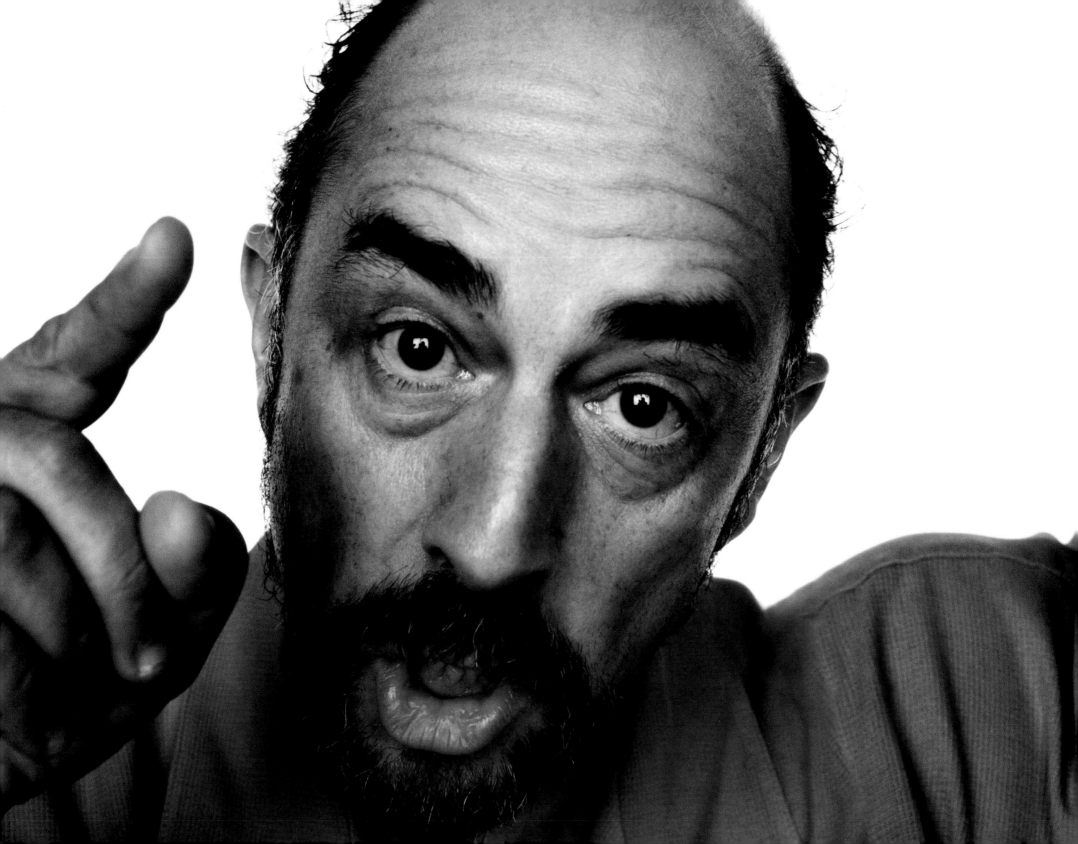

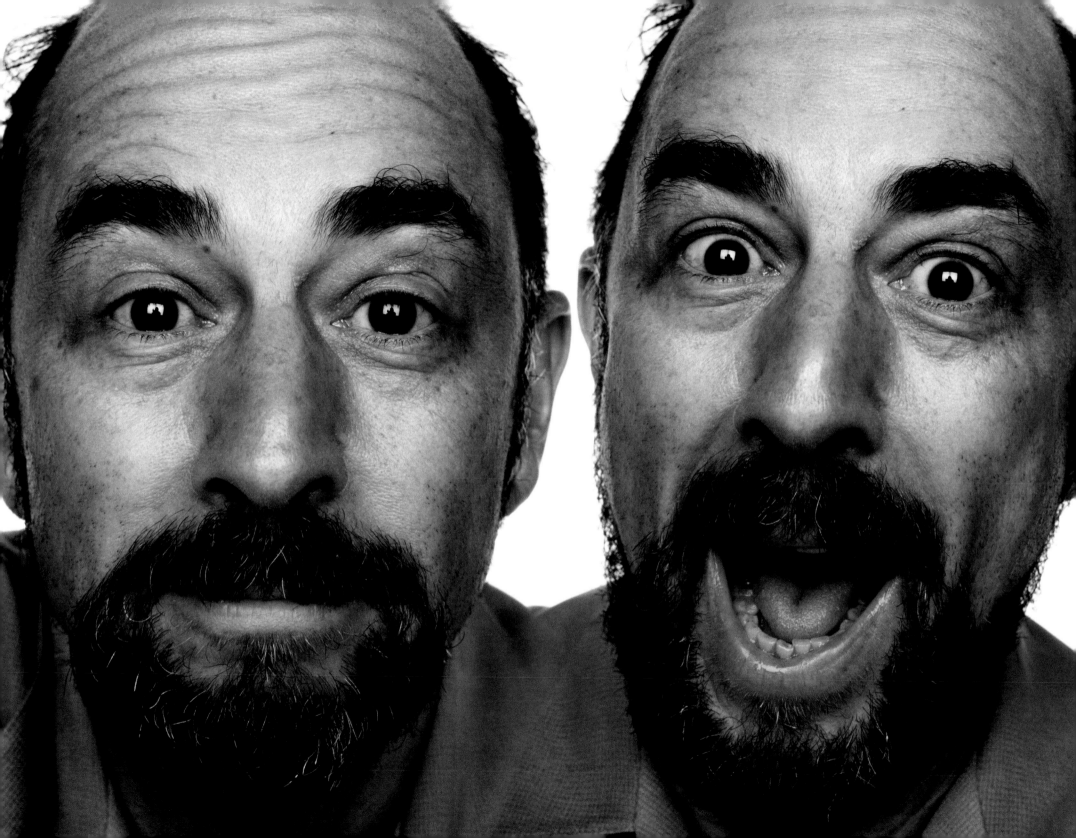

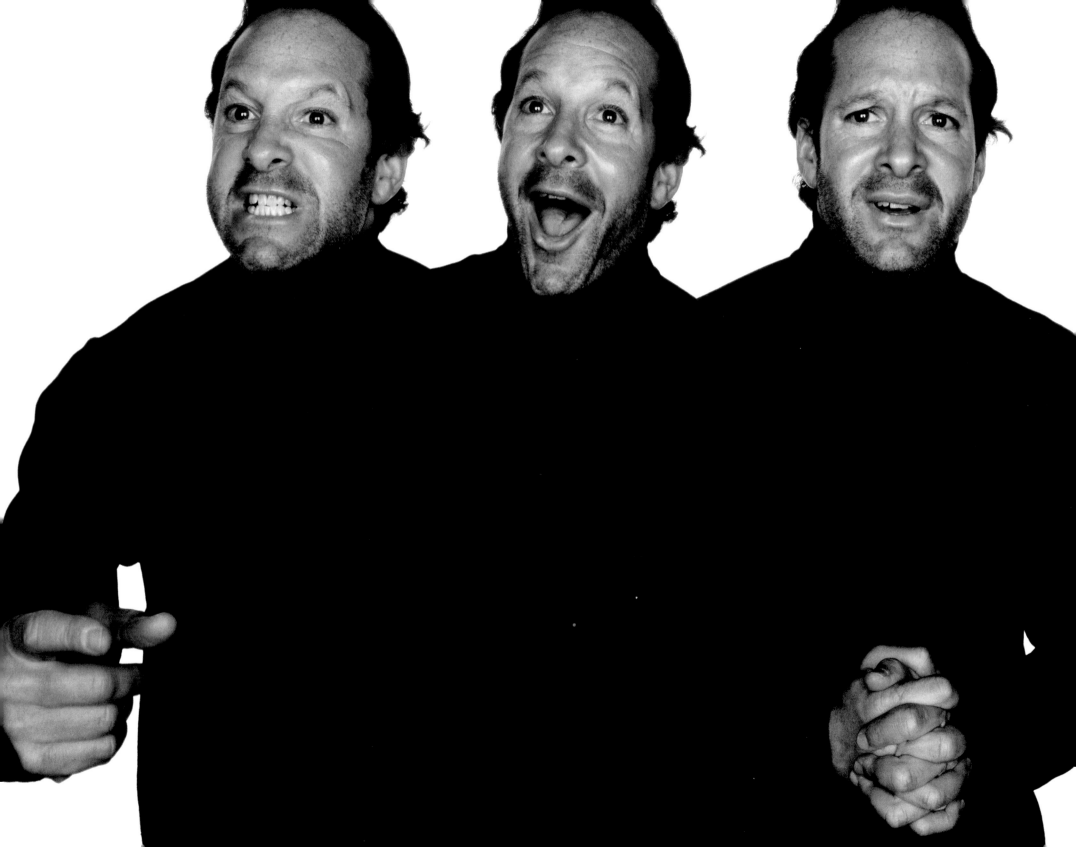

STEVE GUTTENBERG

1. You are…a fanatical

Division III basketball coach

pushing your winless team

on their fifteenth fast-break drill.

2. …a little kid on your first visit to the zoo

as an elephant takes a peanut from your hand.

3. …a married man

begging your wife

for one more chance.

When you are doing eight shows a week there is a routine. You are up at ten or eleven, eat, work out, do a little business, then start thinking about the day, and by eleven or twelve o'clock you are already in the show. You are preparing, you are walking to the theater and you are getting to the theater and you are thinking about that moment at two o'clock when you are on and then when it is over at four-forty you let down and you go back-stage and you relax a little bit and you get some notes from the stage manager or the direc-tor and then you start thinking again about eight o'clock and then eight o'clock comes and you are on and there is a big difference between a matinee audience and an evening audi-ence – a matinee doesn't get as many of the jokes, they are not as hip, as an evening crowd, which is a little more sophisti-cated. But the Tuesday crowd will be different from a Friday-night crowd. A Tuesday-night crowd might be a little more subdued. They just came from work, they've got to get to work the next day, they didn't have dinner or a really great dinner because there's an eight o'clock and maybe they got off at six-thirty and they threw a burger down their throat, whereas a Friday-night crowd knows they have Saturday off, so they can really whoop it up a little bit more.

Actors' Notes

RICHARD DREYFUSS

I said to my mom one day when I was nine, "I want to be an actor." And she said, "Don't just talk about it." And I got up from the table and I walked down to the Jewish Community Center and I auditioned for a part and I never stopped, ever. I mean my ambition, my acceptance of my designation as an actor, my self-definition, my ambition to achieve it totally and completely, were all born in that instant. Like the big bang theory.

I did plays from then on without a break, at temple, at high school – within a year or two within legit theater, equity theater in L.A. with real actors, and without exaggeration there was really no month that was not devoted to acting. I had a nuclear pellet. It never wavered and it never ended and it never weakened. And it was a pulsing, driving, absolute part of my life that created all my momentum and absolute certainty about my future. So that I went through all the years of teenage struggling and looking for work, and TV and agents and all that, thrilled. Thrilled because I absolutely knew that at the end, I would make it. Absolutely without question.

I actually once taught a class in "How to Be an Unemployed Actor in Los Angeles." And when I had made it, I taught these kids, five hundred SAG members, how to schmooze agents, how to make casting directors your best friends, how to do this, how to do that. And it was because I had had such a ball in those years. I was not fraught with discontent or any angst. Not at all. All my angst was reserved for the rest of my life.

If an actor asks me my process, I say I don't have a clue to my process. I just see it like it is a suit of clothes across the room, and my business, my obligation, is to walk across the room and get into that suit of clothes.

GIANCARLO ESPOSITO

I learn more about my personality every time I take on a new character. It started out to be a way to escape the doldrums, to escape the real world. I had a difficult childhood and for me acting was a way for me to make it brighter and happier. When I act I become very focused and I get a better sense of who I am and so it was always a way for me to transcend my own personality and to be all of these other characters I couldn't be in real life.

There are times that I've come home and realized I'm very much like this guy I've been playing. I remember doing a very powerful piece – what I had to go through emotionally to play this character every day was a lot. Each night at the end of the show it would take me at least an hour to sort of come down and be able to feel Giancarlo again – to feel like I wasn't this young man who was always angry and looking for a fight.

MICHAEL YORK

You can be very pretentious about this business and say that the drama comes from this long line of psychotherapy. And indeed, I worked with Olivier – he was quite adamant that the actor's place in society was as important as that of a doctor or psychiatrist. And occasionally you can do projects that are really important. You have a sense of them changing the way people see the world, and hopefully for the better. But for the most part it's entertainment, and I look for creative entertainment.

STEVE GUTTENBERG

Especially in the arts, whatever you make of yourself is going to come out in your work, so my job is to make myself a better person all the time, be proud of myself, like myself, love myself, be proud of my accomplishments, of how I handle myself, how I deal with things. So when I have to act I'm pure. I'm right there. I am able to concentrate and give the best I have inside, and maybe the muse will visit me that day.

I could easily say it's the craft, it's the technique, it's the ability to bring someone's words to life and knowing that when you speak it is the truth and it will have an impact on your fellow actors and the audience that's watching it. But really it's the power, the fame, and the money, which is very exciting.

FRED WILLARD

Unless you're Jerry Seinfeld or Robin Williams, I don't think you ever walk off stage and say, "Wow, that was great." A ballplayer can hit a home run, but when you get up on stage, there's no home run. It's infinite. You can do a good job. You still think, "Maybe I could have done it a little better."

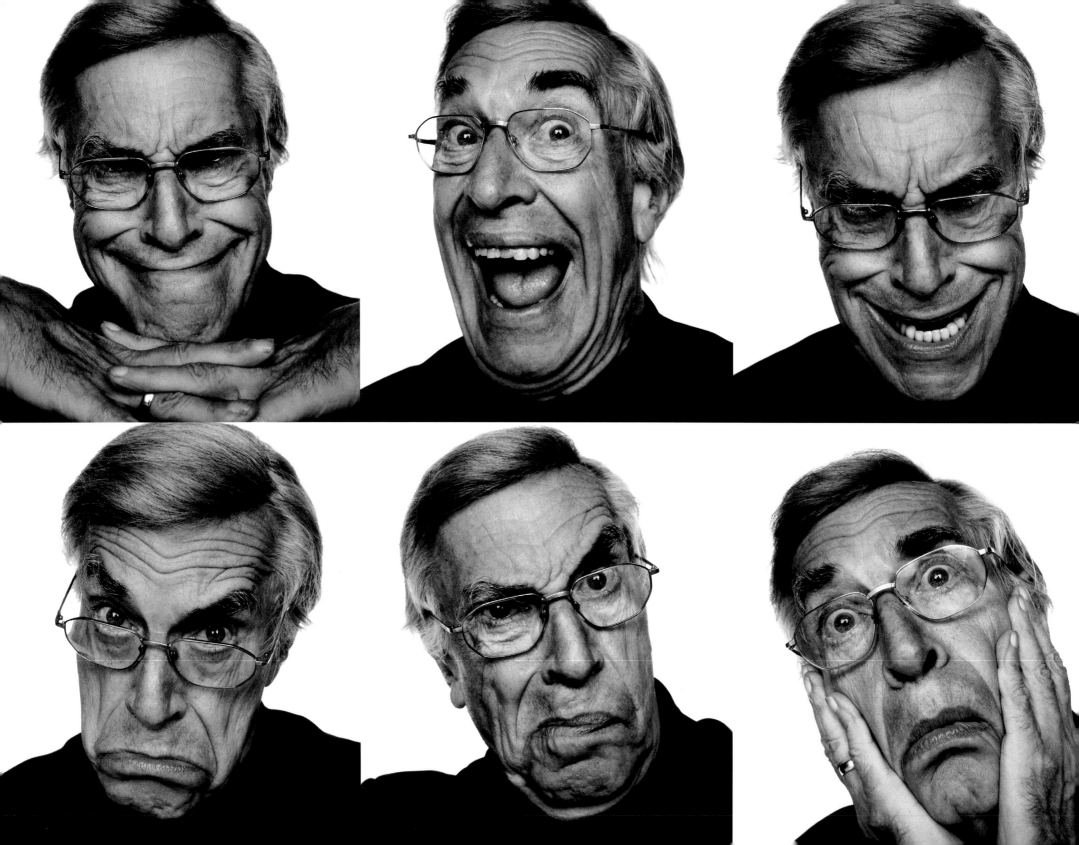

Comedy

First Intermission

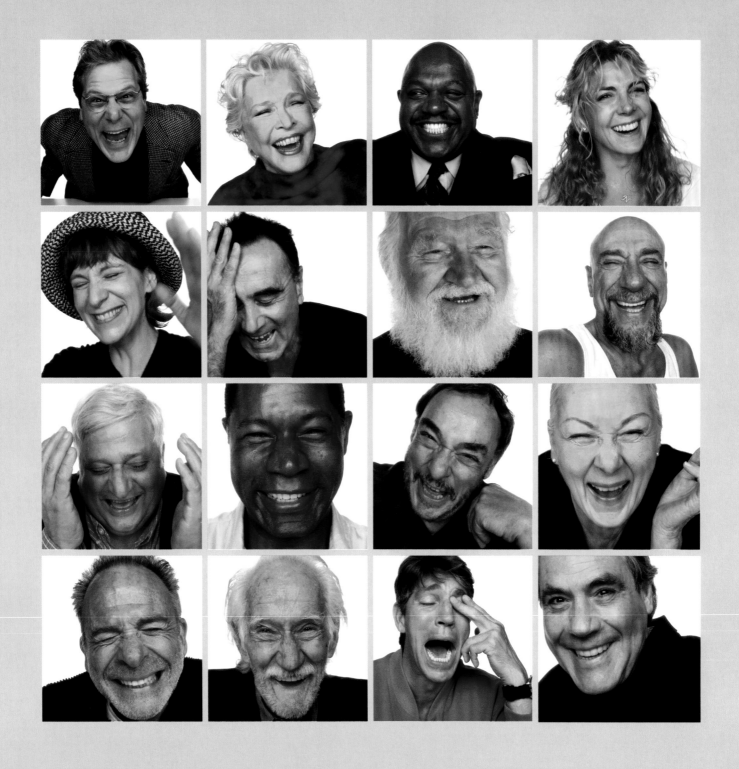

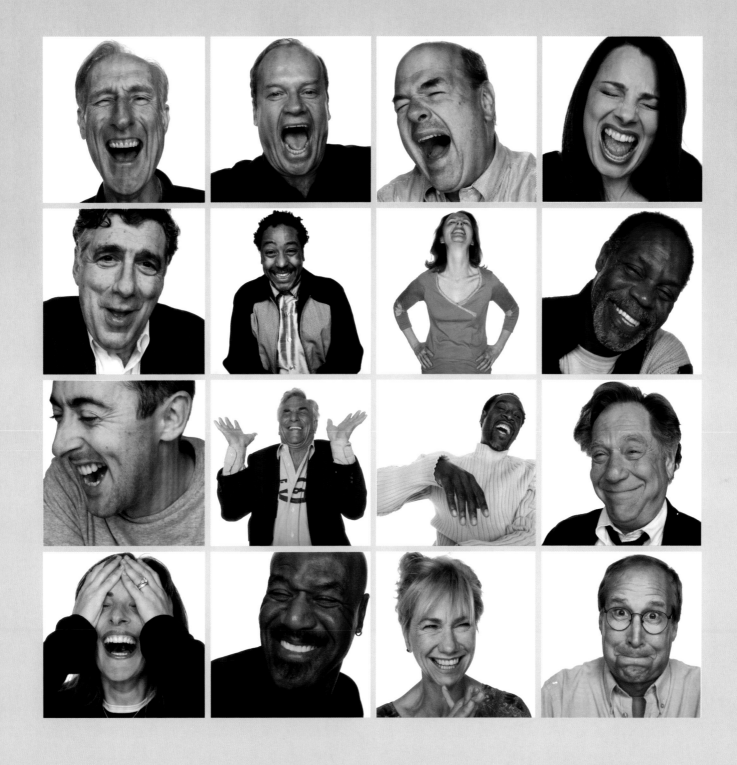

Act II

The Players

MARTIN DONOVAN

MELISSA LEO

LARRY MILLER

CHRISTOPHER LLOYD

PHILIP BOSCO

DAN HEDAYA

CHARLES S. DUTTON

HUME CRONYN

JOHN C. McGINLEY

ELLEN BURSTYN

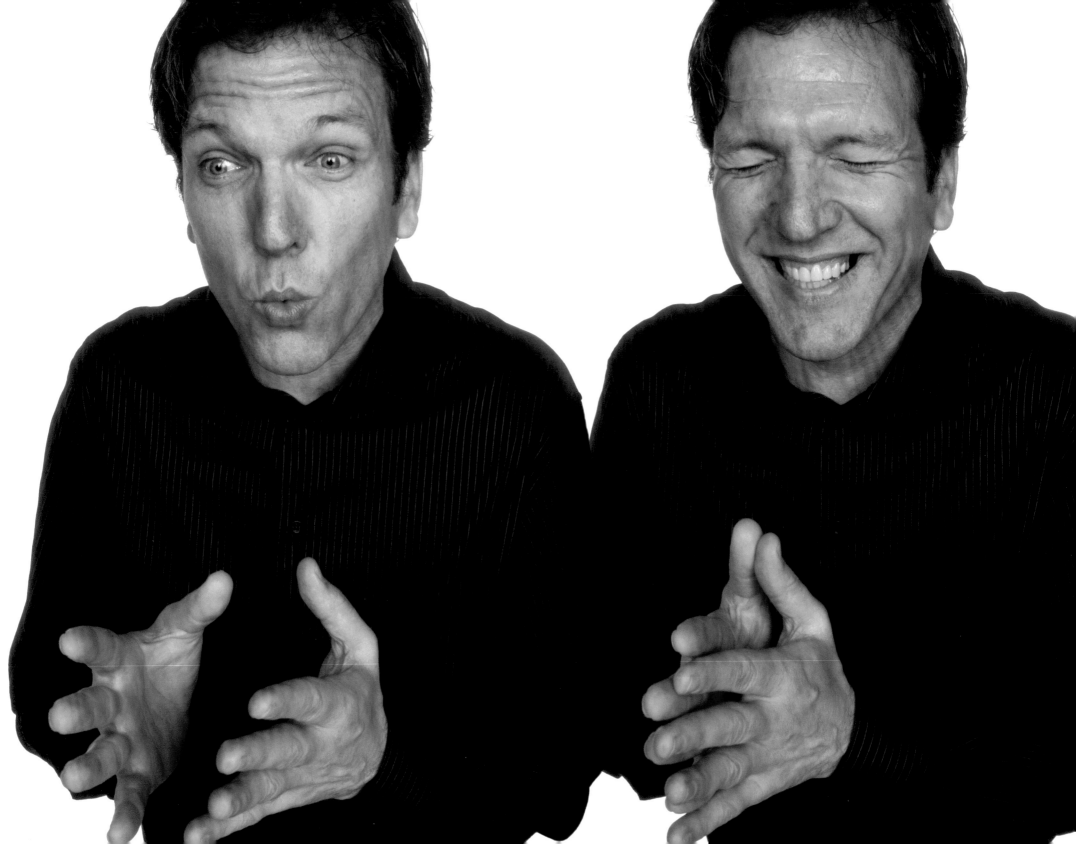

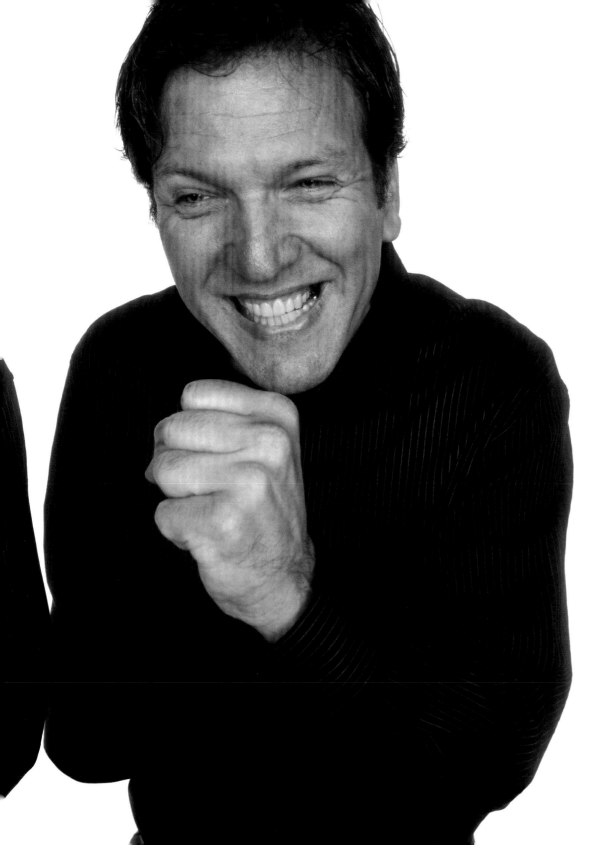

MARTIN DONOVAN

You are a father
 watching your baby daughter
take her first step,
 fall down,
get up again,
 take two wobbling steps,
 fall,
 get up again, giggle,
and waddle across the room.

All the excitement and the sounds of the audience rustling before the performance – the darkness, and then the lights come up – I don't remember being terrified. I got terrified later. Fear of failure, fear of humiliation, fear of being judged. There was a certain amount of anxiety in general about myself, and then acting became the most difficult thing that I could choose to do. That's one of the reasons I forced myself to do it.

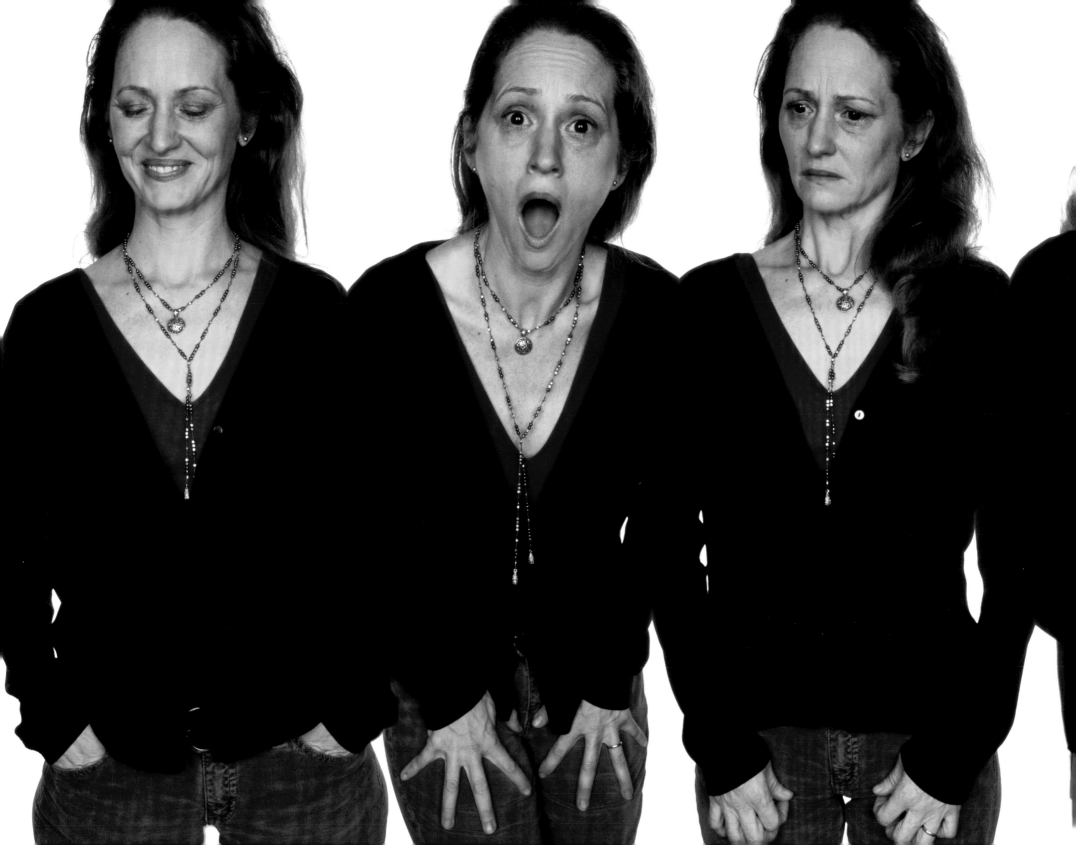

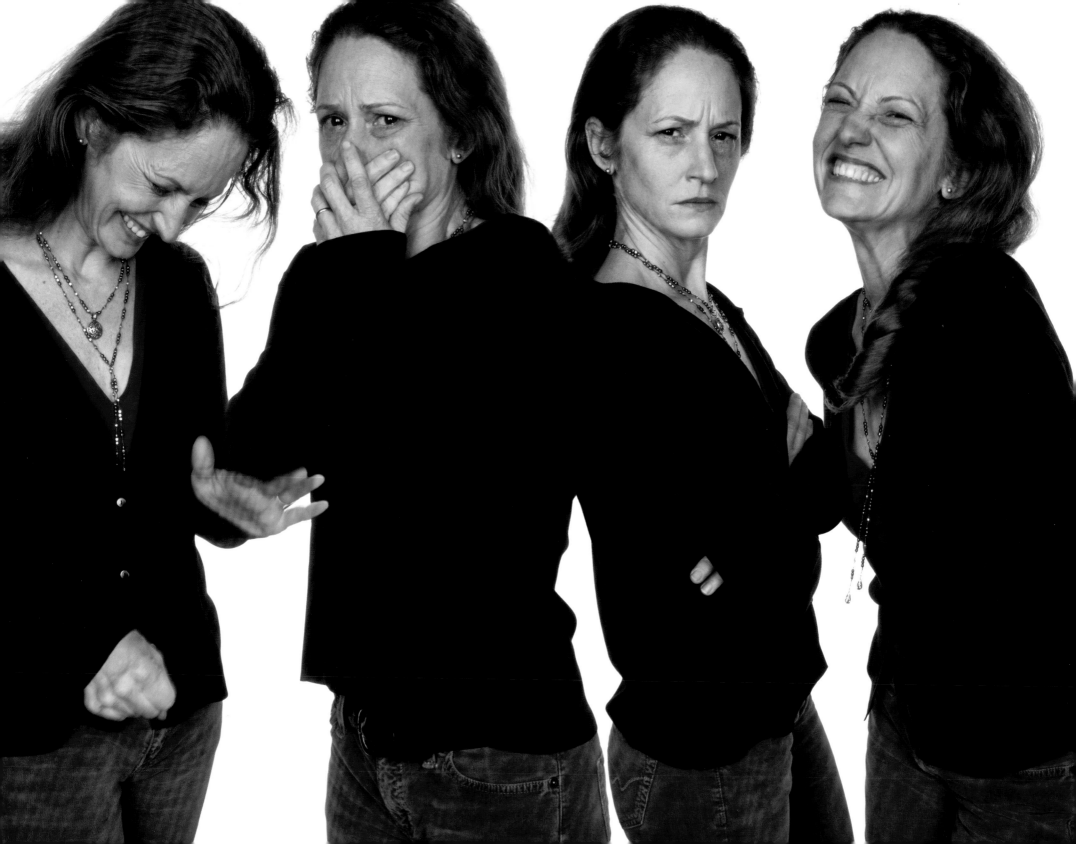

MELISSA LEO

1. You are a thirty-year-old mother of two…

being flirted with

by a good-looking woman at a PTA meeting.

2. …hearing from your daughter that there's a rumor

you're gay.

3. …trying to decide whether to tell your husband

about the rumor before he hears it from someone else.

4. …making a joke about the whole thing with your husband.

5. …hearing him say that he thinks maybe you are gay

because you're so boring in bed.

6. …telling him that if that's the way he feels

maybe he should move out.

7. …at a party with your beautiful new girlfriend.

Theater is this ancient art. Drama is a mirror for humanity to look into and understand ourselves better. I think that actors know human behavior better than others. As an actor my life's study has been human behavior. I think I could have easily avoided knowing who I am. I think a lot of actors, myself included, act so that we don't have to know ourselves. I think being an actor, you can hide behind the character all your life.

LARRY MILLER

1. You are…an eight-year-old girl

who just spelled "onomatopoeia"

to win the National Spelling Bee.

2. …a power forward

just elbowed in the chest by an opponent.

I want to be a performer, I'm meant to be a performer, I'm meant to do someone else's work, I'm meant to be molded, I'm meant to work with a director and to be as empty a vessel as I can be.

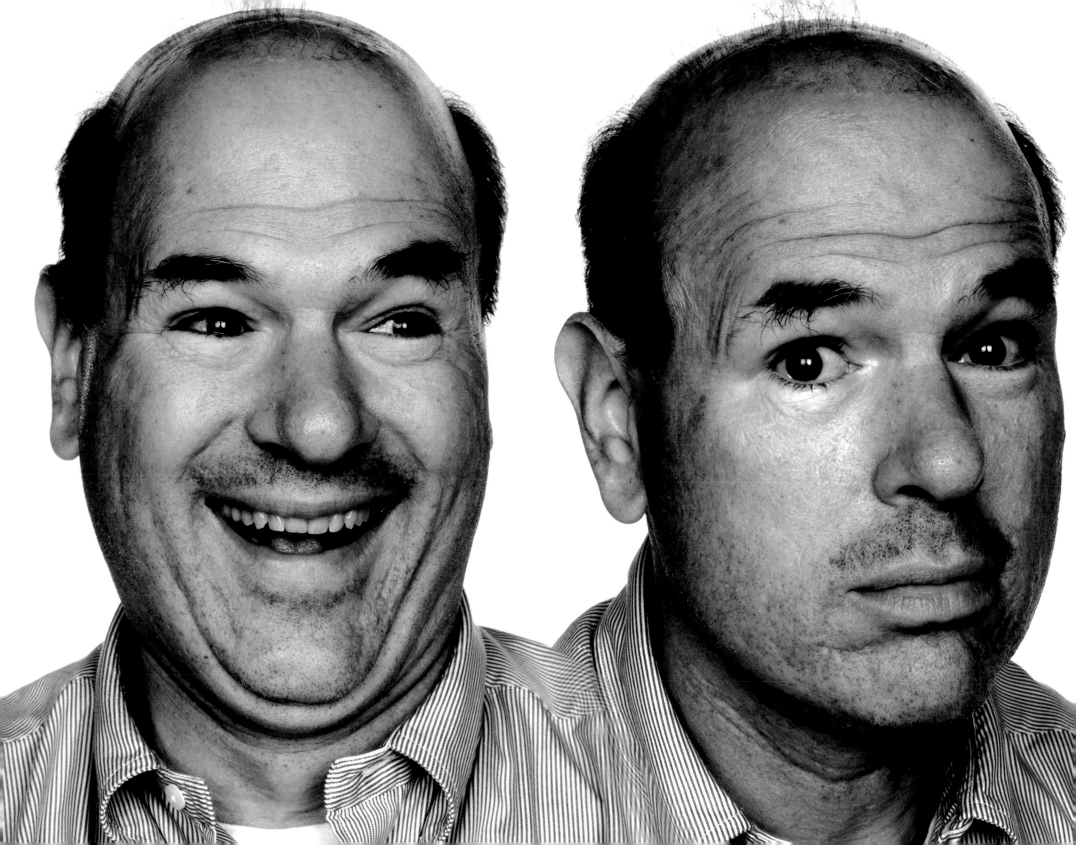

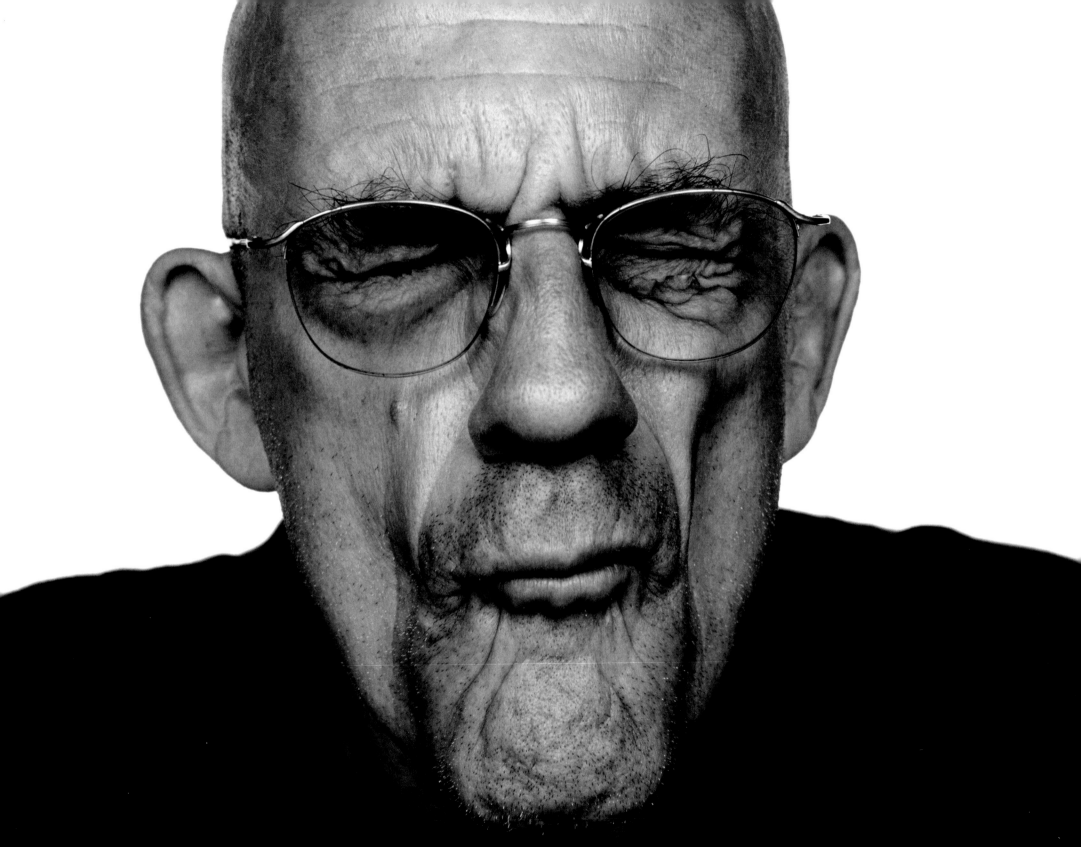

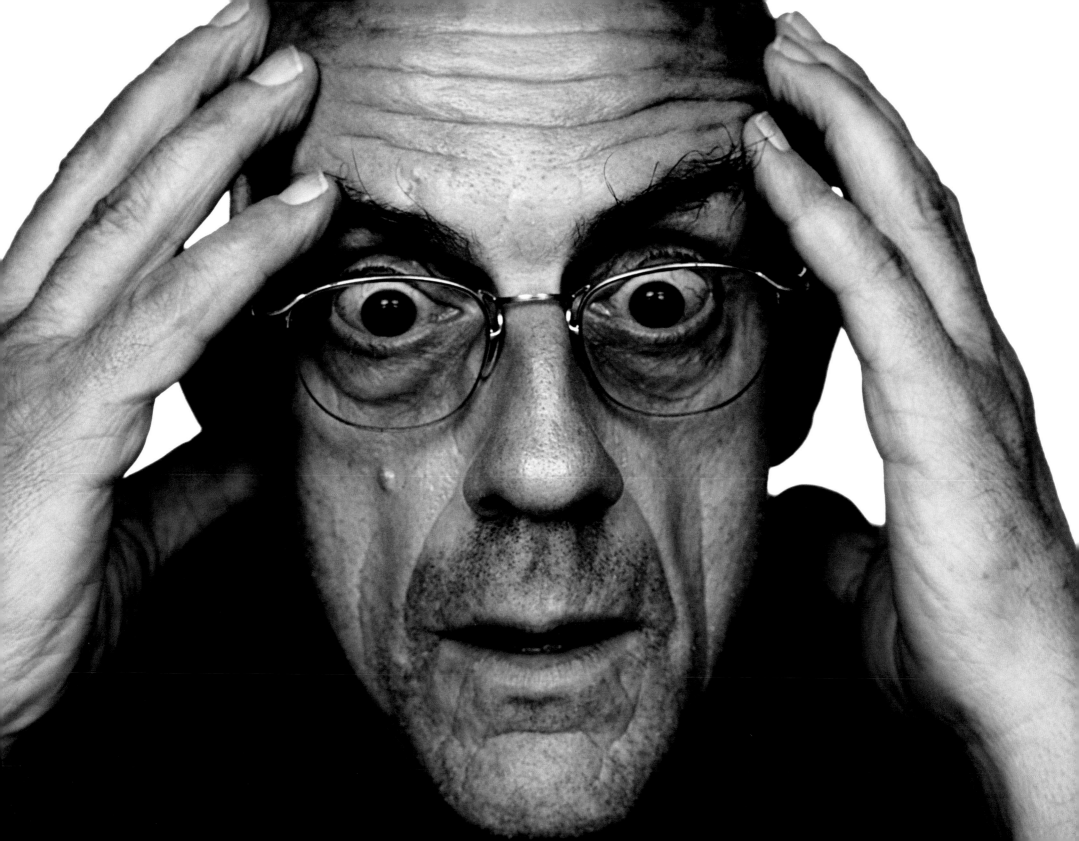

CHRISTOPHER LLOYD

1. You are…a violin teacher

hearing a prize pupil

massacre a Mozart cadenza at a recital.

2. …a father left at home alone

for the first time

with your fourteen-month-old triplets,

all of whom are now walking.

I started out in theater. I feel I'm on home base with the theater. I love doing film, but being on the boards, being where it all began – you don't get that from film. In the theater you're just out on stage on your own. You're much more vulnerable. Being up on stage and being able to convey some sort of universal feeling or thought about a character or an issue, and sensing the audience is picking up on that – that you're able to be the instrument of transferring that thought – is very exciting. Once the lights go up there's no turning back for a retake or anything. You dance on a high-wire there. Continuously trying to monitor your sense of where the audience is at or whether you're communicating. There are moments when the silence in the audience tells me that they are really, really plugged in to what is happening on stage. And that's an excitement that beats all.

PHILIP BOSCO

1. You are a man…

telling your family

that your cancer tests indicate good progress.

2. …later,

alone in your room,

thinking about what your doctor really said.

All you really need to do on stage is have a good play, a good script, with good actors. The rest of it is almost unimportant. Adornments are unnecessary. The quality of the writing and the quality of the acting make everything alive.

In the movies, it's quite the opposite. Most all of the time is spent on the lighting and the set design and the costumes. Everything is technical and it's all done in pieces, and the editor is so important, and the director, and the lighting. The actor is almost an afterthought. I've been in about forty movies, and I've learned enough to know that you're so terribly unimportant in the grand scheme of things.

You do very little acting in movies, and when you do, you work in spurts of a minute and a half. If you play one scene that lasts longer than two minutes, people applaud. On the stage, you'll be on stage an hour and twenty minutes by yourself. It's an entirely different experience. You don't feel important in movies. You feel a part of a very complicated jigsaw puzzle.

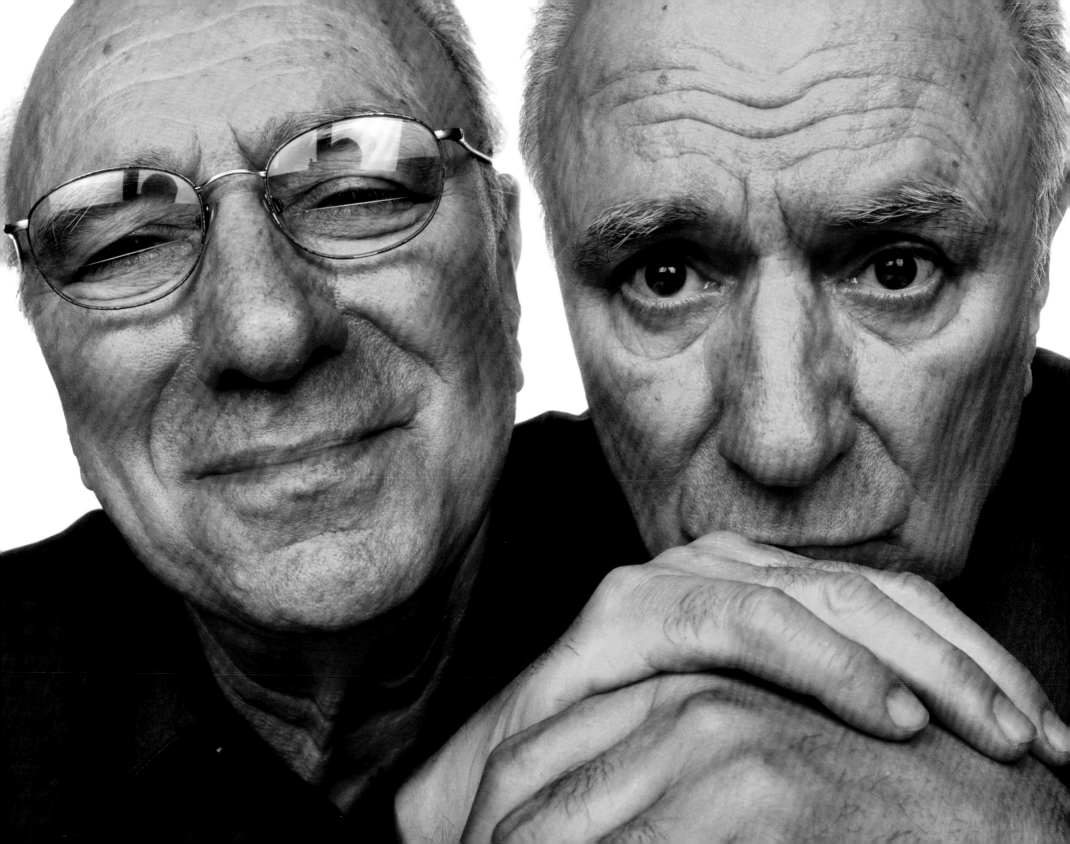

DAN HEDAYA

1. You are...an inventor
with a string of failed gadgets,
 begging your
 skeptical brother-in-law:
"Just do me this
 one last favor and I swear,
when this thing hits,
 I'll make you rich."

2. ...a cross-country truck driver
 on a Kansas highway,
snapping out of
 a momentary doze to see
that you're in the oncoming lane.

3. ...a retiree who has just
 lost your entire
Social Security check
 at the track.

I like to tell stories. I like to
communicate. And it's fun –
on a very simple level, it's fun.

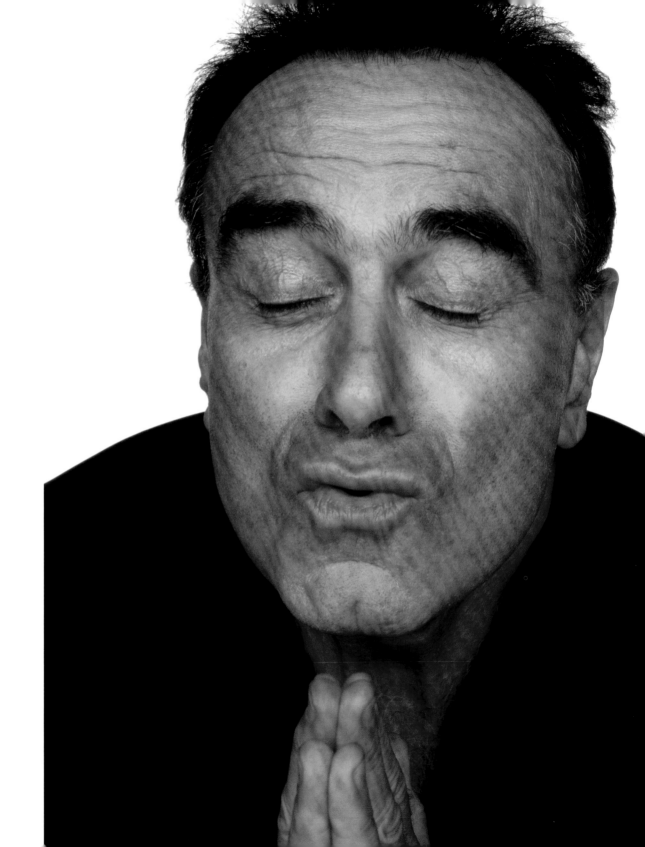

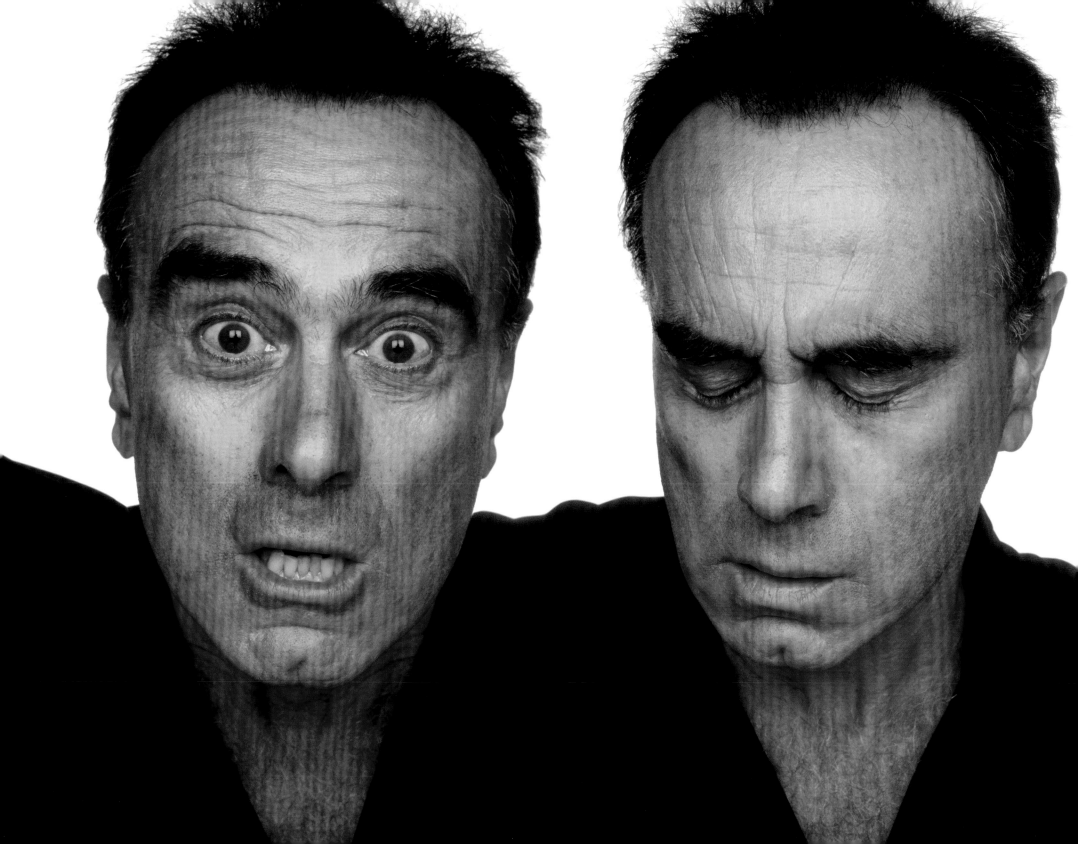

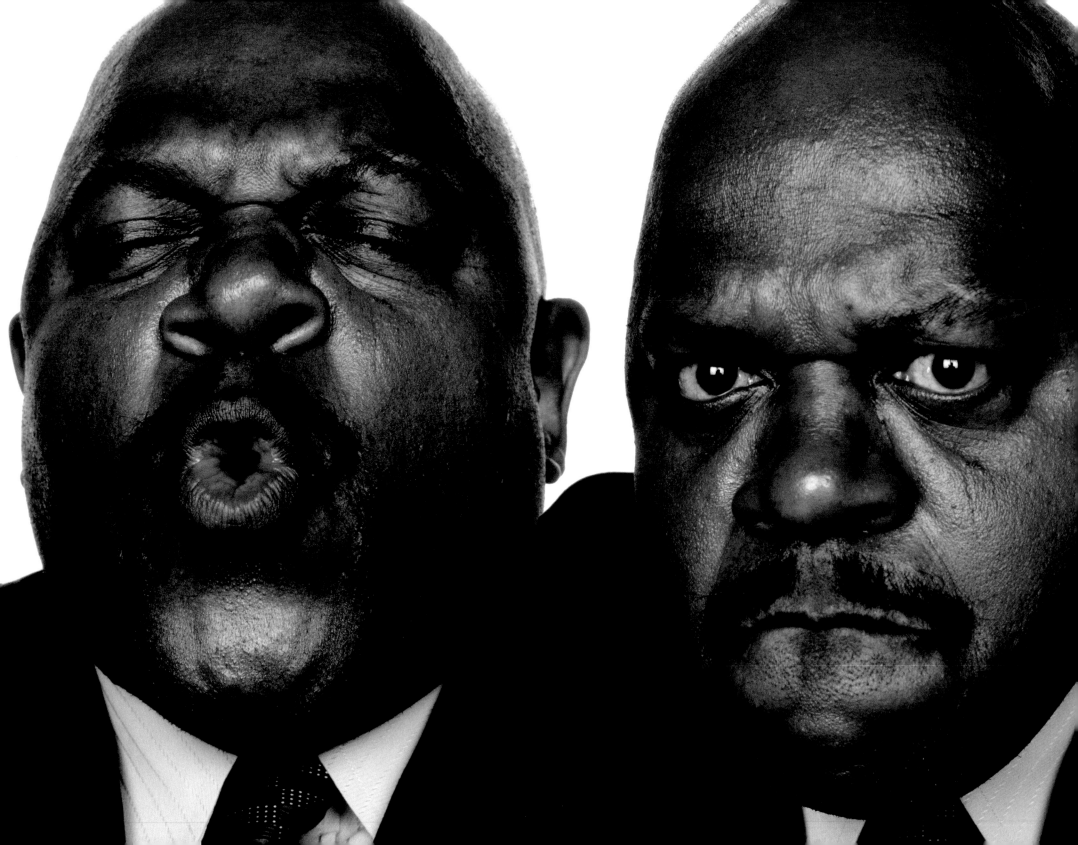

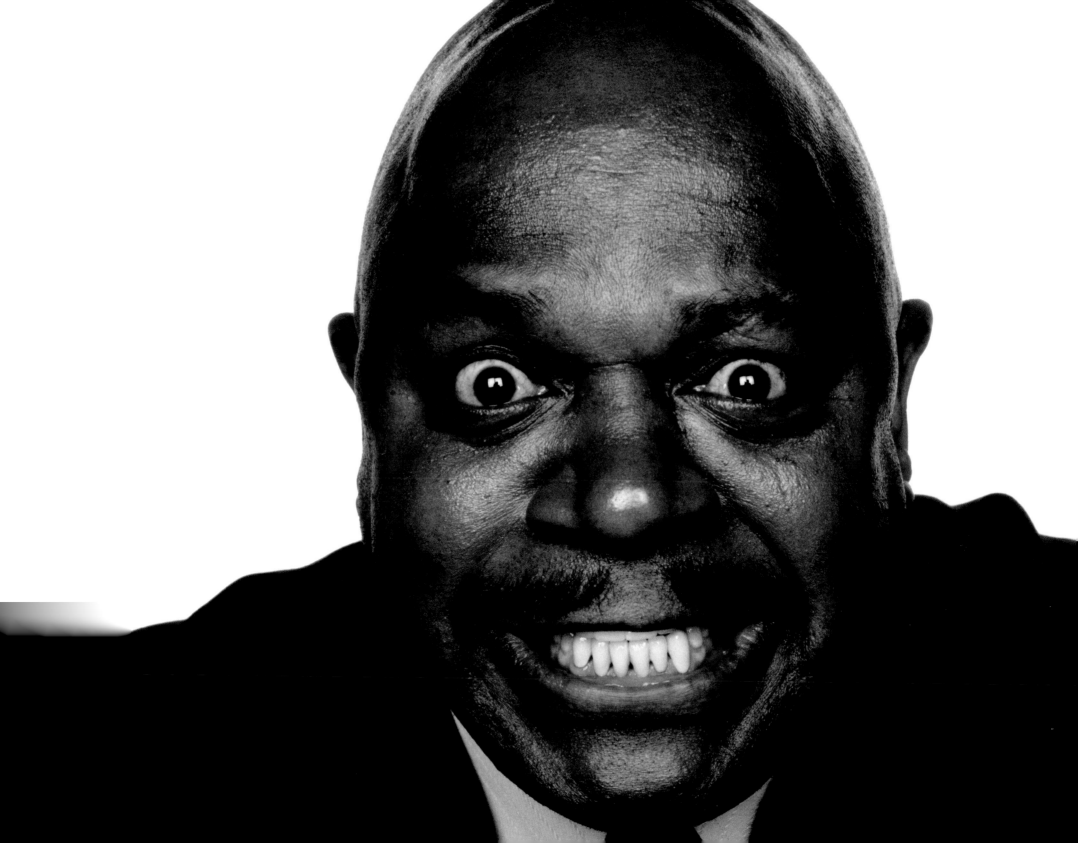

previous pages

CHARLES S. DUTTON

1. You are…a salesman back from a long road trip

being welcomed by your wife

in a particularly intimate way.

2. …a small-business owner just realizing

that your brother-in-law has been pocketing the profits.

3. …a gambling addict, deep in debt to a ruthless bookie,

urging your horse to pass the leader down the home stretch.

To me, going on the stage is the most beautiful violence one can engage in. I look at the other people on the stage as opponents. And before the night is over I plan to knock them out.

I look at the stage as a physical endeavor. I'm going to have more stamina than you. I'm going to have a stronger voice than you. I'm going to have more emotional depth than you have. And I'm going to perspire more than you do. In the end, you're going to be counted out.

I was taught to view the stage as a physical challenge. I don't think you're good on the stage unless you leave an ounce of your internal essence on that floor every night. I'm not the kind of guy who gets so over-wrought intellectually with a character. To me it's a visceral thing. The most intelligent actors are the visceral actors because the intelligence comes through the doing of it instead of the thinking about it. One simply does it by committing to it fully without fear of failing. Character comes in the pursuit of the character. When it's organic you don't even know you're doing it.

HUME CRONYN

1. You are…a judge

listening to a child molester

beg for a leniency.

2. …a Seventh Avenue dress manufacturer

finding out that a competitor

has two thousand peasant-style wedding dresses

he can't sell.

56

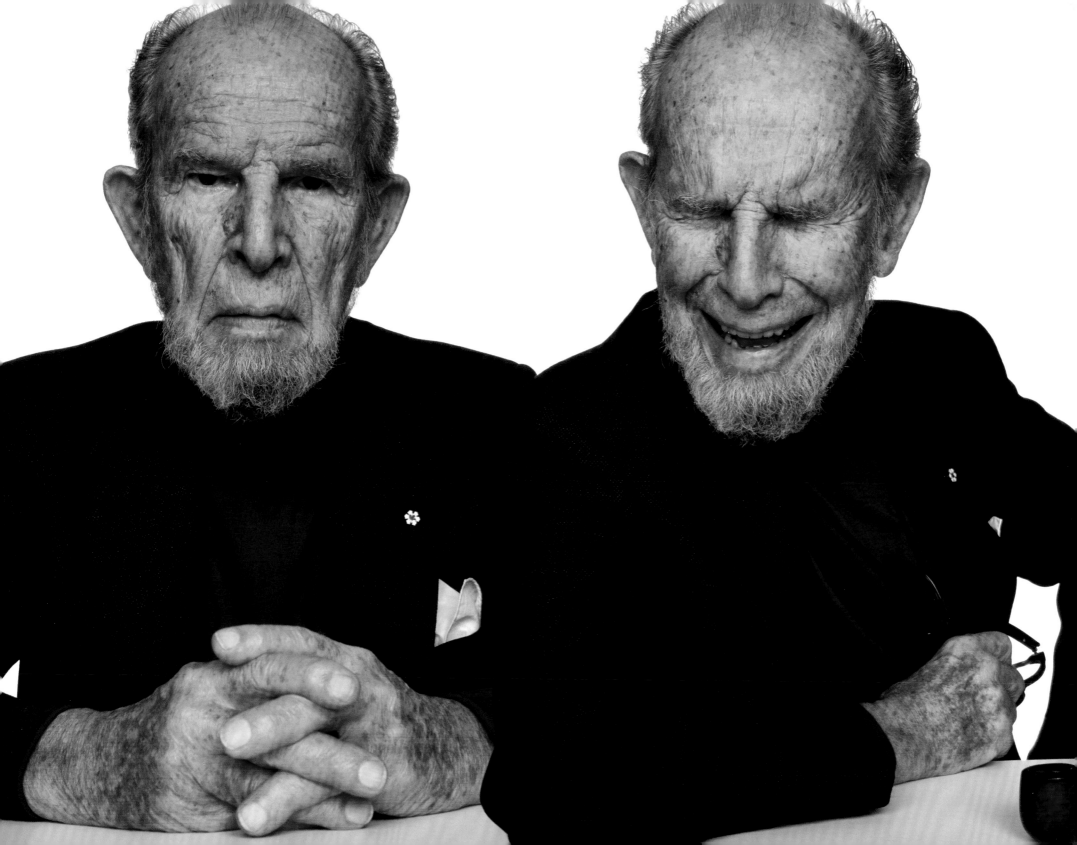

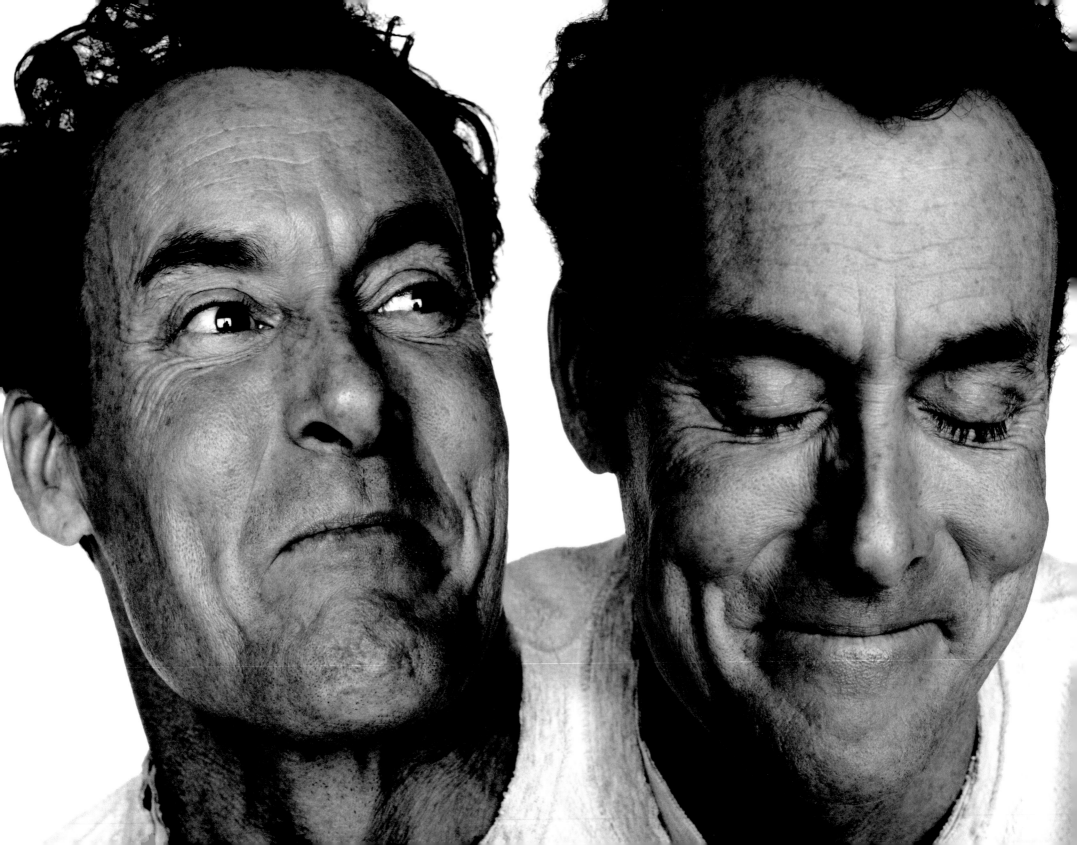

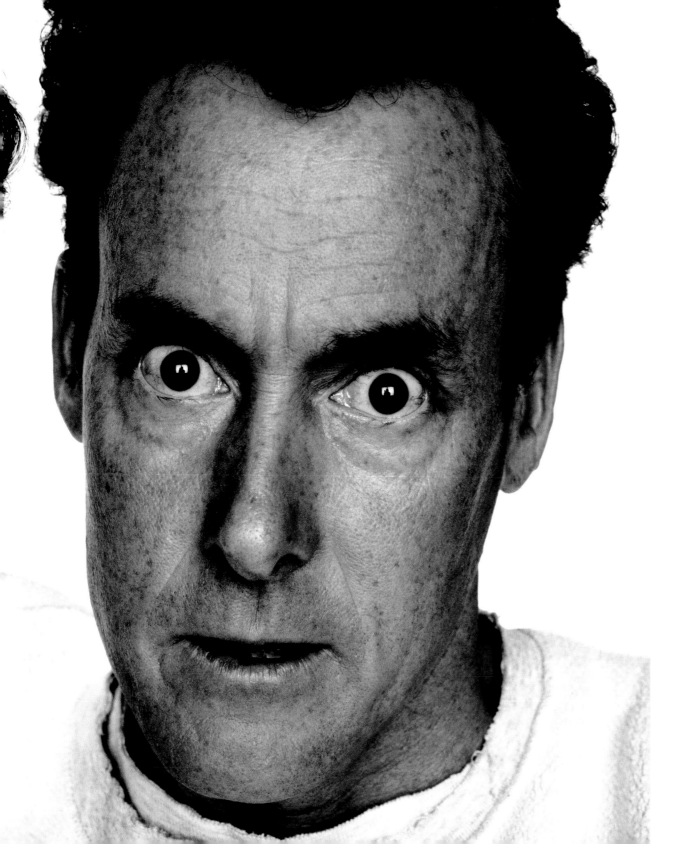

JOHN C. McGINLEY

1. You are...a soccer dad

whose daughter

has just scored

the winning goal

in a championship game.

2. ...a man whose girlfriend

has just said,

"If I could have asked God

to design me a man,

I would have had Him

design you."

3. ...a Hells Angel

ramping up

for a confrontation.

ELLEN BURSTYN

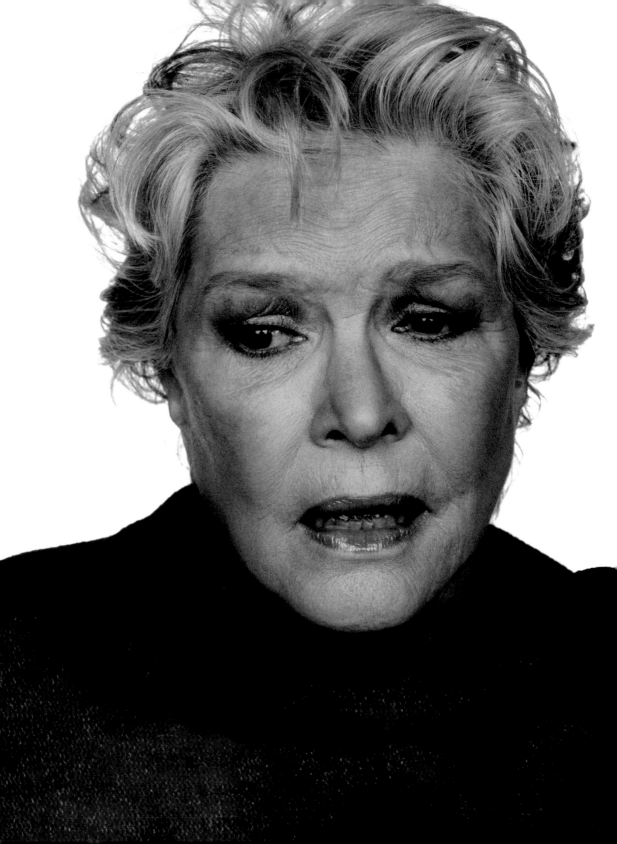

1. You are…a fifty-something

 veteran middle manager

 learning that a merger will cost you your job.

2. …a high school drama teacher

 watching the Academy Awards,

 hearing your name mentioned

 by an Oscar winner.

3. …a woman scorned.

For me there's no substitute
for the connection that occurs
between the actor and the live
audience. I always call it com-
munion. I'm certain it's holy
communion.

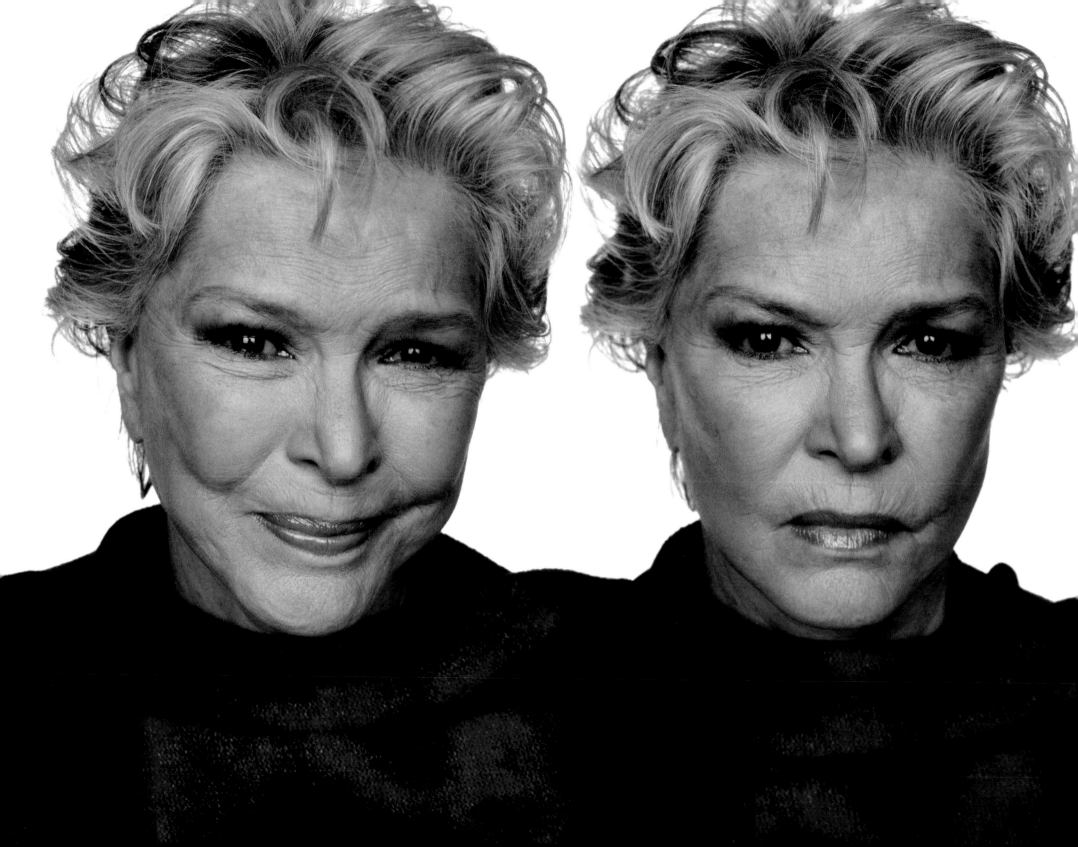

Actors' Notes

PHILIP BOSCO

There were no such things as directors in the great periods of theater before, in ancient Rome, in Greece, and in Elizabethan times, and the Renaissance and also Restoration. You had a script, you had the playwright, of course, and then you had what we used to call the prompter. We call them now a stage manager. Now the director has become this icon, this idol, this genius. It's bullshit, for the most part. The actors say all they really want from a director is to be a traffic manager, so that the actors don't stand in front of one another. Now, that's a gross exaggeration, but, in essence, it speaks to the truth of the importance of theater from the actor's point of view. You do get some great directors who can illuminate the script in rehearsal. But, apart from that, all you really need them to do is to watch that people aren't in front of each other.

I like the stage. I do movies and television, but that's acting of a different sort. In fact, you might call it nonacting, in a way. All the things you learn and study to become an actor on stage – projection, vocal production, all those kinds of technical things – you almost have to forget when you work in film and television. Everything is reduced. It's all minimal. They keep saying, "Down. That's too big. You're acting too much. Just be natural."

I don't really believe you need to act in movies. You can act, and there are many people who do well, and there are some great actors who have been in many movies. "Movie stars" do very little acting. They play themselves in various roles. They change costumes, and the situation is somewhat different. But Cary Grant is Cary Grant, no matter where you see him. And Gary Cooper and John Wayne; nobody in his right mind could ever accuse John Wayne of being an actor, for God's sake. He can barely string two sentences.

They do what they do in films extremely well, but put them on the stage, and they're out of their element. They just don't have the technical ability to do that. So, my love is live theater. That's the great love of my life.

MELISSA LEO

You can be overdirected, you can be underdirected. All of that's scary. People say, "Oh, I want to be a director." Oh, my God, what a massive responsibility…a lot of lives at stake under your control. It's a really serious position to be the director.

The hardest part of being an actor, I cannot go get another job working in a bookstore to keep myself busy. You have to remain available, not only for the work, but sort of psychically available also. My career began the day I left my waitressing job. I made a commitment to myself that I was an actor. And when I worked, I would work as an actor. I was well prepared from my upbringing. I could go without. I didn't build a big credit card debt and get things that I couldn't afford to have. I lived without, and I lived with friends who fed me. That determination, that singleness of purpose, is the thing that for me cracked open the door and still cracks open the door.

ELLEN BURSTYN

In the theater, if you're alive in the role and not just repeating it mechanically like you've done before, it is different every night. It's not that you try to make it different, it just is. When you're alive in the role, you're just being the character in this situation. Yes, you stood on this spot last night saying this word and, yes, you moved on that line to this spot, but you can't step into the same river twice. So it's the first time you've ever been there. You've never said these words before, really.

It's the most thrilling thing in the world, because what happens if you're alive, if you're really turned on in the role, things occur that you didn't expect, things come up, you have impulses you hadn't planned; that's what I mean by being alive. If you're connected to what you're doing in a creative way, and your juices are flowing, that's what I mean by being alive.

I read somewhere that "art is the search for beauty, and religion is the search for truth." And it hit me like a great revelation that it is the search – not the finding. And that search is the process where the art occurs and where the truth occurs. And if, at any time, you think you've found art or you've found truth, it's not alive. It's in that search that you reach and start asking the hard questions. If you already know the answers, you're not engaging your creative process. But if you're saying, "Oh, my God, who is this character? I don't know why she's doing this. Why on earth did she give all that money away?" For instance. "What would make me give all that money away?" You start and you follow a trail and as you go along, more questions come up. And it's those questions that ignite you, that get your juices flowing. To me, questioning is the creative process.

You know what you're doing is investigating and understanding human nature. And you can't understand human nature without having a mind that can work out the complexities of human nature and organize them in a way that you can express them. People who just work superficially don't have to necessarily be all that smart. But people who really go into the art of acting, they're using themselves to express the nature of being a human being. No matter what aspect of a character you're working on, it is a way to reveal what your understanding of human nature is. So, when somebody does something that you don't quite understand, it's your exploration of where that action would lie in you and what the implications would be that help you to understand why she did it.

The inner work of preparing for a role is pretty much always the same. That's the real work. The deep work, connecting with the character, having your psyche connect with the character's psyche. And that work is consistent in any medium. There's more time in the theater, less time in film, and least of all in television. I equate time and depth. You can go further in, and stay there longer and come up with the fish on the bottom of the sea, when you have enough time. And in lieu of time, in film and in television, you just have to do the best you can possibly do with the amount of time that you're given. For me it's all about rehearsal. The more time you have rehearsing and exploring and delving into a character, the deeper the work is. I've seen people have to get in bed with somebody and make love to them and introduce themselves as they begin the scene. The camera, the lighting, and everything can create an illusion. But deep exploration takes repetition and time.

CHARLES S. DUTTON

I went in prison when I was nineteen and I got out at twenty-six. When I read a play for the first time I was in isolation in prison in "the hole" – a five-by-seven room with a sink where you can get water and a grated hole in the floor. I was sent a book, an anthology of black playwrights – you're allowed to take one book into isolation. I finally got adjusted enough to the stench, to the cement floor, to the loneliness, to the depression, and I lay on my stomach and I read the book of plays on my stomach. There was a door about a half inch above the ground, the light seeped under the door. I read *The Day of Absence* first and I found it so hilarious I said, "When I get out I'm going to get the craziest guys I know in prison and we are going start a drama group." I didn't know a damn thing about it, but it was interesting. When my six days in the hole were up I practically had memorized every one of the plays. When I got out of the isolation that last time, I knew what I wanted to do while I was in prison. And I got together ten, eleven guys and we started this little drama group and I directed *Day of Absence*, not knowing a damn thing about directing. And I played the lead.

During one of the shows, when I was doing a speech from the play, I saw I had this captive audience, pun intended, in the palm of my hand and I felt this eerie kind of power. I couldn't articulate it at the time, but later on I understood it to be stage presence. I felt wherever I went the eyes of the audience shifted with me, although there were eleven other guys on the stage. I automatically knew how to gesture to be effective. I automatically had a sense of fearlessness physically. I instantly knew to be unpredictable.

It was the freest that I had ever been in the three or four years that I had been in the prison. I felt whatever I did would be totally captivating to the audience. And, I don't know if it was a second or ten seconds or a minute, but there seemed to be a pause and I knew then – it had dawned on me that I knew then – that I had just discovered what I was born to do while I'm on this planet. I really felt that it was a way for me to rediscover – or discover – my humanity.

Acting really and truly was the thing that really saved my life. I look at the stage as a sacred place. I think once I'm on a stage, as beat up as it gets me physically, as much as it wears on my voice and body, there's something so delicious about it, something so freeing. You feel privileged to be able to do something that allows you to leave this world and this life for two hours.

I want intelligence from a director on a stage. I want a well-read director who knows Chekhov, Ibsen, Strindberg, Sartre, Genet, Ionesco, on and on. I want to hear a certain loftiness of ideas. I want to hear colors in his speech when he talks. I want to be able to listen to him or her and really feel a sense of freedom as an actor, that I can embarrass myself and won't be judged. And they have to be just as fearless as I am.

I listen to directors and then I don't listen to directors. I'm the easiest guy to work with in the world. You're not going to find one single director that says Charles S. Dutton is difficult. But I act what's in my head. I act what I envision. A director can give me a thousand notes, but I'm going to act what's in my head and I guarantee you it's going to be just what he wants. Or he's going say, "I didn't know I wanted that."

It's a lonely life being an actor, particularly a stage actor. You do eight shows on Broadway a week. Your whole life is changed during the time that you're doing a play. Something happens to you bodily, something

happens to you emotionally and spiritually, around five in the afternoon. Your whole being starts to change because now your whole focus and psyche are geared toward eight. You know you have to go to the theater in another hour or so.

And yet, you spill your guts and by eleven you leave the theater and the loneliness of it all is that, yeah, there's applause, yeah, there's people out to get your autograph, but no one understands what you just put out. Yes, they appreciate it, they applaud it, they're moved by it, but not one single fan can look you in the eye and tell you something that can really make you say, "Ah, they know." So you get in the cab, you go in the subway, or you walk, and it's a certain amount of abject loneliness that you experience at the time the plays come down.

And not in the cliché way of you're still carrying the character with you. It's just that you've actually purged a bit of yourself. You've actually exposed your humanity to be judged by everyone in that house, the other actors.

The worst thing for me doing a play is the curtain call. I wish the lights could come down and that could be it. The most embarrassing time for me is the curtain call. I cannot go from a three-hour performance to doing the curtain call. I could never get into dropping it that fast and come out and take five bows.

First of all, I'd be embarrassed to take one bow, let alone two or three, no matter how much they were applauding. I'd rather take one very quick and go. That's the moment for me where the mask has fallen and I'm your actor no more.

CHRISTOPHER LLOYD

I sensed pretty early on, somewhere in my adolescence, that I had a kind of a knack. If I felt threatened or uncomfortable, I found that if I resorted to something that prompted others to laugh I would get myself out of these awkward situations.

If a director has cast me in a part, then I like to feel he's cast me in it because he innately trusts that I'm going to deliver what he wants. If I'm with a director who's going to second-guess me every step of the way, I close off. But Bob Zemeckis, Mike Nichols – they just have faith that it's there, they know it's there, and I feel I can't go wrong. That to me is the key, the trust.

I spend a lot of time going over and over and over and over the script. Trying to find clues, bit by bit going through the script to give me some inkling or idea of what this guy is like so I can make a portrait in my mind of how he feels, what his reactions would be to this circumstance or this situation or this scene. If I don't feel any real connection I just keep going over it and finding ways to build a coherent human being out of it. Sometimes that comes easily because it's so clear to me. Other times it haunts me. I'm unable to really do anything until I'm satisfied I've figured out what this guy is about and I've got him tucked away and ready to expose. It may take a long time and suddenly one day I'll say, "Oh, that's it. That's it."

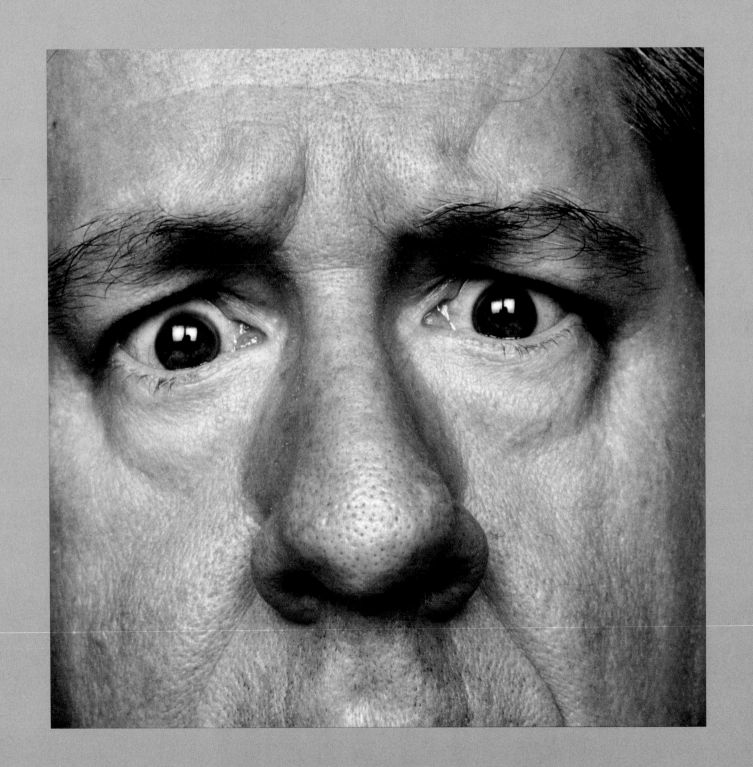

Fear

Second Intermission

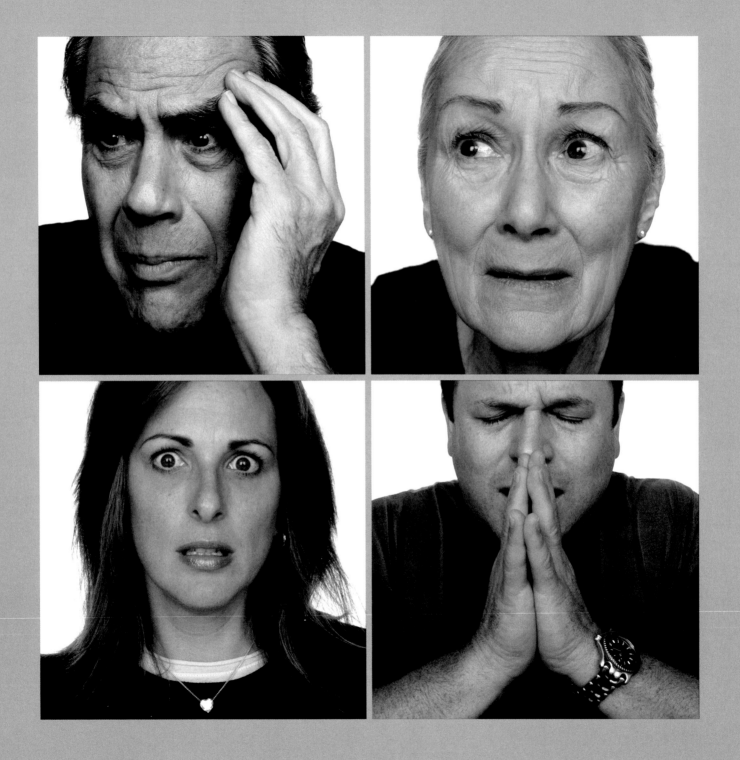

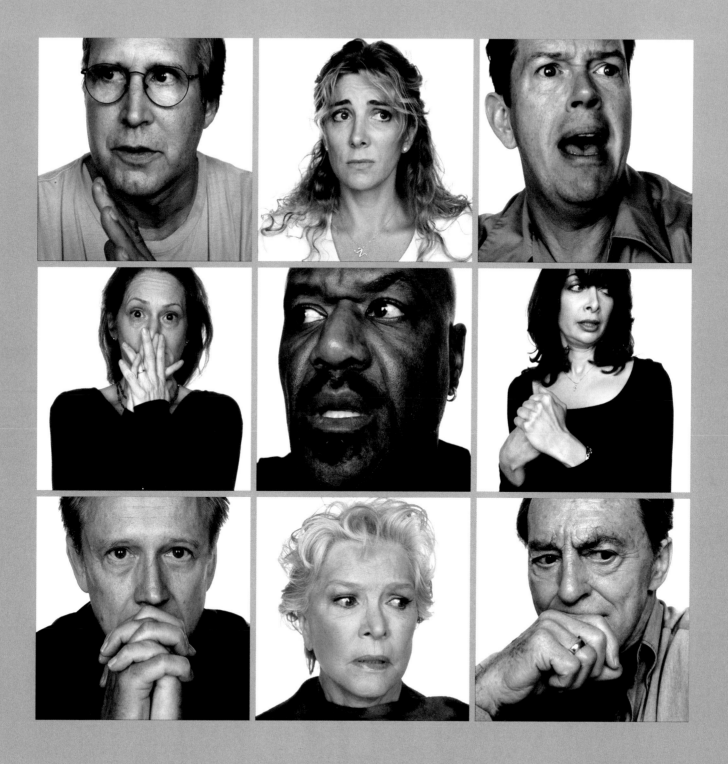

Act III

The Players

HAL HOLBROOK

ELLIOTT GOULD

KATE BURTON

DELROY LINDO

ERIC STOLTZ

MARIANNE JEAN-BAPTISTE

JAMES CROMWELL

TOM SKERRITT

MARTIN LANDAU

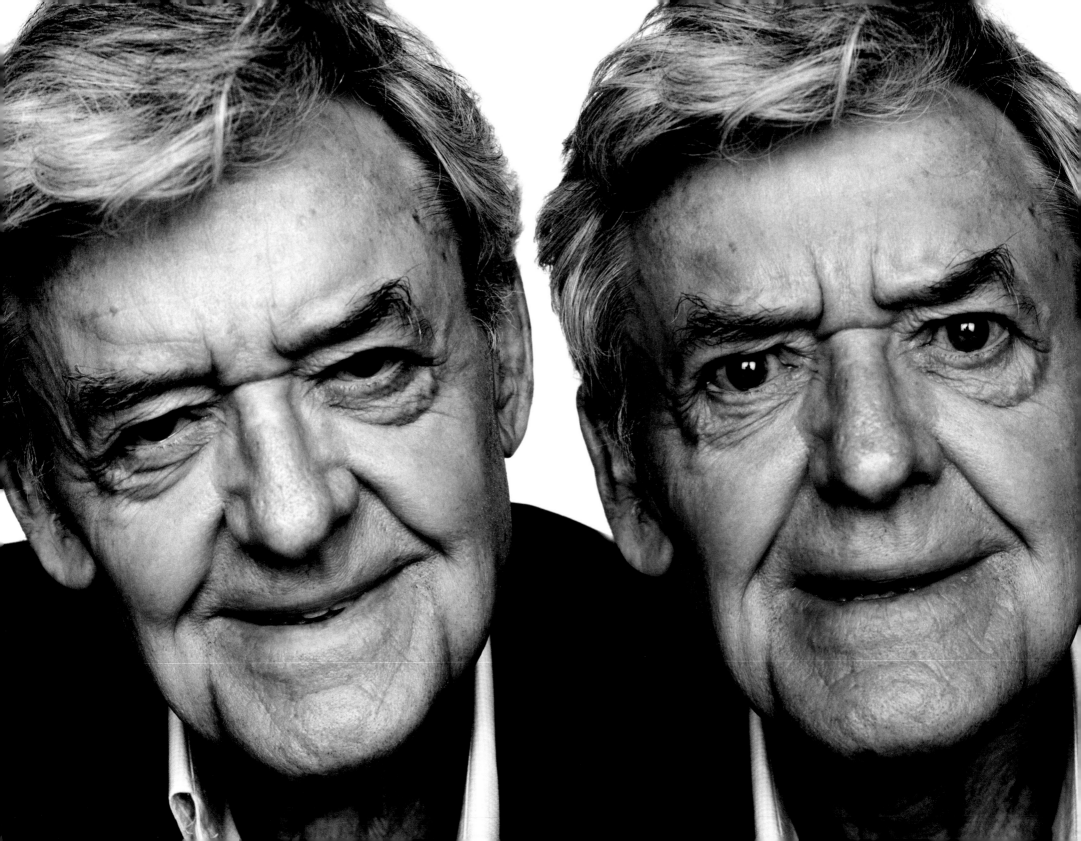

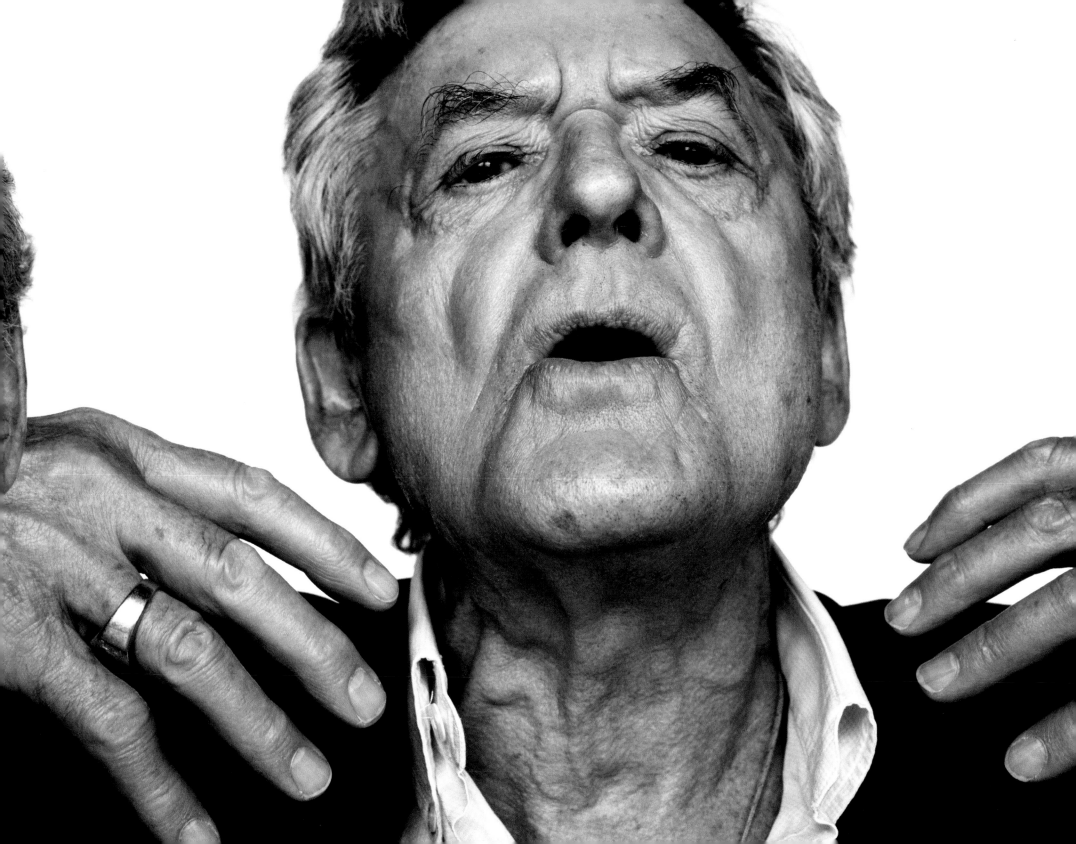

HAL HOLBROOK

1. You are…an interrogator in a police state.

You'll tell your men to stop the beating

when your prisoner admits he did it.

2. …a confused homeless man

wondering why you're being arrested.

3. …a Baptist preacher

calling your flock to come to Jesus.

On stage the first time, that light hit me out there – that blue light – and a great silence of anticipation, waiting out in front of me – this great heart-throbbing going on out there that you couldn't see. And it was an overwhelming sensation that I never forgot. It was the first time in my life that I felt people were going to listen to me.

I always loved to be behind a mask. When I was young, I did everything to escape playing myself, but now, hiding behind a mask isn't really a mask any-more, because I know that to play a role honestly you have to dig down into your own self and you have to find that little devil in there who is you, and you have to enlarge on that devil; you have to find that lit-tle angel – whatever is in there, you have to find it.

No matter how many times you get humiliated, and no matter how many times your own courage fails you and your own confidence fails you, actors have to expose themselves. You have to expose the person inside that you're afraid to let loose. Once you have discovered things about yourself and come to accept some version of who you really are, it's not that difficult to find lots of different people in you.

ELLIOTT GOULD

You are in a high-stakes poker game,

holding four aces,

while a brash young bluffer sees you

and raises another $100,000.

I believe in modesty and humil-ity. I am uncomfortable with ego and vanity, but I must rec-ognize my own ego and vanity so as not to be a hypocrite. To interact, to interpret, to play together in the form of performance – that can be extremely joyful, very chal-lenging, and also quite reward-ing in terms of expressing an inner feeling and developing relationships. I think it's one of the best avenues in which to establish a relationship, by communicating through play.

I discovered my very first objec-tive relationship in life during the filming of my third picture, *Bob & Carol & Ted & Alice*. After hours of rehearsing and setting up on the soundstage, union regulations dictated that the cast and crew take a ten-minute break for a brief rest. Everyone stepped outside, but I stayed by myself on the soundstage with the scenery, the lights, and the cameras. Alone with my insecu-rity, my doubts, and my fears. I realized that the camera didn't give me problems. I did. The camera couldn't manipulate me; it's inanimate. It's incapable of lying to me. My first objective relationship was with my friend the camera.

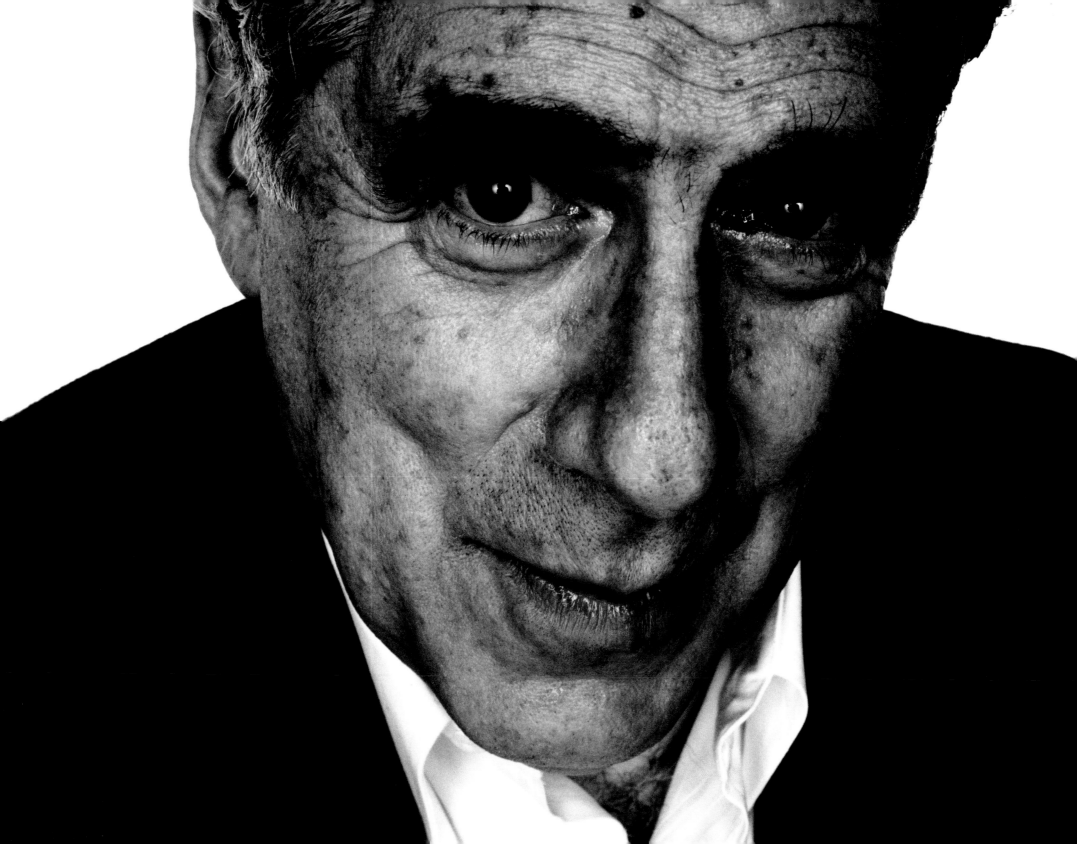

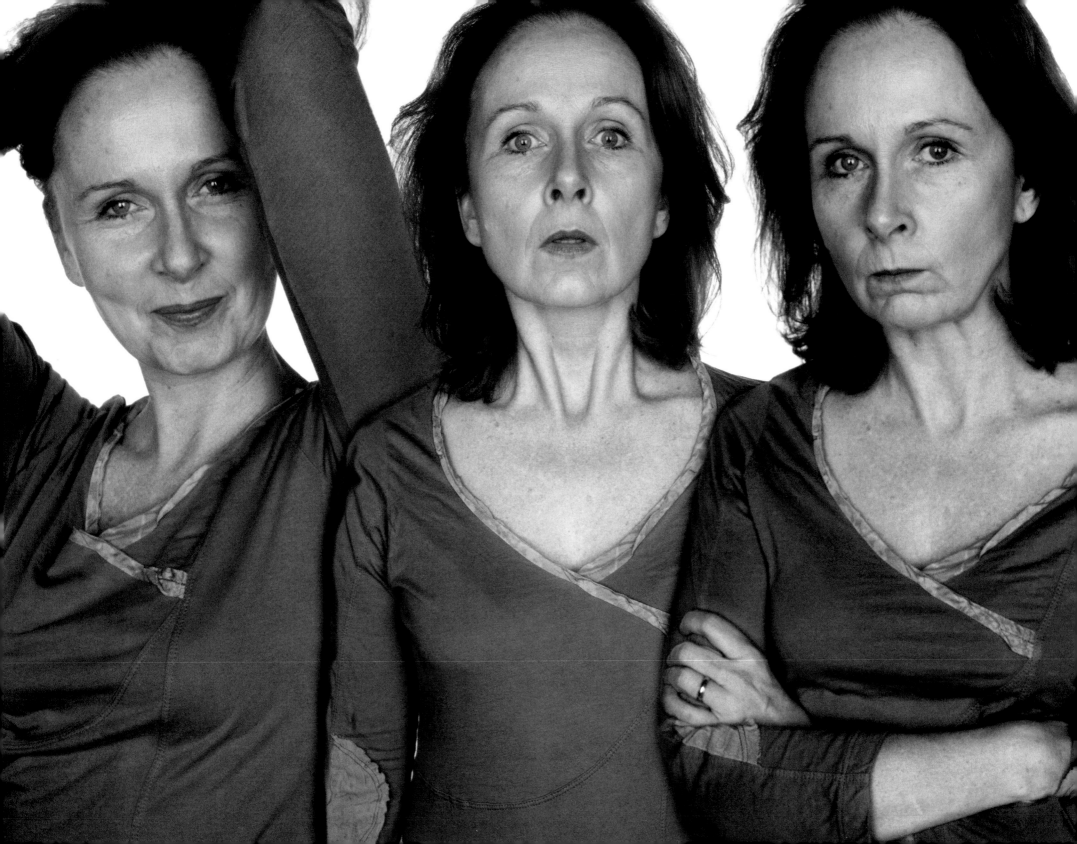

KATE BURTON

1. You are…an elementary school teacher on vacation,
flirting with the cabana boy at your resort in Cancún.

2. …a working mother coming upon your husband
kissing the babysitter.

3. …a woman who has just received the failing grades
of your daughter in college
after she's been lying about how well she's doing.

DELROY LINDO

1. You are a cop…
whose son has just been brought home by fellow officers
from your own station.

2. …hearing that your son was caught driving drunk
with four more very drunk teenagers in the car:
"What were you thinking?"

I want to be surprised by a director. I want him to tell me something that I don't know. I like to come in like a blank slate.

I love the rehearsals; I love the day of performance, getting ready for the show, putting on costumes. My stepfather was an actor, my father was an actor, my stepmother was an actress, and I just kind of assumed that it would be part of my path.

The moment where it became something more than just fun was when I did O'Neill for the first time in college, at Brown. It was endorphin releasing. It happened to me with *The Beauty Queen of Leenane*. In rehearsal one day, there was that moment of a euphoric kind of eureka, and I realized that there was for me the moment every night in the play that I could escape into that character. I was forty years old; it was a really interesting thing that it took me fifteen, sixteen years of doing this work to kind of arrive at what was the nub of probably why I do this. I realized sort of in one big blinding flash, "Oh, my God; it's all about collaboration." And that every great play, every great musical, every great piece of art, dance, music, photography, is a collaboration between the audience and the artist, the creator, the interpreter.

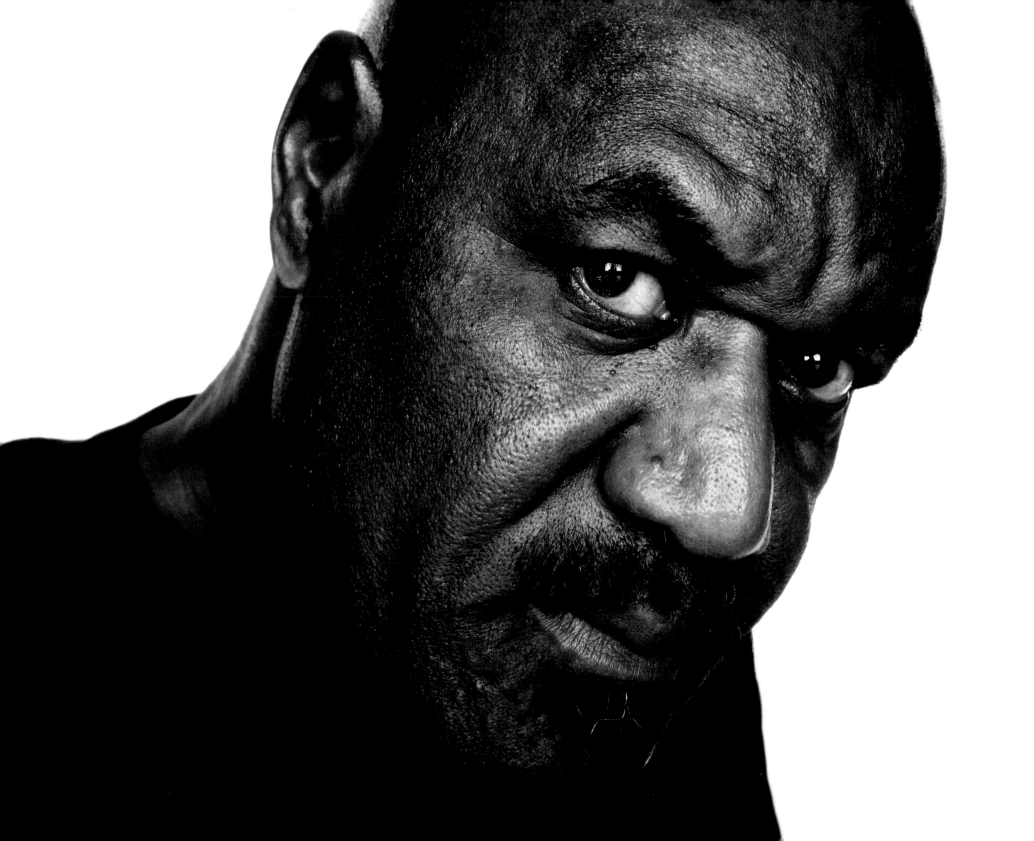

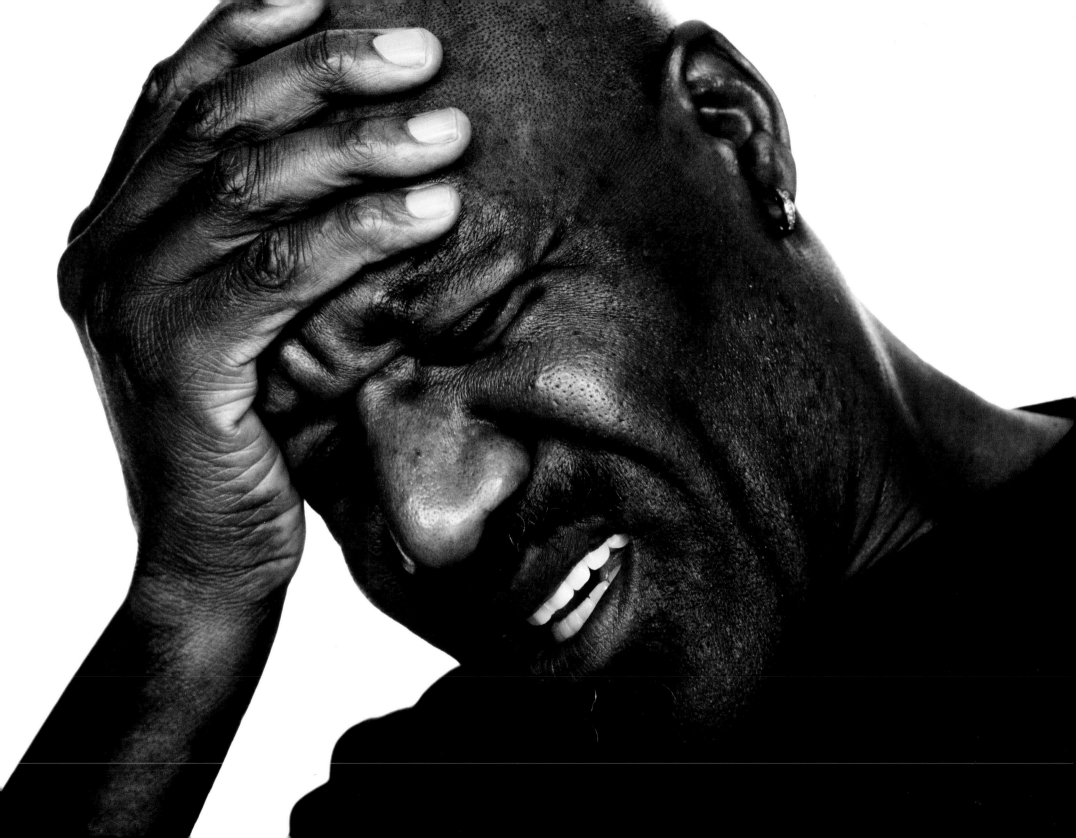

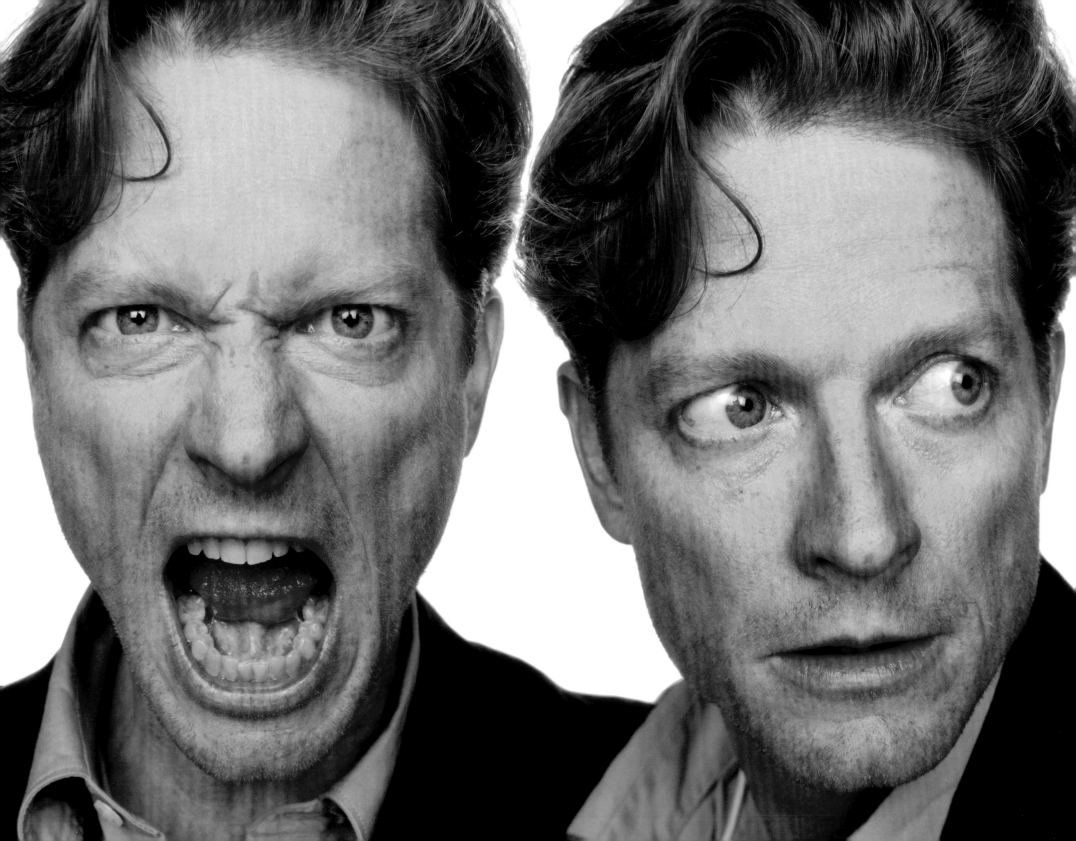

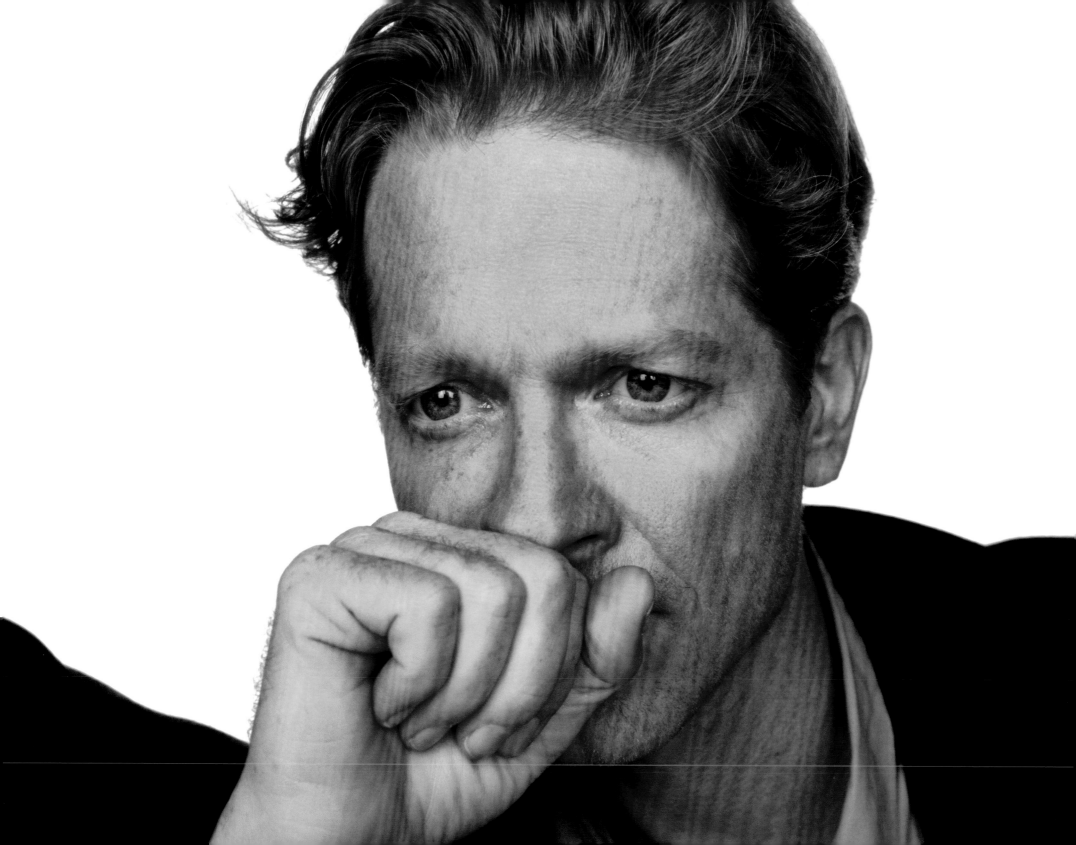

ERIC STOLTZ

1. You are…a hard-pressed fourth-grade teacher:

"For the last time, settle down!"

2. …a heli-skier who hears the roar of an avalanche
somewhere high above you.

3. …a conscientious CEO of a small company
just before telling your employees
that there's not enough money to meet Friday's payroll.

The theater is a visceral medium. You get an instant response, and it's a thrill. You're on the tightrope every night, and it's wonderfully exciting. Television can have that too, simply because it moves so fast. You don't, however, have the time in television to explore any nuance or really go into the harder questions of the character, because everything is so fast.

Film is probably the most relaxed of the three. But it can also be so relaxed that it gets a little enervating, because sometimes in film you shoot two pages a day. On the big-budget studio films, you shoot so little that it tends to lose its forward momentum.

MARIANNE JEAN-BAPTISTE

1. You are…a ten-year-old
taunted by your older brother's friends.

2. …the Wicked Witch
watching the Scarecrow
catch fire.

I come from the theater background, that's where I started. I went to the Royal Academy of Dramatic Art. I studied there for three years and left there and went straight into theater. The first, say, seven to ten years out of drama school, that's all I did. I think that's what you do in England because there isn't a lot of television work and there isn't a lot of film. I think you get to find out what kind of actor you are by actually doing theater because you're really thinking on your feet. You're in the moment at the moment with a live audience there, watching. Nobody says "cut" when you drop a line or someone hasn't made the right entrance. That's what makes it exciting as well. If theater paid well, I'd never, ever do anything else. I like the danger, the fear, but also the excitement of knowing that I can do it.

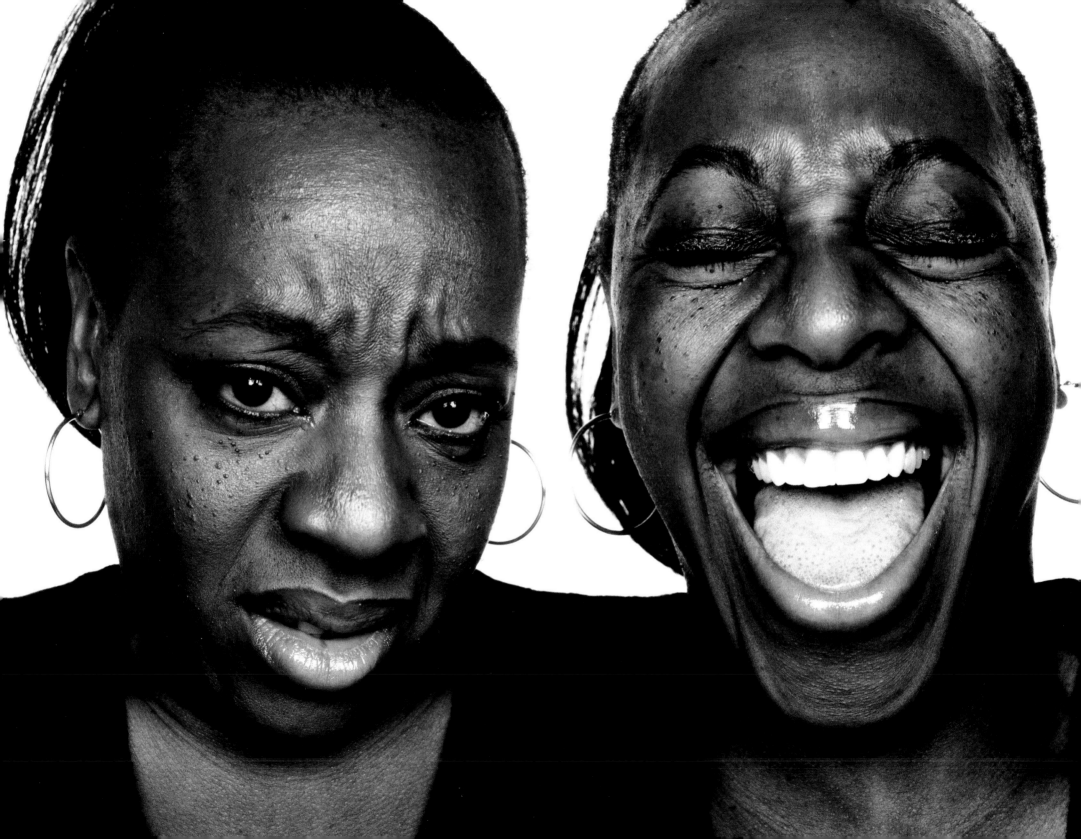

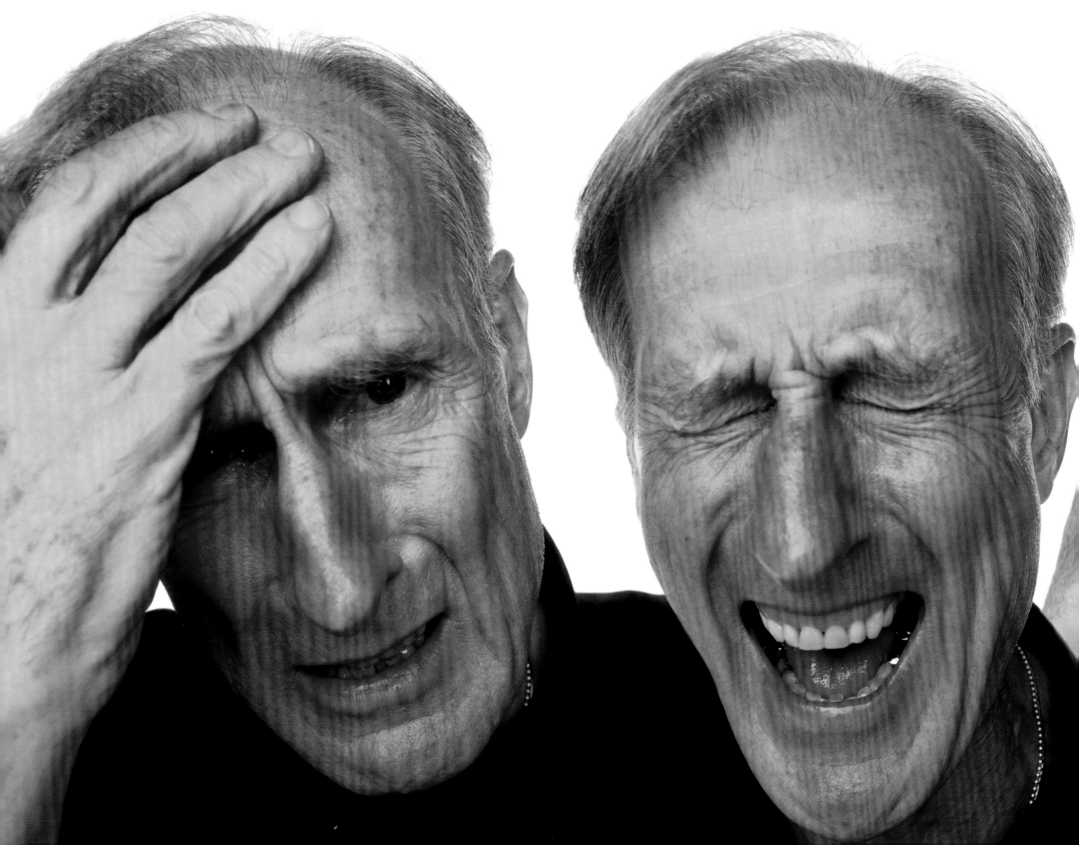

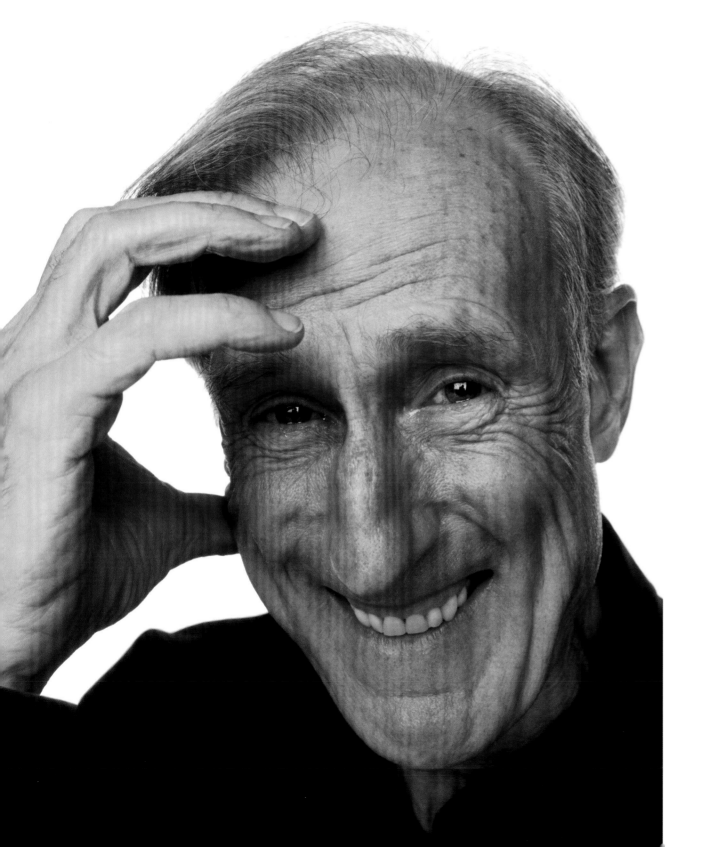

JAMES CROMWELL

1. You are…a man
who has just been told you
have inoperable
cancer.

2. …watching the final game
of the NCAA tournament
as a last-second basket
keeps you from winning the
office pool.

3. …a devoted father
watching your
handicapped daughter
receive her high-school
diploma.

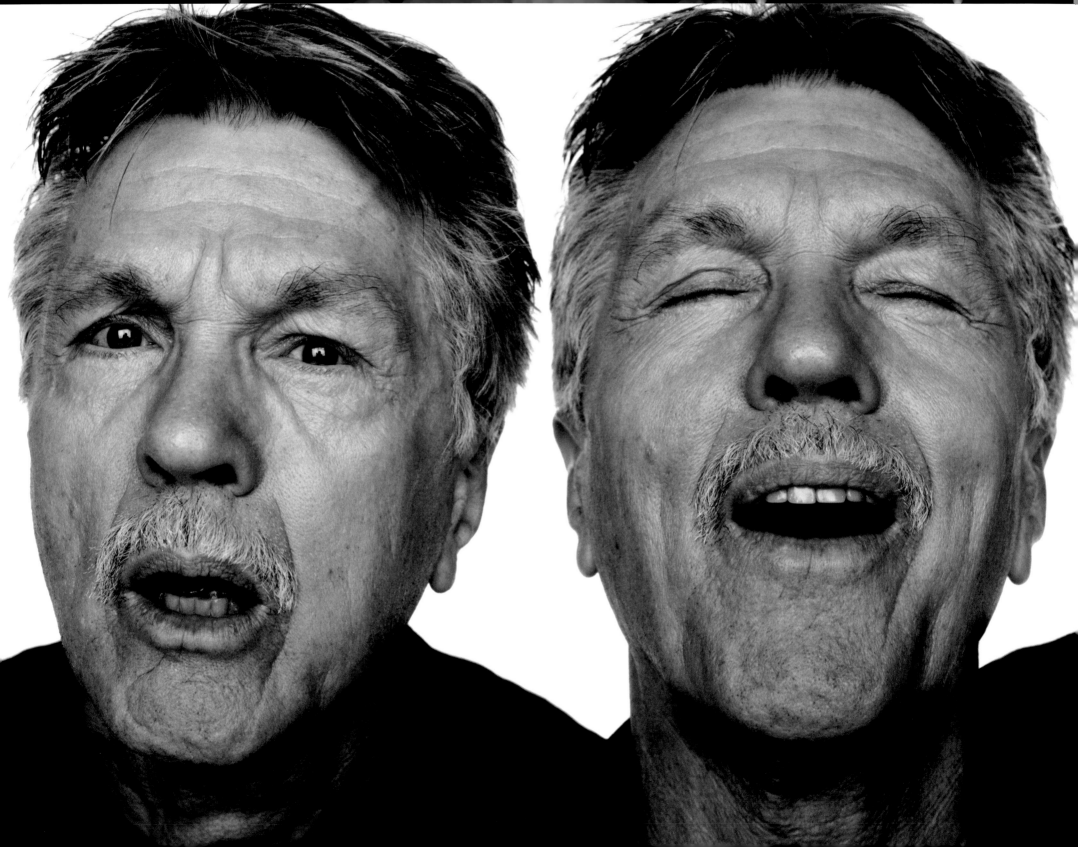

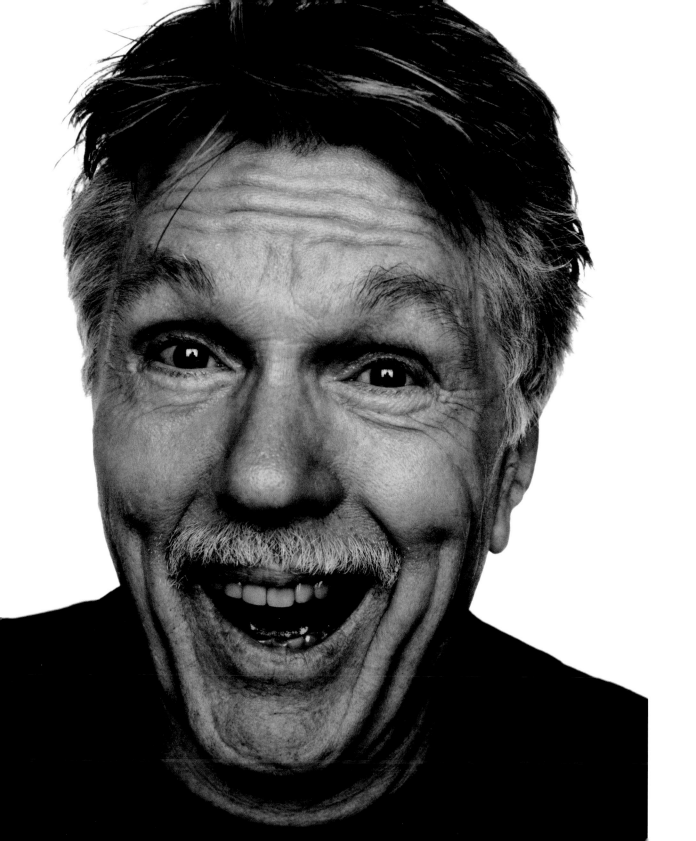

TOM SKERRITT

*1. You are…a retiree
in Florida just realizing
that your bank account
has been emptied
by identity thieves.*

*2. …a man on business
in Hong Kong
enjoying the "happy ending"
to a very expensive
massage in your hotel room.*

*3. …a high-school
varsity linebacker:
"Jeez, Mr. Farnsworth,
me, cheat on the final?
You gotta be kidding."*

Acting allows me to never have to grow up. There's something about any creative discipline we do that regenerates the youthful quality that we had when we were dreaming about doing these things when we were little.

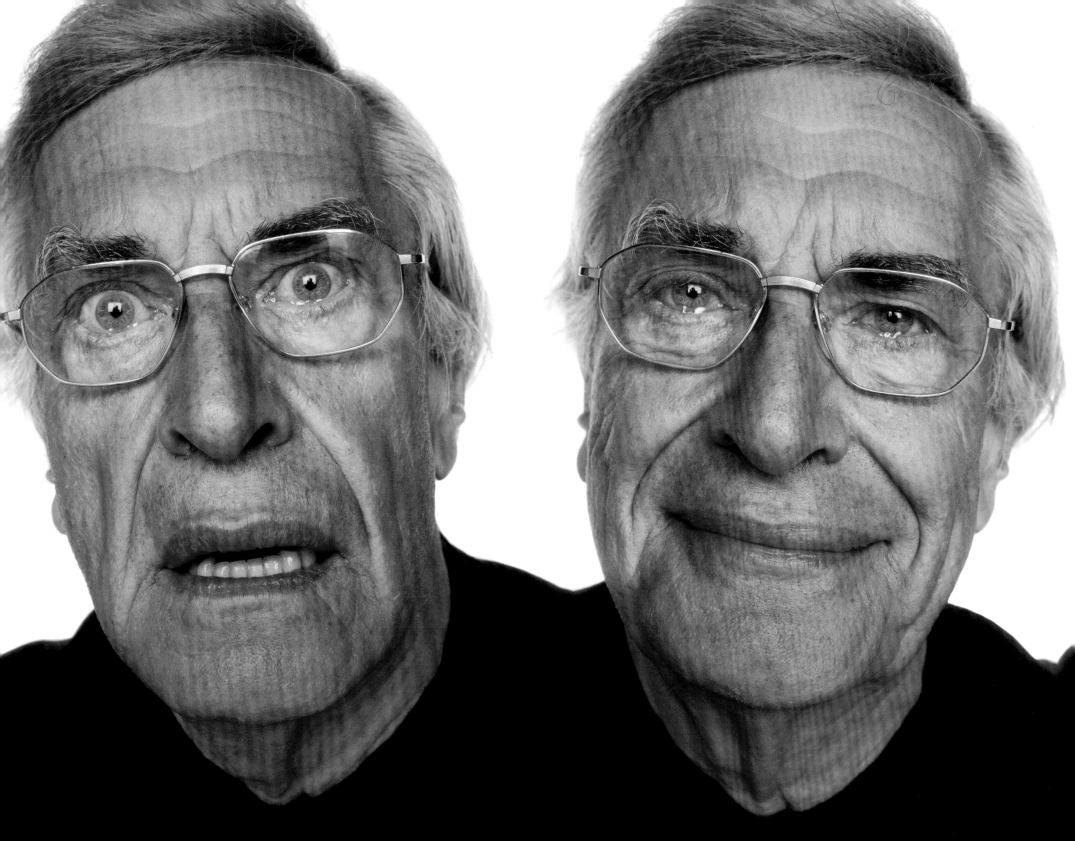

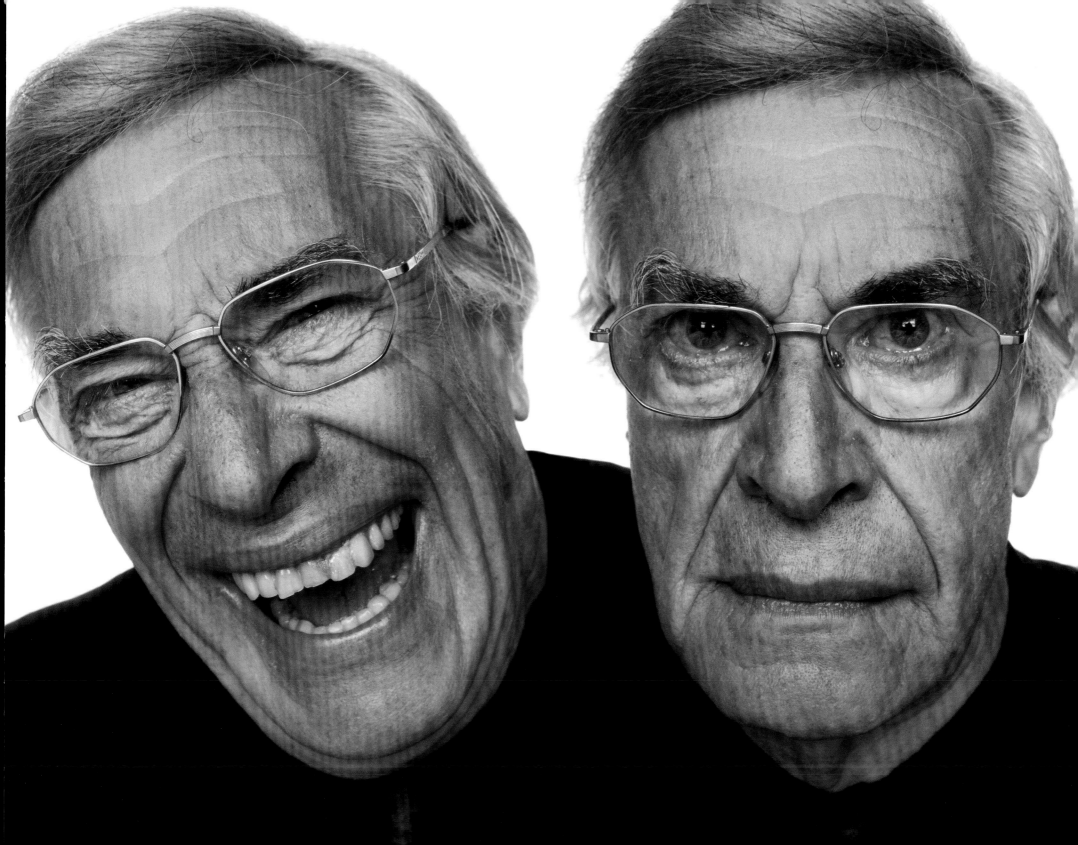

previous pages

MARTIN LANDAU

1. You...see a shooting

 on your quiet, tree-shaded block in Brooklyn.

 2. ...hear the speeches

 at your fiftieth wedding anniversary party.

3. ...hear a dirty joke

 at the weekly neighborhood pinochle gathering.

 4. ...are a Mafia don

hearing a feeble denial from a stoolie.

Acting is not showing. Only bad actors try to cry. Good actors try not to. Only bad actors try to laugh. Good actors try not to. Only bad actors play drunk. Good actors play sober. How a character hides his feelings tells us who he is. The only people in the world who exhibit or show their emotions are bad actors. How a character distills and holds on to his feelings tells us what slips through. The power of that emotion is what tells us who our character is.

In a well-written script, what people say to each other – the dialogue – is what a character's willing to reveal, willing to share with another person. The 90 percent he or she isn't willing to share is what I do for a living. The subtext is what makes the people do what they do. I watch people. It's not what they say that tells us who they are, it's their behavior. And this applies to theater or to film.

Every character has different predilections, different needs, and different reasons for being in the movie, and needs to fulfill a particular arc. I start by saying "I" as opposed to "he," because I immediately join up with him. Once you start saying "he," you're creating a separation. Once you accept the role, you acknowledge the fact that from that point on, when you walk into the room – on film or on the stage – it is you.

Actors' Notes

MARIANNE JEAN-BAPTISTE

Television is quite a different discipline, really. I'd only ever done movies before. The pace is very different, it's very quick. There's a lot of dialogue that has to do with discovering crime. It doesn't come from the emotional place. It comes from just giving facts, and that can be very difficult to learn and very difficult to deliver with any kind of nuance. It was interesting, getting used to doing that sort of thing and not always basing everything in an emotional area. It's interesting and exciting, because you're on your toes all the time. They're always changing the script. Before you can finish working on the one that you're doing, you get a new one that you have to get your head 'round.

ELLIOTT GOULD

I usually have to study to learn my lines to be prepared to come to the stage, whether it is in theater or motion pictures or television, and I do a good deal of my work at home and at the studio or location where we're bringing it to life. I think that one should be aware and careful not to take it too seriously and not to allow the role to overly influence the personal. Some of us don't have personal lives. Some of us live through the roles. No matter who it is, the actor is an extension of the role the actor plays. Your own being is our instrument. We are the instrument through which you communicate and play.

In 1978, I had the rare privilege of spending time with Alfred Hitchcock over lunch in his dining room, in his office, in his building at Universal. "It's all music," he said to me, "but if somebody tries to be more outstanding than the rest, it can be a distraction. Take Beethoven's Ninth. Do you realize that one person wrote every note for each instrument but that everyone must be playing together for me to see my picture?"

We're all professionals and we all have a responsibility to one another. I consider myself to be the part of the crew that works in front of the camera.

ERIC STOLTZ

One of the perverse joys of acting is that you actually do get to walk a mile in another man's shoes, and feel what that's like. In *Mask*, as an actor, you're putting yourself out there to be mocked and humiliated and made fun of. That is, however, exactly what the kid went through. So it was very beneficial for me to try and go through that. It gave me a key; it gave me a window, to see what it must have been like to go through that every single day for sixteen or seventeen years. I was surprised and saddened at how cruel people were. And I was just an actor pretending. I knew I was going to go home and take the makeup off, but it was an eye-opener.

During *Pulp Fiction*, I spent some time with some drug dealers and drug addicts. It was the first time I'd really gone into that world. I've always been a clean-living kind of guy. I didn't feel any power or anything positive; I felt like it was a world that existed below the streets, where people slept most of the day and came out at night and did things that polite society frowns on. And once you're in that world, it's enormously seductive. You start feeling like, "The laws don't apply to me." And it's a very interesting place to go.

This isn't necessary for *every* role…. Most roles are very close to us, but, on occasion, there is a role that comes up that is foreign to your experience. And, for me, I feel like I need to try and live that way as much as I can. I try and see what that world is like.

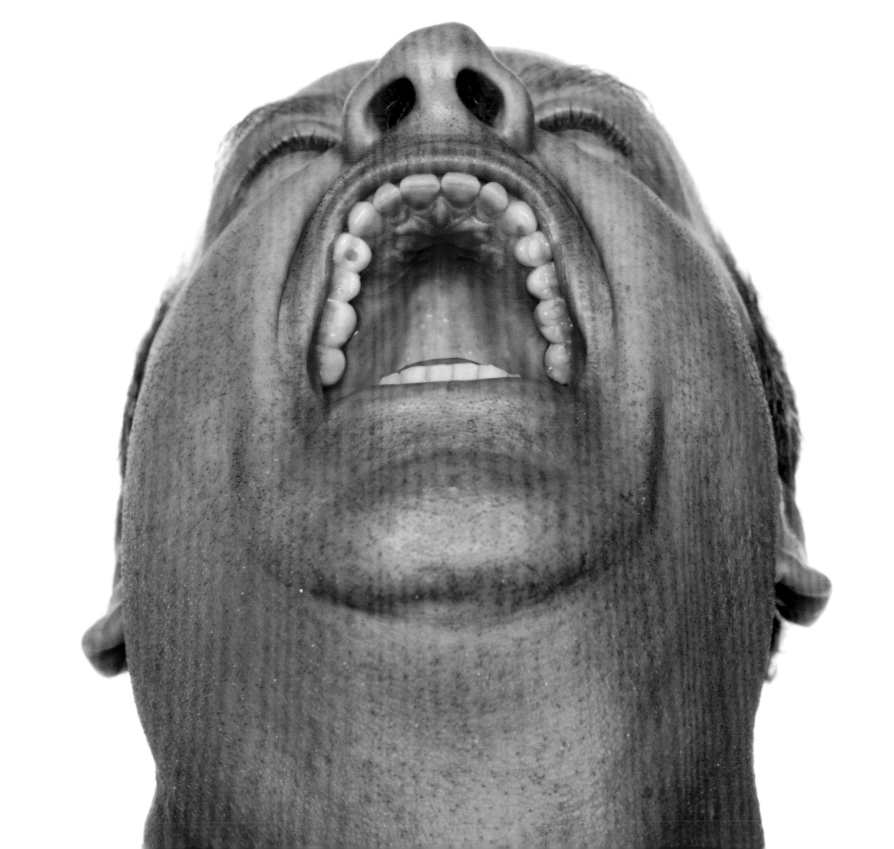

Over-the-Top

Third Intermission

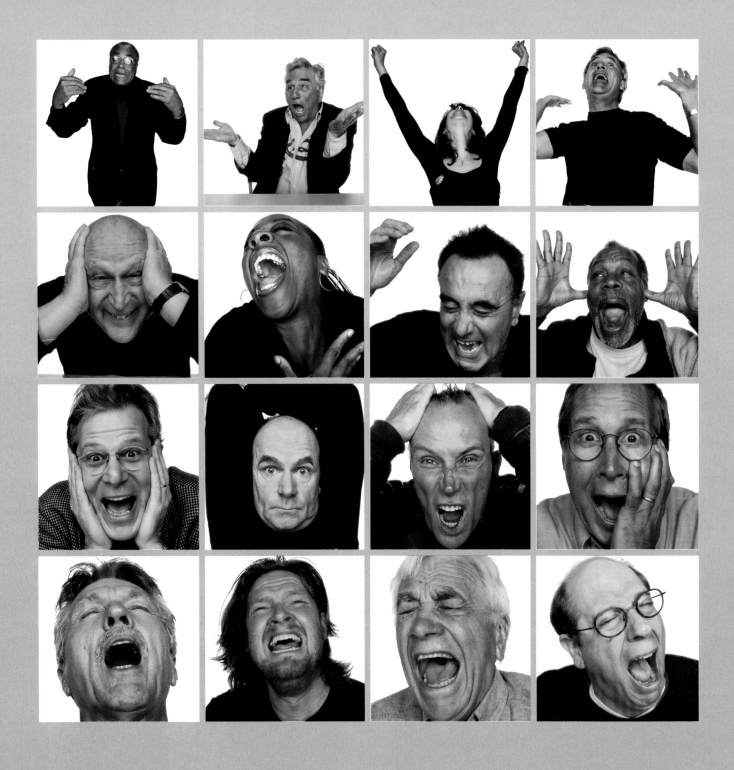

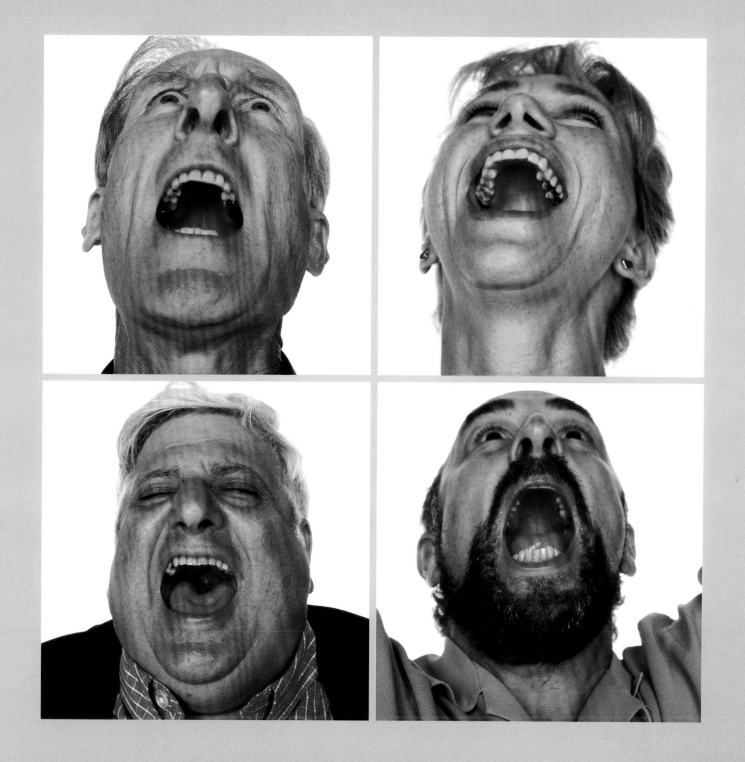

Act IV

The Players

DENNIS HAYSBERT

MARLEE MATLIN

KEVIN POLLAK

F. MURRAY ABRAHAM

DON CHEADLE

MARTHA PLIMPTON

PATRICK STEWART

ROSIE PEREZ

BRUCE ALTMAN

JASON ALEXANDER

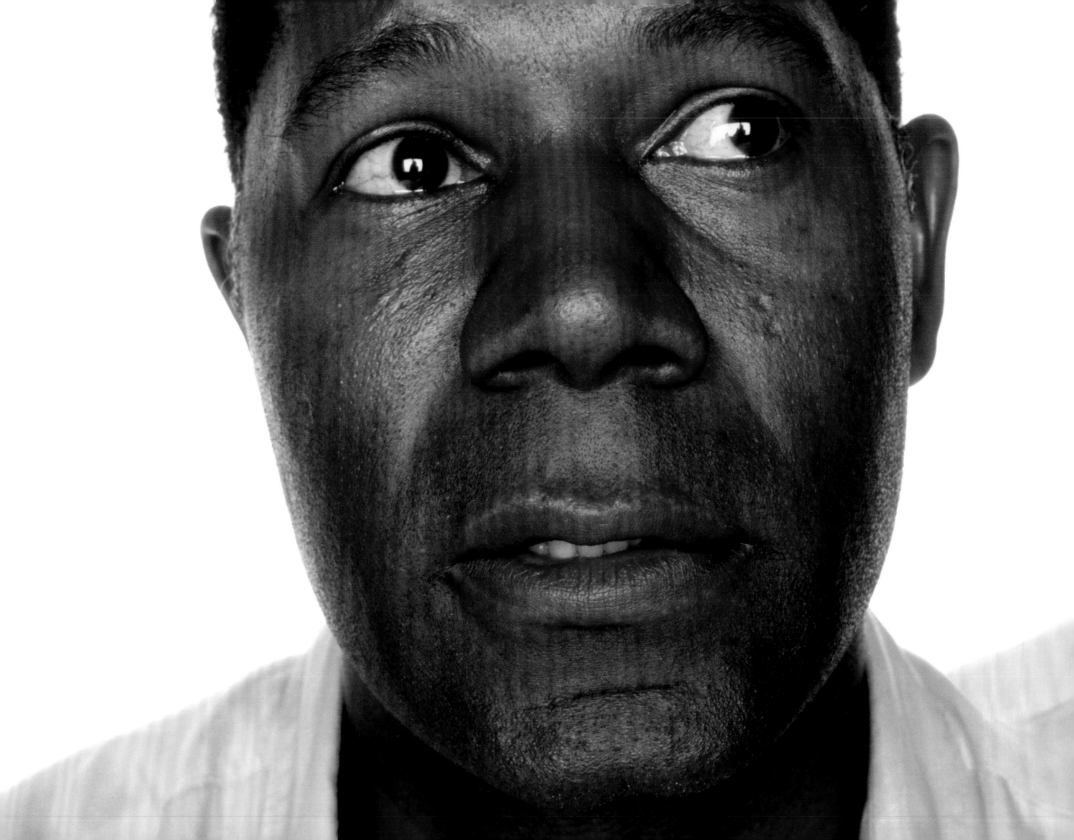

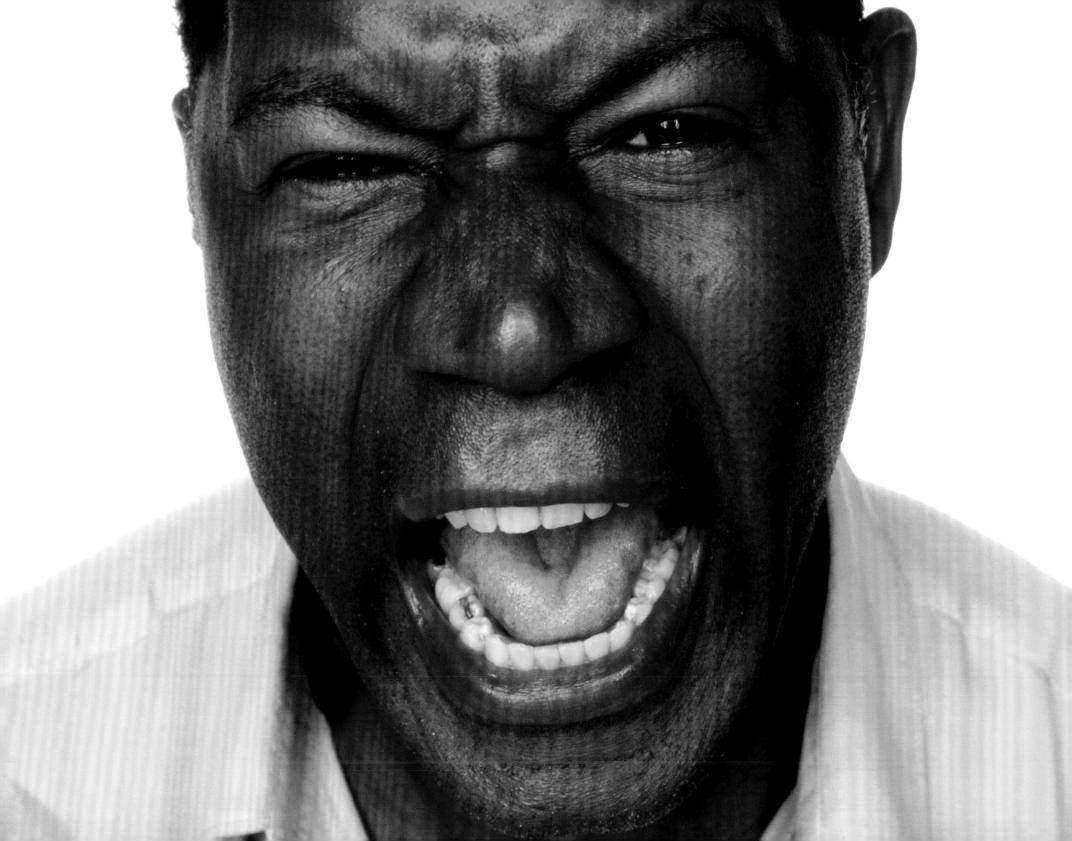

DENNIS HAYSBERT

1. You are…a man in a taxi headed home,

wondering how you're going to explain to your wife

where you've been 'til three in the morning.

2. …a motorcycle dude

coming out of a biker bar

just as a guy in a Porsche

backs into your gleaming Harley.

To develop a character, I figure out who the person is, where he's from. Who were his parents, how did he relate to his parents? Where did he grow up? How did he grow up? There's a small part I had in *Heat*. It wasn't small for me. It's small in size, but I thought it was very poignant and a very important role. It was kind of a gang-banger, thief, a getaway driver. And he had to spend some time in jail. And that was challenging to me because I've never been in that position. But I have a brother who did have that problem and I found out you don't have to be from a ghetto or anything like that in order to make that mistake and slip up. I basically took my brother's history and tried to apply it to myself.

For *24*, I tried to figure out what president I had to follow, which president I would vote for. And I also had a couple models for it. Colin Powell is one and Jimmy Carter is another, and Bill Clinton. I chose Clinton because I think he's probably one of the most intelligent presidents we've ever had. I love the way his mind worked and I loved the way he really was a president for the people. He did more for women and minorities than the last two or three presidents.

MARLEE MATLIN

1. You are…a tourist

on a sightseeing boat in San Francisco Bay,

watching a man jump off the Golden Gate Bridge.

2. …a woman furious with your husband

for arriving a half-hour late

to your couples therapy appointment.

When there is a part where you have to cry you need to give me five days before the scene and I'm a different person. I become the character, completely and totally, when I'm working. And that's a very frightening thing because I'm not Marlee any longer, I'm completely somebody else. And I usually stay away from people during that time. And I warn my husband. For example, I did a scene in *The Practice* that David Kelly wrote for me, and I was nominated for an Emmy for that role. There was a courtroom scene where I had to basically talk about how I killed the man who molested and killed my daughter. And so I'm in court, testifying, and after a very, very calm testimony, I just lose it. And in that particular scene I knew it was very vital to keep it under control—for the character, not for Marlee. It took me about a week and a half and it was nuts. And then that morning I went to the director and I said, "Shoot me first. Shoot me first." I got in and I was ready and I was not Marlee at all. And I did the first take and that was it and then I lost it. And I did it and I kept crying after the "cut." Because I was so scared, I got so into the character, it was completely terrifying. I was still the character. It scared the hell out of me.

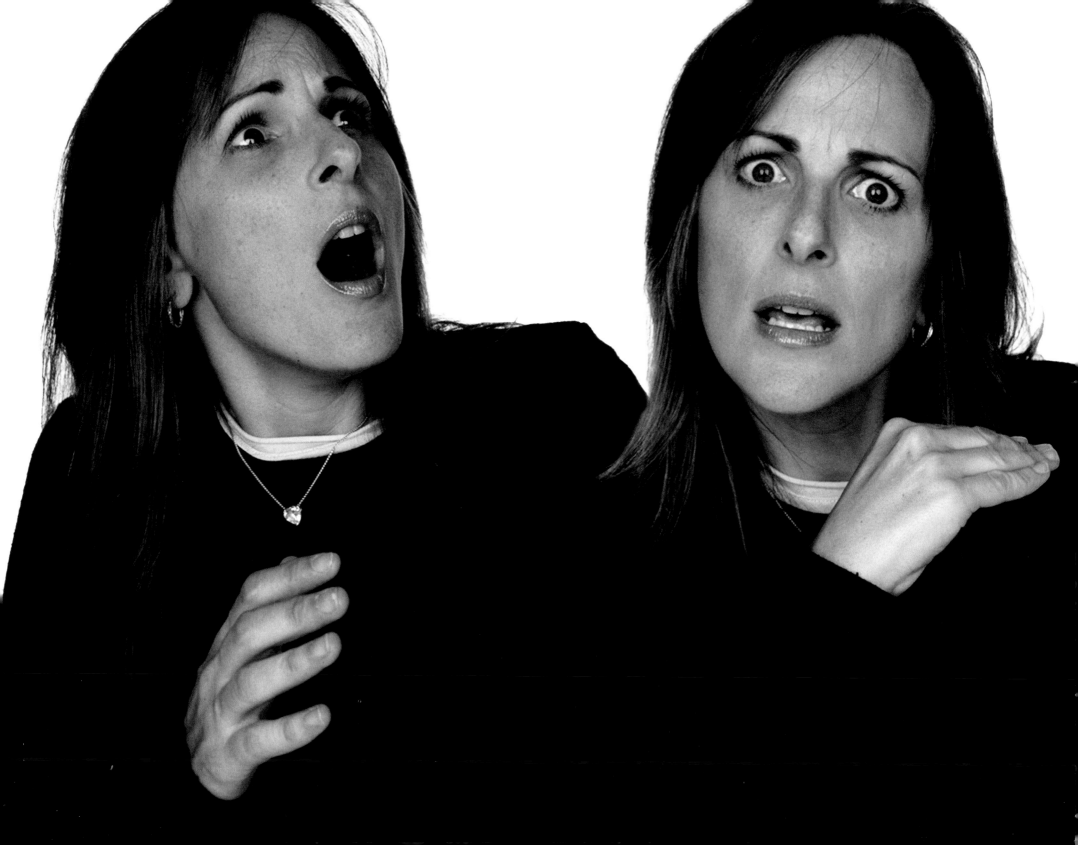

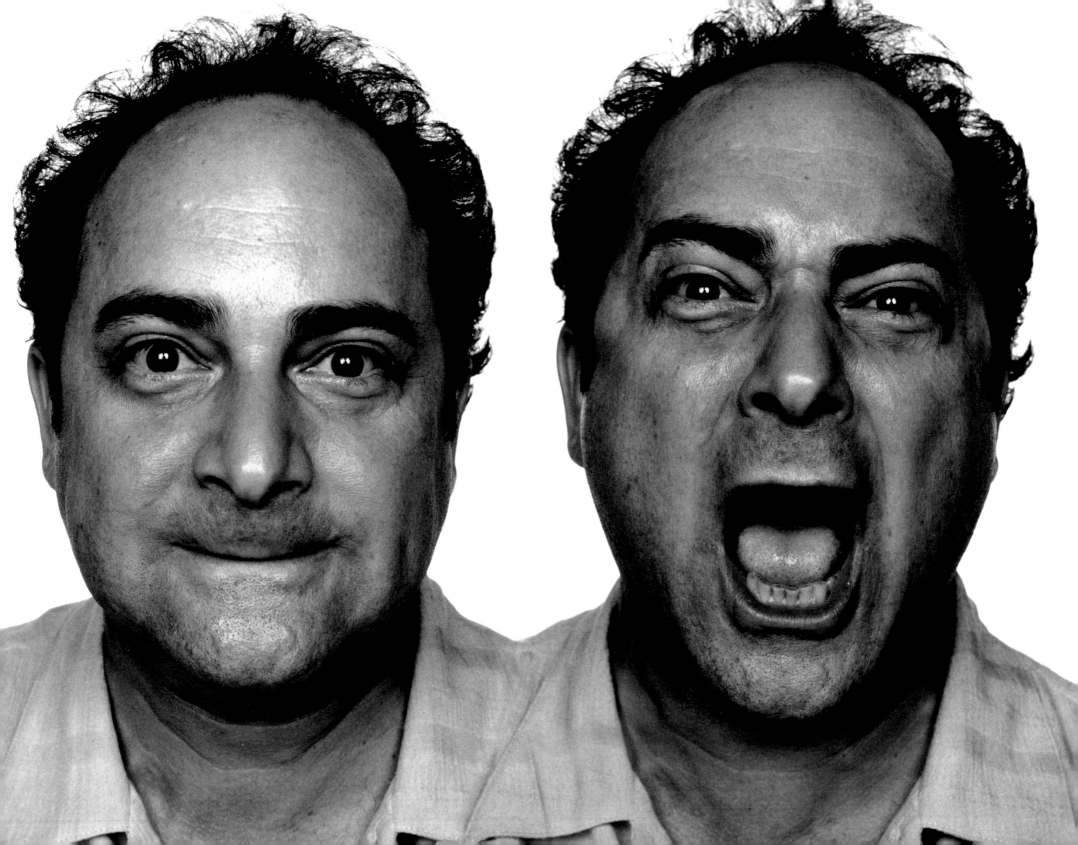

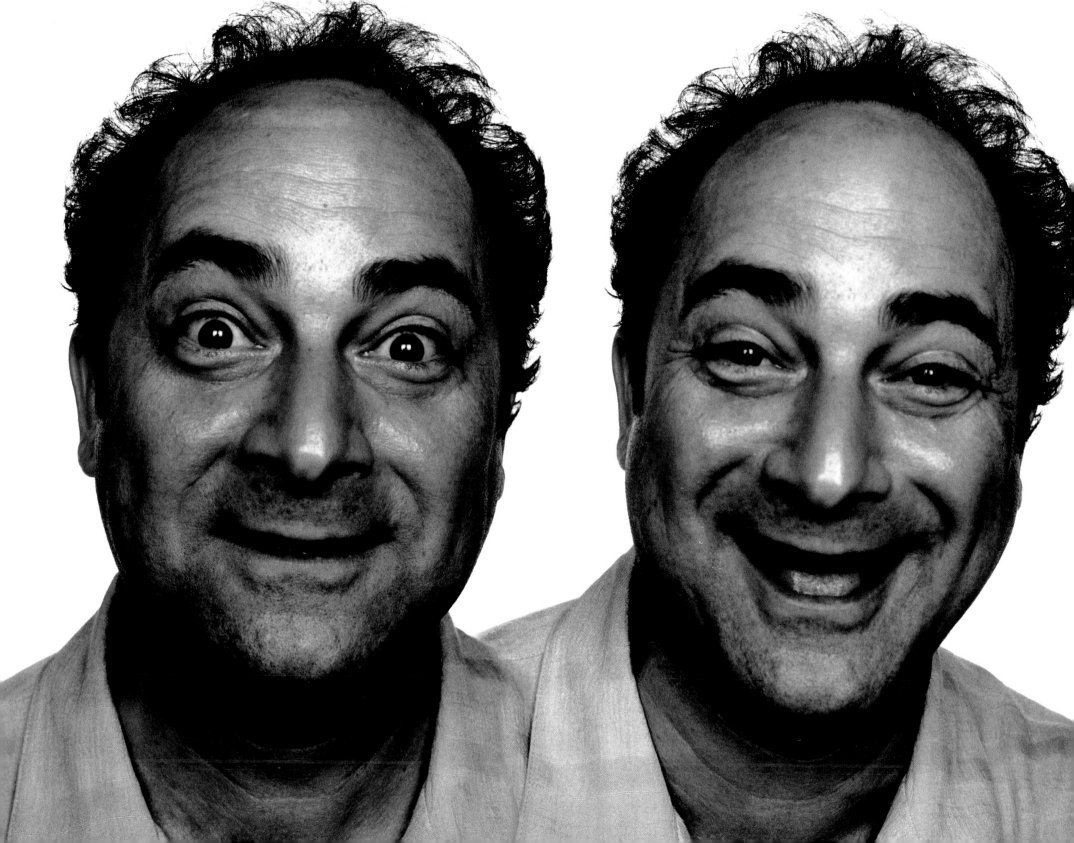

KEVIN POLLAK

1. You are a football bettor…

 in hock to a mob bookie,

hoping your team,

 which is ahead,

can hold on to cover the spread.

 2. …seeing a defensive blocker

on the other team pick off a pass

 and run in for a TD in the closing minute.

3. …seeing that a flag is thrown down and the play called back.

 4. …watching your team's quarterback

put his knee down as time runs out.

I always wanted to be an actor. I would go to the movies when I was six, seven years old, and be mesmerized and become sort of focused on one particular actor in the movie. And then I would walk out of the theater as that character. And it would stay with me for days. I remember walking to school as if I were in a movie. I would picture a camera crew sort of going backward down the street as I walked toward them, and I was acting in a movie. I became the character in the movie I saw from the day or two before. And sometimes just me, Kevin Pollak, six-year-old, walking to school.

F. MURRAY ABRAHAM

1. You are…a teenage girl

 chosen to go backstage

 at a Justin Timberlake concert.

 2. …a father disappointed

 and angry with your son,

 who stole a

 neighbor's car.

The truth is a constant search, because it's constantly shifting and changing. It's the looking. It's the searching.

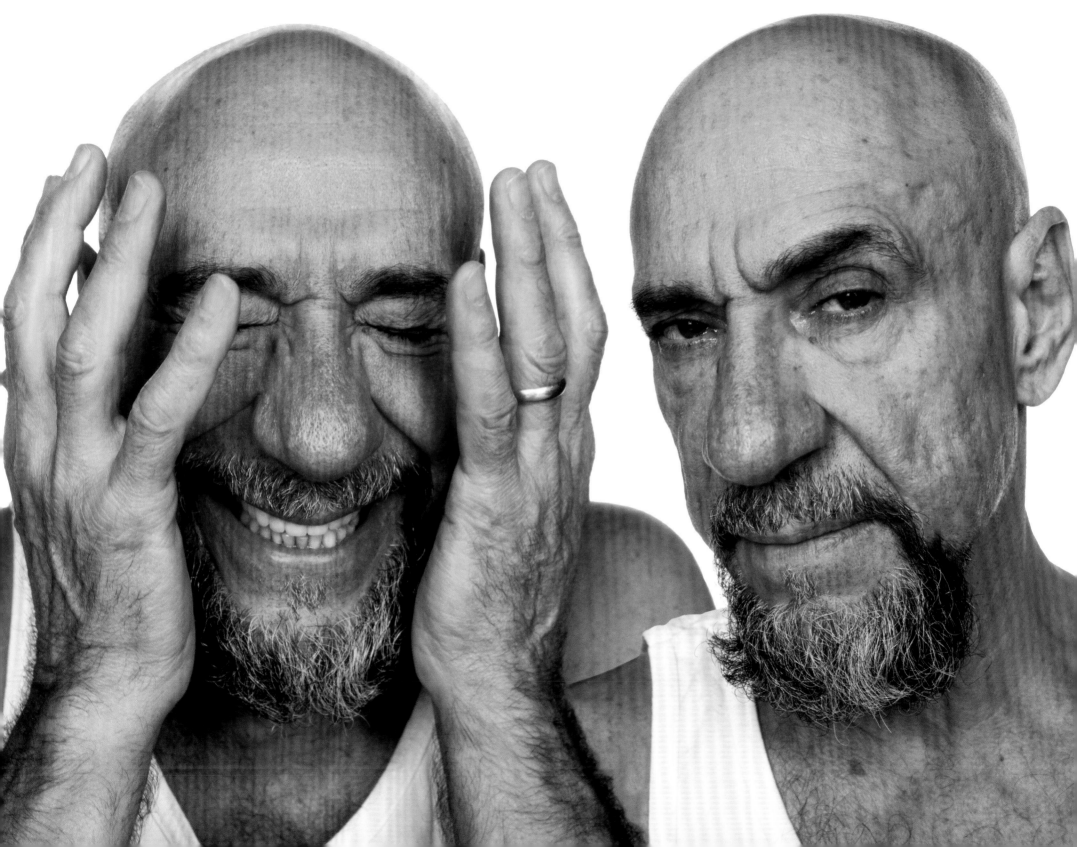

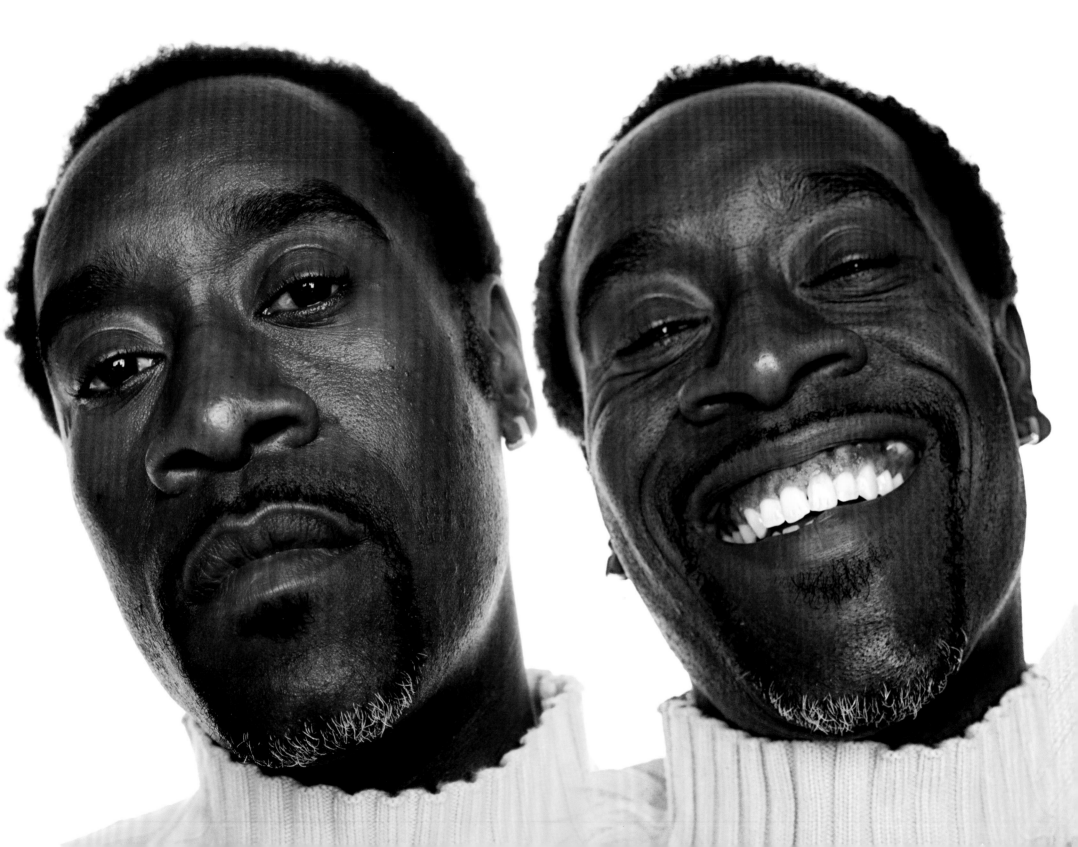

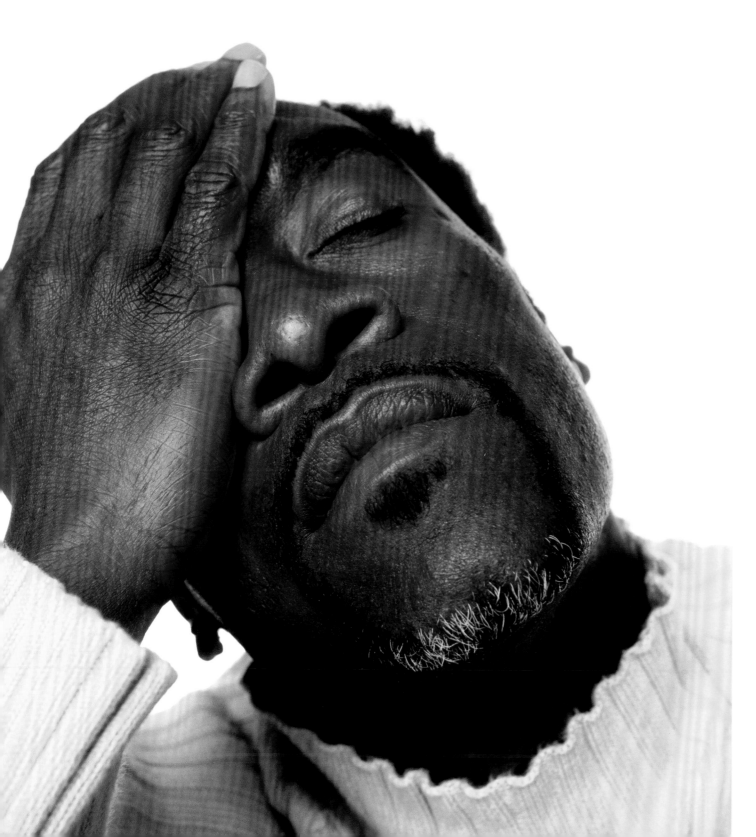

DON CHEADLE

1. You are…a man
at a bar,
 overhearing another man
telling his friend
 about your wife.

2. …the same man,
 realizing the conversation is
actually about
 your sister-in-law.

3. …a stockbroker
 discovering that
you've just lost
 half a million dollars
of your best client's money.

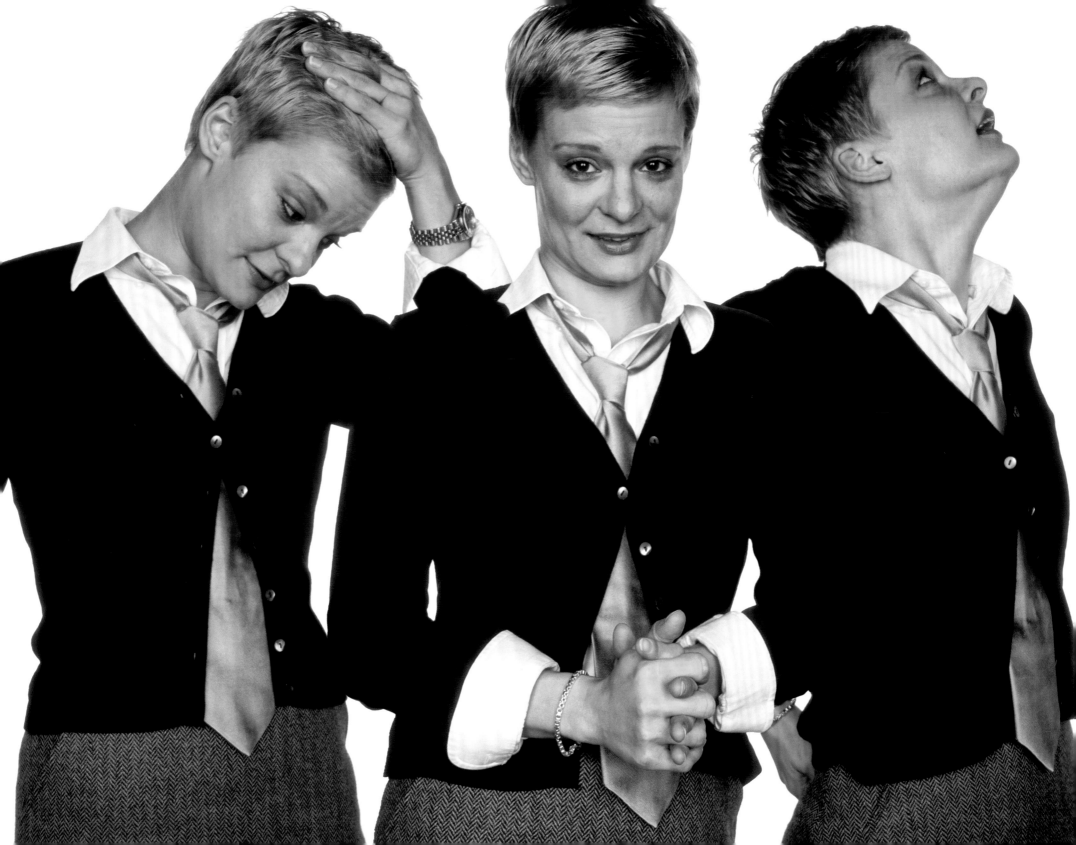

MARTHA PLIMPTON

1. You are an unmarried waitress with two small kids…

 walking out of a restaurant

 where you've just told the lecherous owner

what he can do with his job.

 2. …back in the boss's office an hour later,

pleading for your job back.

 3. …hearing him relent.

I like that acting affords me the ability to communicate with people on a visceral level, an emotional level, and that I get to express an idea through someone else's character. But I don't trust the impulse to merely act to feeling. I don't think that's good acting. If I feel as though I'm just acting a feeling I know I'm being ineffectual. If my mind isn't engaged in some sort of intellectual process of that feeling, I don't trust it.

following pages

PATRICK STEWART

 1. You are…a man listening to your wife and daughter scream

at each other at Thanksgiving dinner.

 2. …a middle-aged tax accountant

 told by a beautiful young colleague that you're

"incredibly sexy."

 3. …a CEO who knows that the compensation committee

is going to okay your massive raise.

4. …a struggling restaurant owner

 confronting two protection-racket collectors:

"That's it, you bloodsucking bastards, not one more penny!"

For a long time as a young actor I had difficulty portraying anger, rage, fury. I grew up in a home environment where there was a lot of it and it frightened me and so I realize now, looking back, the reason that I was not good at communicating anger, rage, fury, was that I was afraid of it. I didn't want to reproduce those childhood experiences. So I would fake it, and I was not good at faking it. I don't fake it anymore now, because I've acknowledged that all of these feelings do exist inside me. They are there. There's nothing I can do about them. I can get in touch with them but also stay in control, except when I work. When I work I can let it out, and now I'm not afraid to let it out.

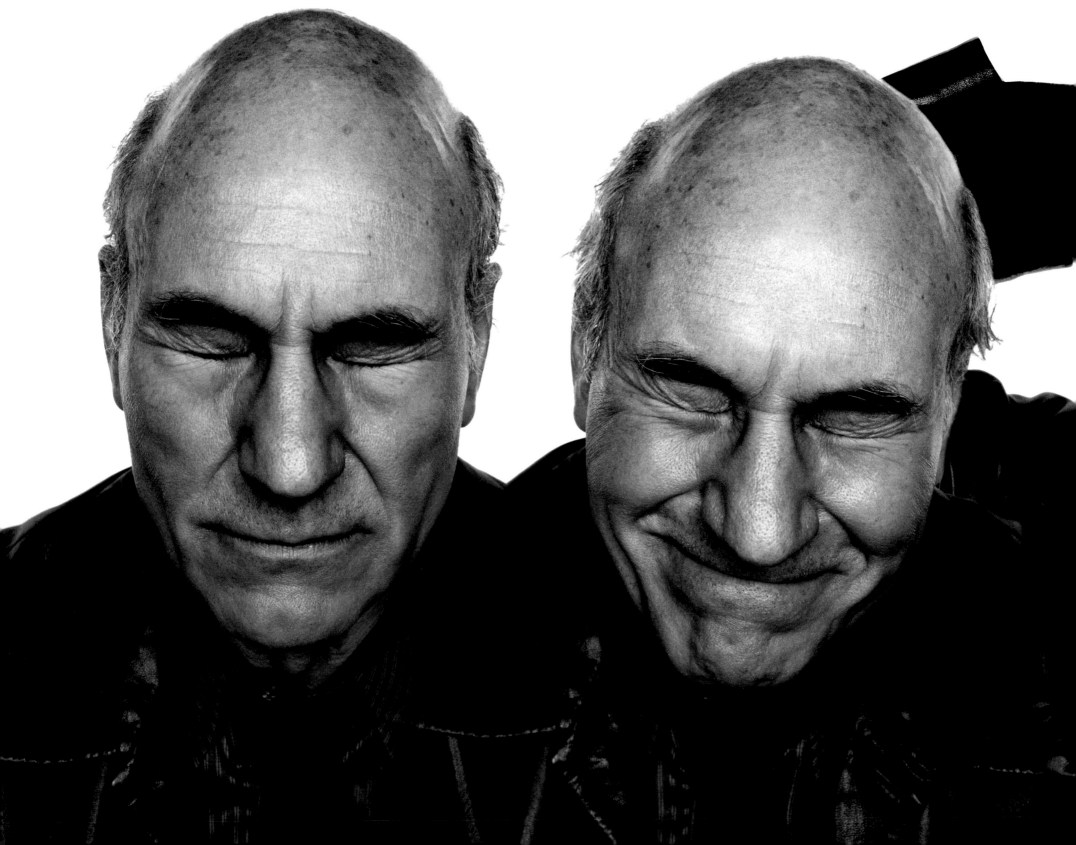

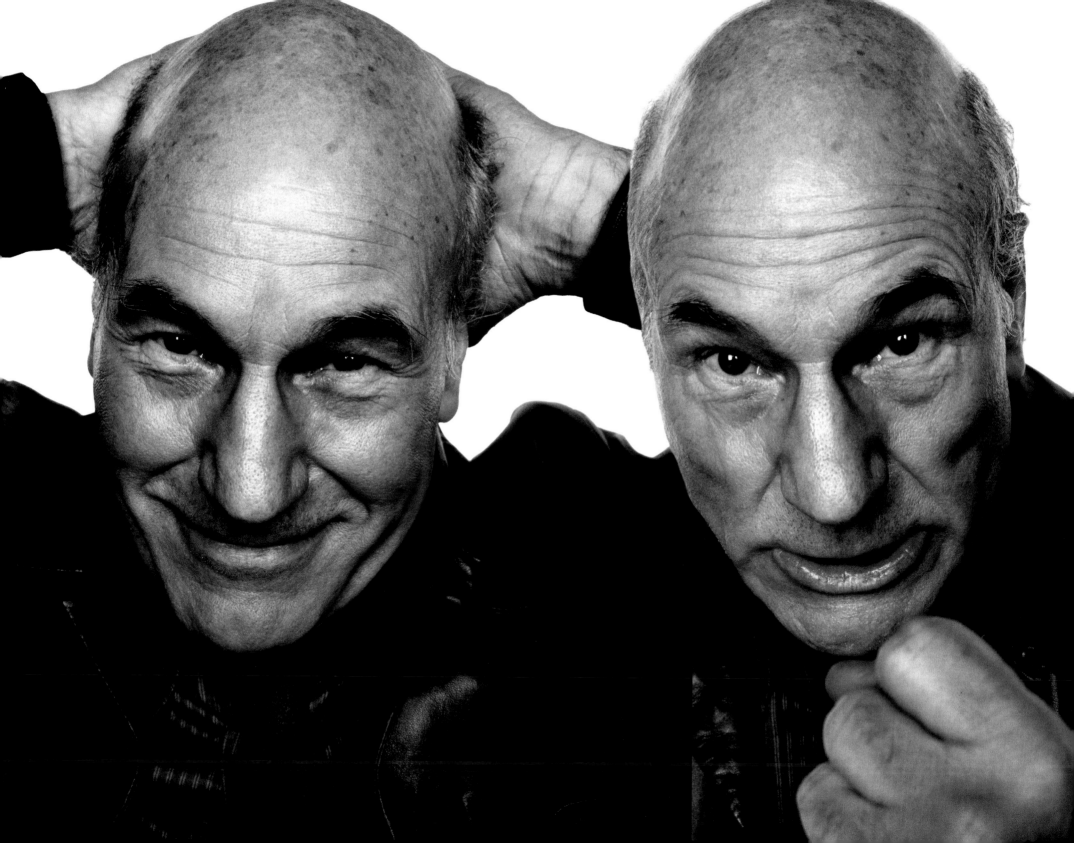

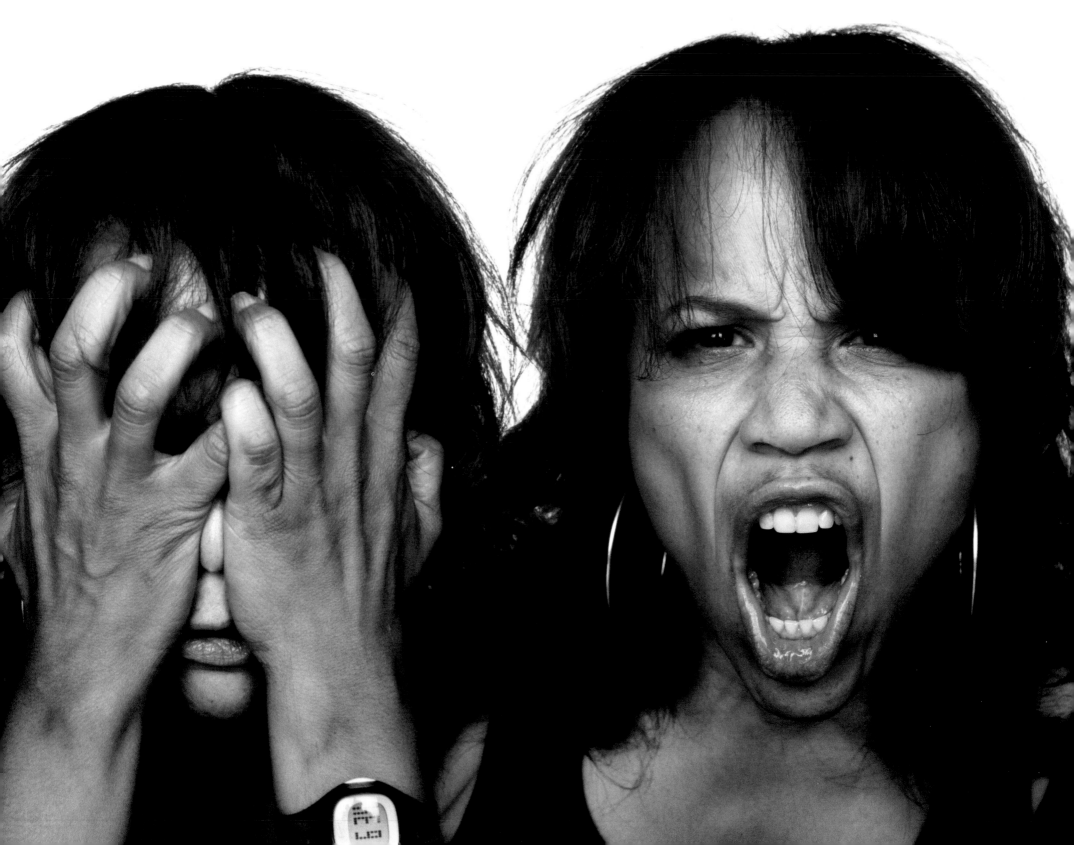

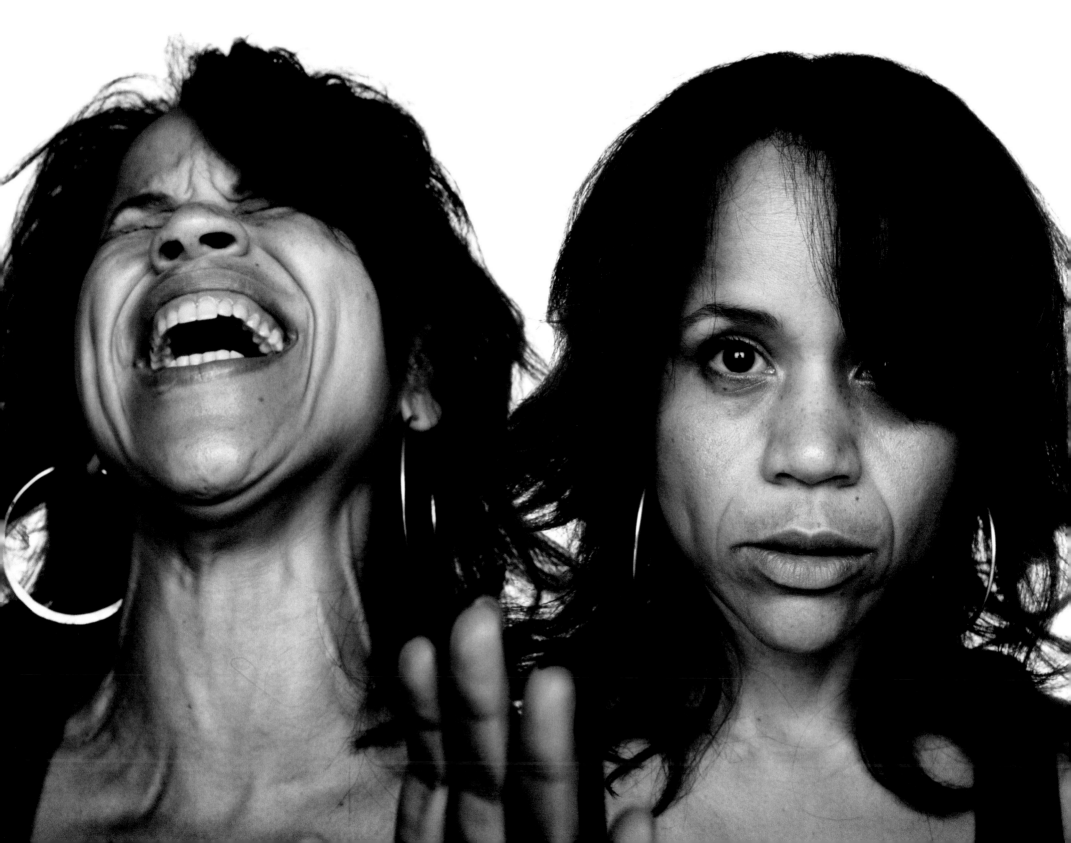

ROSIE PEREZ

1. You are...a woman

whose sister has just called to say

she knows you slept with her husband.

2. ...an L.A. girl gang member who has just been cut

off on the 405 by a blonde in a Hummer on her cell phone.

3. ...a woman talking with your girlfriends about boyfriends.

4. ...a young teenager seeing the love of your life

kissing another girl.

I had no aspirations to be an actress. I was nineteen and I was going to college for bio-chemistry. My friends took me to this club, and by coincidence Spike Lee was having a party there to launch *School Daze*.

A month later, after meeting and talking, and meeting my family, he asked me to be in *Do the Right Thing*. I would come on the set and watch everybody else before my scenes were up. Days, weeks before my scenes were up, just watching everybody. I watched John Turturro and Danny Aiello, two completely different styles. And

Giancarlo Esposito. By the time I got to *White Men Can't Jump* I had figured out something: as soon as I put on the wardrobe I was good to go.

A lot of actors that I see are very conscious about their bodies, and their looks, their gestures. I wasn't aware of that. When I played being angry, I was really angry. I wasn't conscious of any type of restraint.

When you finish and you feel like you did something good, whether you made them cry or laugh, you moved somebody. If you can do it and there's no pretense, it's just pure art.

BRUCE ALTMAN

1. You are...a famous divorce attorney

who has just been beaten in a bitter negotiation.

2. ...a father

watching your daughter

belt out a song

in her school's production of Grease.

Sanford Meisner described acting as the ability to live truthfully under imaginary circumstances. The camera is sort of godlike. It looks in your soul, it loves you. The director can hate your guts. The other actor could be trying to upstage you. The camera looks at you and says, "If you are honest, Bruce, you're going to do great. We're in this together." So, you always have a friend in the camera. If you start lying to the camera, the camera turns away. It's biblical – the camera turns away and you're left to be fucked.

JASON ALEXANDER

1. You are...an alcoholic

who fell off the wagon

at the company Christmas party,

trying to remember

if you offended anyone.

2. ...remembering

that you came on

to the woman you work for.

There's not a lot of me in most of the characters that I play. The most glaring one being George on *Seinfeld*. The notion is that I must be very similar to that character, because I did it rather seamlessly, and for so long. But the energy, neuroses, and histrionics, and the emotional makeup of that character are not me. I understand them, obviously, or I couldn't play them, but they're not me. I am much shyer, much more somber, thoughtful, speculative. I am quieter. I had a teacher in college who nailed it – he said, "Here is the irony of your life: your heart and soul is Hamlet, but your body is Falstaff."

Actors' Notes

ROSIE PEREZ

I haven't done a lot of movies, because if it's not on the page I can't do it because then my imagination is not stimulated. If a script is extremely well written and has a concise beginning, middle, and end, and has fully developed characters, fully developed plot…even if a nincompoop were to direct you, you would have a good chance of still delivering a good performance.

I find reading helps me with my imagination with the characters, because in a script the character's not really spelled out. It's between the lines. In a good book it's there, in print; it's also in between the lines. You get inside the head of the character more in novels because you hear their inner thoughts. I try to apply that when I work.

Theater helped me lose all sense of self-consciousness. And it's ironic, because people are staring right at you. I learned that the theater audience is so intelligent; they can tell when you're acting. They can tell when you're not connected and you're not in the moment.

MARLEE MATLIN

I was at a summer camp and there might have been seven or eight deaf kids out of two hundred kids altogether. And a woman who was in charge of our little group asked us if we wanted to act, and I said, "What's acting?" And she said, "Let me show you." She took me on the stage. I saw lights and seats all set up for the show. She said, "What you're going to do is you're going to be singing for your family and your teachers and your friends and strangers." And I said, "You know, I don't sing." But I could sign the song. So, I was the only deaf member of this chorus that was all hearing and I was signing the song called "John Brown's Body Lies A-Moldering in His Grave." And I loved it. I loved it. That night, I was hooked. I saw the audience and I saw their laughter and their applause. It allowed me to come out of my shell.

I got my first professional work in a feature when I was nineteen. And that was *Children of a Lesser God*. It was a great experience because I really got to delve into every single aspect of a character. To explore and give time and develop the character in film. As opposed to television, where you work very quickly. Depending on the script and depending on the role – I mean, I like television, but the time factor makes it so different. I get more frustrated sometimes.

Film is like giving birth. You bear a character, because I'm the one who's creating the character. Someone has put the seed in there and I'm trying to water this seed and cause this seed to flower. I always go up to the director and say, "Look, please do not be shy with me. Please do not be intimidated by my language, please do not hesitate to direct me." I want the director to simply direct me down the path. If he has ideas and if he knows the character, please illuminate her for me. I don't want a director – which, unfortunately, happens a great deal, to assume that in signing I've said my lines correctly. "She signs; it's good enough." That is a danger when you're working with people who don't know sign language.

JASON ALEXANDER

The best directors have a very clear reason for why they are doing the piece they are working on. There is a story that speaks to them. There are themes that speak to them. There is a design that speaks to them, and they know why they're telling the story, and they are articulate about it. The other thing that they can do that is wonderful is help to articulate the challenges that I, as an actor, have to meet. They can be physical challenges. They can be emotional challenges. They can be storytelling challenges. When a director is very specific about those, you can get something brilliant.

What every actor craves is to get to a place where you are thought of as being capable of anything. Most people do not think of me in a dramatic sense at all. They will think of me in a comedic sense, and even in a comedic sense they are pretty narrowly focused to the kind of characters like George or the part I did in *Shallow Hal*, which was also a pretty manic, high-energy guy. I'd love to have the opportunity to play more thoughtful roles, a greater range of roles.

I've seen kids who have a lot of desire but not a great work ethic. I've seen kids who have a great imagination but not a lot of life experience. I've seen kids who have a lot of life experience but no imagination, and all of them have to come together in order to make an actor.

PATRICK STEWART

For most people who are not actors what we do is terrifying – the idea of walking out onto a brightly lit space in front of several hundred or even thousands of people in a darkened auditorium. I think for most actors it's the exact opposite, and certainly for me this was my first taste of it. That brightly lit space where I was being observed was far more secure and safe than the outside world.

When I was growing up life was a dangerous place, chaotic and dangerous. I found the formality of theater reassuring. It was an antidote to the chaos and danger of my offstage life. And as years went by and I became a professional actor I found that there was value in exploring all the ways in which you can bring the chaos and the danger from your own life onto the stage in safety.

There are roles that you cannot leave in the dressing room and you wouldn't want to. You need to keep them simmering all the time. Sometimes when I work I'm aware that it's probably far better that I'm on my own, that I'm alone rather than with someone. Because the role simply requires all of me, and so you spend your waking hours with the role just bubbling away in the background until either the camera turns over or the curtain goes up and then you turn up the heat.

DENNIS HAYSBERT

I totally believe in emotion. That's the one constant in all the ways that you perform, whether it's television, films, or theater. It's the emotion. You can't care how people perceive you or how they think of you, good or bad or indifferent. What you have to do is hit your mark and tell the truth as you know it to the person you're dealing with. And you have to react.

I think I really knew when I was about ten years old from the movies I watched: *On the Waterfront, The Young Lions*. I watched everything Poitier did. And I think he is probably the driving force in the way I work.

Actually, I think the word *acting* is a bad word for what we do. If we're doing it correctly, we are being. And that, I think, is the single hardest thing for any person to do, whether they're in front of a camera or on stage or talking to your girlfriend or your friend or whatever. It's just to be.

In high school, I would take on roles, and they would really get under my skin. It wasn't until I got to the Academy with Michael Tolland, who'd tell us, "From the time you leave the stage, just after you pass that curtain and you walk off stage, five steps after you get off stage, you have to become Dennis again." And that was the best direction I could ever have received. You have to be able to understand that this is a character; but you have to use yourself in order to bring him to life. But you have to understand that it's not you.

MARTHA PLIMPTON

I find that acting is a collaborative discipline; drama or the art of story-telling requires multiple hands, and so I find it very difficult to sit in my room the night before shooting a scene and figure out exactly how I'm going to play it the following day when there are so many variables, not least of which are the other actors in the scene.

Each actor is telling his own version of the "truth." But it's very difficult unless you have someone who's a real maestro there drawing everyone in together to tell the same story no matter what their differing styles might be. It's a very isolating feeling when you're on a movie set and you don't have that person who really is there to shape things.

I think that there are ways to manipulate actors that are loving and generous. *Manipulate* is often a bad word, but for me it's really not. I'm there to be an instrument for something, for someone else's ideas. I may contribute to that within the parameters of their idea. I'm not there to play myself in this context, in other words.

You often hear actors talk about the microcosm of the rehearsal room or the theater where you're forming this new family and these new, incredibly tight, incredibly fast-forming bonds with people who are virtual strangers to you. And in the end, they remain virtual strangers because you've been forming your relationship based on this artificially constructed world. And it can be very, very difficult to close a play, and very frightening and very depressing. Very painful. The pain of that loss is real, in the gut, like you feel when you lose a lover or at the death of someone that you care for. It's a very physical feeling. And I know that people in our lives who are sitting at home waiting for us to

come back, or watching from the outside, are affected by the fact that our minds are very much elsewhere.

I've worked with some great directors who really knew what they were doing, were really in love with the form and imbued the entire atmosphere with joy and comfort and pleasure by making the work not just fun but also enriching and thoughtful. I want a director to infect everyone in the room with a joyous enthusiasm for their vision. And I want them to be able to sort of plant the seed of their idea in everyone and then help that seed to grow and flourish in the individual actor at their own pace.

I want someone who has an excellent eye for honesty and who can really cut through all of the bullshit and be honest without being cruel. And who's very exceptionally intelligent. I need to work with a director I respect and can look up to and who I feel can be a mentor. I think it's good for a director to infuse an actor with his or her concept or vision of the play and at the same time make the actor feel as though they thought of it themselves.

KEVIN POLLAK

You'll hear many stories of people feeling really sick backstage, flu, cold, whatever, and then ten minutes into their act, they're completely well. It's a euphoria that can't really be described, other than to say it transcends all illness; it transcends all stress, and problems of your day.

Suspicion

Fourth Intermission

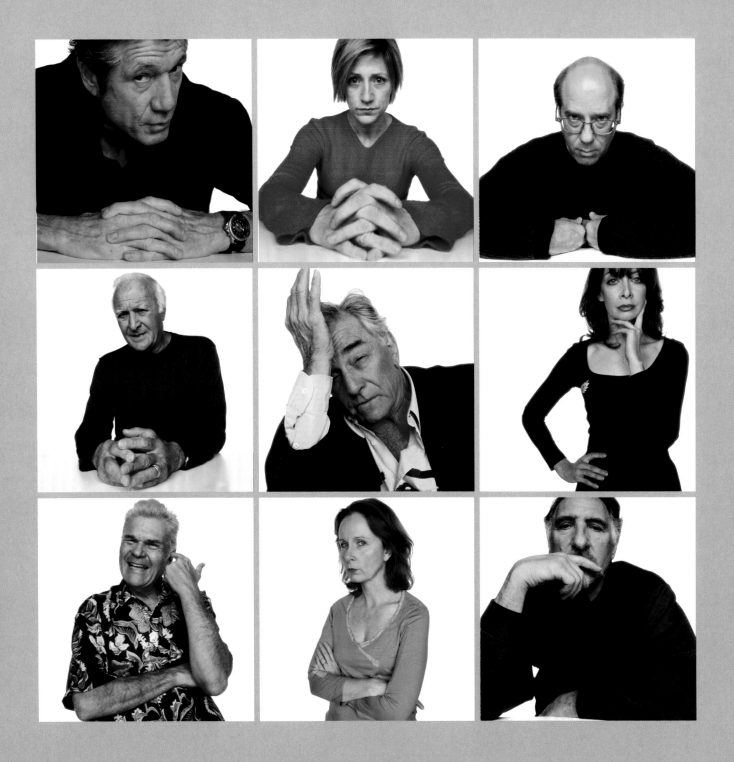

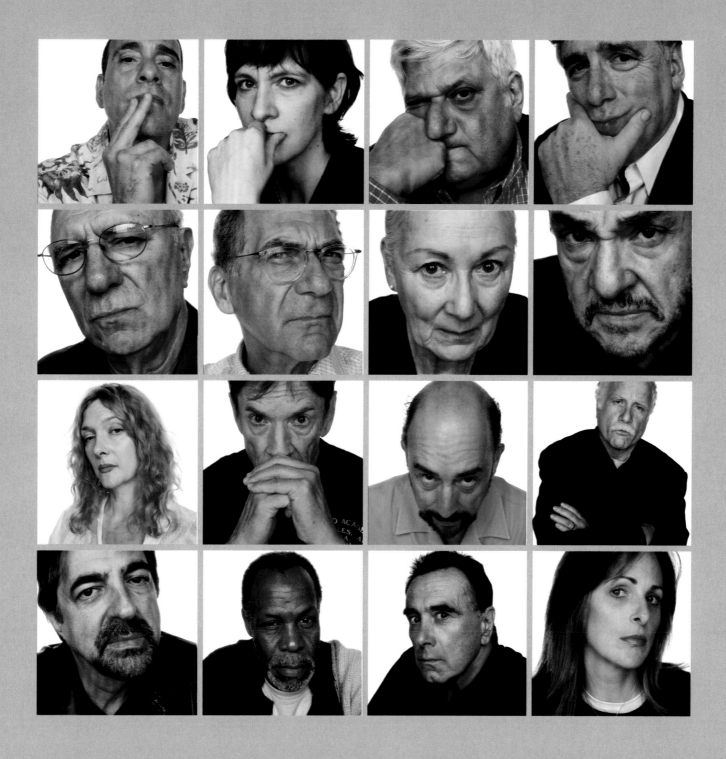

Act V

The Players

CHARLES DURNING

JOHN FINN

CHEVY CHASE

PETER WELLER

FRED WARD

BUCK HENRY

ILLEANA DOUGLAS

DANNY GLOVER

RON RIFKIN

MICHAEL LERNER

NATASHA RICHARDSON

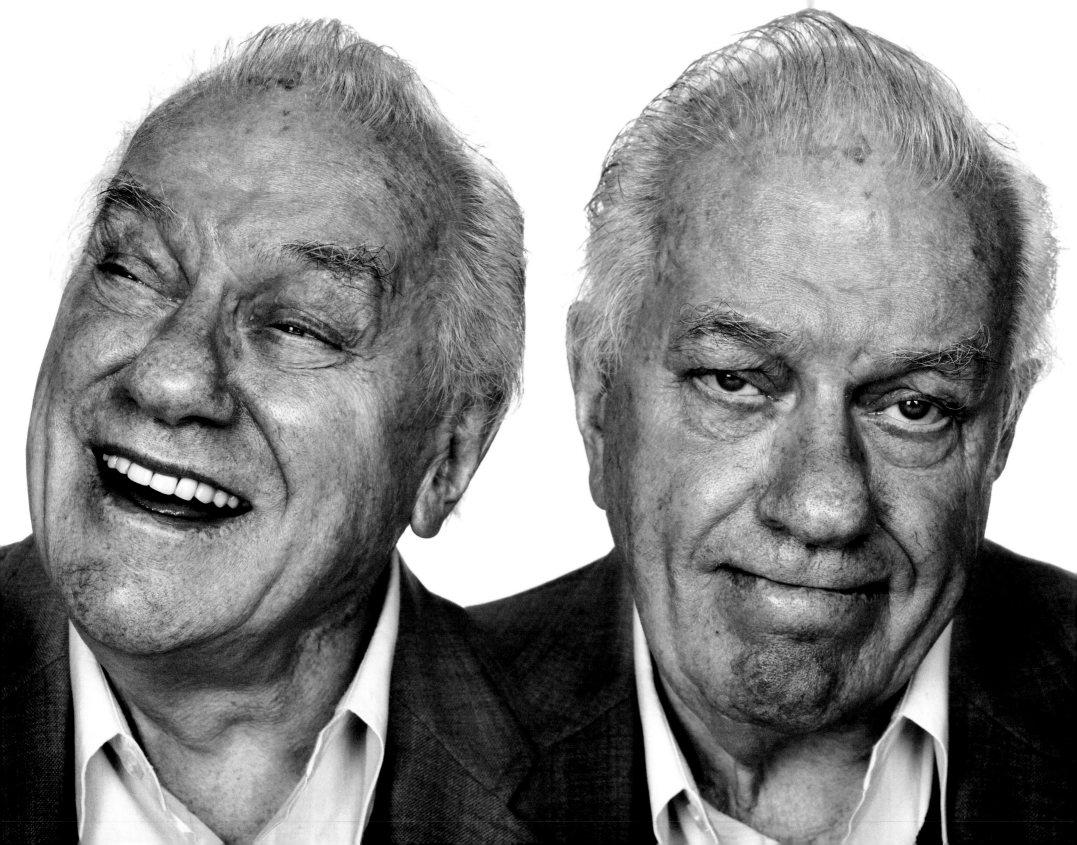

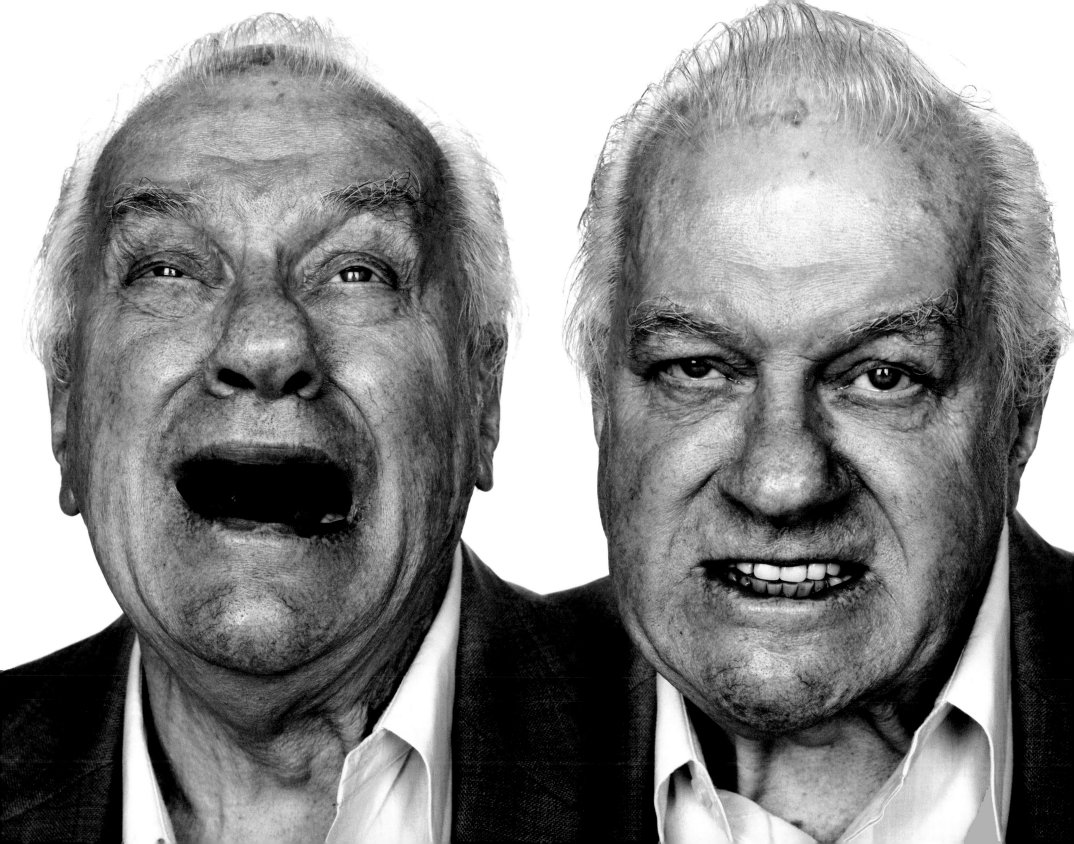

CHARLES DURNING

1. You are...a criminal defense attorney

getting a standing ovation from your colleagues

the morning after winning a big case.

2. ...a Broadway producer

telling a young actress that you're replacing her

with a better-known Hollywood star.

3. ...a man getting the news that your son and his family

have been killed in an earthquake.

4. ...a retired cop

who has just been told,

"Fuck you, gramps"

by a couple of young punks on the block.

I went to the American Academy of Dramatic Arts on my GI Bill; they said I had no talent. Another World War II veteran called Jason Robards got kicked out with me, although it was an exceptional class – Grace Kelly, Colleen Dewhurst, Anne Bancroft, Conrad Bain, Don Murray, John Ericson, Don Rickles. Cagney said it the best. He said, "Who can teach you emotion? Who can teach you how to be happy? Nobody. All there is to acting is find your mark, look the guy in the eye, and tell him the truth," and that's a great lesson.

JOHN FINN

1. You are...a father at your birthday party

whose children have just asked you to close your eyes

because they have a surprise for you.

2. ...a marine gunnery sergeant

coming back from a patrol

where one of your men was killed.

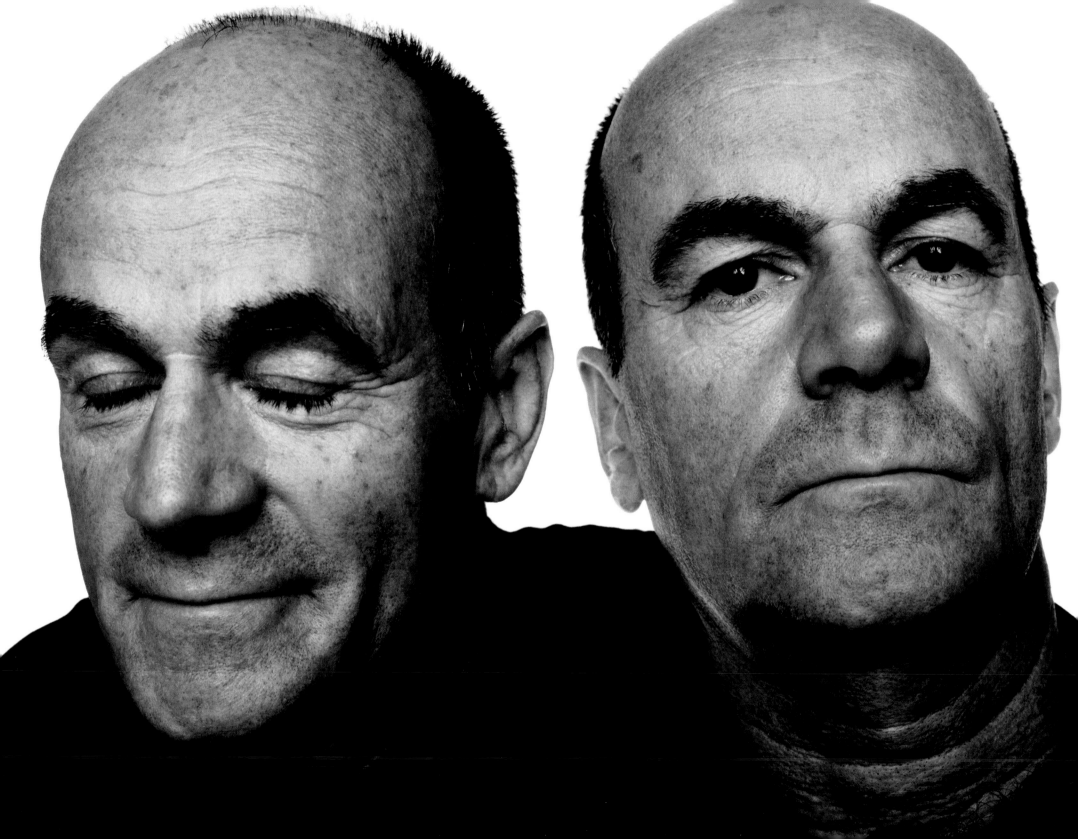

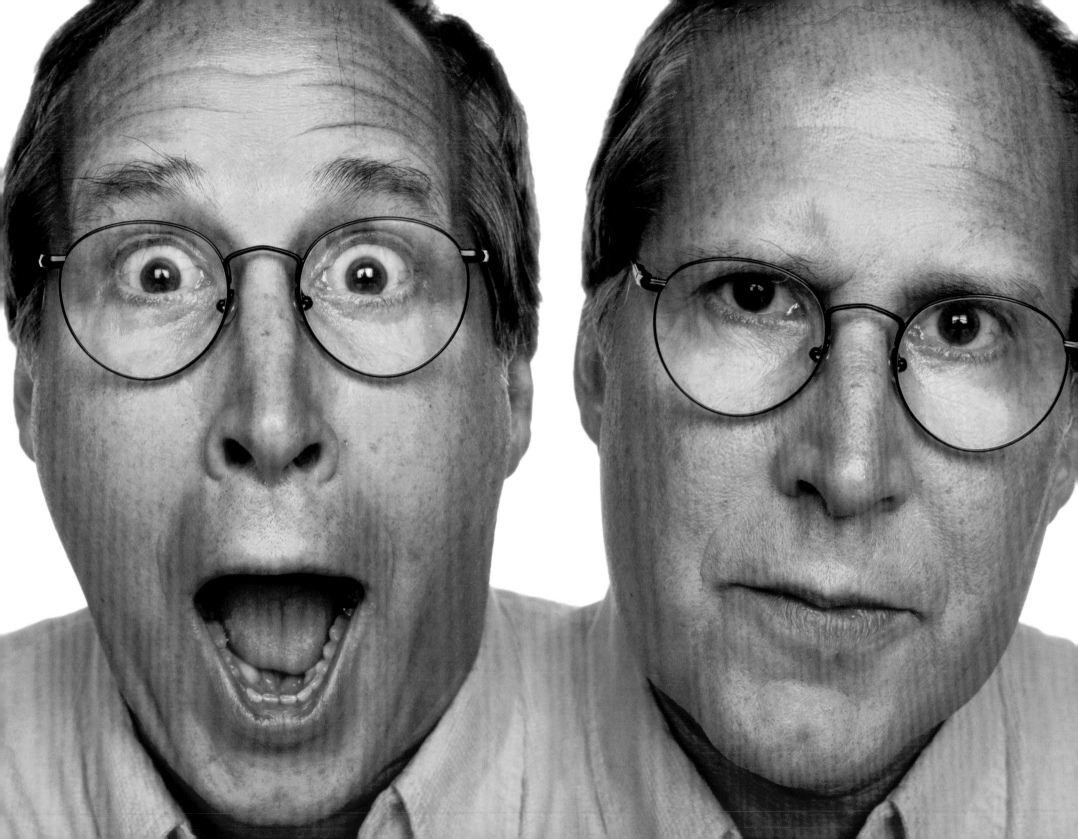

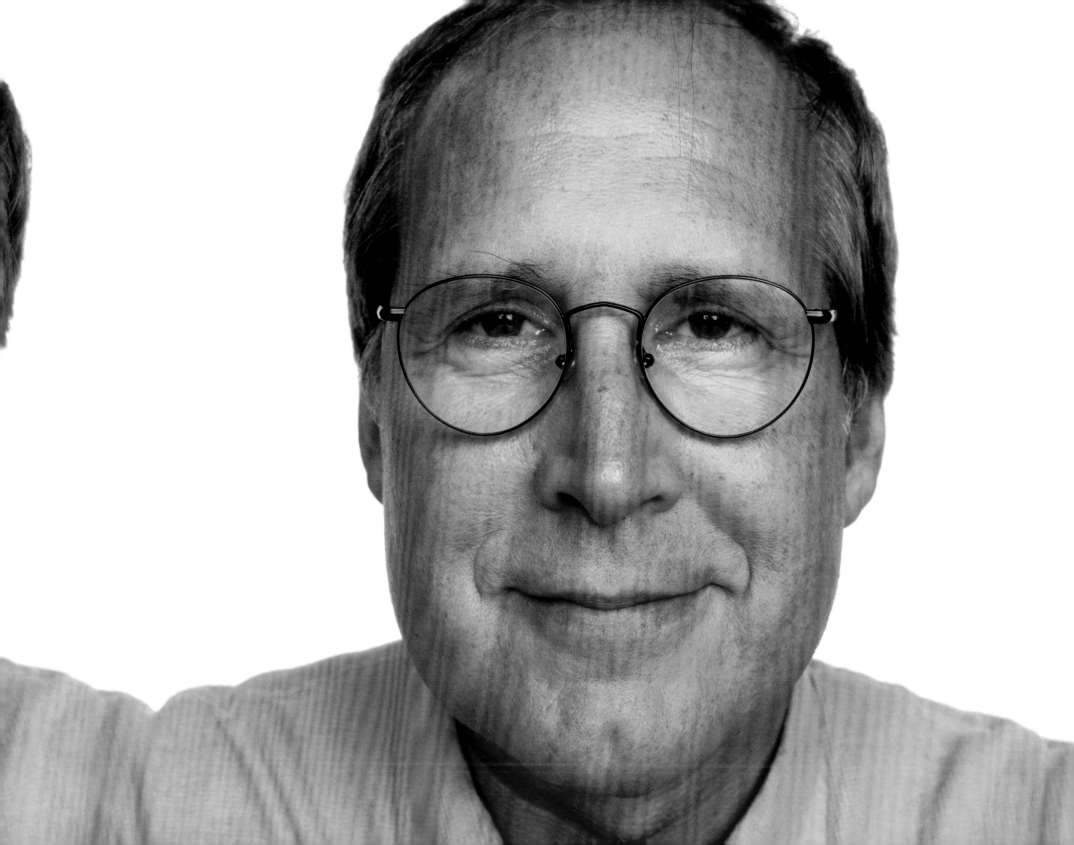

CHEVY CHASE

1. You are…realizing that the woman at the corner

holding open her raincoat is wearing nothing else.

2. …hearing your adolescent daughter

proudly announce

that she's had "something" pierced.

3. …at a sales convention, meeting Fiona,

a beautiful new hire in the Chicago branch office.

I love acting. What I enjoy is understanding every little part about what's going to happen from the time I walk onto that stage. And from before, when we're doing pre-production and the post-production, which is the most fun for me. I really understand sound. I understand lenses. I understand lights. I've made myself learn it. I really can edit. I used to work as a sound engineer for a year before I could make any money as an actor. So I've learned every aspect of making movies and I love it. But the act of doing it is great fun. I love it. It's the movement. It's whatever I'm doing with my body. And since I've concentrated predominantly on comedy, it's the way in which I use my body which makes me funny and makes it fun for me.

PETER WELLER

1. You are…a middle-aged man

who is beginning to understand that the love of your life is

never coming back.

2. …the director of a very expensive,

highly anticipated Broadway play

being told that your famous female lead

hates her dressing room, hates her costar, and hates you,

and is not coming to the dress rehearsal

unless some changes are made.

This guy I'm playing now in *Exonerated* is from Texas. I'm from Texas. He grew up in a military family. I grew up in a military family. He was a juvenile delinquent in high-school and a hell-raiser. I wasn't, but I knew a lot of them. So I start connecting those dots. He suffered a lot of horrors in prison. I've never been to prison, but every man's fear is to be in a box and be physically victimized or brutalized by human beings. I've felt the effects of people's manipulation and domination and fear. And that makes us feel weak and incapacitated. So I start connecting to discover who the person is.

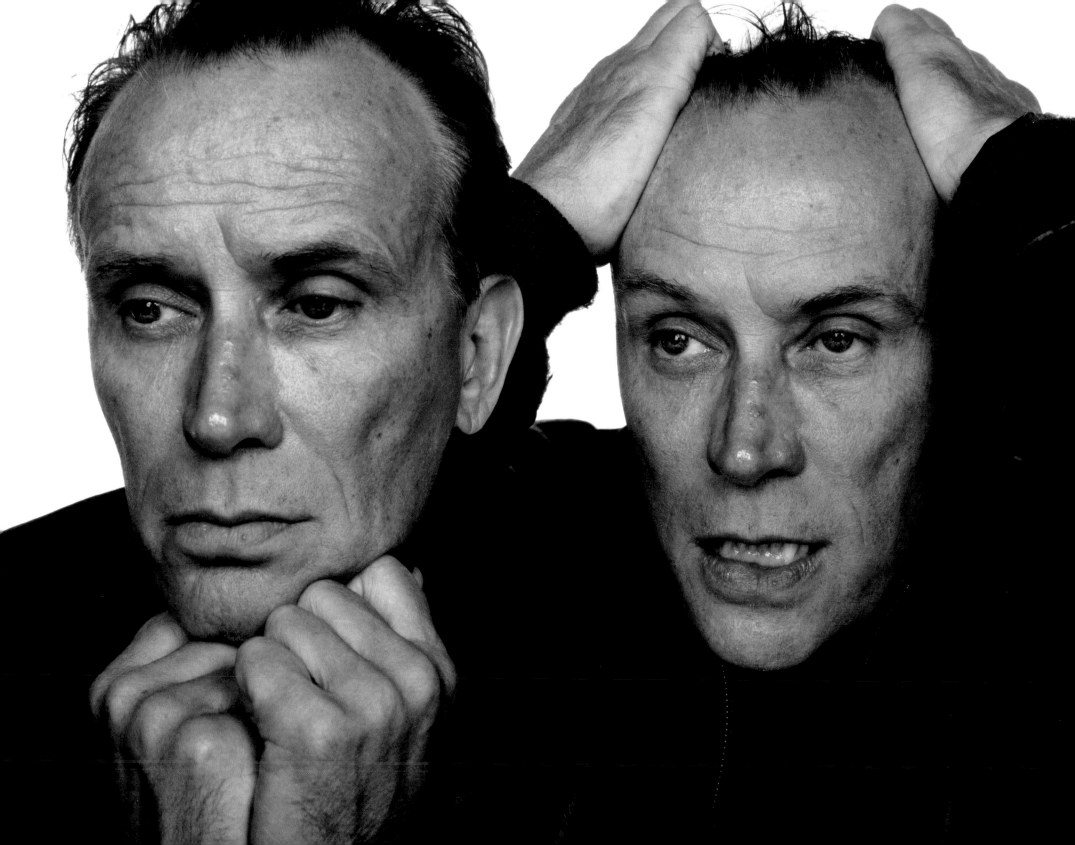

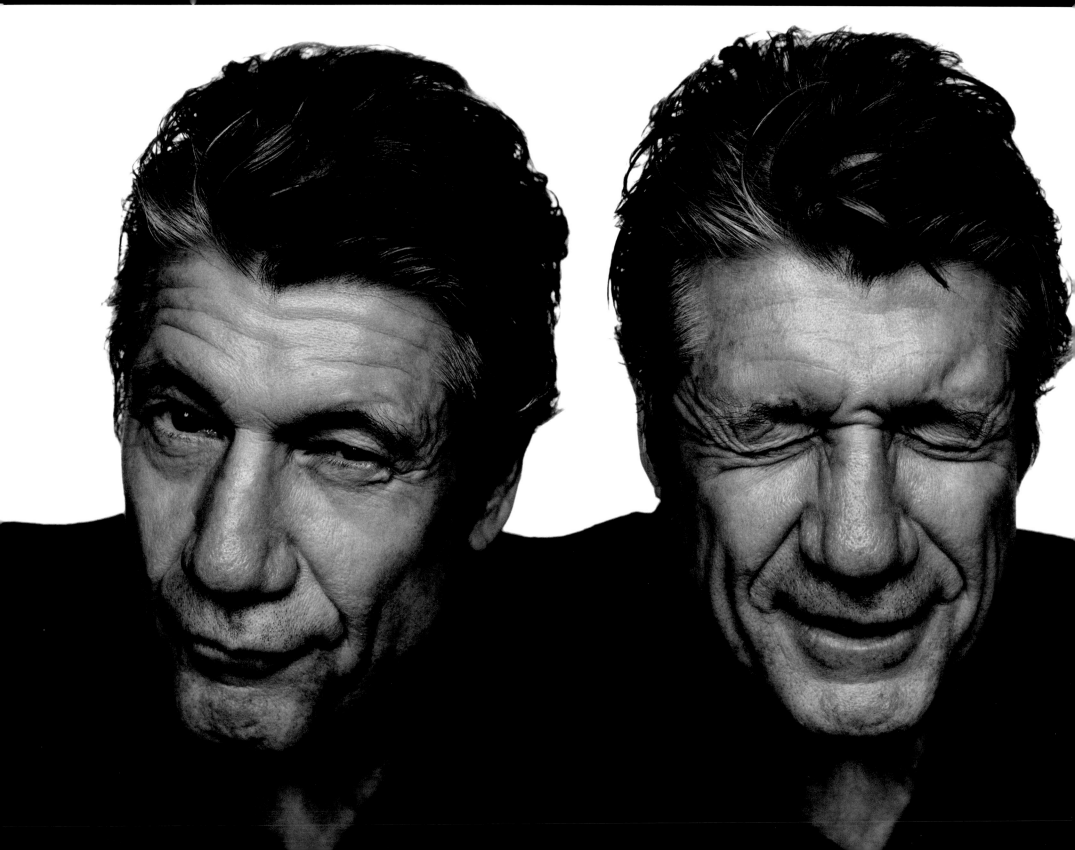

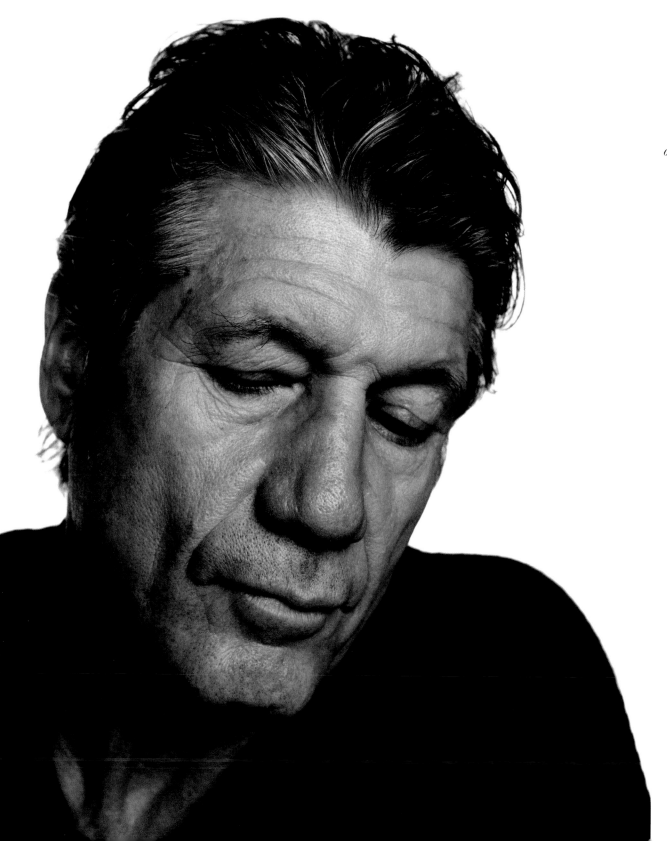

FRED WARD

1. You are…the crusty old owner

of a neighborhood toy store

who has just caught

two eight-year-old boys

stealing action figures.

2. …a passionate car collector

hearing the sound

of a 1963 Ferrari.

3. …a district attorney

in a celebrity murder case

as the jury foreman announces

a "not-guilty" verdict.

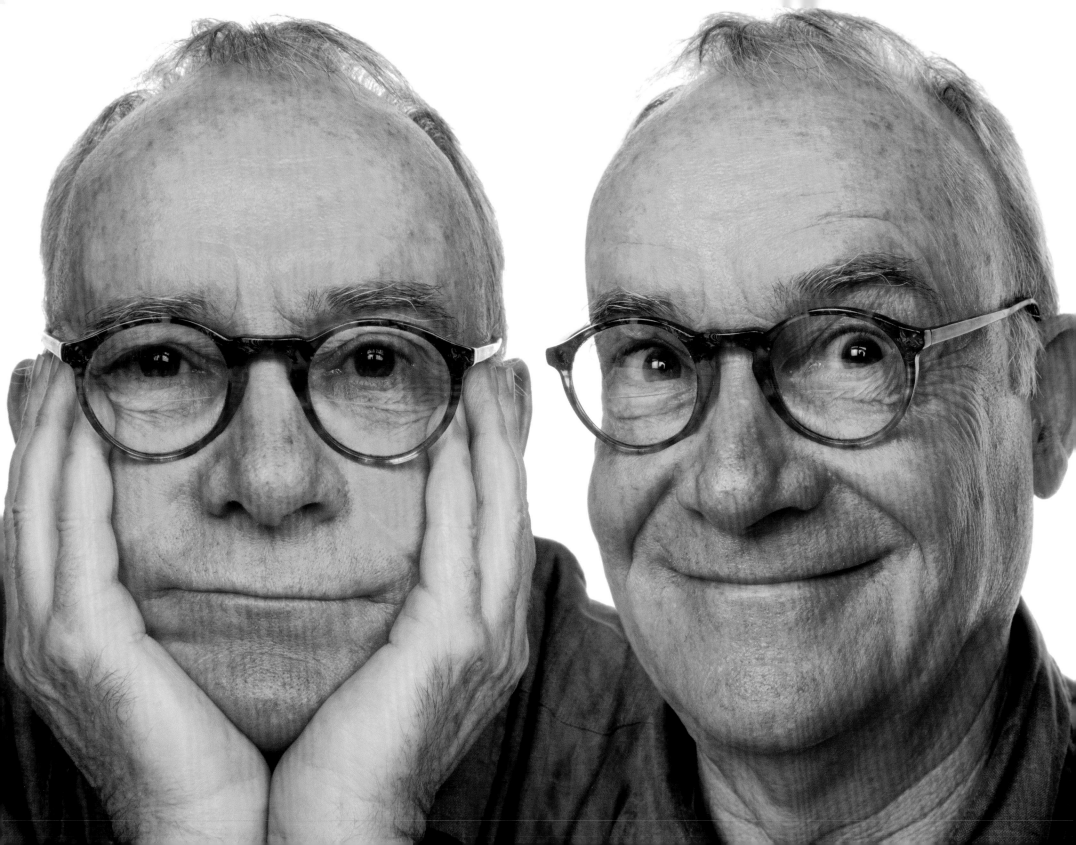

BUCK HENRY

1. You are...a middle manager

listening to one last excuse

 from an inept employee you're firing

 (though you're actually wondering

 if you should have used a three wood

 instead of a driver

on the eighteenth hole yesterday).

2. ...a used-car salesman

smiling at his coworkers

 as a customer signs a contract

for the biggest clunker on the lot.

The experience of being in front
of a live audience is not like
anything else.

There's a huge high after which
sometimes there is a very, very
significant depression. It's
consuming and fascinating and
sometimes it can lead to incred-
ible fears. Stage fright is one of
the scariest things there is.

following pages

ILLEANA DOUGLAS

1. You are...a young Pentecostal worshipper giving in to ecstasy.

2. ...a thirteen-year-old girl asking your mother,

 "Mom, please,

 do we have to have the big sex talk now?"

3. ...a recently divorced woman

 wondering how you can get through the rest of the evening

with a disastrous blind date.

4. ...a frantic wife

 telling her unfaithful husband

to get out and never come back.

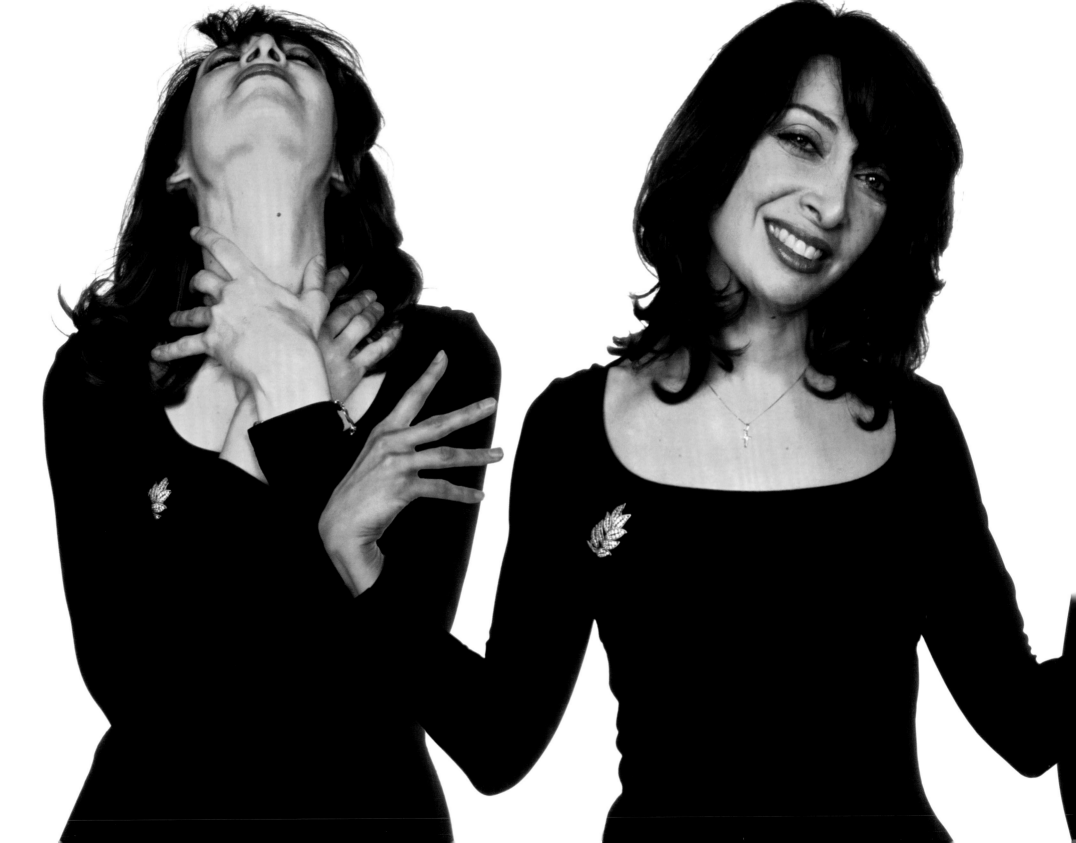

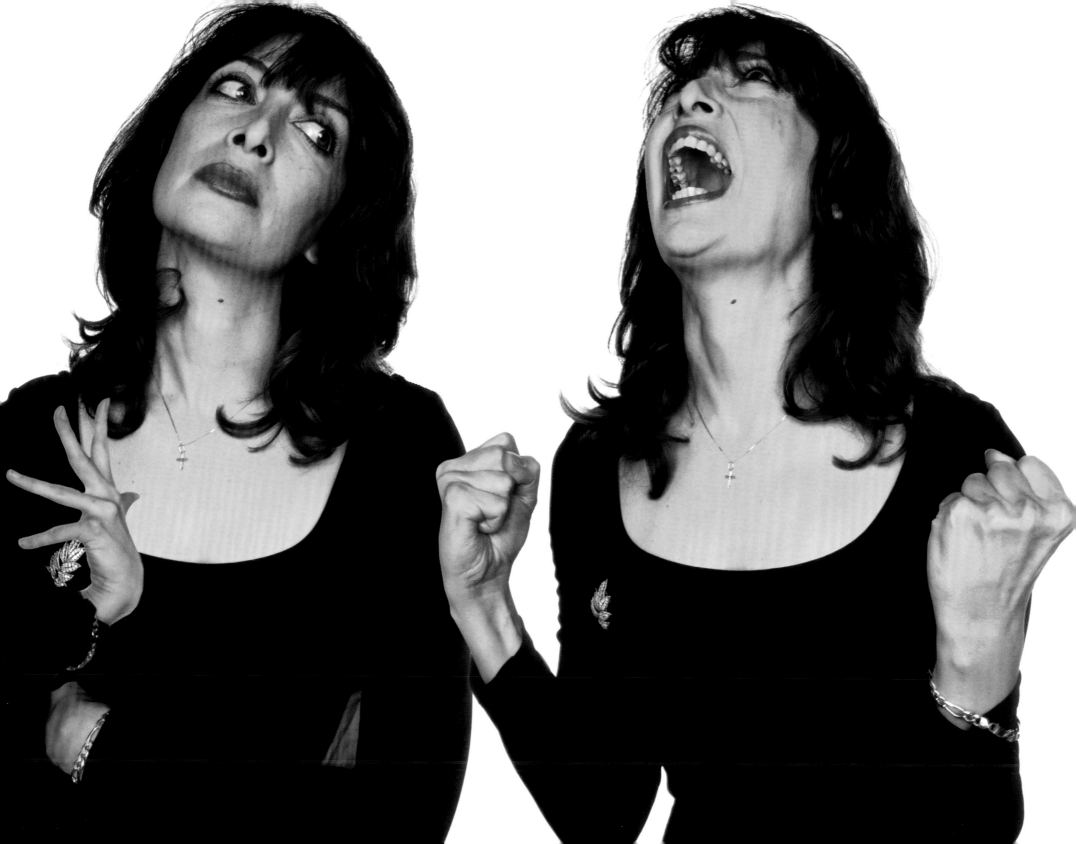

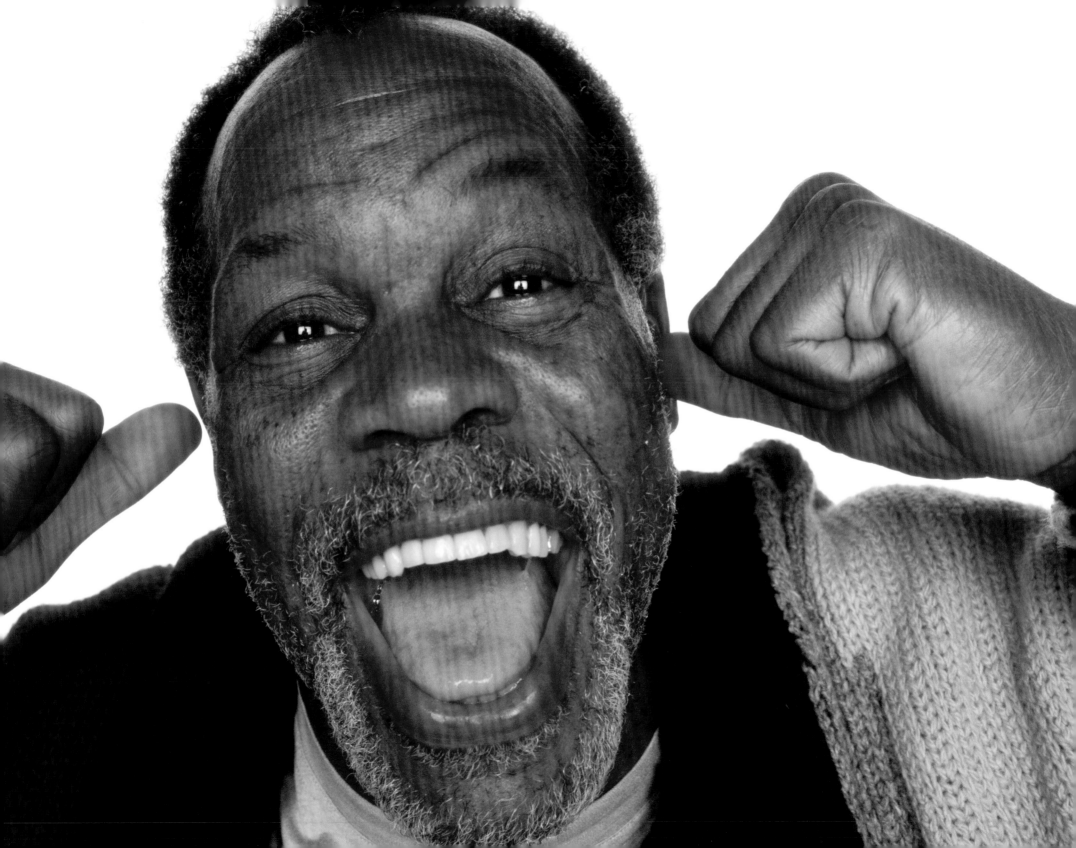

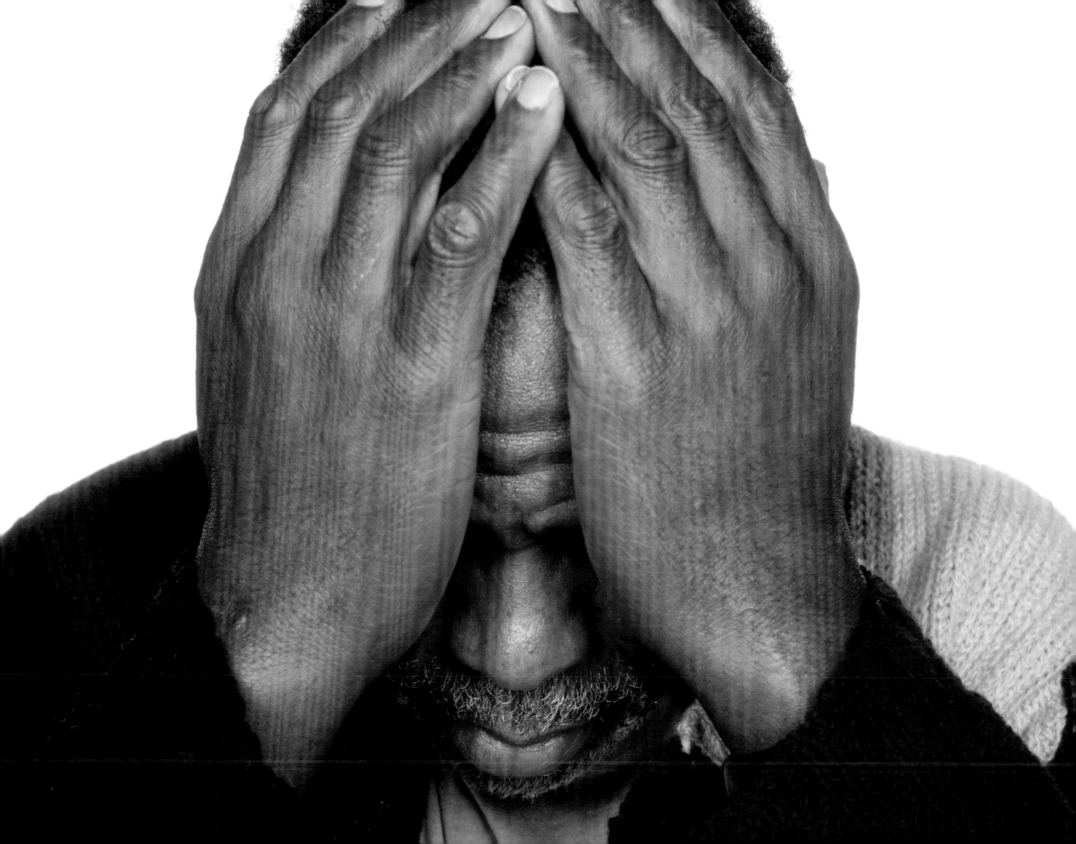

DANNY GLOVER

1. You are…the coach of an underdog basketball team,

watching your center make a game-saving shot block

at the last second against last year's division champs.

2. …a veteran narcotics detective

learning that the man you shot and killed

earlier in the day was carrying a toy pistol.

An actor's job, an artist's job, is not to be judgmental. An artist's job is to tell his truth, or to tell the truth that he envisions.

RON RIFKIN

1. You are…a five-year-old

hiding something from your uncle.

2. …a rookie detective

practicing your interrogation technique

in front of your bathroom mirror.

One knows when the audience is engrossed in something, enraptured in something. One can smell it, and feel it, and taste it. I certainly know when they're not. I know when they're not happy. I can hear the fidgeting, and I can hear the coughing, and I can hear the movement. Out of my periphery I can see someone leaving. But when they're dancing with you, and when they're in sync with you, it's beyond anything that I can explain.

The bow never means anything for me. I'm always embarrassed to take a bow. I would rather not take a bow. My coming out and taking a bow, a curtain call – I'm Ron, and I don't want to be there as Ron.

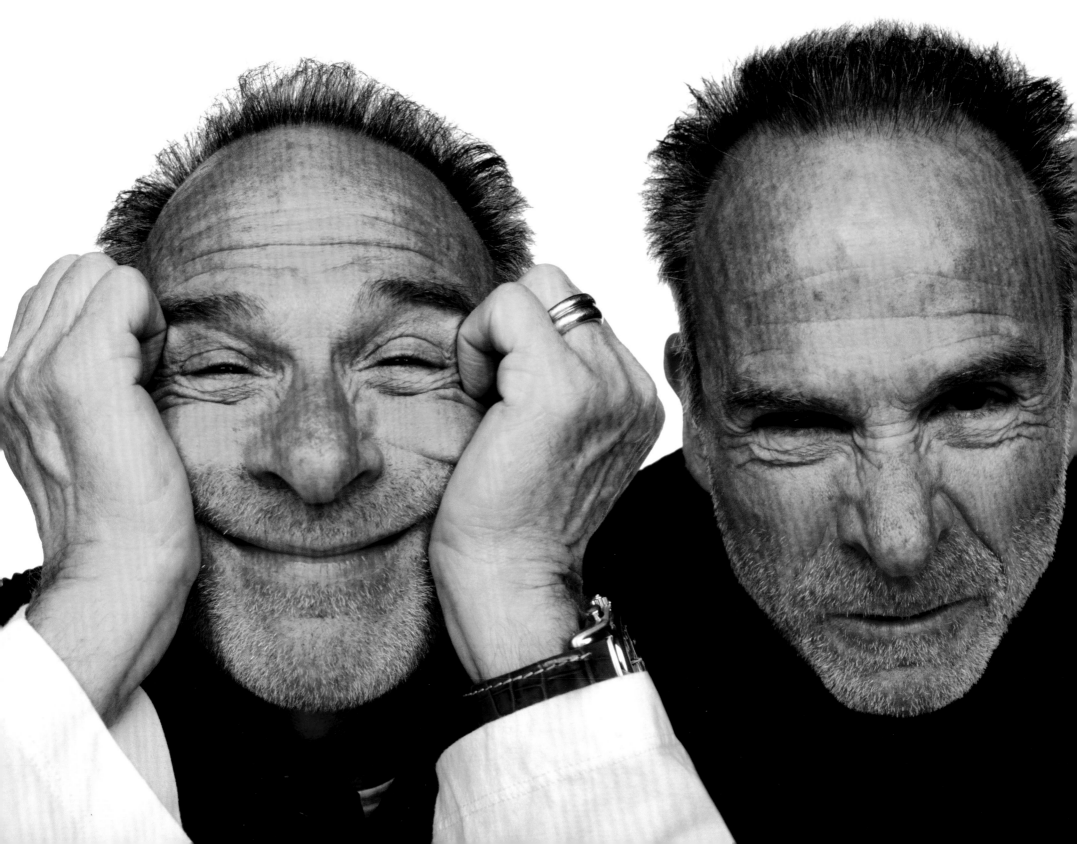

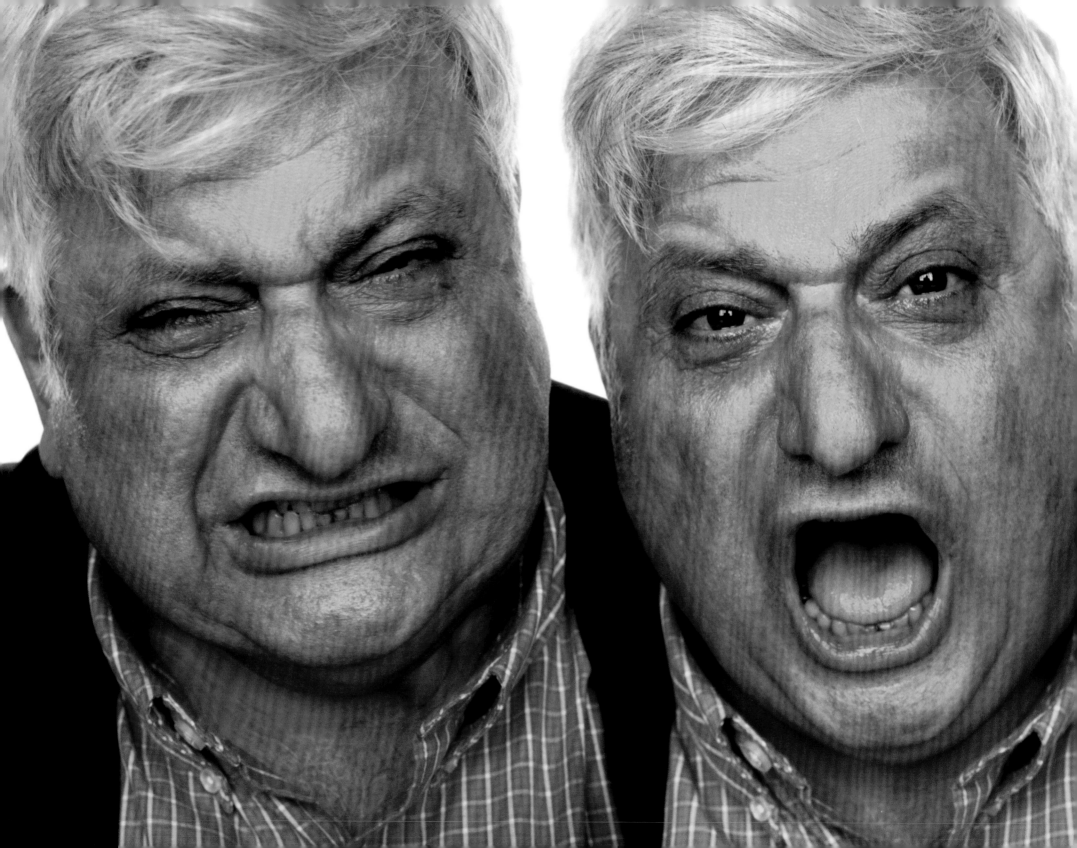

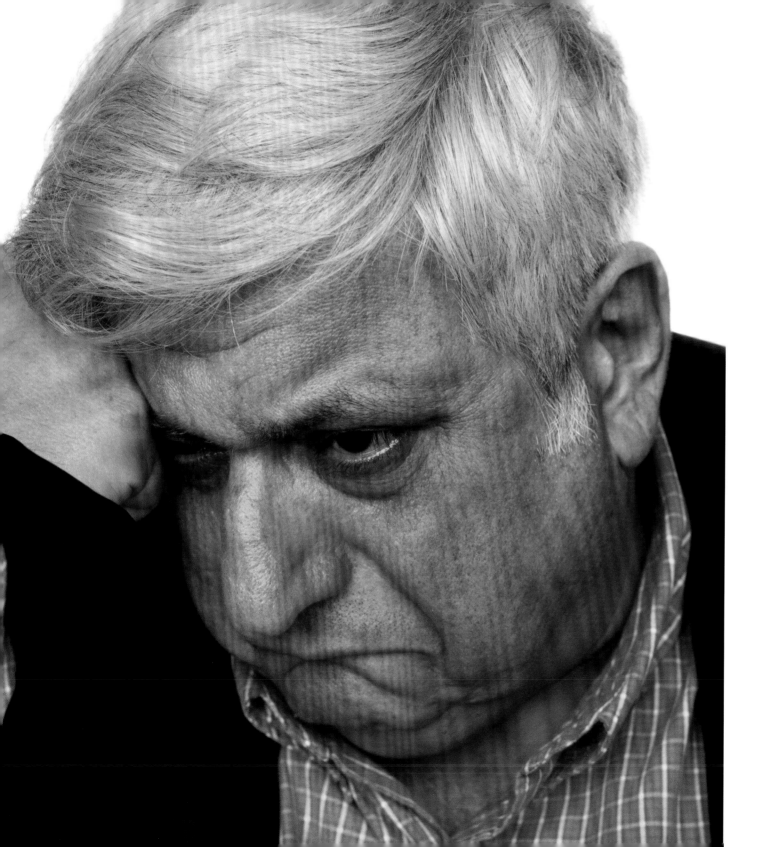

MICHAEL LERNER

You are a four-year-old

who's just been told:

"You can't have

the Kill or Be Killed *video game,*

and if you don't stop crying,

I'll really give you something

to cry about."

147

NATASHA RICHARDSON

1. You are…a woman beginning to wonder

 if the man you've been dating for a year

is just stringing you along.

2. …the former class weirdo, now a rock star,

 in your limousine

on the way to your high school reunion.

3. …a computer whiz

who has hacked into your English teacher's files

and has just aced the final.

When you have a performance in the evening, it's looming at you constantly during the day. So you do everything in your day to protect yourself and be ready for that performance, whether it's resting or working out or whatever it is. The day is always colored by the fact that you have that coming up.

But after a show, whoosh! Relief, exhaustion, high. Huge high, and there's no way to just turn it off. You're up and you're exhausted at the same time. You're physically exhausted and yet you're wired. And it's also your only time of day that you can relax.

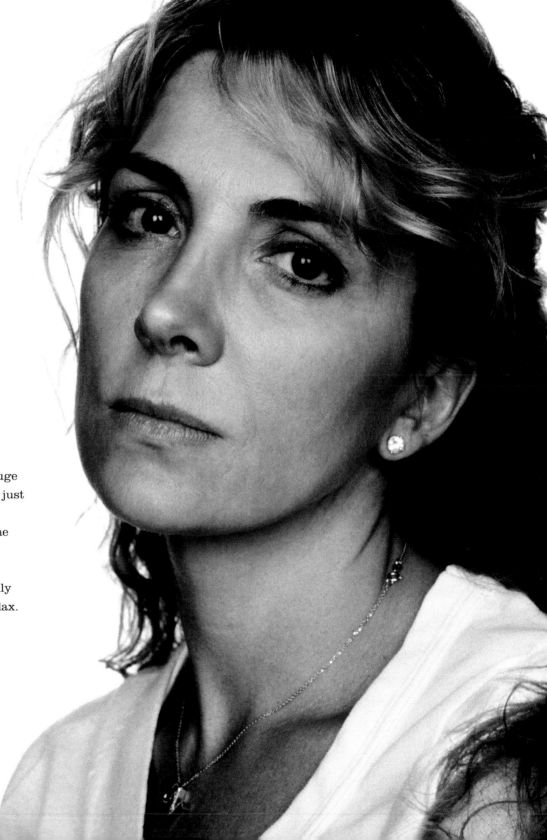

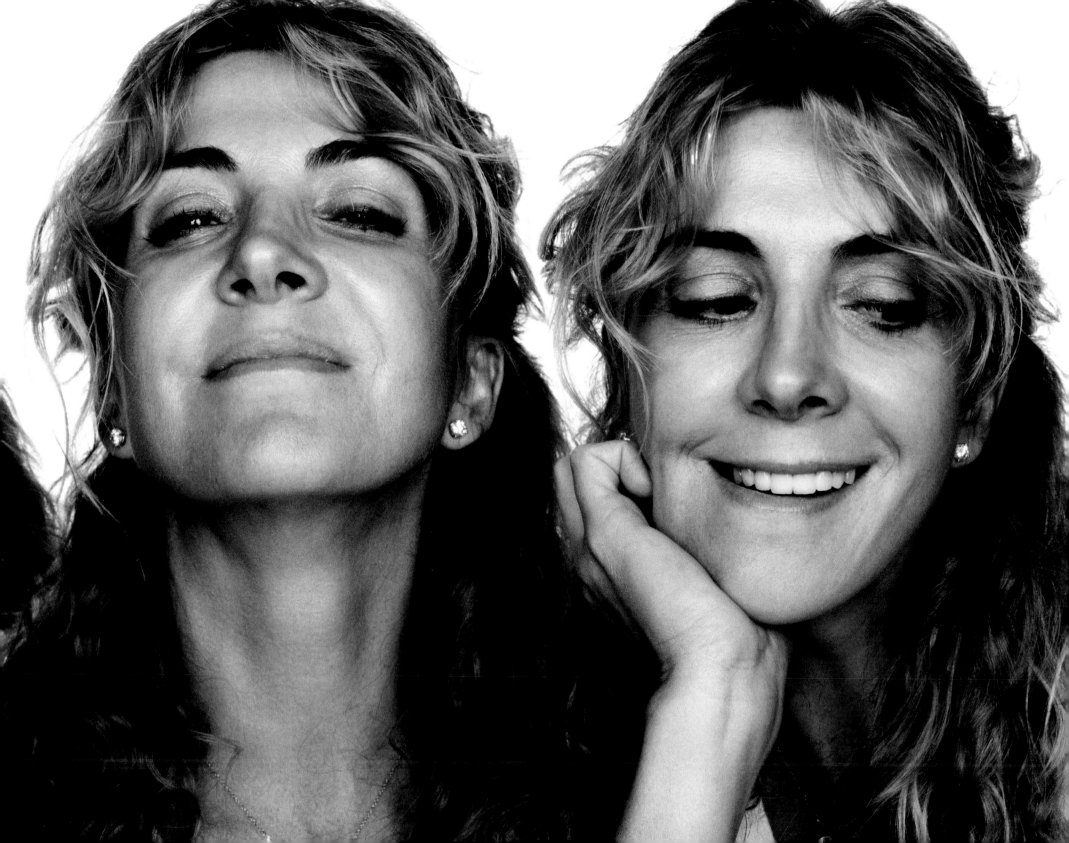

Actors' Notes

ILLEANA DOUGLAS

What I want from a director is trust; it's the most important thing, for me. The best directors have cast you because they trust you. My best experiences have been when somebody trusts you, because it's all about revealing what's inside of you. I think everybody has a palette of sadness, happiness, sexiness, all these things. And all it takes from the director is a coaxing and a trust to get you to reveal those things and not feel like you're going to make fun of me, you're going to judge me, you're going to milk me until the well runs dry. Those are all actors' fears – why a person holds back.

CHEVY CHASE

It's frightening to be famous… to be recognizable by everybody everywhere you go. No matter what you're feeling, what your face is saying, it's being looked at all the time. You have no privacy at all. That's quite frightening.

DANNY GLOVER

Acting is, for the most part, creating a world and believing that world that you create, and being committed to the world that you create. It's all from what I imagine, all from what I've drawn from my own life.

CHARLES DURNING

From a director I want understanding. I want to be able to trust him like I trust my father or brother. I want to be able to ask him questions, and I want him to give me some answers. You need a third eye, and you can't do it on your own. You've got to have somebody to say, "That's wrong." I don't want a director giving me line readings, "This is the way I want you to say it." I'll tell them, "Let me find it. Don't tell me. I'll find it." I've gotten in a lot of trouble that way on occasion.

I always am hesitant with a director at the beginning of a project, and inadequate, in my mind. I think, "Maybe he won't like me. Maybe I'm the wrong person." And I don't trust anybody who says they're not nervous on opening night or at any time when they go on stage. If I can get the first line out, clear sailing—but if I stumble over that first line, I stumble all night.

Acting is my passion, still. If I'm out of work two or three weeks, I'm gnarly. You can't come near me. I think, "I'm finished. I'm done. They'll never use me again."

I don't think it's imagination as much as it is imagining. Sometimes, I'll just stand on the street – lean up against a building and watch people, and you can tell by the way they walk, by the way they act, the way they're… what they are, you know? You watch animals. You go to the zoo, and you watch what an animal does, watch what a gorilla does, watch what an otter does, you know? And you try to move that way. A lot of my characters are bearlike. You walk like that. They're deceptively faster than you think. They might be walking slowly and unconcerned, but they see everything, and, so, that's what I do.

NATASHA RICHARDSON

From a very early age, I wanted to be an actor. I went to an incredibly academic girls' school and it was very odd to know that that was not my focus. Everyone else in the school was geared to Oxford and Cambridge, and I knew I wanted to get out as soon as possible so that I could audition for drama school.

One of the things that I love about the profession is that we're not confined to a routine. One minute you're filming somewhere and the next night you're doing a play somewhere else. Your hours change. The people you're working with change. By the nature of what you do, you have to be very open and sensitive to all sorts of different circumstances.

In theater there's this wonderful trinity – just the actors and the audience and the writer. And they each feed the others and nothing can get in between. So it's very much an actor's medium. You go through a story from start to finish every night. The downside is that you have to reinvent it every night so that you can never say this was perfect, can we just roll that, again and again and again. Because some nights you find it and some nights you don't. It's having to refashion a brooch out of a piece of gold every night. It can be very difficult, but you get fed by the audience being live.

Film, for me, is a director's medium, it's not an actor's medium. You have absolutely no control over your performance. It can be completely cut to smithereens. Your best work might never be seen. It's all up to the director. But what you can do is go for little moments of absolute truth. Because you're not going to go through it all start to finish, you really work with the moment.

BUCK HENRY

People think that actors just act, so they can do it anywhere. It just isn't true. There are great stage actors who don't do much on film. And there are endless film actors who can't walk across a stage. They are very different disciplines.

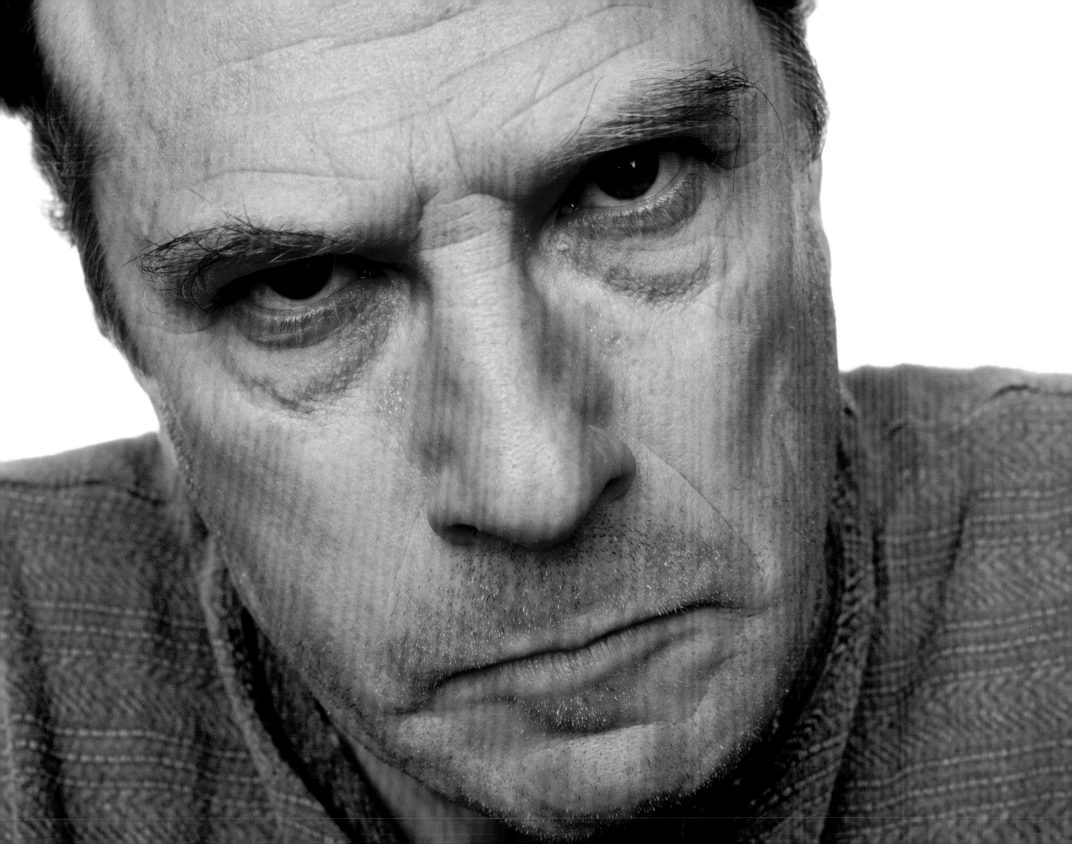

Anger

Fifth Intermission

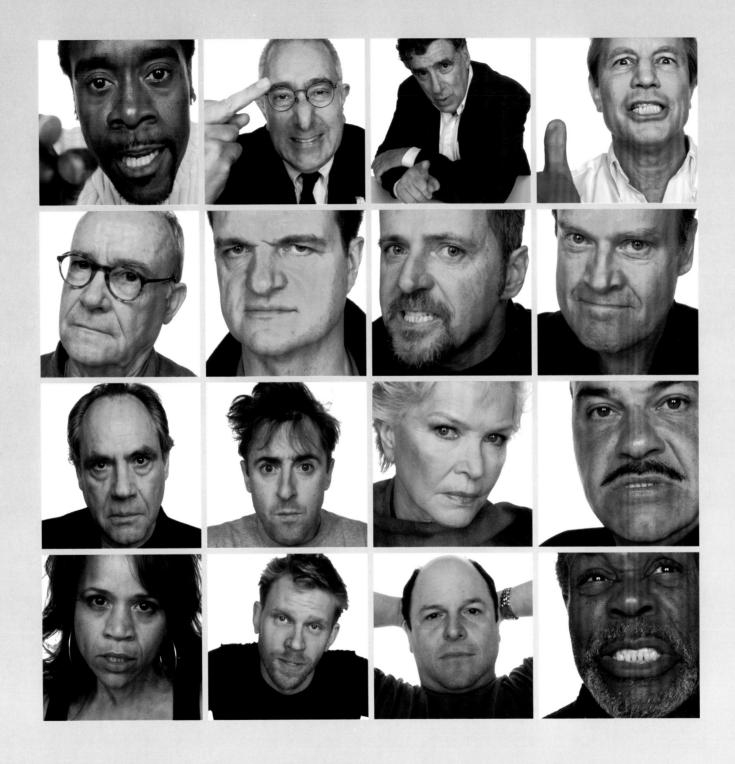

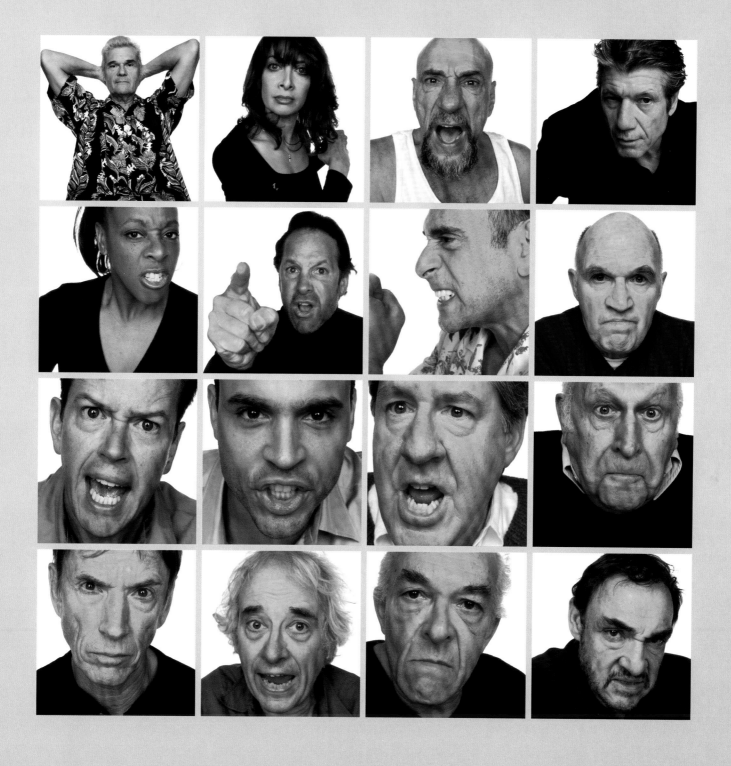

Act VI

The Players

ROSEMARY HARRIS

JOE MANTEGNA

BILL PULLMAN

BEN STEIN

ALAN CUMMING

GEORGE SEGAL

JAMES EARL JONES

GLENNE HEADLY

SCOTT GLENN

AIDAN QUINN

JUDD HIRSCH

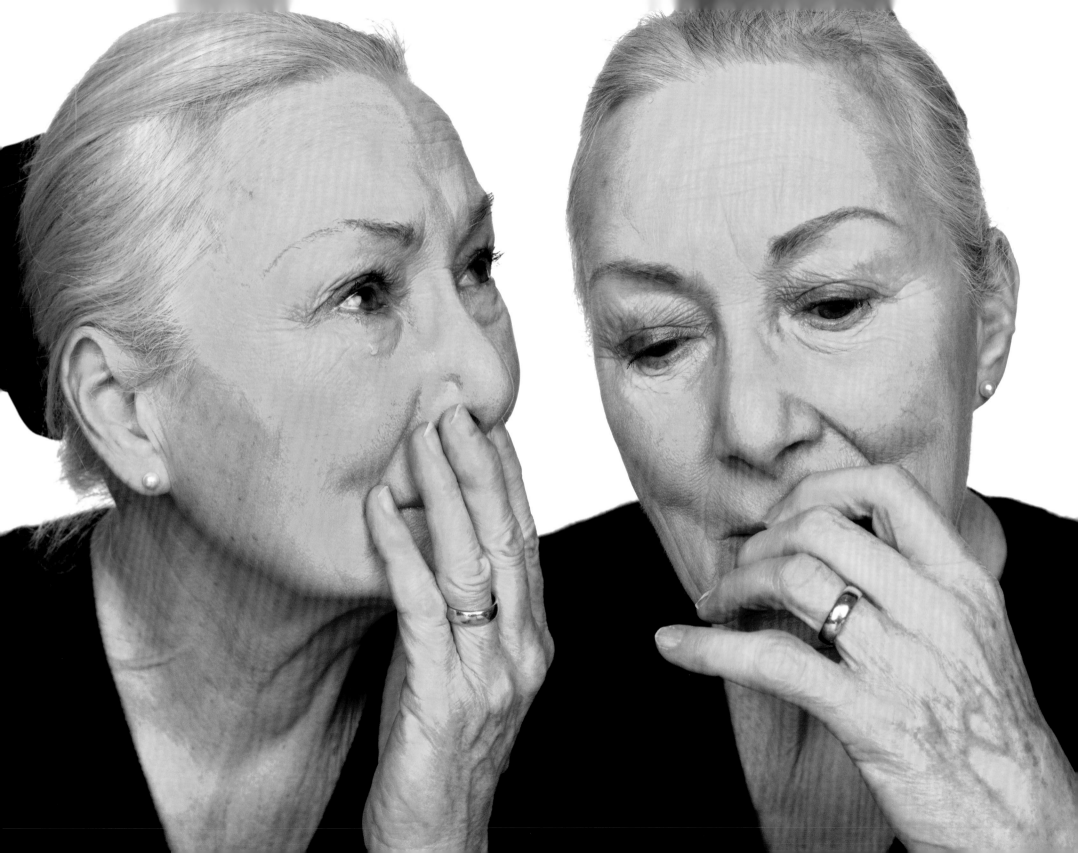

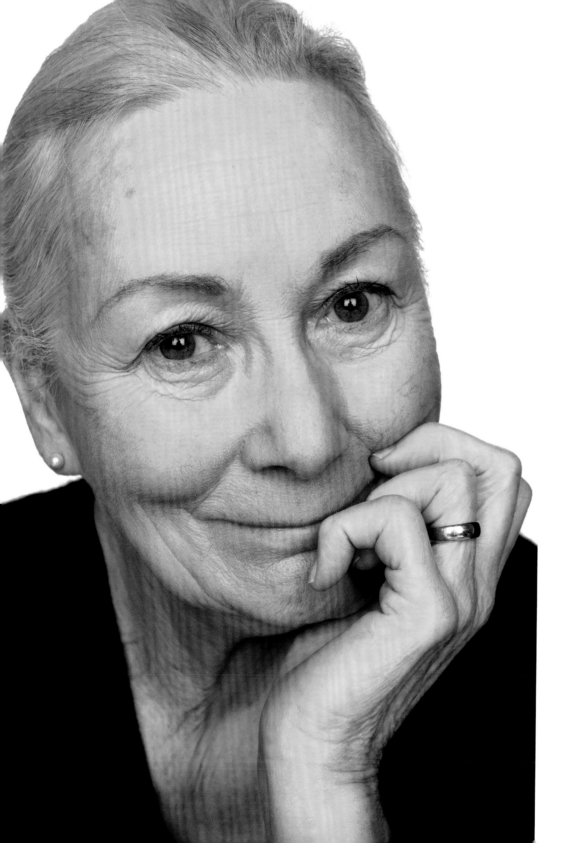

ROSEMARY HARRIS

1. You are…a loving wife after a visit

to an assisted-living facility,

where your husband

can no longer remember your name.

2. …reading a New York Times

obituary of the man

who was your first lover.

3. …the head of a girls' school

telling a troublemaker

that she's being expelled.

I want the director to know
more than I do, which is get-
ting tougher because I know
a lot of stagecraft now. So I
don't suffer fools gladly, and if
they're younger they usually
don't know as much as I do.

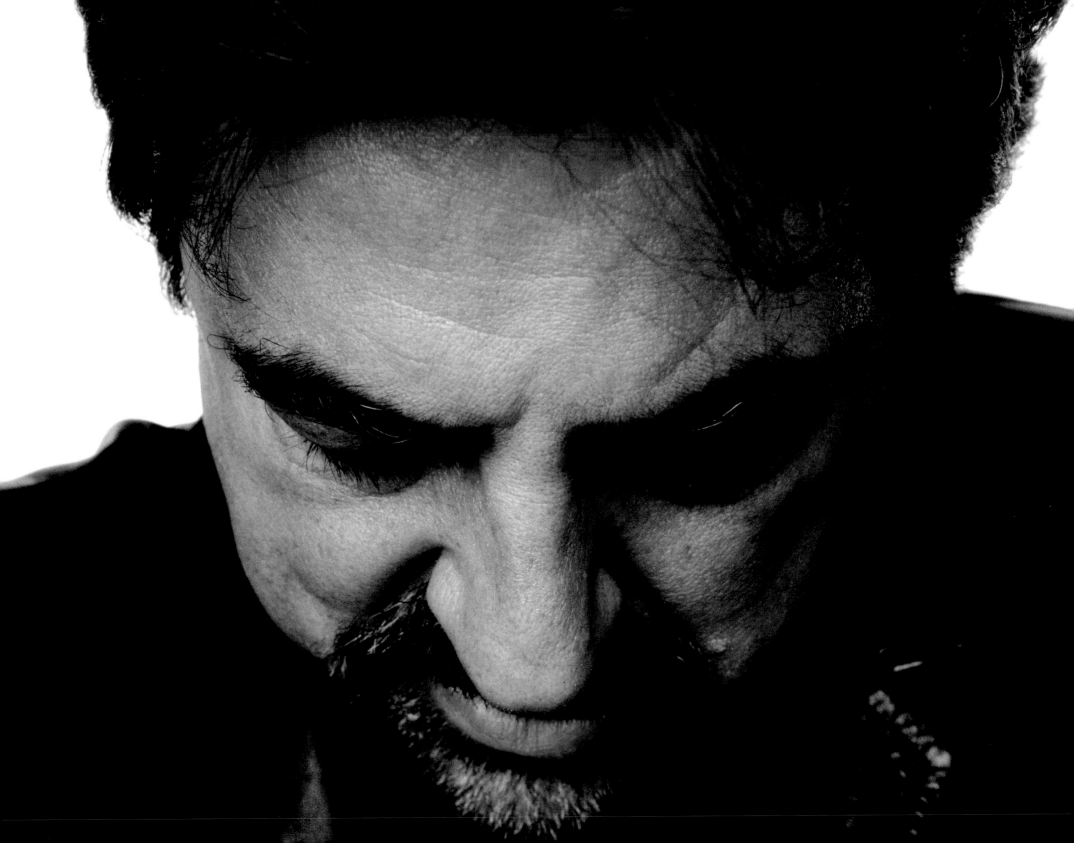

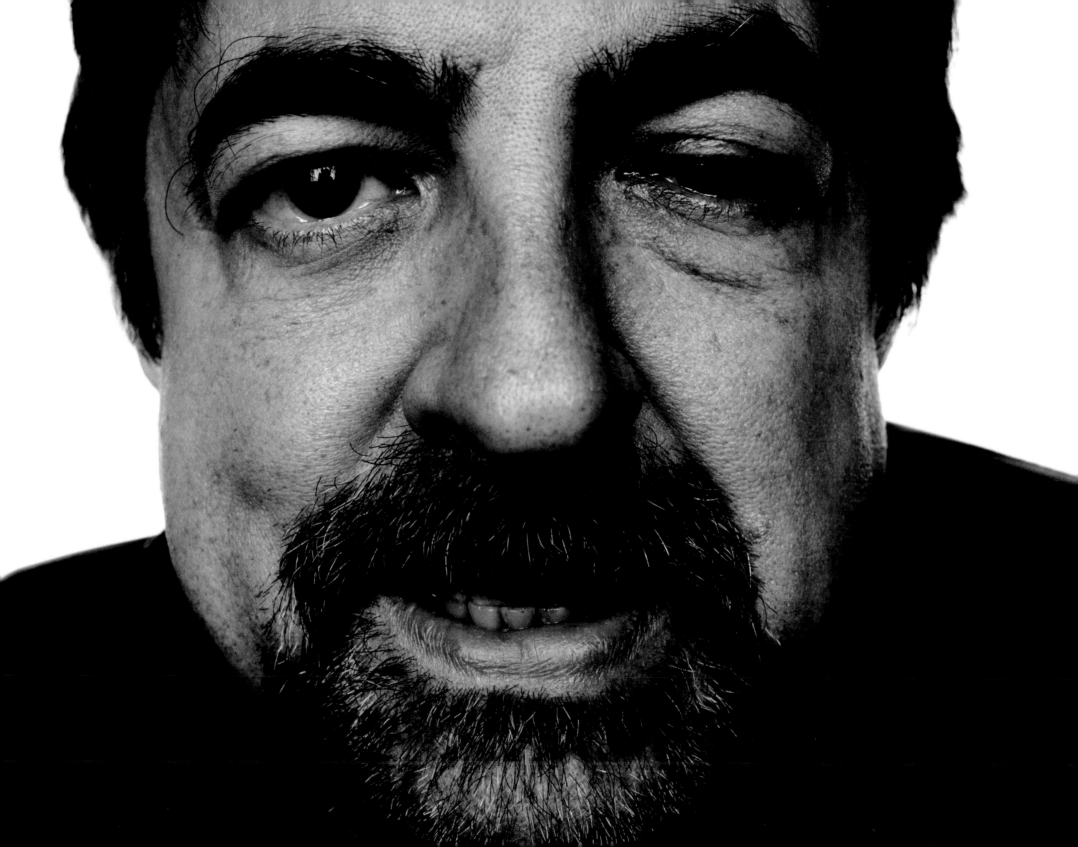

JOE MANTEGNA

1. You are a crime boss…

> *confronting an underling you suspect of treachery:*

"I'm going to ask you this just once…"

> *2. "…Where the fuck is the money?"*

BILL PULLMAN

1. You are…an actor hearing from your agent that

> *after weeks of callbacks and readings,*

> *you got the part.*

2. …the same actor the next day,

> *hearing that the director has changed his mind*

> *and wants someone else instead.*

When I saw *Bonnie and Clyde* the performances were truly enlightening to me. They had a veracity that made me quake. You want to think you're truthful and you know often you're not and there are those times when you can achieve it. But you're never quite as purely human as you are in those dire circumstances.

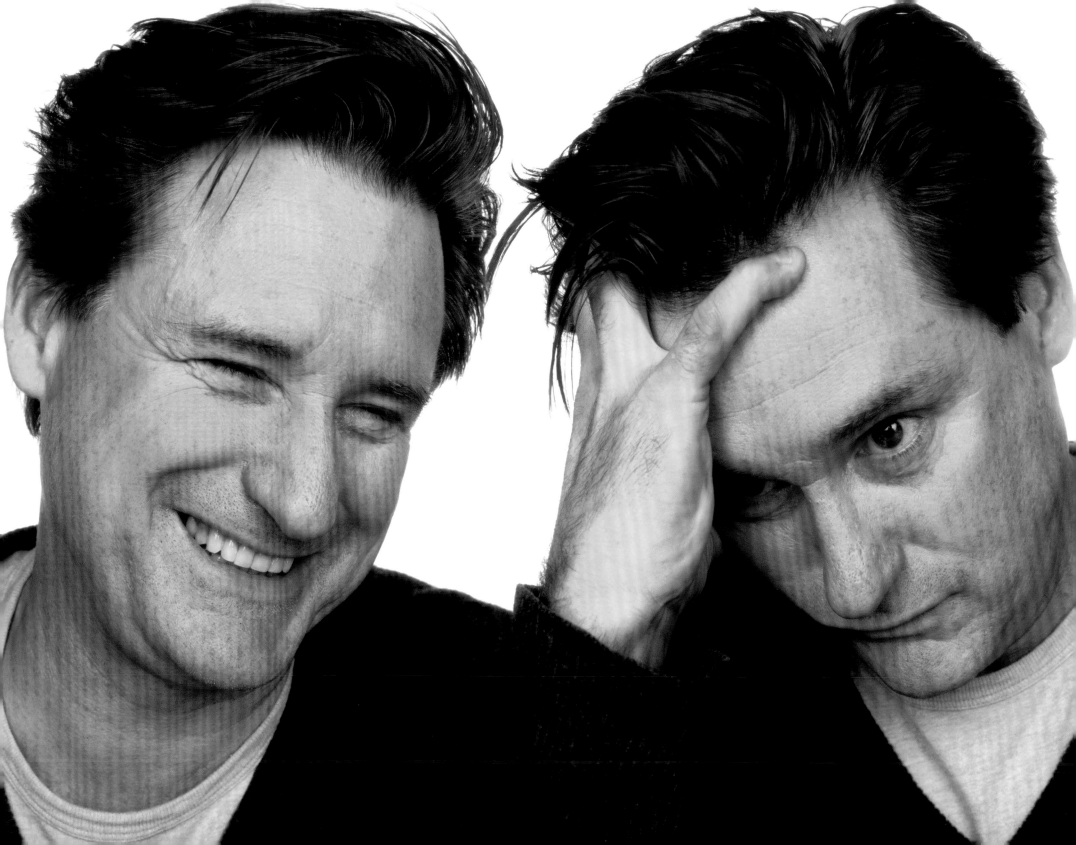

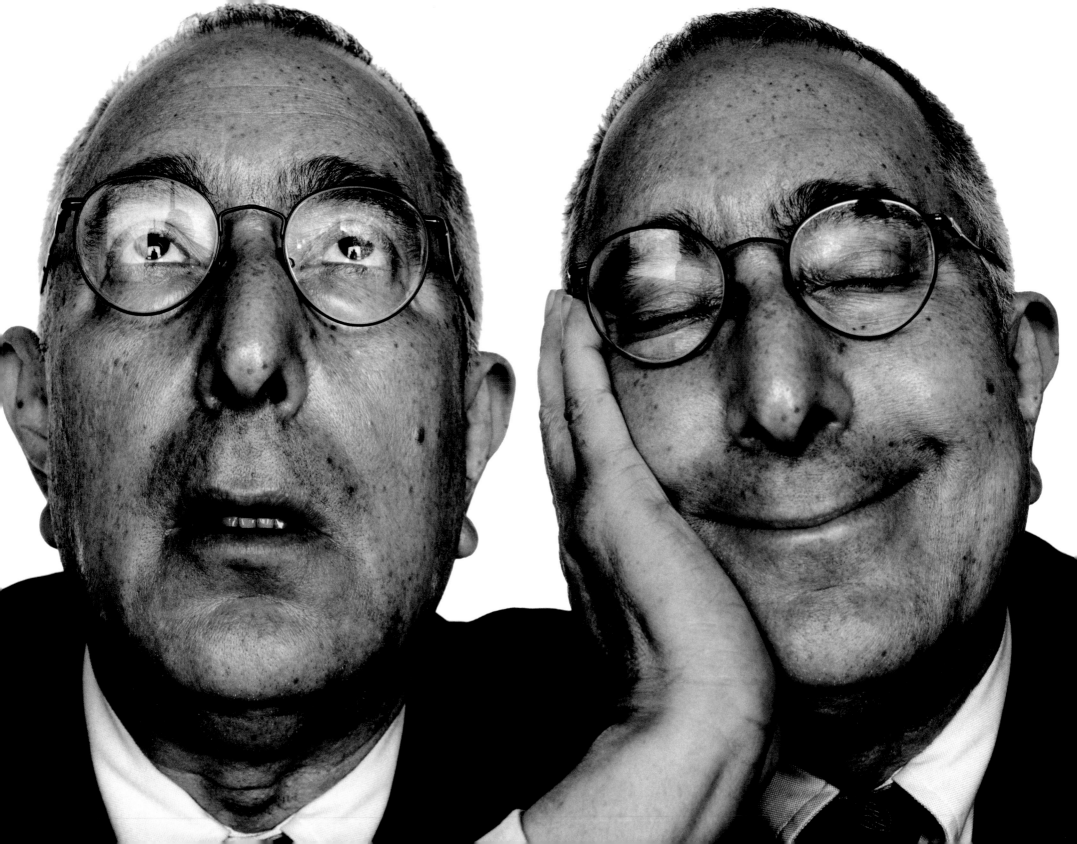

BEN STEIN

1. You are…a high-school geography contest finalist

trying to remember the capital of Tajikistan.

2. …a mother whose daughter

has just declared

she's broken up with her street musician boyfriend

and plans to marry an investment banker.

It's almost like a curse to want
to be an actor. The curse of act-
ing is that you act and have all
this insecurity – but the joy of
it is that when you're actually
doing it, it's bliss. It's worth
going through a lot of trouble
for that bliss.

following pages

ALAN CUMMING

1. You are…a four-year-old

letting the family's pet parakeet out of its cage.

2. …shutting out your mother's angry reprimand

after the bird flies out the front door.

3. …a man imploring your partner

to come with him to visit to your parents.

4. …betrayed.

Every time I do a play, when
it's about to open, I get so
angry with myself. I promised
I would never do this again. I
promised myself I would never
go through this feeling, this
fear. And of course, three hours
later you've forgotten all about
that and you're elated and feel
euphoric.

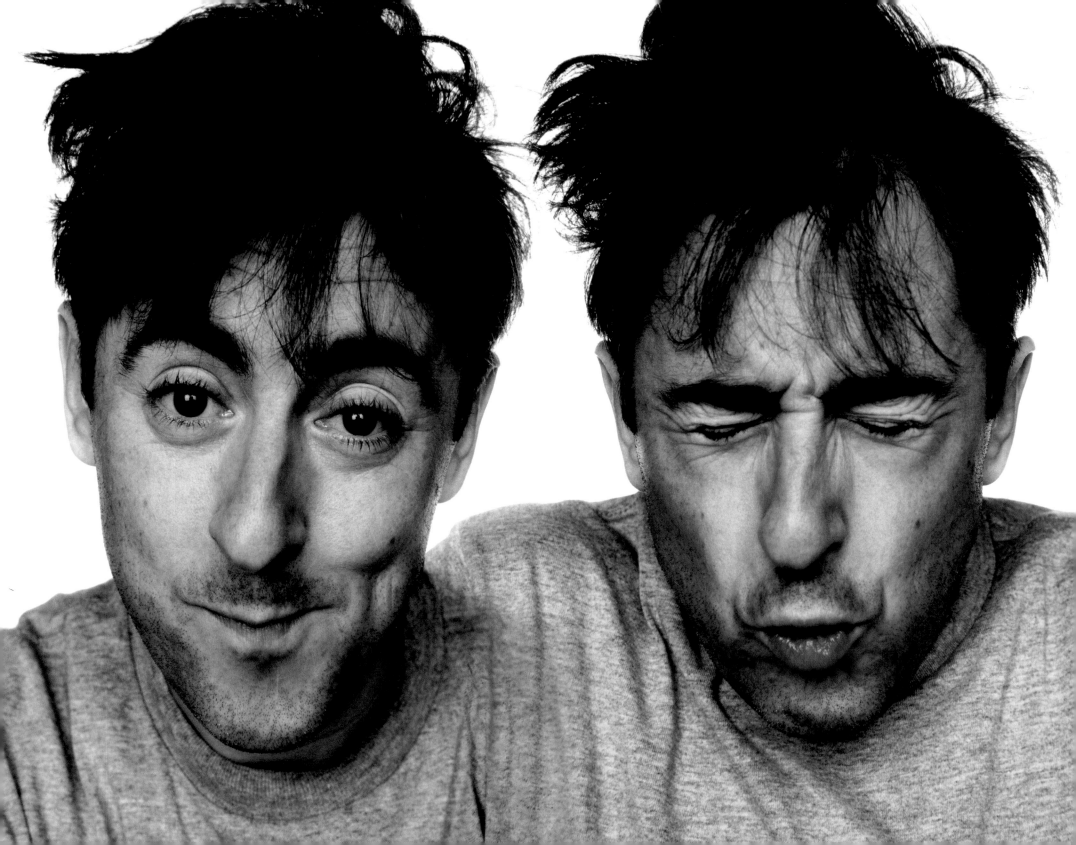

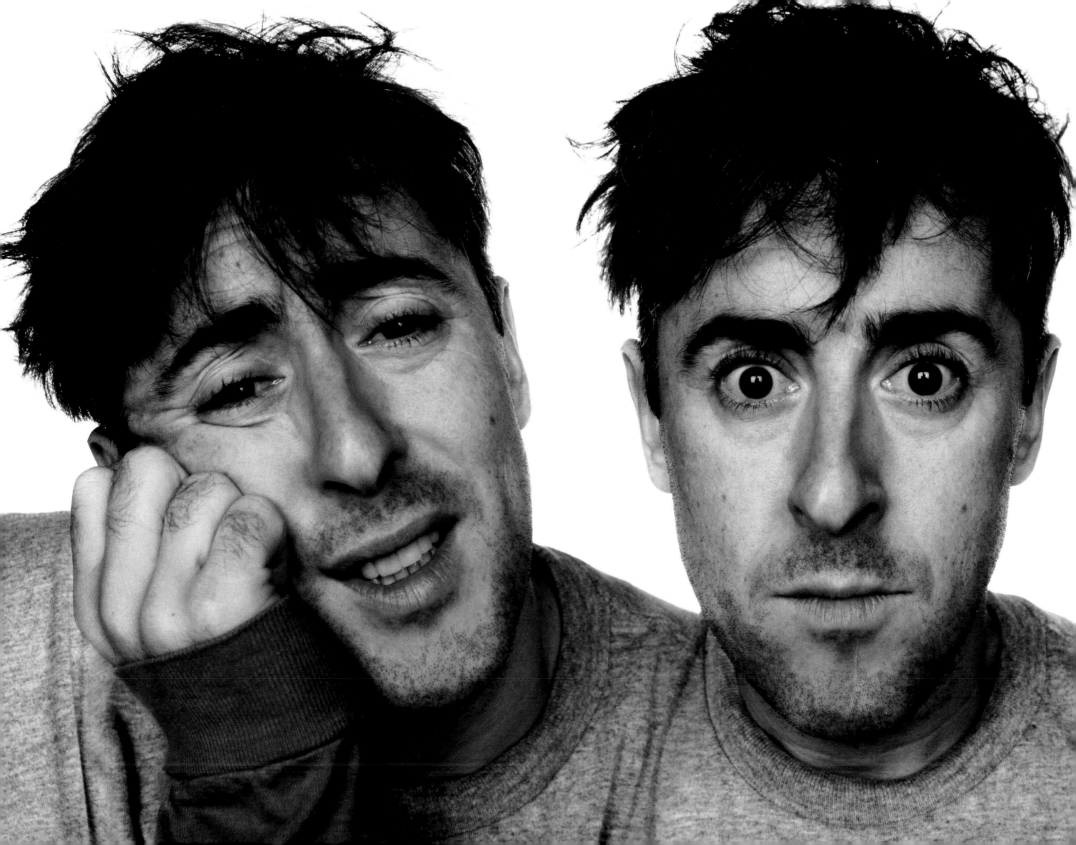

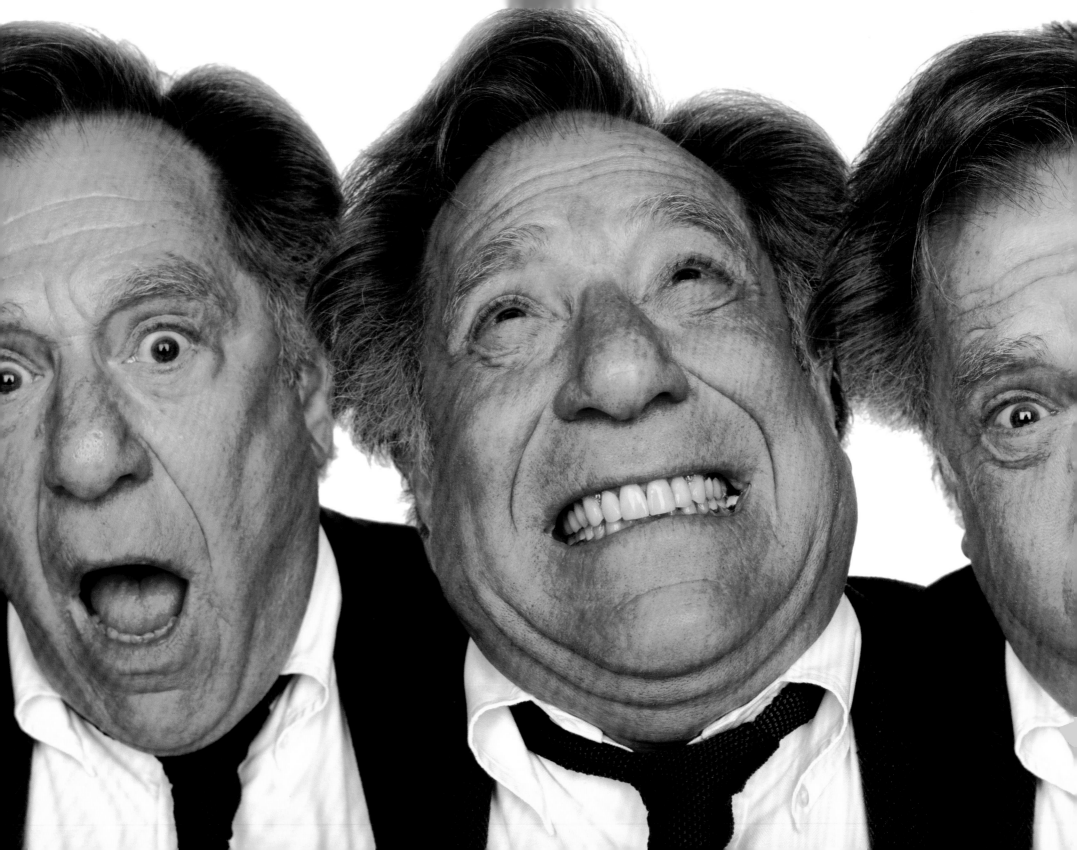

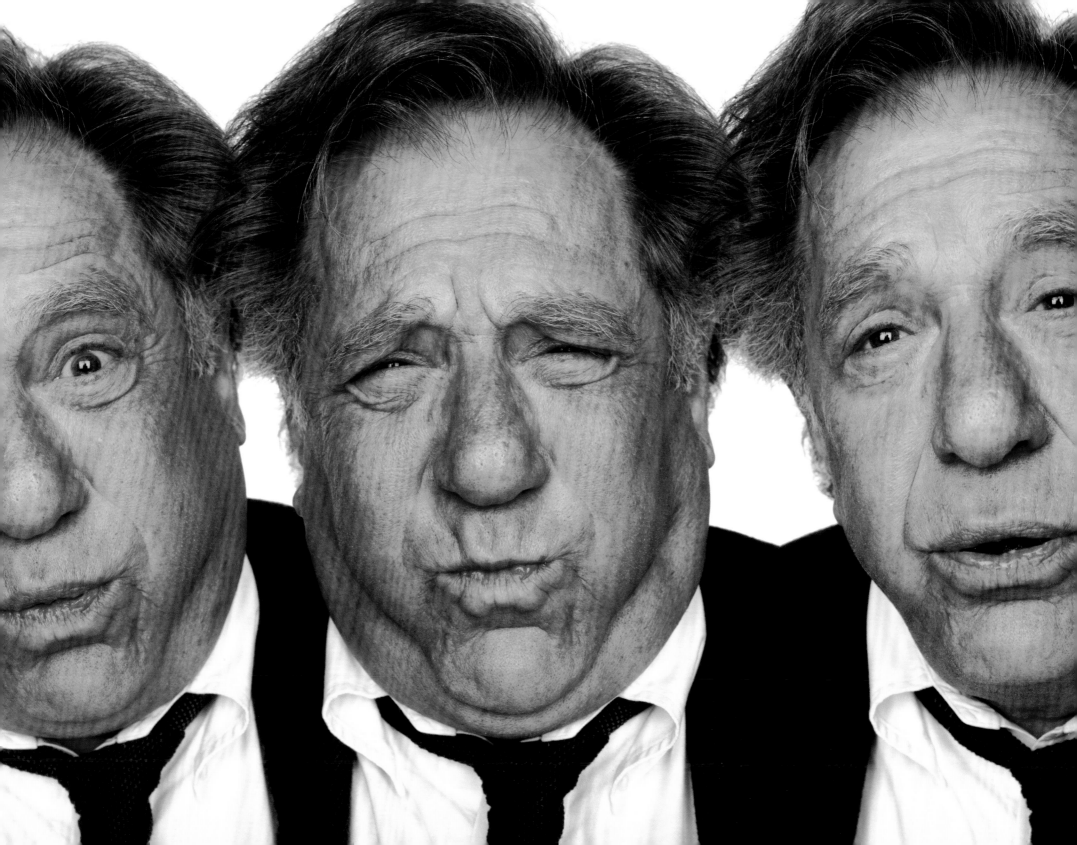

GEORGE SEGAL

1. You are a woman, nine months pregnant…

feeling your water break at a cocktail party.

2. …in your twelfth hour of labor, ten centimeters dilated,

with a contraction coming on.

3. …hearing your OB nurse: "Push!"

4. … "Push!"

5. ………………………

In the movies, no matter how you rehearse, that first take is "all bets are off." You have no idea what the other actor is really going to do. And if you're alive to that first take, it can be brilliant – in ways that you have no idea. That's being in the zone. When you're in the zone you're out of the way. Something else is taking place. And that's what's addictive about being on stage or acting – you lose yourself.

JAMES EARL JONES

You are a district attorney

whose star witness has just perjured himself.

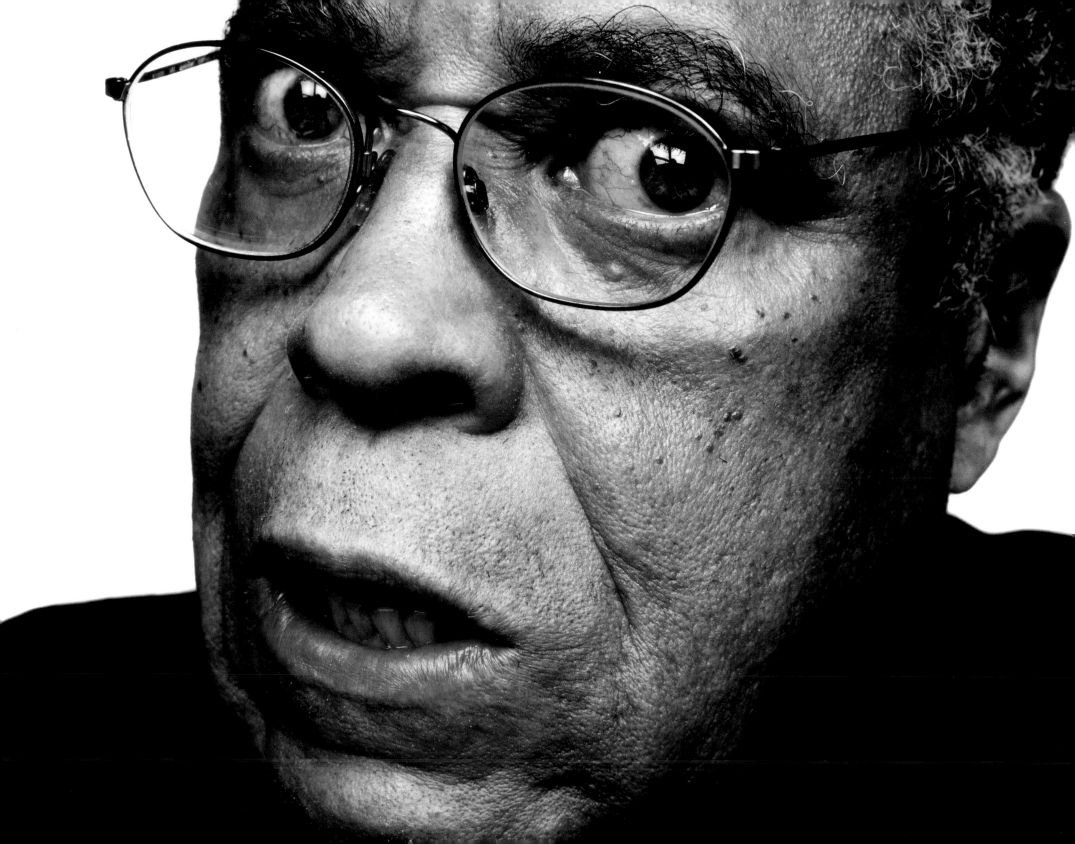

GLENNE HEADLY

1. You are…a harried CEO

 at a staff meeting,

 considering which of two

 bickering subordinates

 you're going to get rid of.

 2. …a woman who has

 just heard that your

 ex-husband's

 new, young wife has walked

 out on him.

3. …a middle school teacher

 hearing from a student

 that she's been abused by

 her mother's new boyfriend.

I knew I wanted to act when
I was just a kid and I used to
put on little shows for my
friends in which I would act
all the parts and be the narrator.
I thought that I wanted to be
a writer, but I found it easier
to act the parts. It seemed
more effective to dramatize
the stories.

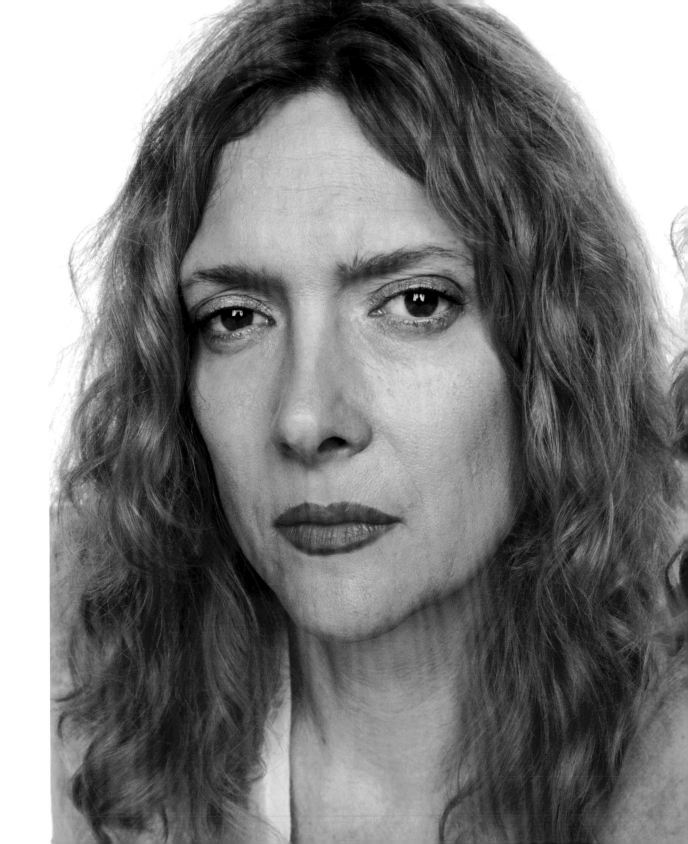

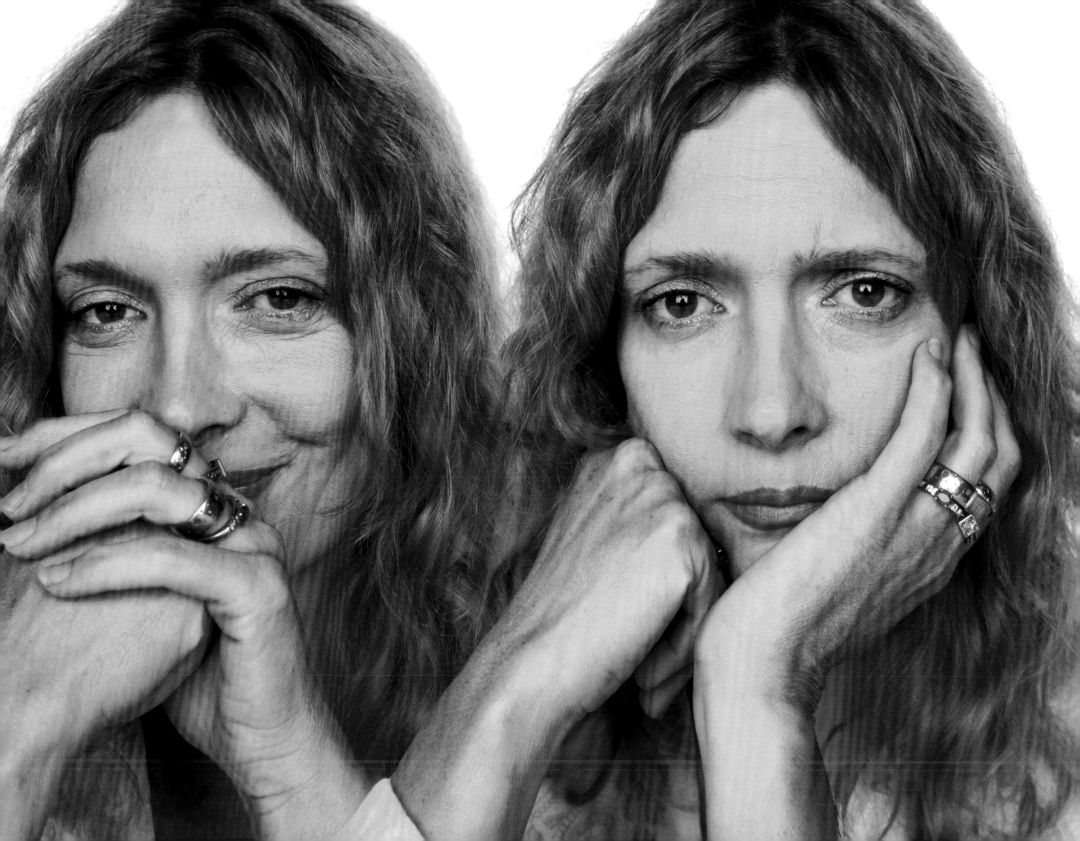

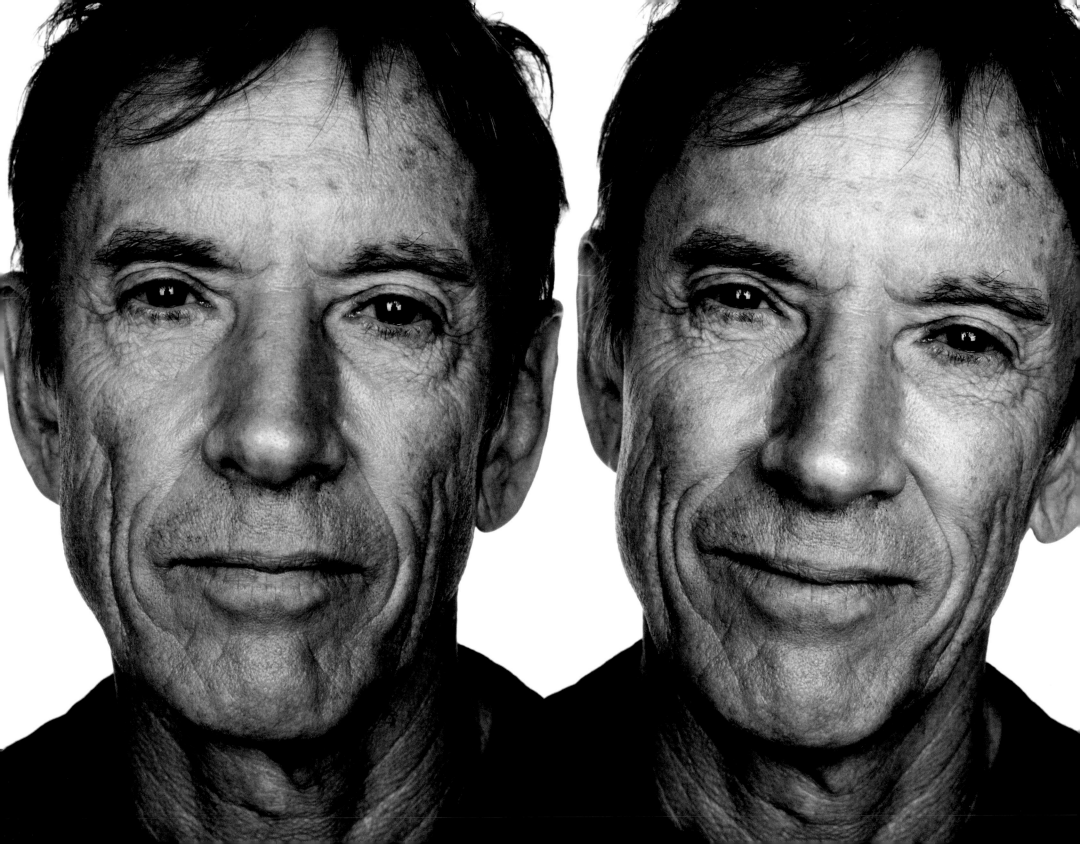

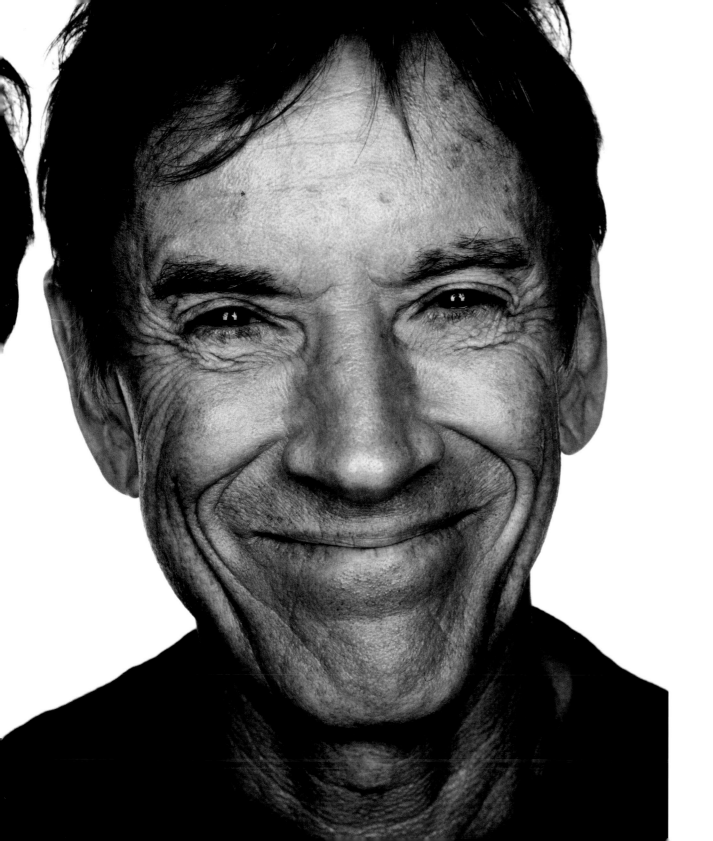

SCOTT GLENN

1. You are the dark-horse challenger in an international chess final, waiting for your opponent to fall into your trap.

2. ... "Check."

3. ... "Mate."

The big thing is how do you combine at the same time 100 percent concentration with 100 percent relaxation? The two things seem to go against each other. I will always work on this until the day I die; I'm not even close to it – and I think it's probably the secret of any art – I know it's the secret of any physical art, whether it's playing baseball or acting.

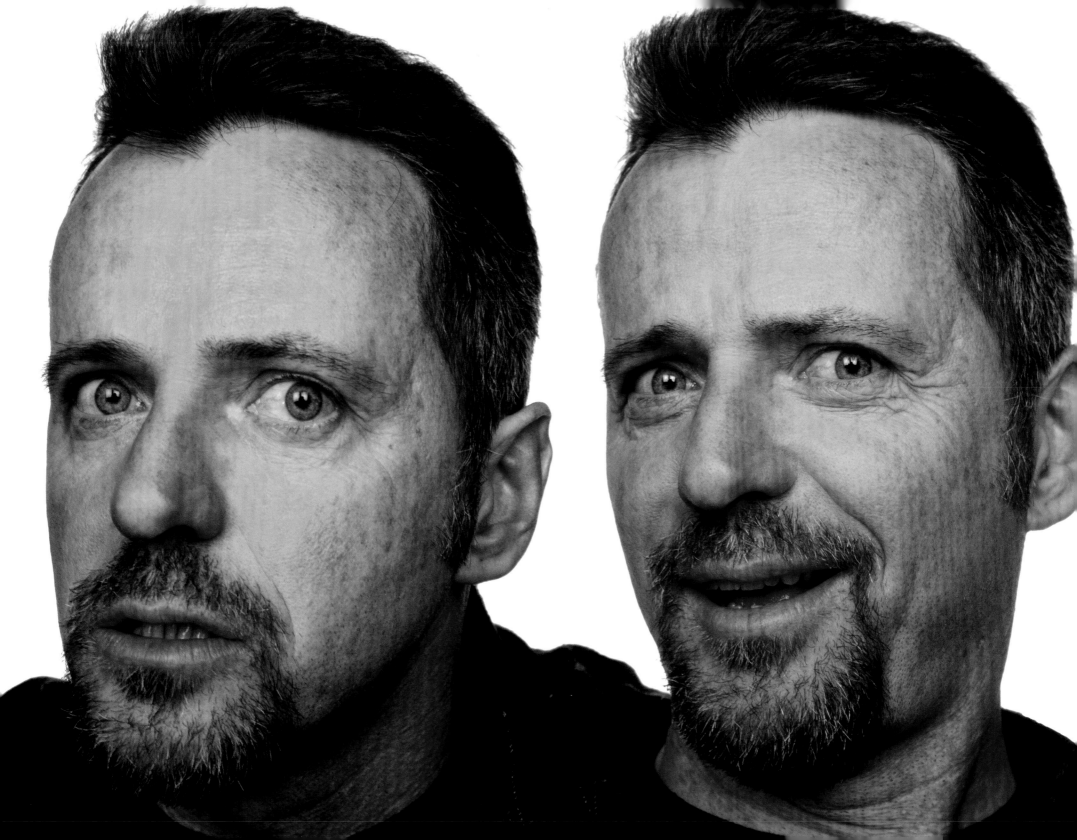

AIDAN QUINN

1. You are…a street tough in a confrontation

with someone you're beginning to suspect

is even tougher than you.

2. …a suspect with a long rap sheet,

reacting to a detective's suspicions:

"What are you talkin' about, man?

I was home with my mom watching Antiques Roadshow."

It's a great feeling when you are in the midst of an emotional moment and you can hear a pin drop in the theater with fourteen hundred people in it, because they are transfixed on what you, and the playwright, and the director have all created.

I'm a little leery of the elixir and the drug of that, because I really think acting is at its best, and my acting is at its best, when it's a kind of an emptying – where you're becoming a channel. You're always going to be partly yourself in whatever role you do. I don't ever believe in that bullshit where people say they completely transform. I don't care how great a character actor they are, they still retain something of themselves. How could they not?

My best work is when you get out of the way and let the material and let the muse take you, if you will. It's something very ancient – it feels aboriginal. And pure. It is empowering, and it is intoxicating.

following pages

JUDD HIRSCH

1. You are…being booked

on suspicion of murder.

2. …the warden.

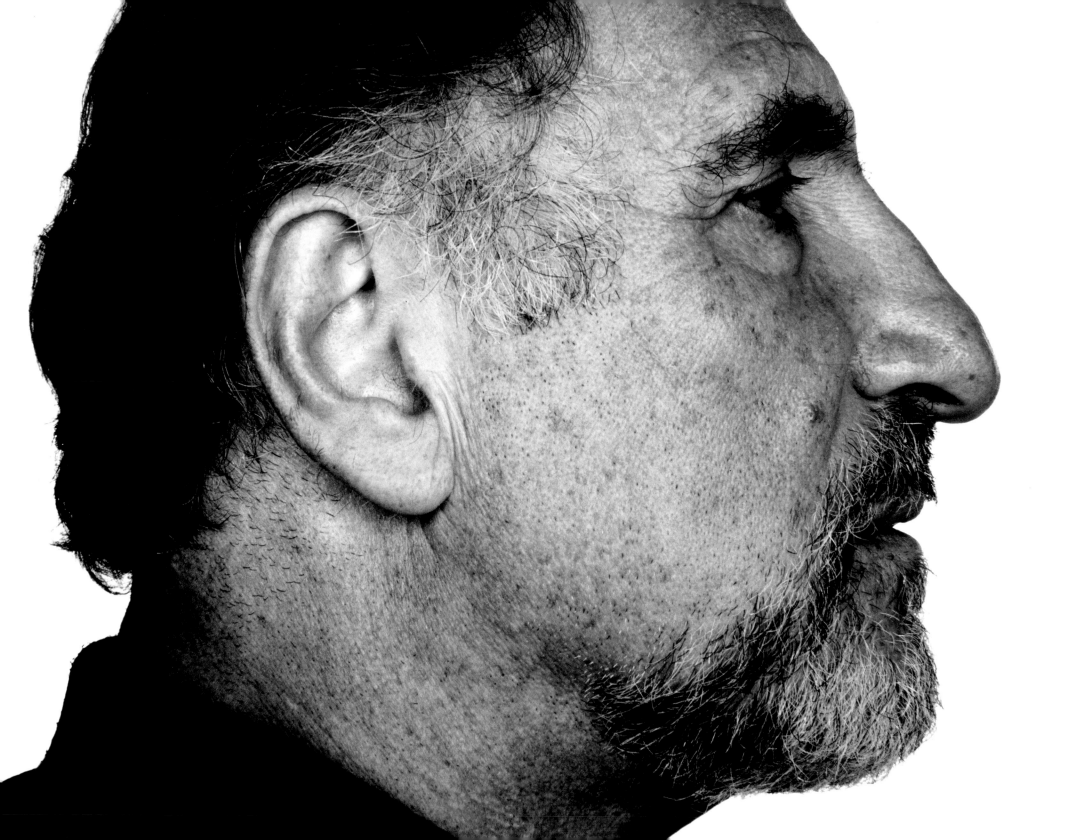

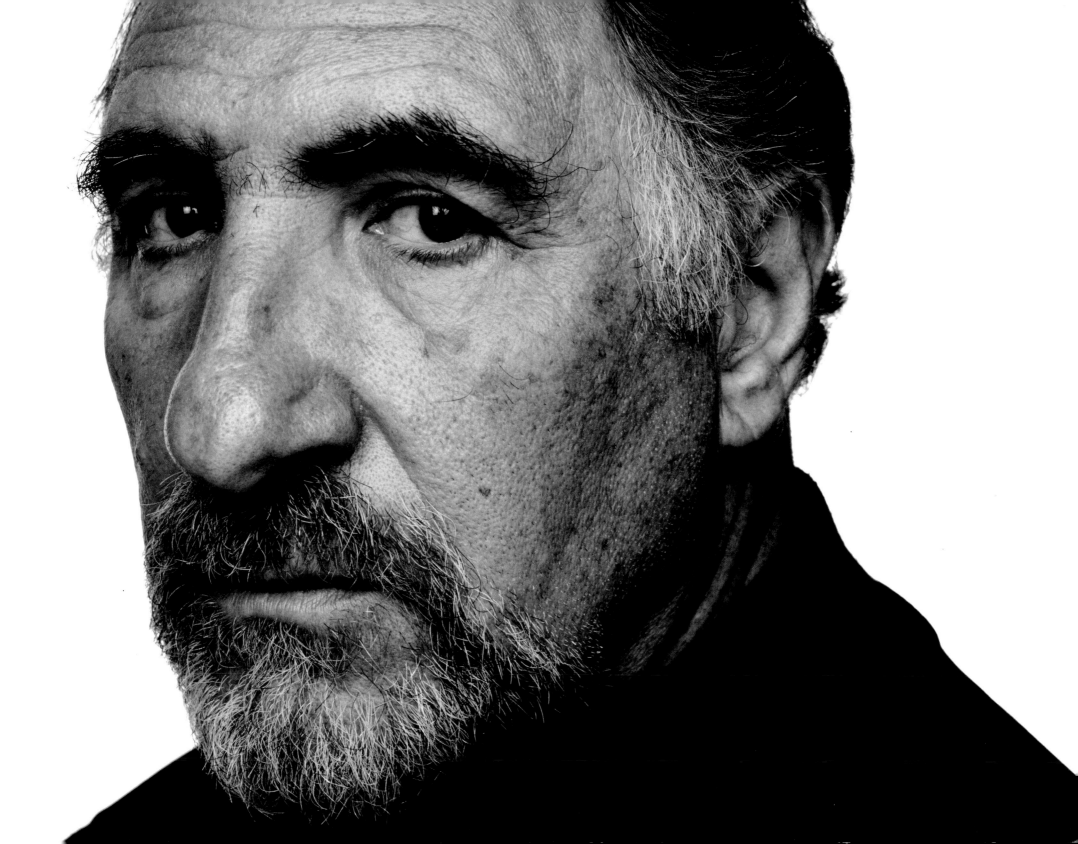

Actors' Notes

ROSEMARY HARRIS

I was four years old and I was in a production of *The Dance of the Seven Veils*. I played the queen, which was a nonspeaking role. My sister taught me to walk across the stage and then turn and kick my train and then look with disdain at her and the king and walk out again. I remember feeling this wonderful power. Then all the years went by and it never occurred to me to be an actor, because I knew I could act, but I wasn't sure I wanted to be an actor – because I thought they were rather flighty people and rather inconsequential, and I wanted to be a nurse.

When I joined the little local stock company in England it was an extraordinary training, because we did a different play every week, and then I went on to another company, where we did two performances of that play every week – two performances every night but a different play every week. So we did fifty plays, and one got to play fifty different parts. That was exhilarating. Far from being flighty, I was the most dedicated person. I adored it. I absolutely adored it. I couldn't wait each week to see what part I was going to be given to play and who I would become. It's almost like an addiction, that feeling of becoming somebody else. It becomes a kind of addiction. It's awfully tempting to change your personality, to become somebody else. I played Blanche in *Streetcar* at Lincoln Center and I think I was probably rather difficult to live with during that time. I was getting rather neurotic. I was also very thin. I'd lost a lot of weight. I lost my appetite. I became a little bit anorexic while I was doing it. And it's an enormous role. It's so painful. You don't have a friend in the world. You have to go through that experience. There's nobody on your side.

I started in the theater and it never occurred to me that I would do film. Because in my day, your ambition was to become a stage star. I didn't have any dreams of being a film star, because that meant going to Hollywood and that was so out of my realm. I wanted to be a stage star, I wanted to be John Gielgud or Peggy Ashcroft or Dame Sybil. They were my gods. I feel I've become a creature of the stage. I breathe differently on the stage.

Laurence Olivier, I think, was probably the best director I've ever worked with because he could play every part. I think the best directors I've worked with have been actors. I was in the opening production of the National Theater of *Hamlet*. I played Ophelia and Peter O'Toole played Hamlet, directed by Larry, who was one of the great Hamlets of our time. It was like dreaming you were on the center court at Wimbledon.

SCOTT GLENN

In movies, I always think of my job as putting globs of paint on an easel, for the director to paint his or her painting with long after I've left. For instance, I get hired for red and black, and I'd better have really iridescent black and vibrant red. I'll throw in some green, and brown, and purple, and yellow, too. But they'll do with those colors what they want.

I love movies because they're like a magic carpet. You're sitting in your apartment in New York, the phone rings. And a week later you're in New Zealand learning how to climb vertical ice.

On stage that's not the way it is. The curtain comes up and it's between the audience and me. And nobody comes running on stage and says, "Cut, I didn't write that," or, "Why are you doing it that way?" There's an energy you pick up on each night that happens between you and the audience that you're in control of. You make your own decisions. It's dangerous.

AIDAN QUINN

I had been working as a roofer for about six months, and having a grand old time being a young man making good money, and working with a great bunch of guys, mostly black but wild hillbillies as well, a group of degenerates who were all roofers. And I remember we were sitting on the edge of the roof, and we were looking out over Lake Michigan and we were twenty-six or twenty-eight stories high. It was seven-thirty in the morning. And the guy to the right of me was passing me a pint of whiskey, and the guy to the left of me was passing me a joint.

I just looked at the joint and I looked at the whiskey and I just remember passing the joint back, passing the pint back, and looking out over the lake and literally having an epiphany; I said to myself, "What are you going to do with your life? You have to do something." And it came, almost like a voice, and it said, "I am going to be an actor." It was strong and clear. Almost uncanny. Almost to the point where it made me laugh.

It's astonishing to me in film how many, even good, directors have not the least concept of what acting involves. And it's not necessary that even a good director knows what acting involves. But it would make the work so much easier if simple considerations as far as creating a space that is not like a war zone, which is what film sets are always like. Particularly in delicate emotional scenes. Most of the good directors I've worked with are great largely because they hire good people, and they create an atmosphere where talented people can flower.

I'm forty-four and I still have a hard time with rejection. It's just so hard. I remember being twenty-two when I started and I said, if I don't get well-known and established by twenty-five I'm quitting. I can't take the rejection – just can't take it.

It's a constant hustle. Constant hustle. That's exhausting. And in the end I think that's why so many actors, like myself, that have established themselves, have a name, and have made some money, start to branch out to do other things. Because if you think rejection's hard in your twenties, it doesn't get easier in your forties.

BEN STEIN

I had the luckiest career as an actor, because until I became famous I had never had an acting lesson, never had any ambition to be an actor, never an acting agent. And then I did this one part – in *Ferris Bueller's Day Off* – and, wham, suddenly overnight I was famous. I really basically can only play myself. I can't really play a wide range of characters. I only play a small range of me.

It's incredibly wonderful money when you're doing it. It's so much fun while you're doing it that it amazes me that we have anybody in this country who wants to do anything else.

GEORGE SEGAL

I was a painfully shy kid, but I was always most comfortable on the stage. My father brought home some magic tricks, and I was fascinated with them. I never had any skills, but I think I liked having everybody's attention. All of my inhibitions, my defenses, went away, and I would be in what basketball players call "a zone." That was a magical feeling – a feeling of being in the zone.

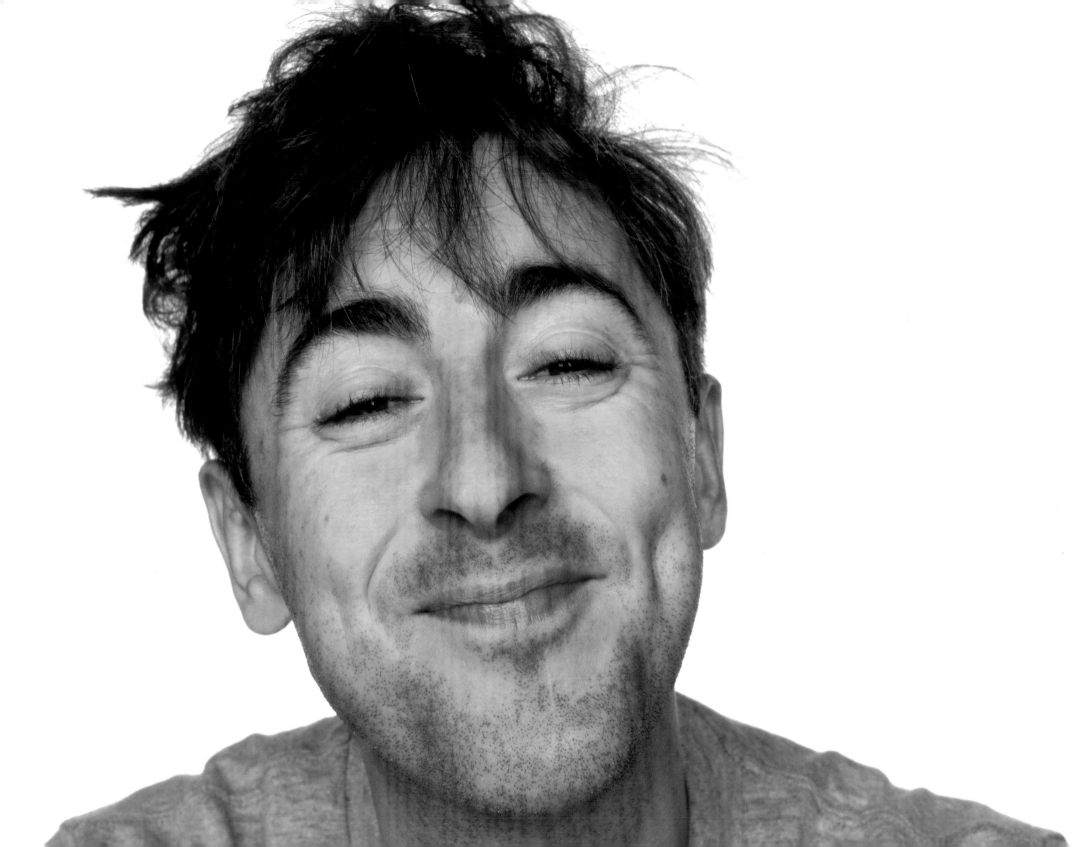

Flirtation

Sixth Intermission

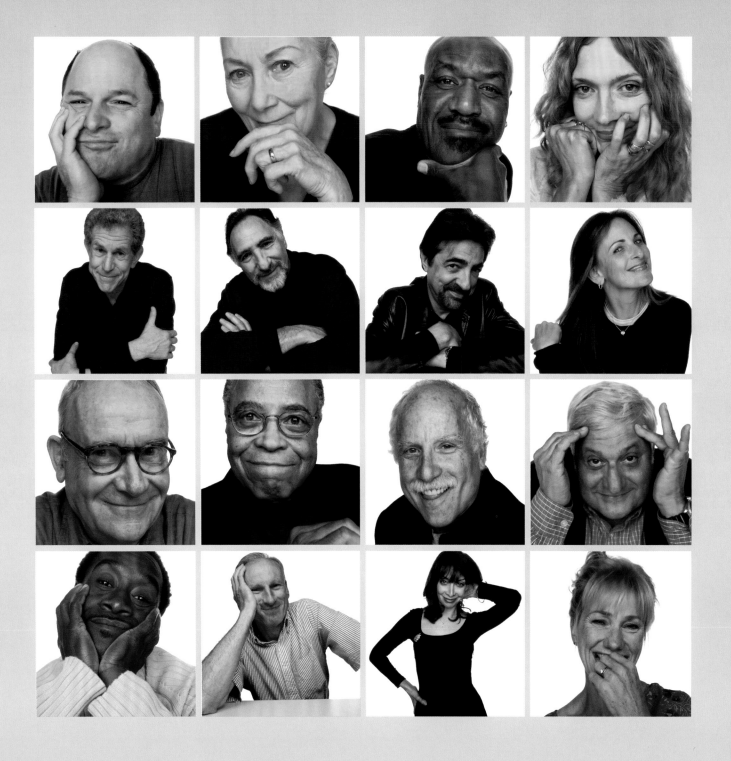

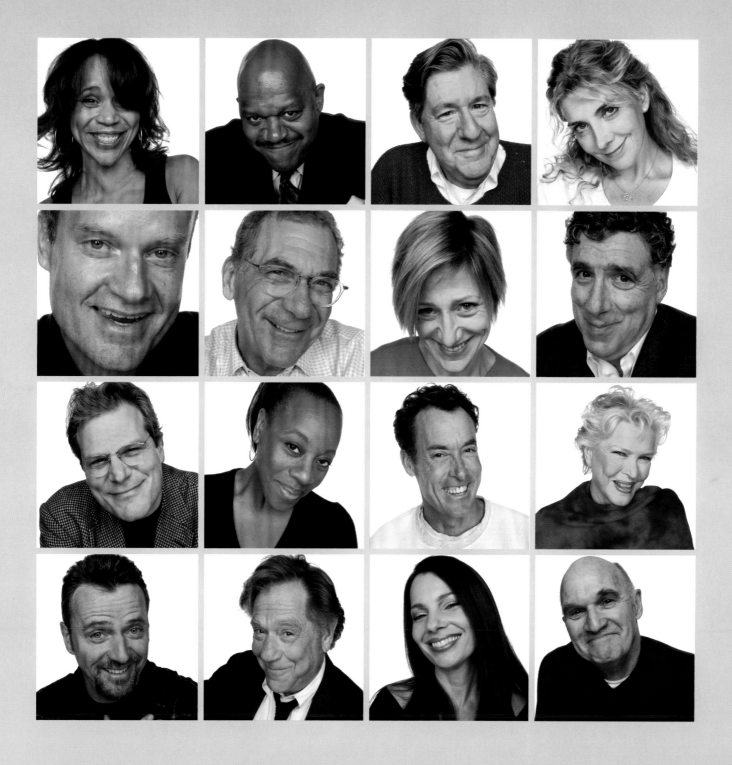

Act VII

The Players

EDWARD HERRMANN

ROBERT PROSKY

FRAN DRESCHER

MARK MARGOLIS

DAVID CARRADINE

ROBERT KLEIN

DYLAN BAKER

MIGUEL FERRER

BOB BALABAN

AMANDA PLUMMER

EDWARD HERRMANN

1. You are…a deer hunter

telling a whopper

to your buddies

about an encounter

with a brown bear.

2. …a Big Ten football coach

telling your university

president that he'd

better keep his ivory-tower

hands off your program.

3. …a loving father

hearing your daughter tell

of physical abuse

by her husband.

You don't really have to be a pedophile to play one. You have the uncomfortable feeling that all of these characters are within you, and the criminals out there are people who don't have an outlet. They're actually acting it out in real life.

ROBERT PROSKY

1. You are…a man in a hospital waiting room,

being told that your wife of fifty years

has suffered a "setback" during an operation.

2. …a priest hearing that a friend and colleague

has admitted to molesting young boys.

3. …a grandfather being asked by your grandson

if you fought in the Civil War.

I was frightened to death the first time on stage and I've never really gotten rid of that feeling. It always occurs the first day of rehearsal, then you get the play open and the anxiety dissipates. I do love it more than anything else. I like creating the performance with an audience. It's different every night, and the being frightened tends to disappear in the act of doing it, because your concentration and your involvement take over. You build anew each night with the audience. With film there's no reaction; you use the theater craft and technique, but you're literally playing to an audience of one, and it's right in front of your face.

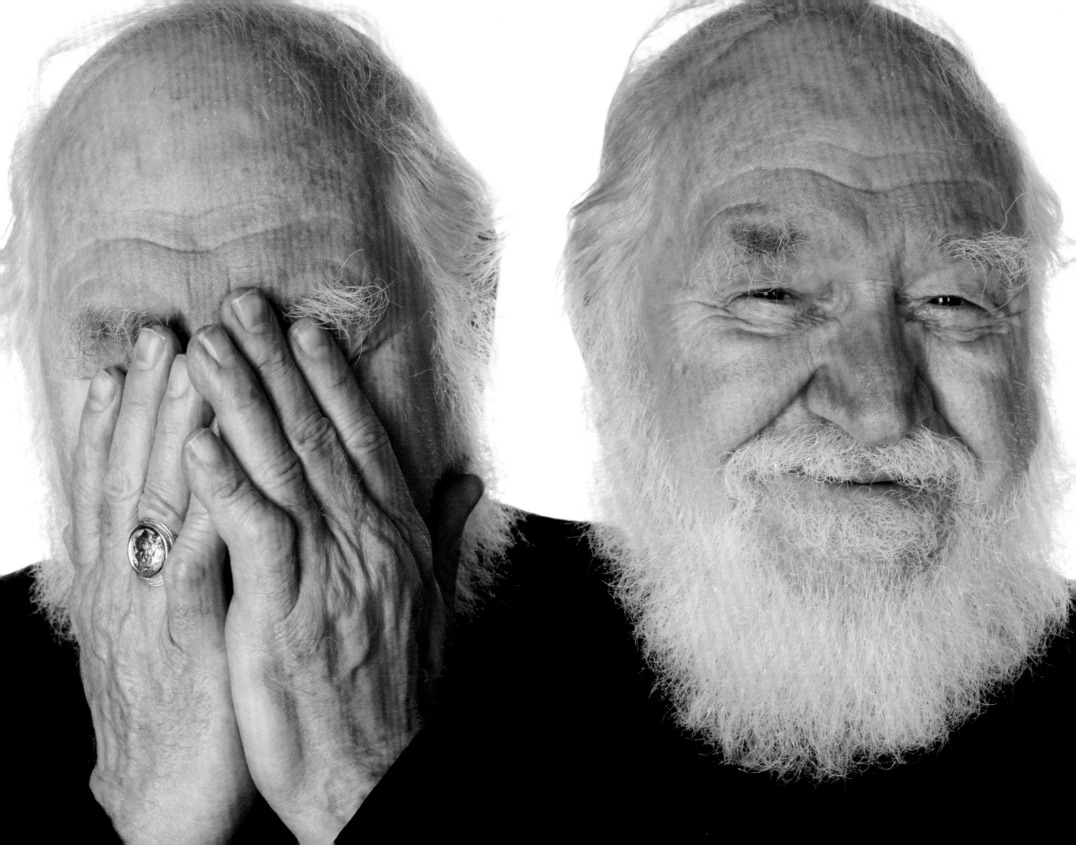

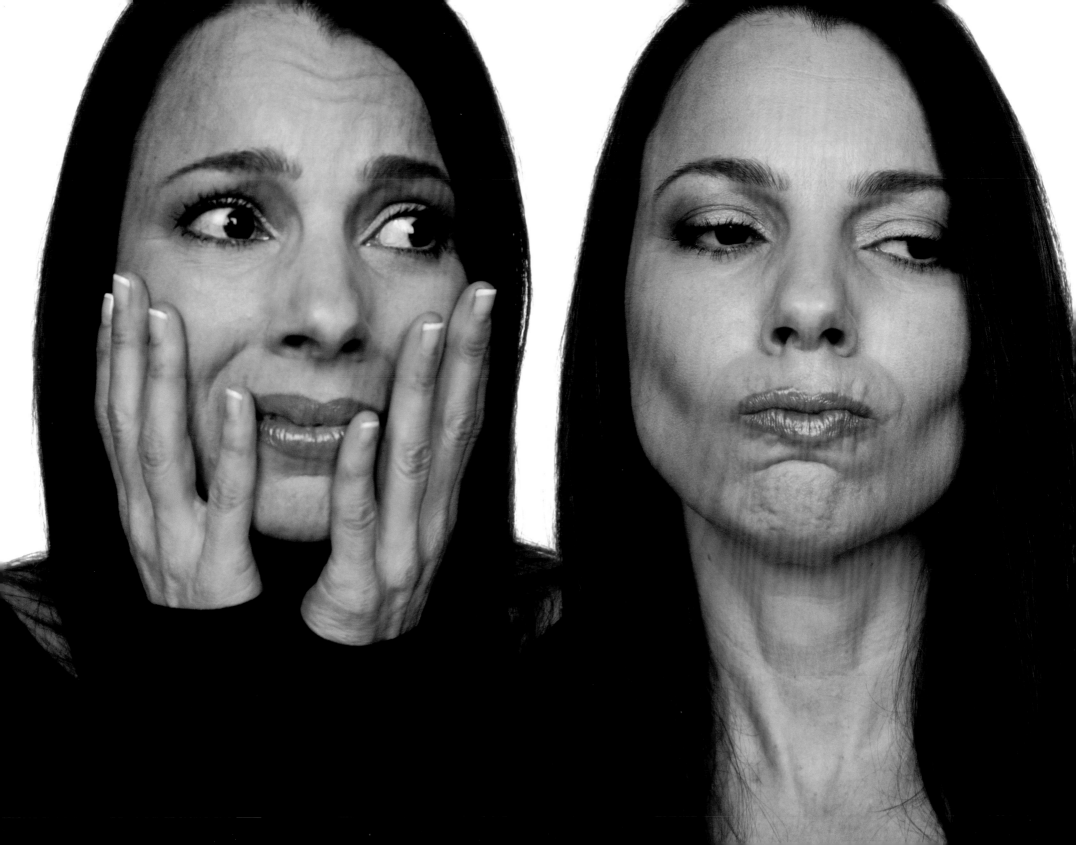

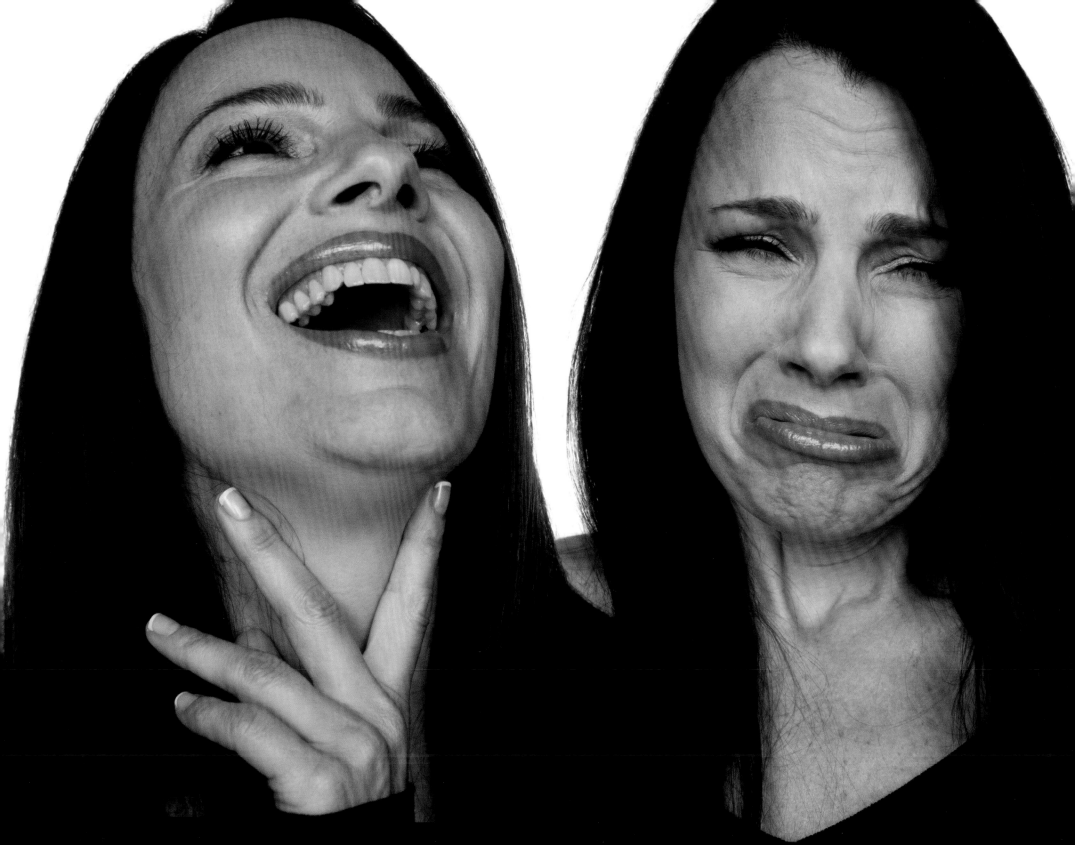

previous pages

FRAN DRESCHER

1. You are...a young, single mother

in the middle of the night,

hearing someone downstairs in the kitchen.

2. ...a scheming nun

plotting to bring down a rival

for the affections of the abbess.

3. ...a lady-who-lunches hearing gossip

about one of your circle.

4. ...a kid being made fun of

by "the clique."

I don't have a problem tapping
into a wide range of emotion,
but it might be hard for me to
reach a very shy, introverted,
very insecure person. I want a
director that's going to push
me to take chances.

MARK MARGOLIS

1. You are...a fertility specialist

telling one of your most desperate patients:

"Guess what. You're pregnant!"

2. ...a high-flying CEO

being told by your financial officer

that the past four years of profits

will have to be restated as losses.

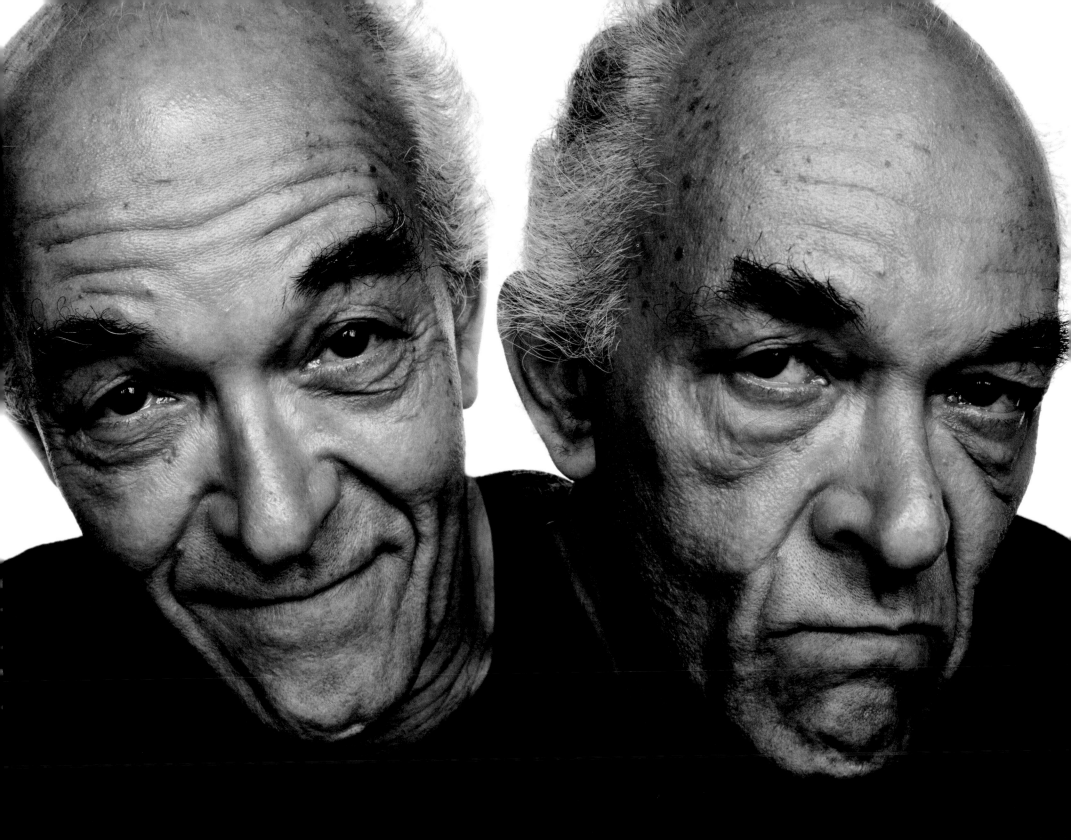

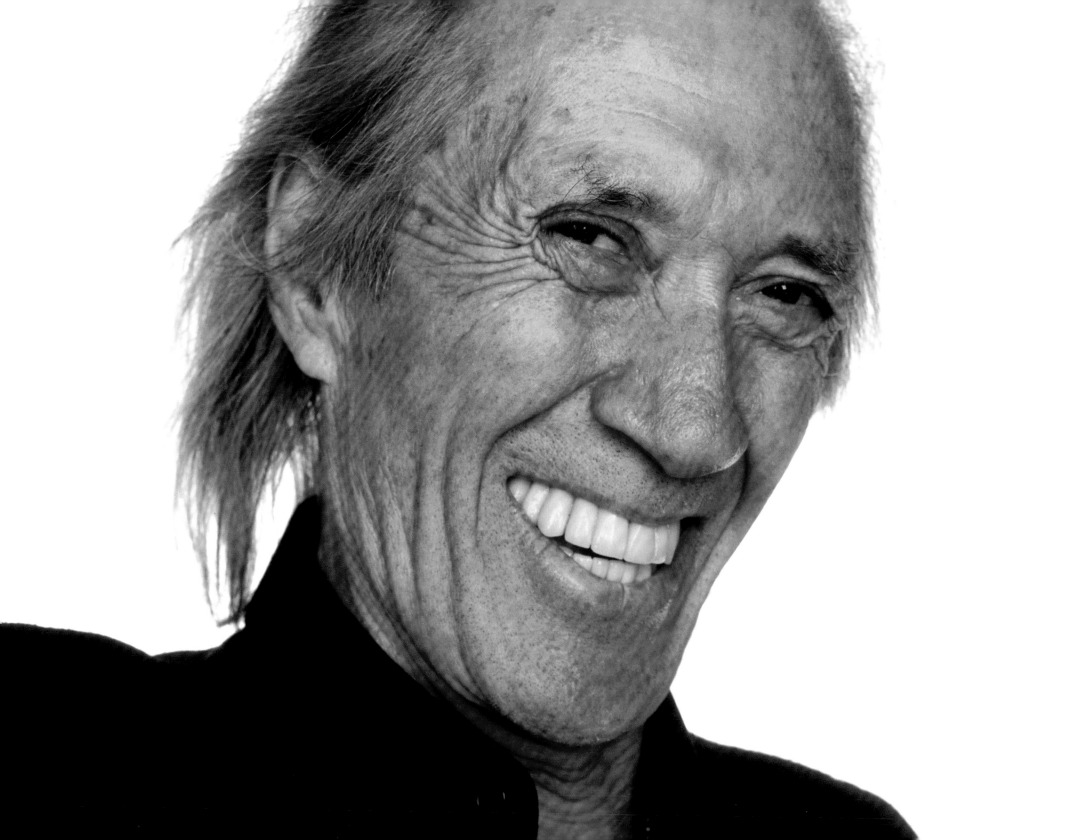

DAVID CARRADINE

You are a senator

 greeting a big campaign donor

you secretly can't stand.

The first performance I gave
outside of high-school or
college was in a little theater
production of *Romeo and Juliet*,
and I was playing Tybalt, the
bad guy. I come on stage and
I stand there for about five
minutes before I say anything.
And I could feel my knees
shaking. But the moment that
my line came and it was time
for me to say something, the
shaking went away and it has
never, ever come back – in
forty-something years.

following pages

ROBERT KLEIN

1. You are…a little boy

 refusing to even think about

eating your broccoli.

2. …the same little boy,

 stricken on hearing your mother say,

"No broccoli, no Power Rangers."

3. …trying to distract your parents with a story

about a monster in your bedroom closet.

4. …glaring at your older sister,

 who is eating her broccoli with theatrical pleasure.

Truth is the important thing,
and that's not always easy. For
the undiscerning eye, it doesn't
take that much to be believable.
If you have the costume on,
and the set is right – if you
have that badge on and you're
in a police car and you're a cop,
it's not that hard, but when you
have a good magnifying glass
on it, and a focused eye, it's a
little more complicated. The
object is pretending you're some-
one else and doing it with as
much truthfulness as you can.

197

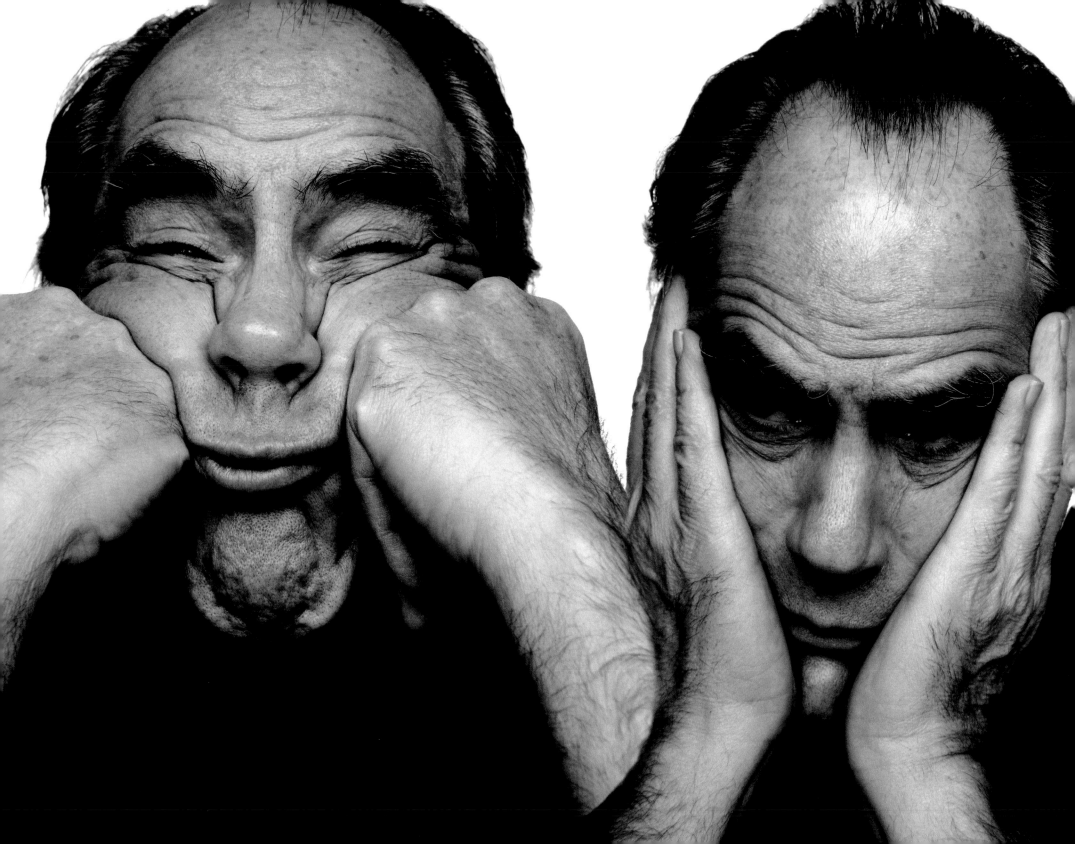

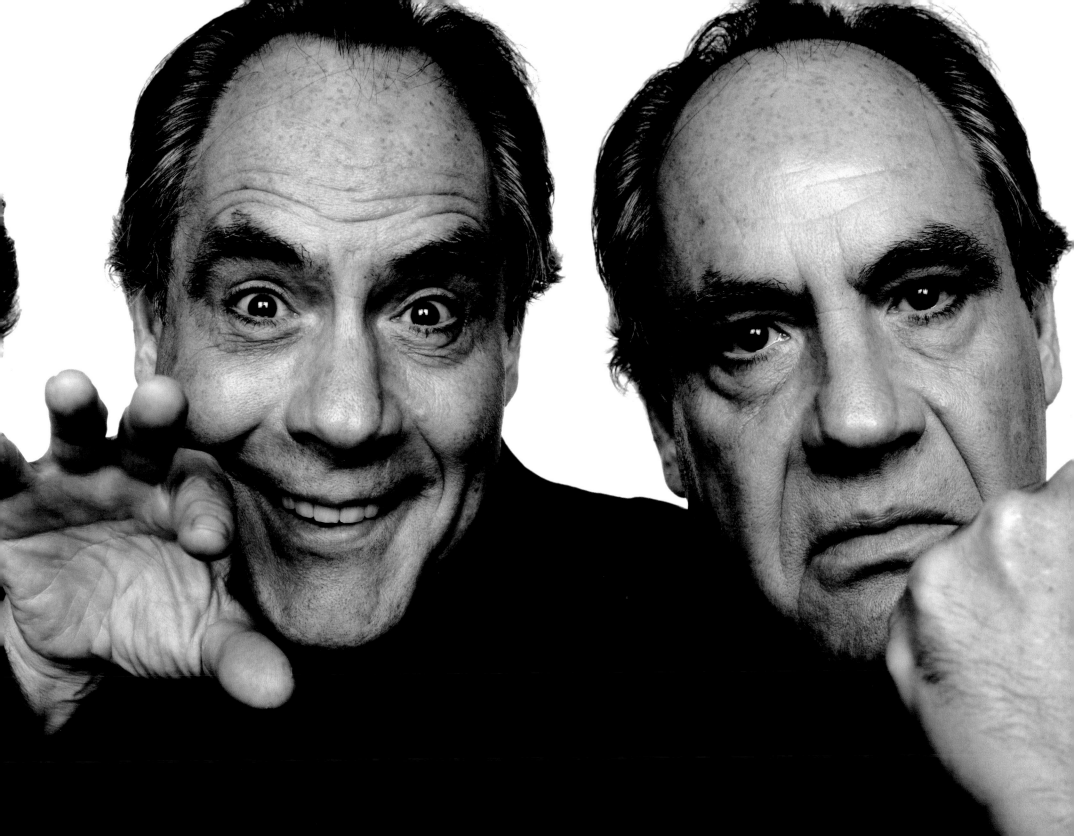

DYLAN BAKER

1. You are...a loser at a bar,

asking a pretty girl what her sign is.

2. ...a high school jock bullying a nerd.

3. ...a man hearing that the little girl you hit

when you ran a red light

has just died.

The first day I was at William and Mary, I walked over to the theater and there were auditions for *The Clouds*. I walked in and I auditioned and I got a part. That was it. The audition, the rehearsal process, the performance, I just thought it was the greatest thing I'd ever done in my life. I had an ability to kind of lose myself in the play. I can remember just throwing myself into it and being fascinated by the process – and on opening night, the curtain was going up and I could hear that sound of people when the curtain went up. I'll never forget that feeling. It was like sort of tapping into possibilities – opening up a wellspring of energy – I loved the response.

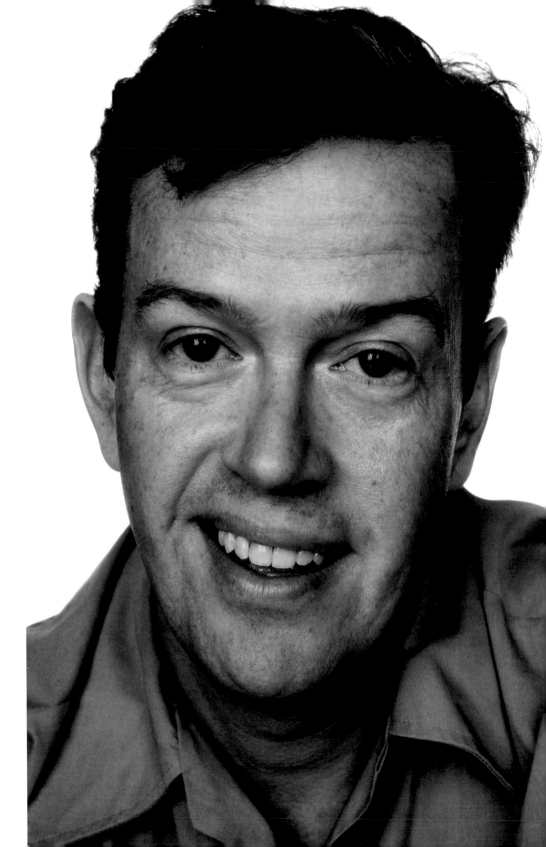

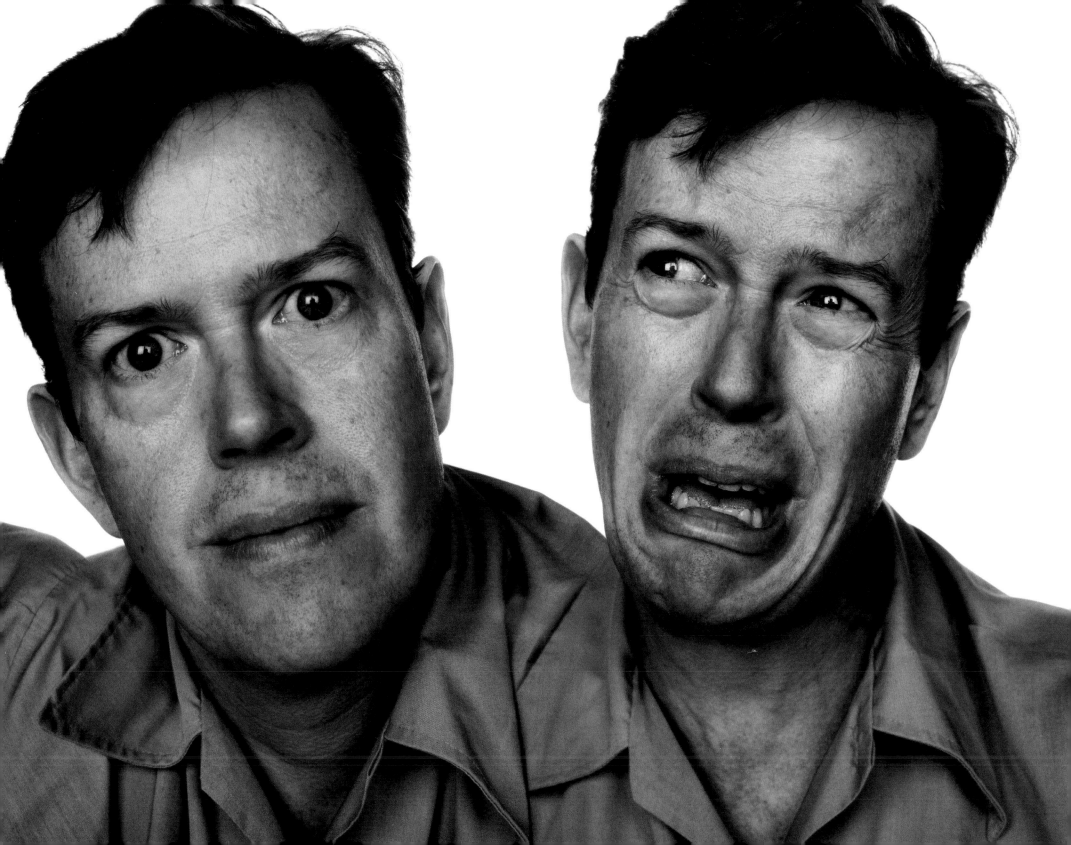

MIGUEL FERRER

1. You are...a young father

 breaking down

 in front of local TV cameras

after your daughter has been kidnapped

 from your backyard.

 2. ...a small-time bank robber

seeing that three police cars

 are pulling up just outside,

telling your bumbling partner

 to shut up while you figure something out.

 3. ...a first-time lottery player

who has just won two million.

I don't think you need to kill
someone to play a murderer.
I don't understand actors who
sit there and figure out what
flavor ice cream their character
liked when they were four
years old.

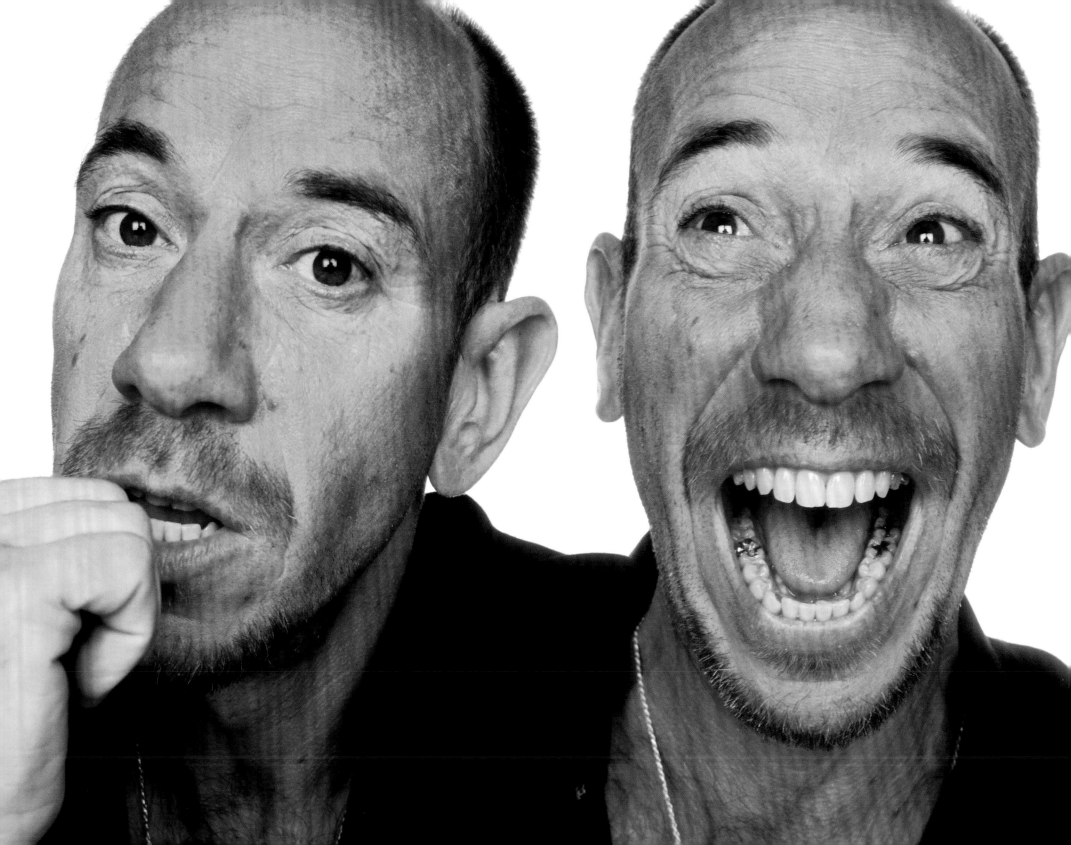

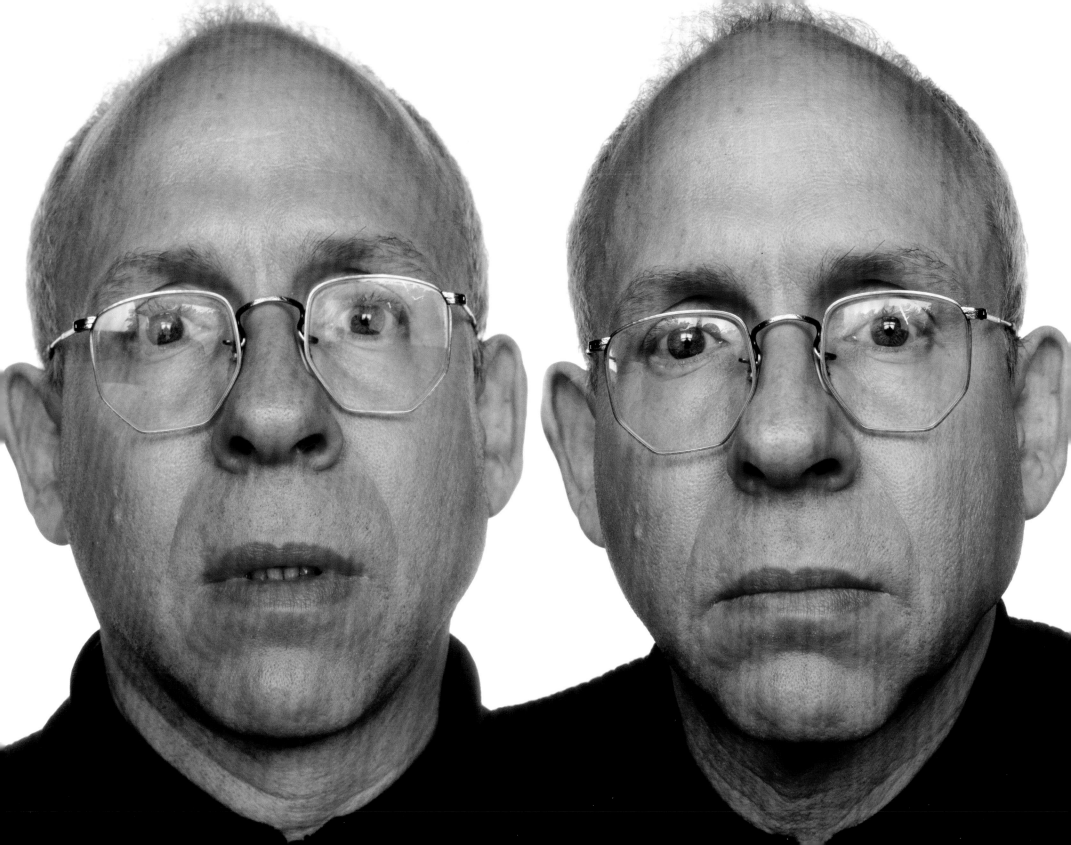

BOB BALABAN

1. You are…a central post office superintendent

who hears gunshots down the hall.

2. …a man with a socially ambitious wife,

being refused membership in an exclusive country club.

following pages

AMANDA PLUMMER

1. You are…a driver on a country road,

watching the final throes

of a golden retriever you've hit.

2. …a teenager

who accidentally enters your parents' room

while they're making love.

3. …a woman who thinks your husband

has forgotten your birthday,

walking into your house to find all your friends shouting,

"Surprise!"

4. …the mother of the bride, hearing your daughter say, "I do."

I don't know too much about truth. Because as Don Quixote said, "What is a truth but a sort of a myth? What is a myth but a sort of a lie?" That frees you up immediately. There is a quote from Stanislavski, "Live truthfully in imaginary circumstances." You believe in a role so much that you cross some borderline in your head, and you might not get back who you are.

You are always observing. You watch people eat. See how furniture sits in a certain place. And it goes in that part of your brain that keeps it for a future role. You have to get rid of the ego, the self. There's a lot of sweeping away, and then all of a sudden, I get a different walk, I have different thoughts, I have different memories.

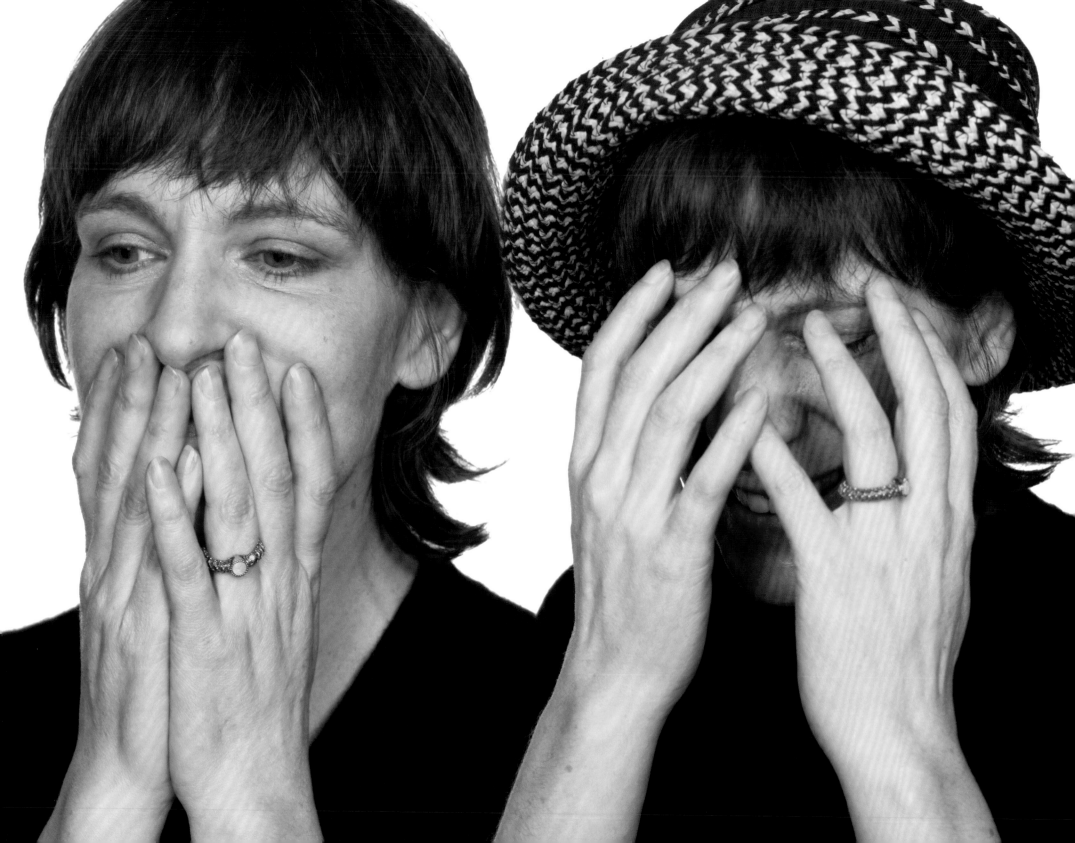

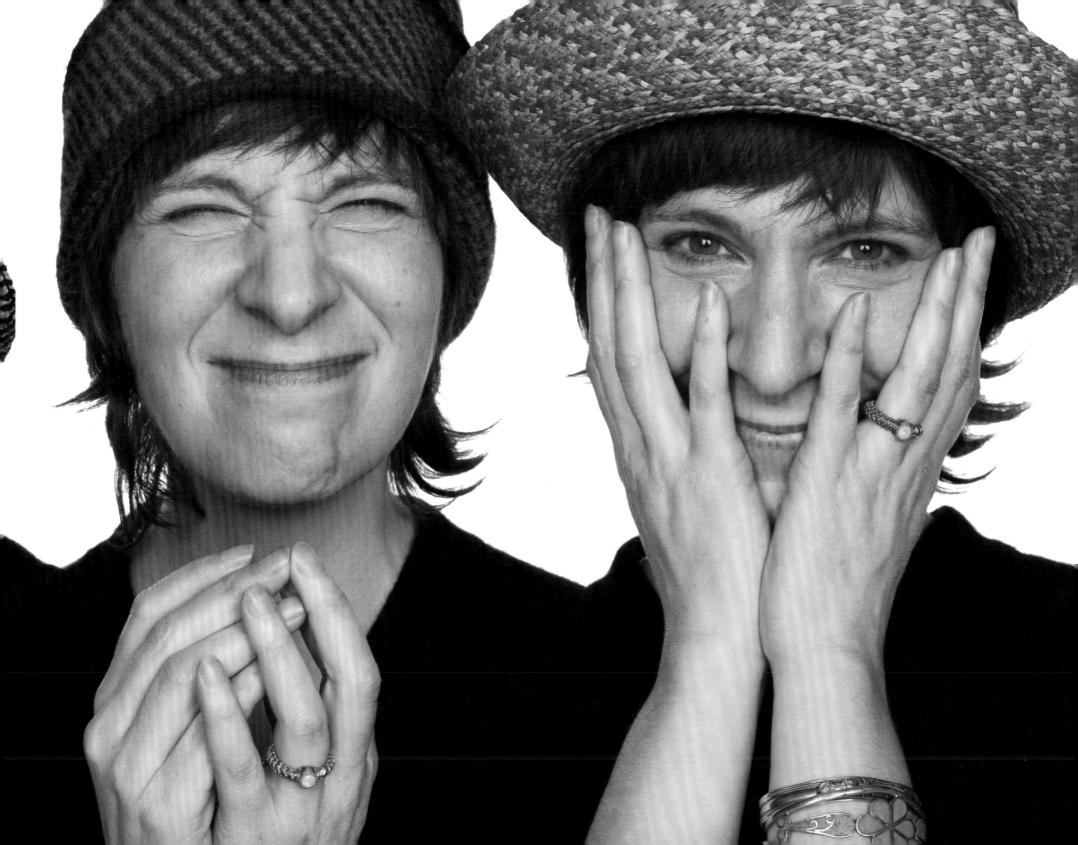

Actors' Notes

EDWARD HERRMANN

One of the basic attractions of acting, at the beginning, was that we have all of these characters in us. We have all of these demons in us. We have all of these heroes and charlatans and murderers and pedophiles and lovers and godlike, saintly people in us. Most people spend an awful lot of money on their shrinks to find them. Acting is a way of exorcising those demons or at least dealing with them in a very creative way. It's a way of actually pushing your ego aside and inhabiting another skin.

I've had maybe three or four or five directors who really understood acting, and what actors do and how actors find things – and could talk, either conceptually, or emotionally, or physically, to find what this character's all about. That can be really fruitful and wonderful. It's a process that you do together. In film and in television, you work so quickly – especially in television – that you don't have time for these kinds of explorations, and you have to work shorthand. Ninety-nine times out of a hundred in film and television, you direct yourself as an artist.

ROBERT PROSKY

The actor creates a human being out of his own spirit, and that is the same whether it's film or on stage. How you do it is a mystery. One of the ways is certainly to do as much research as you can. You don't know what you're going to use, but in the act of rehearsal you find things here and there, and you choose which bits you're going to use, so the wider the scope of the research, the better. That's one of the reasons why I live in Washington. I love acting, but I need a wider circle of experience. Of course modern conveniences help a great deal, plane travel, the Internet.

ROBERT KLEIN

A novelist sitting in front of his work, that's as singular, as personal as it gets, because there's absolutely no other collaboration. When a playwright writes a play, the orthodoxy says that he would be well advised not to direct it himself because a director will find things in it. The director has a vision of what this play is about, what its meaning is; even if it's not what the playwright had in mind, the playwright might just love this discovery of all these things that the playwright himself did not see in the work, and that's the more complex part. Intelligent actors should not be treated like automatons, because they can find things, the set designer will find things, the composer of the music. It's a collaborative venture, and as personal as writing a play is, we could add tremendously to it.

DAVID CARRADINE

There was one guy who once told me, there are no failures in Hollywood, there are only people who gave up too soon. There are so many people who are right on top who don't seem to have much of a grasp on actually acting. But what they have a grasp on is confidence and maybe getting the job, maybe even just business – making the connections. The problem is not that it's hard – the problem is that there are 128,000 members of the Screen Actors Guild, and there are a hundred jobs.

MIGUEL FERRER

Most actresses are completely insane. Just square that and you've got actors. I just think you've got to reach down and put such a private, precious piece of yourself on sale that you become soulless.

AMANDA PLUMMER

I love both theater and film. They're neck to neck; they're running a good race.

I want a director to be a mad genius. I don't care if he's the ugliest, meanest, kindest, warmest, most loving, or most selfish. I don't care what his personality is as long as he's a genius. If he's thought to be mad, I probably will understand him, what he wants from me and what I want from him.

In film the director gives the point of view of the whole. And he hires the actors that he wants at the beginning, he casts accordingly, so that they won't get in the way of what he sees. On stage you're the moving picture and the people in the audience are like living cameras. You can feel them even when you turn your back. You're in a circle of cameras and they're all seeing things differently. So you've got in the same minute totally different reactions going on. And you feel that on stage. You do a gesture that maybe only three or four people will see, but those three or four people will see it. Do something else and more will see. So you can play with many different levels in your effort to express the unconscious as well as the consciousness of your character, and it's so brilliant and you can't always be sure all of these things are going to be caught on camera. So you really want to work with a great, great, great director.

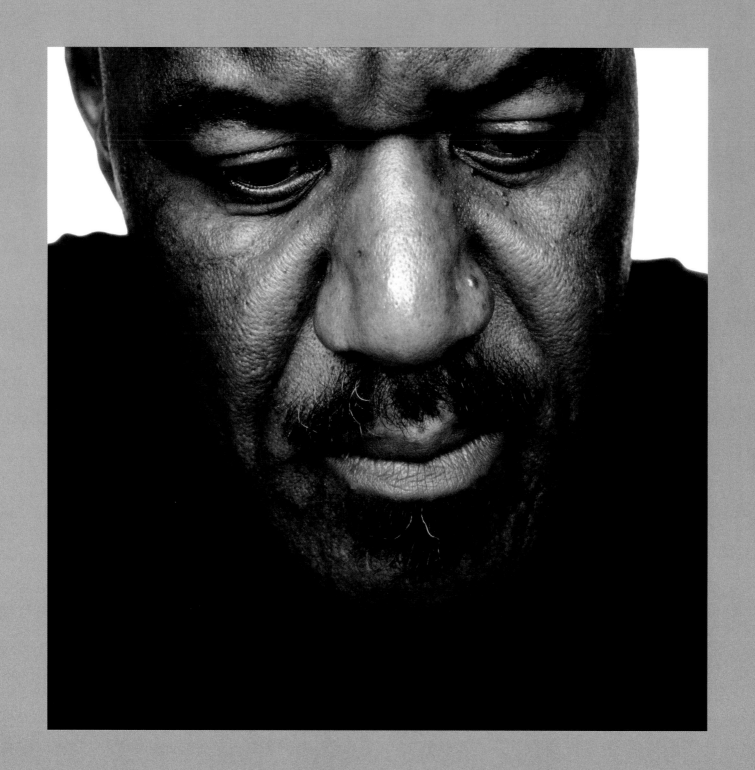

Tragedy

Seventh Intermission

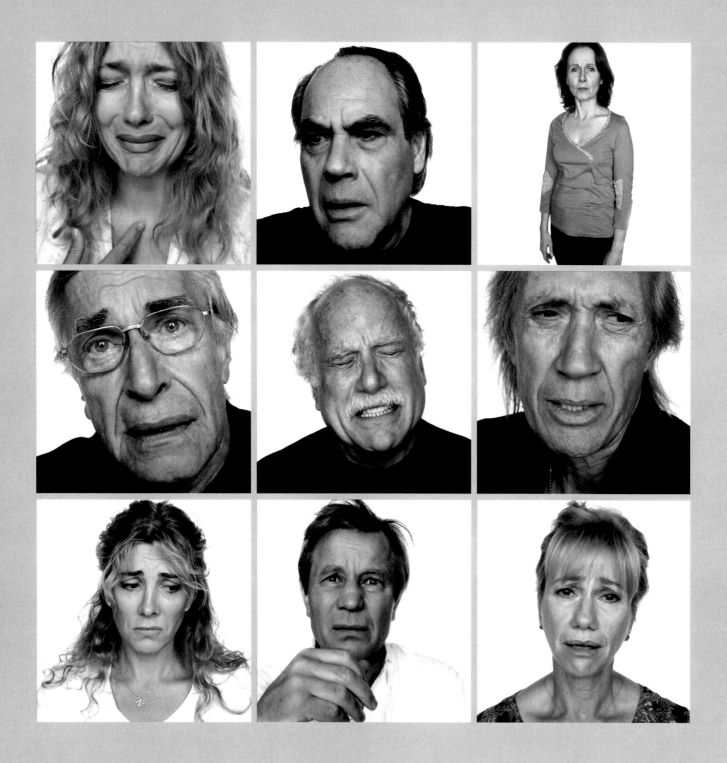

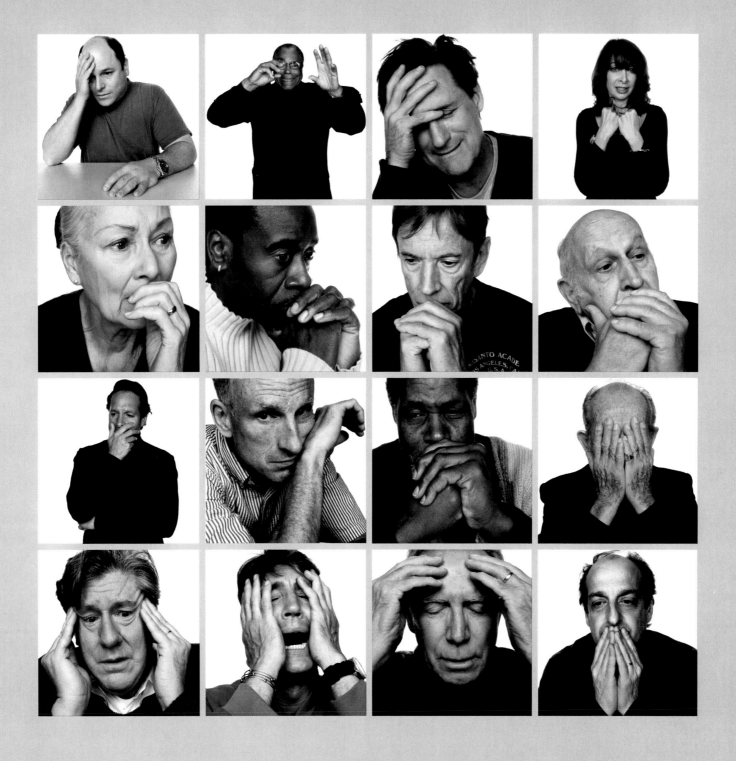

Act VIII

The Players

KATHY BAKER

MICHAEL CUMPSTY

HARRIS YULIN

SYDNEY POLLACK

ERIC ROBERTS

ROBERT LOGGIA

HENRY WINKLER

DAVID PAYMER

KELSEY GRAMMER

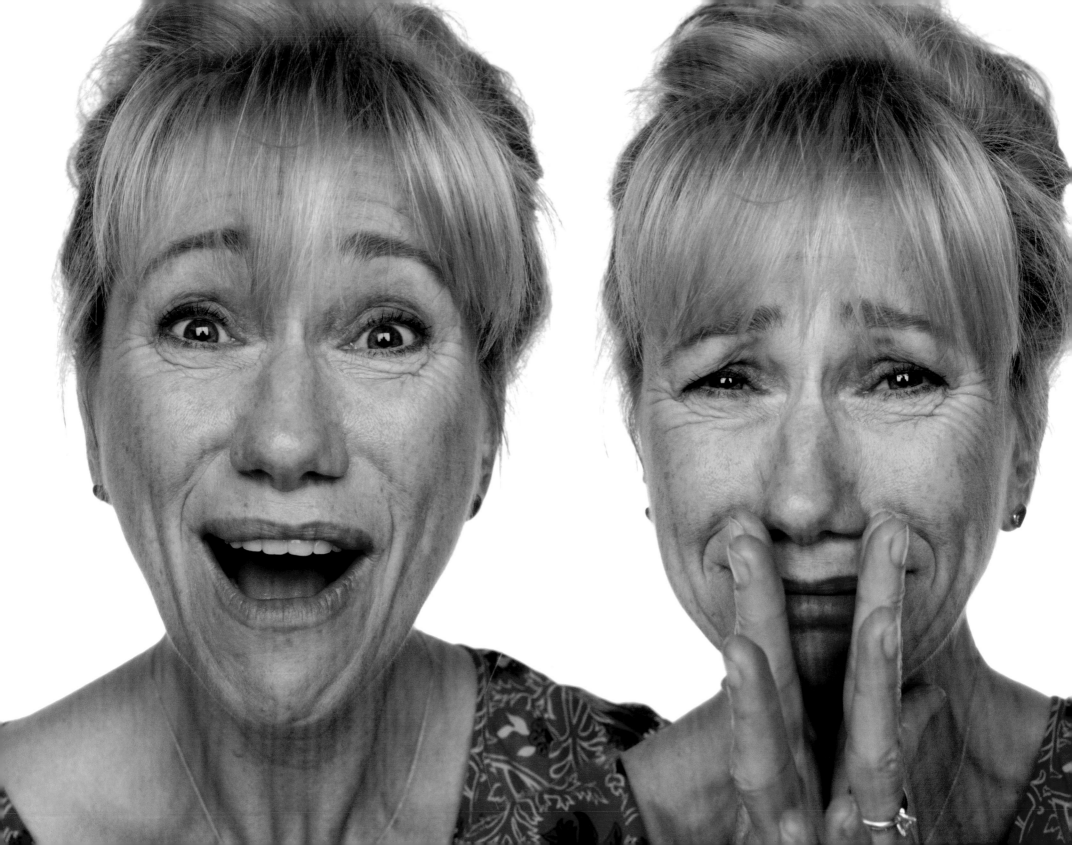

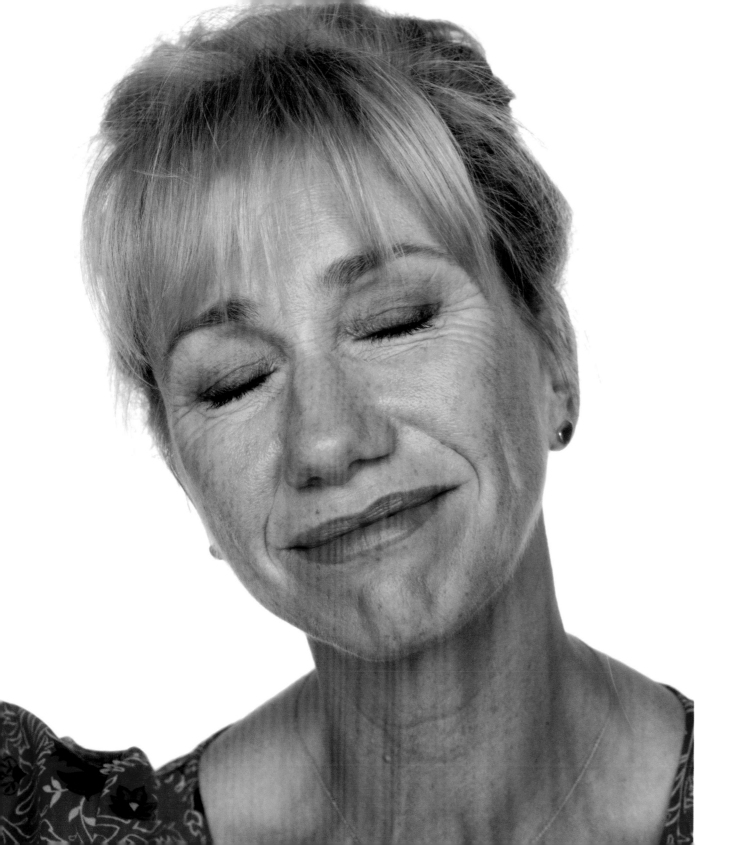

KATHY BAKER

1. You are…an unmarried aunt
babysitting
your sister's child.

2. …hearing that your best
friend has committed suicide.

3. …a valedictorian
surrounded by your family
after graduation.

I've played a prostitute and I've played a drug addict. When I was about to play a coke addict, I said, "Oh, I've never done any coke." But I realized that I could do "as if." Anything that they throw at you, you can pretty much find in your life the parallel – the "as if." As if I, Kathy Baker, were a prostitute, as if I, Kathy Baker, were a drug addict. I do truth. I don't lie. I don't do fabrication. I don't do makeup. I do truth. I can feel it when I'm lying. I can feel it when I'm faking. A lie is a fake. Truth is a good performance. Truth is real.

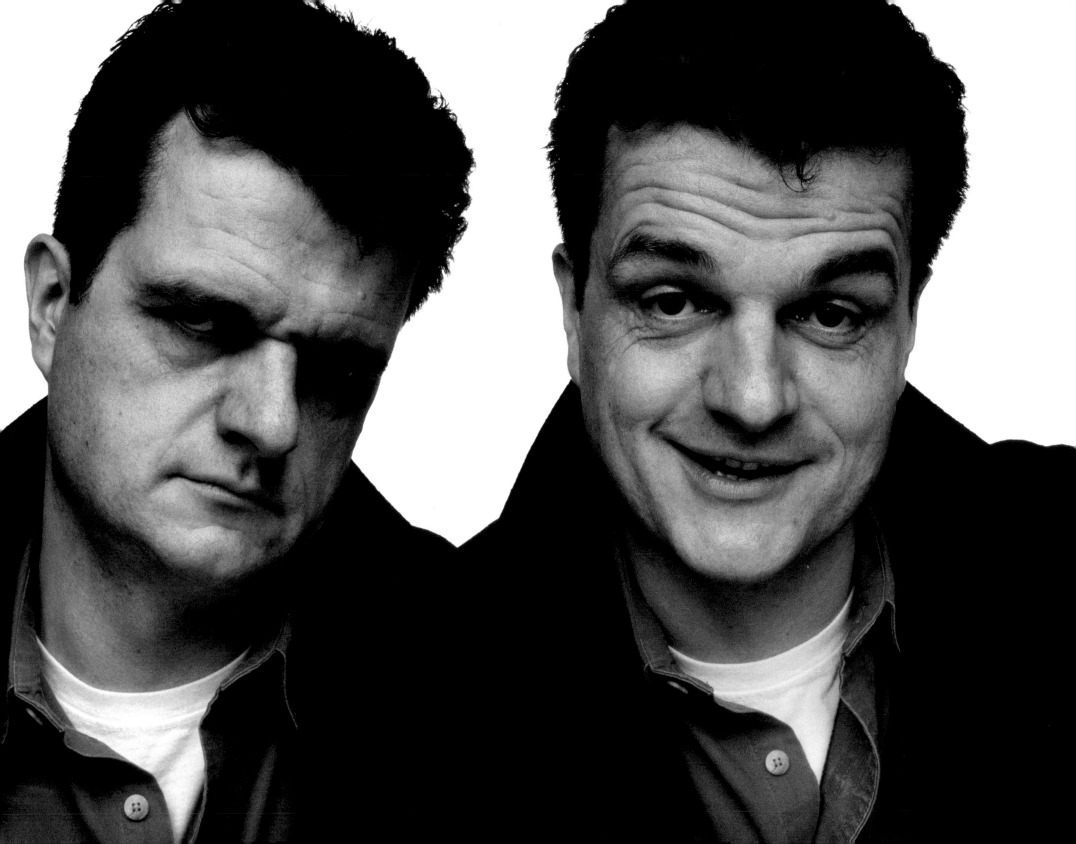

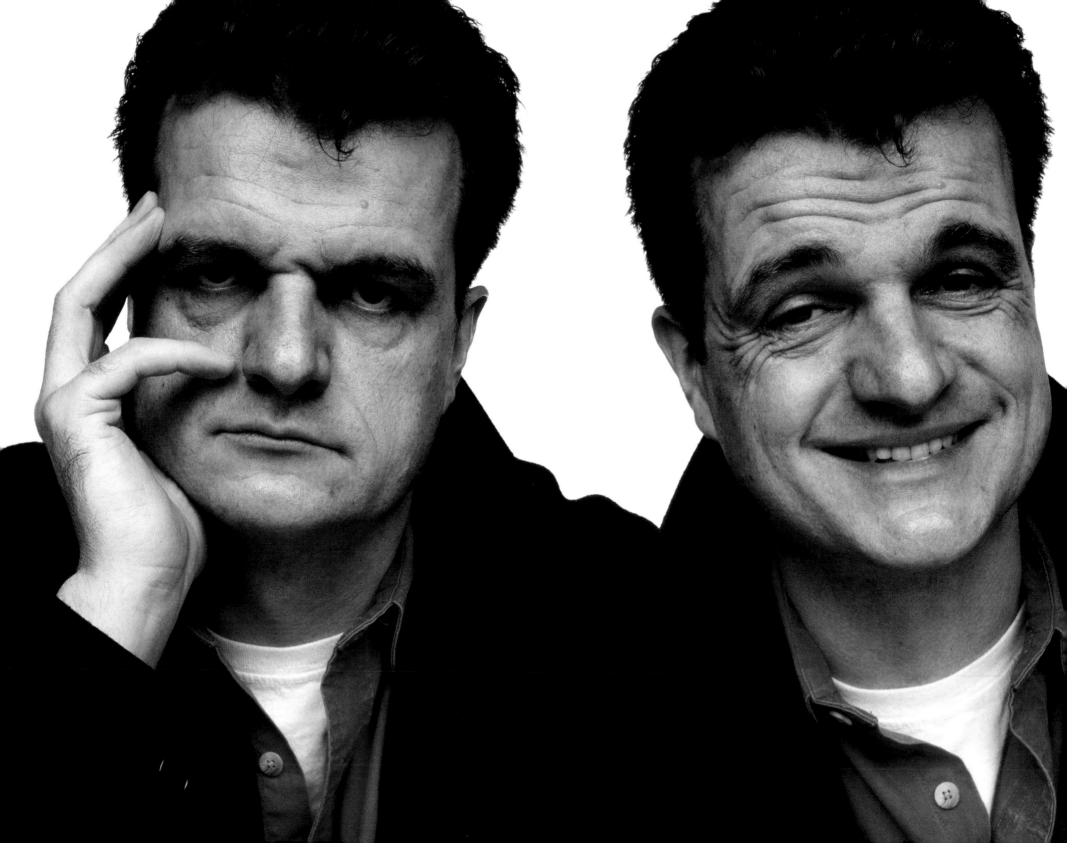

MICHAEL CUMPSTY

1. You are…a highway patrolman

peering into a car filled with smirking teenagers.

2. …the young driver telling the cop

that you're the designated driver, totally sober,

and that you were weaving back and forth

to test the tire traction.

3. …the cop, leaning on the door,

waiting for the driver's license.

4. …the driver, admitting that maybe you've had half a beer.

"But, jeez, officer, you're not gonna hassle

a guy for that, are you?"

I try to proceed only from the material and the specifics of the material, and when I discover something that's true about the character in one moment, I try not to extrapolate it through the rest of the play. I try to keep what is true of the character in the moment true in that moment and then discover the true thing about the character in the next moment from the material. Not only does that better realize the author's intention for the character, but it also makes the characterization more interesting because you're constantly mercurial, chameleonlike.

HARRIS YULIN

1. You are…a young surgeon

coming out of an operation

where everything went wrong.

2. …an elderly resident in a nursing home,

feeling the vague, unfamiliar stirrings

of lust.

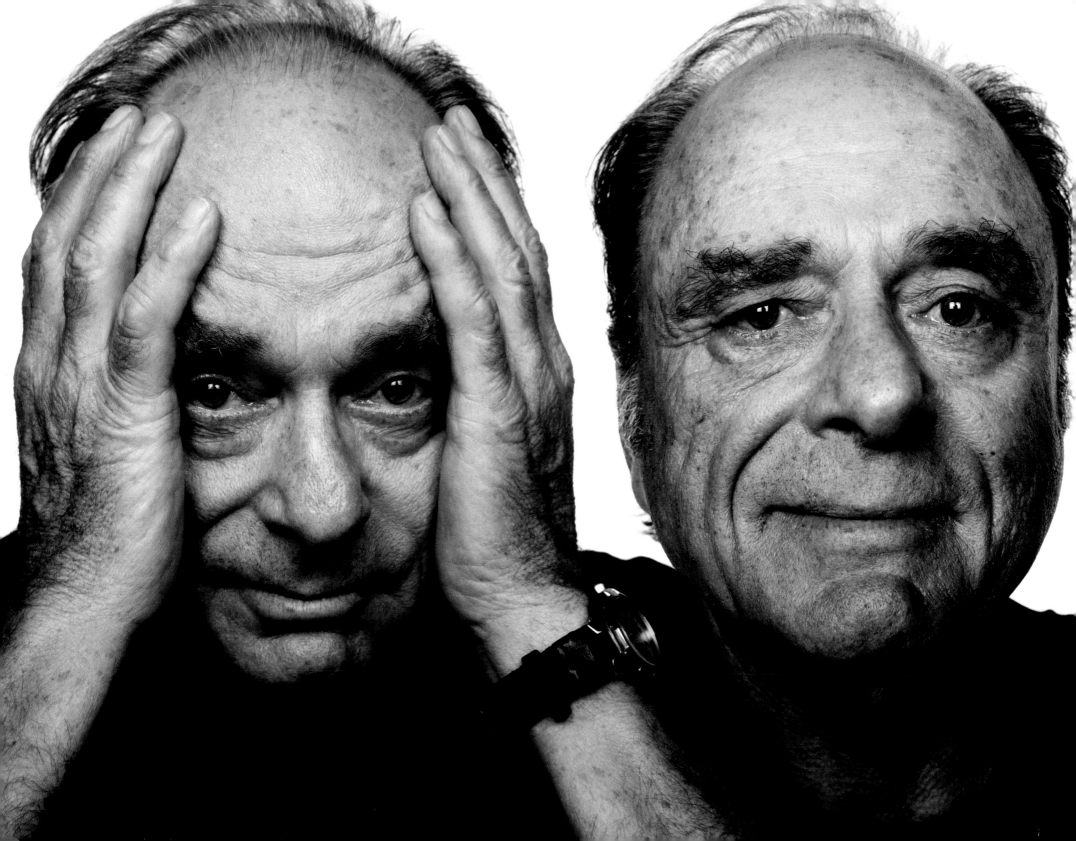

SYDNEY POLLACK

1. You are…a candidate for office,

 polling badly,

 listening to your consultants argue.

2. …a tailor watching a hard-to-please customer
admire himself in a new suit.

 3. …a mathematics genius
 realizing that your life's work
 is based on a flawed formula.

There was something magical
about getting up in front of an
audience, and the auditorium
getting dark, and then living
out this imaginary world.

The problem with acting is that
it's very hard to lie, really lie.
If you hate what you're doing,
it shows in some way, or if you
feel insecure, it shows, either
in tension, or in unconsciously
winking, or excusing yourself
from it in some way.

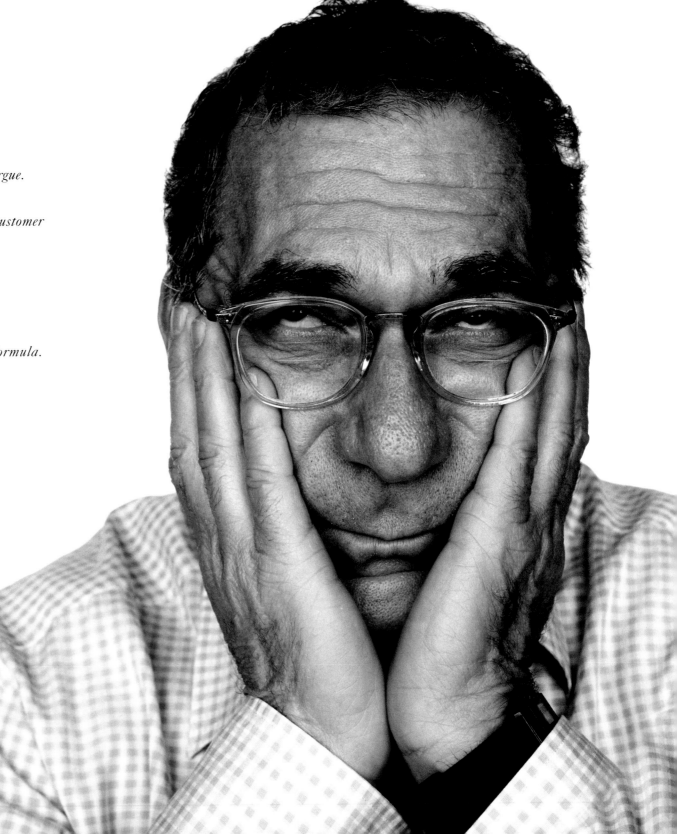

222

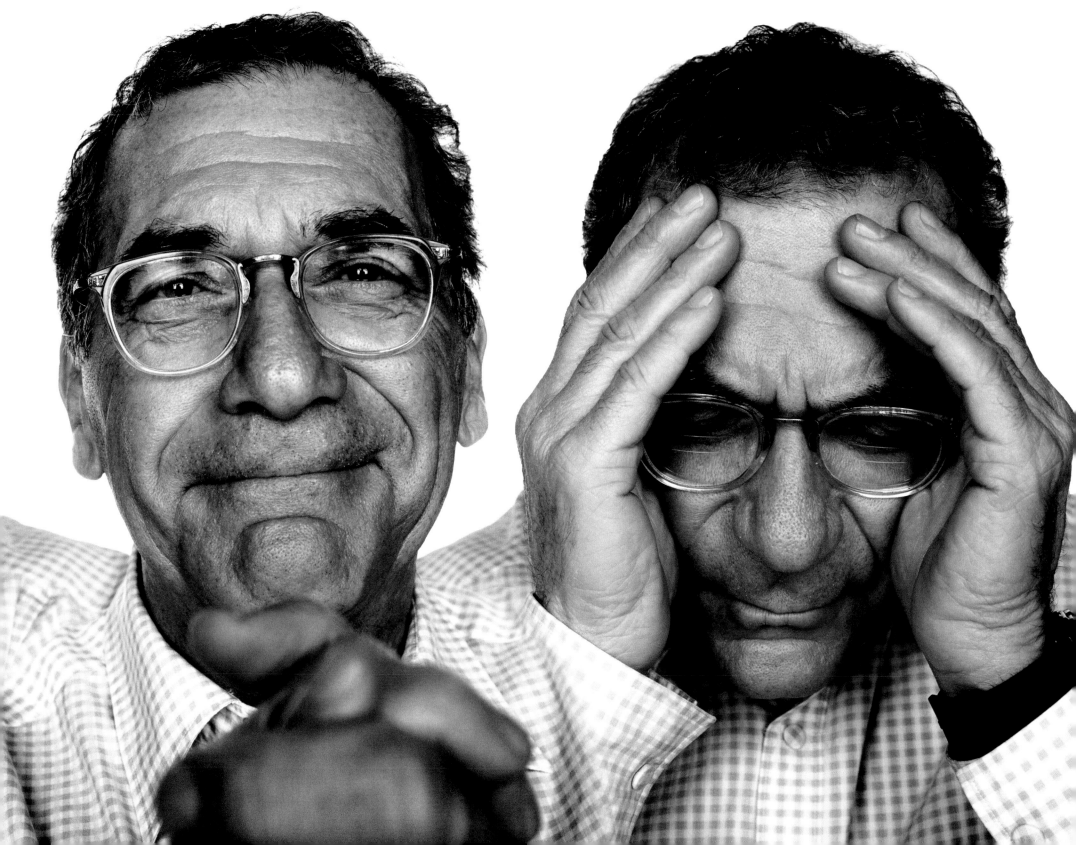

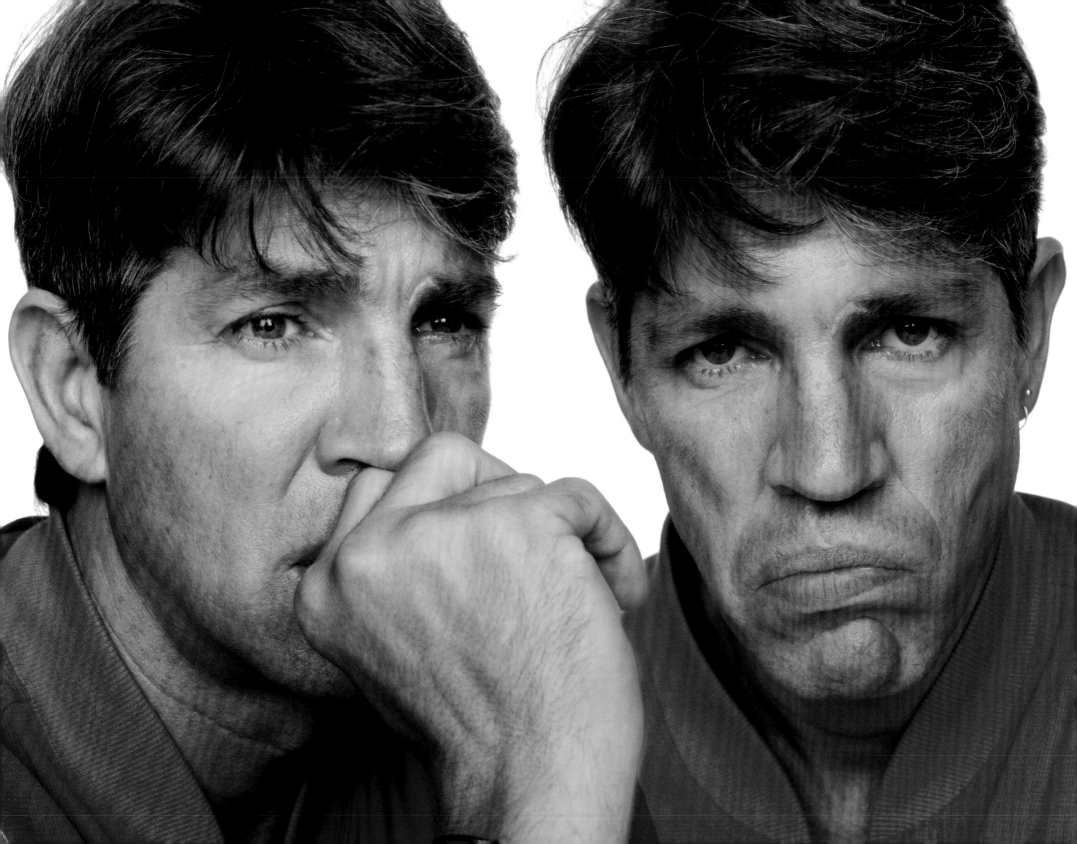

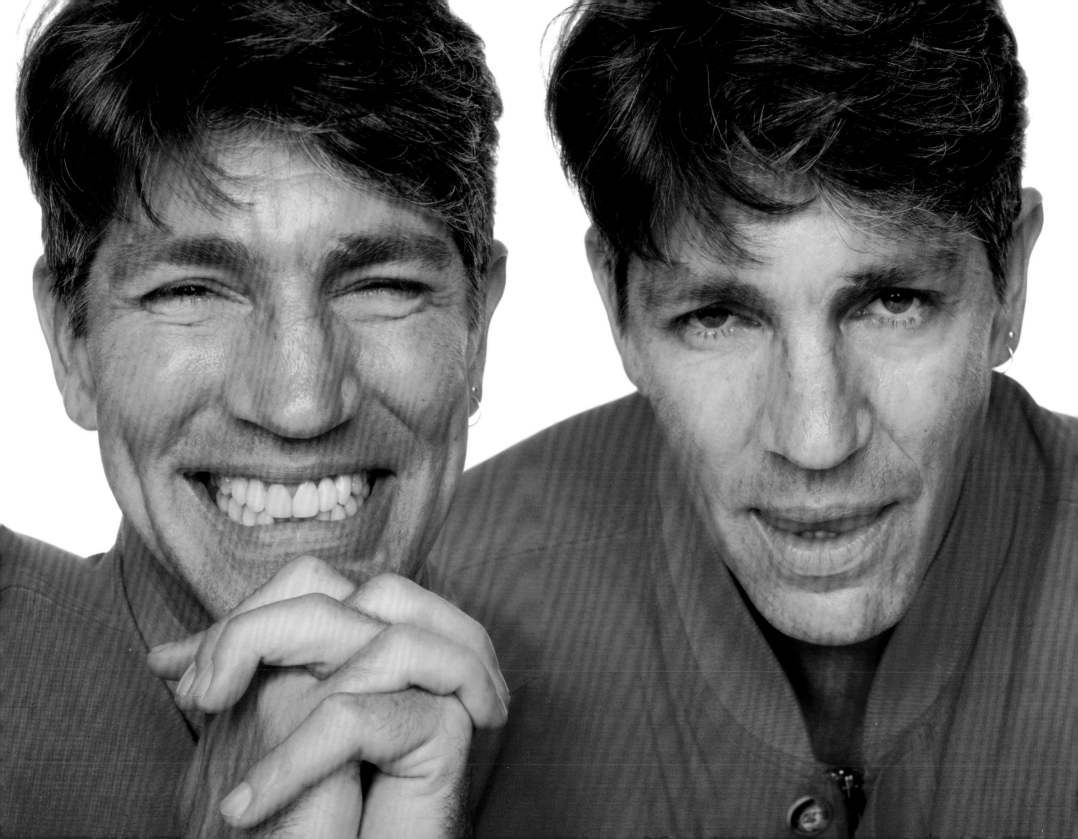

ERIC ROBERTS

1. You are…a young lieutenant

> *thinking about tomorrow's combat jump.*

2. …a washed-up prizefighter
being told you're going to take a dive, or else.

3. …a contestant for Miss Mississippi

> *who has just been named one of the ten finalists.*

4. …a man of power

> *coming on to a vulnerable woman.*

As I start to feel the character, I get clues as to what he would wear, how he would speak, what mannerisms he may have. It's hard to play just neutral, decent people. The easiest are the ones that are the most brilliantly written, no matter what the characters are. In all cases, acting is listening.

ROBERT LOGGIA

You are a veteran Chicago detective

> *hearing an inconsistency*

>> *in an overconfident suspect's alibi*

>> *after a six-hour interrogation.*

Stella Adler had an ad for interviews, and I went to 50 Central Park West, went to her interview place. They said Miss Adler is backstage. I went back there and there was this incredibly beautiful, statuesque woman, showing great décolletage by candlelight – in the middle of the afternoon, mind you. She had a flair for the theatrical. She had me sit down and then took my hand, put it inside her blouse, on her breast, and said, "Tell me about yourself." That was my interview.

She gave me a scholarship.

Stella became my absolute goddess of knowledge. I studied with her for two years and immediately started working. I'm one of those actors who never had to drive a cab, wait on tables, do anything like that. I got into *Bullfight*. I did my first picture, *Somebody Up There Likes Me*, in 1955. I did *Man with the Golden Arm* Off-Broadway.

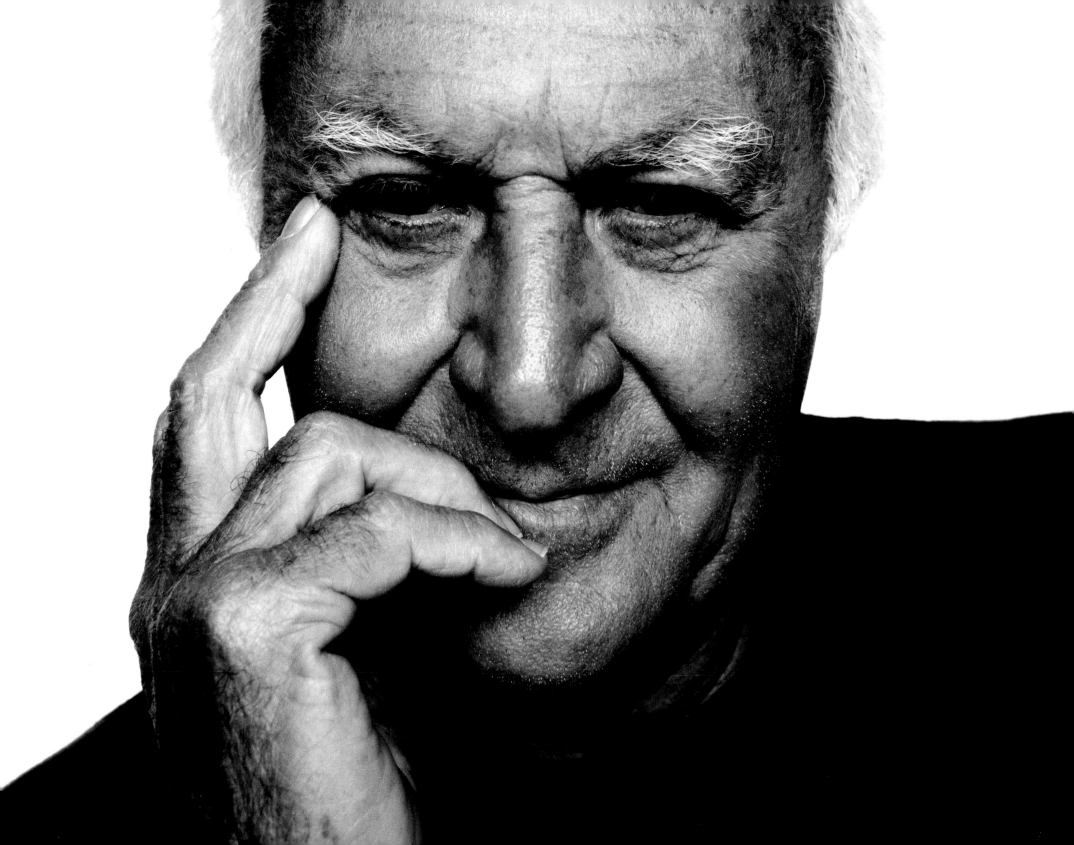

HENRY WINKLER

1. You are…just hearing from your accountant

 that the silver mining tax shelter

 you've been declaring

 for the past five years

 has been disallowed by the IRS.

 2. …taking a late-night shortcut

 through a back alley

 in a bad neighborhood,

 hearing the echo of your own footsteps.

3. …the best and most-hated girl in class

 basking in parental applause

 after a solo recital.

What interests me the most is
to get to be like Spencer Tracy,
like Anthony Hopkins, like Jack
Nicholson. They are effortless.
They are a country lake at five
in the afternoon: sheer glass.
There's not a ripple. They have
somehow tapped into releasing
their soul so that it flows in
and out with a smoothness that
I would love to achieve.

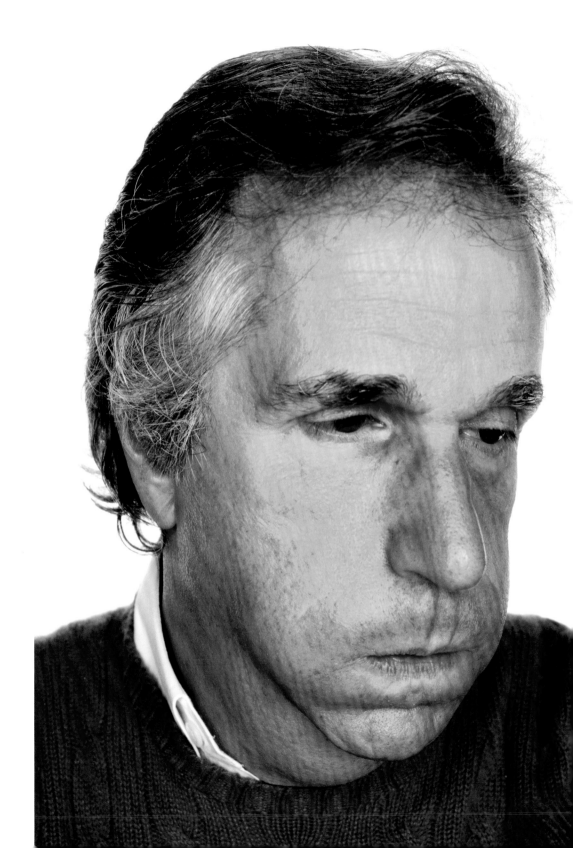

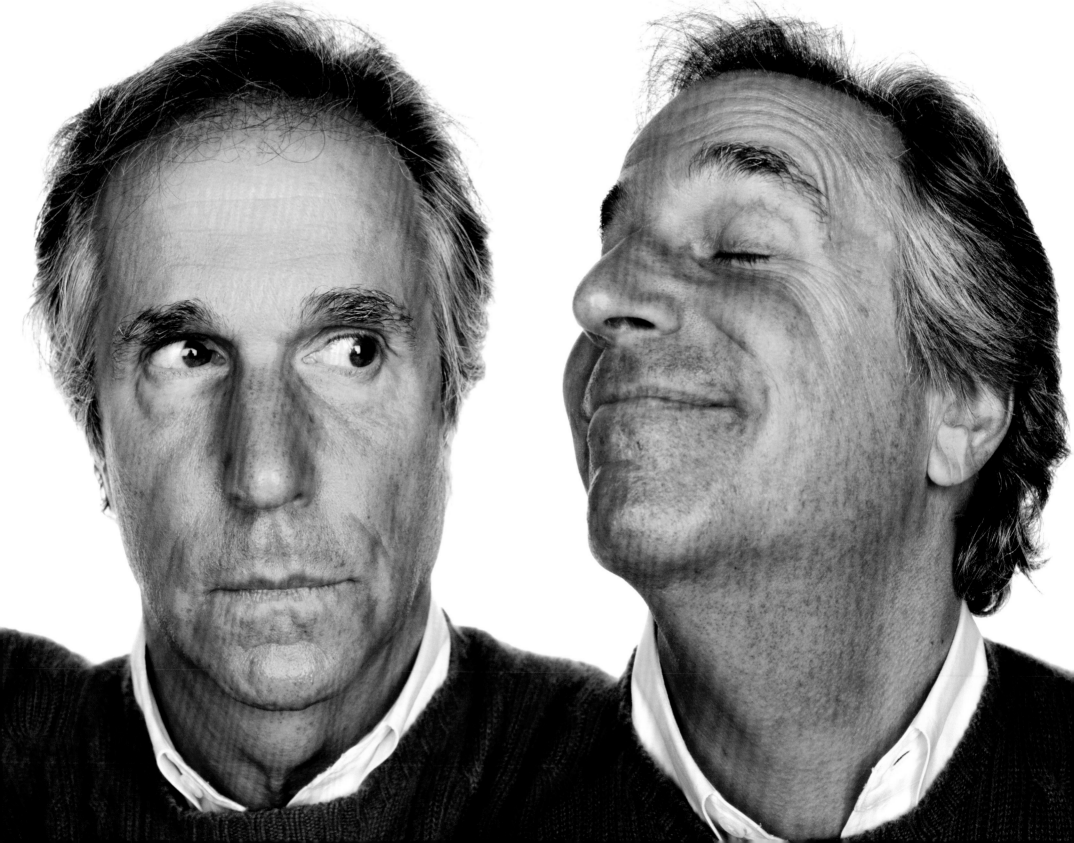

DAVID PAYMER

1. You are...a deli owner, late at night,

handing the day's cash to a crackhead

who's pointing a gun at your chest.

2. ...a big-time mob gambler sending one of your goons

to pay a visit to a college basketball player

who broke an agreement to shave points:

"I don't want the kid dead.

Just make sure he never plays ball again.

Am I clear?"

I did plays during high-school and through college and kept getting reinforcement that I was on the right track. When I graduated from the University of Michigan I went to New York and I started auditioning for open calls. I walked into an open call for the show *Grease* for the national touring company and, lo and behold, at age twenty-one I landed a role in the show. I could sing, I could move well. But the truth is I couldn't dance. I kind of faked it. At that time if you were a young actor and you could sort of carry the tune, you'd be in the production of *Grease*. There were bus and truck tours; there were lots of *Grease*s. Treat Williams was doing it and Richard Gere was doing it in London and Patrick Swayze; John Travolta got his start in it.

Mr. Saturday Night changed my career because it was a wonderful role and I got an Oscar nomination. That put me on the map in the industry. Following that nomination I worked for Spielberg, Oliver Stone, Robert Redford, David Mamet, and Larry Kasden, almost in succession. That would not have happened without that kind of recognition.

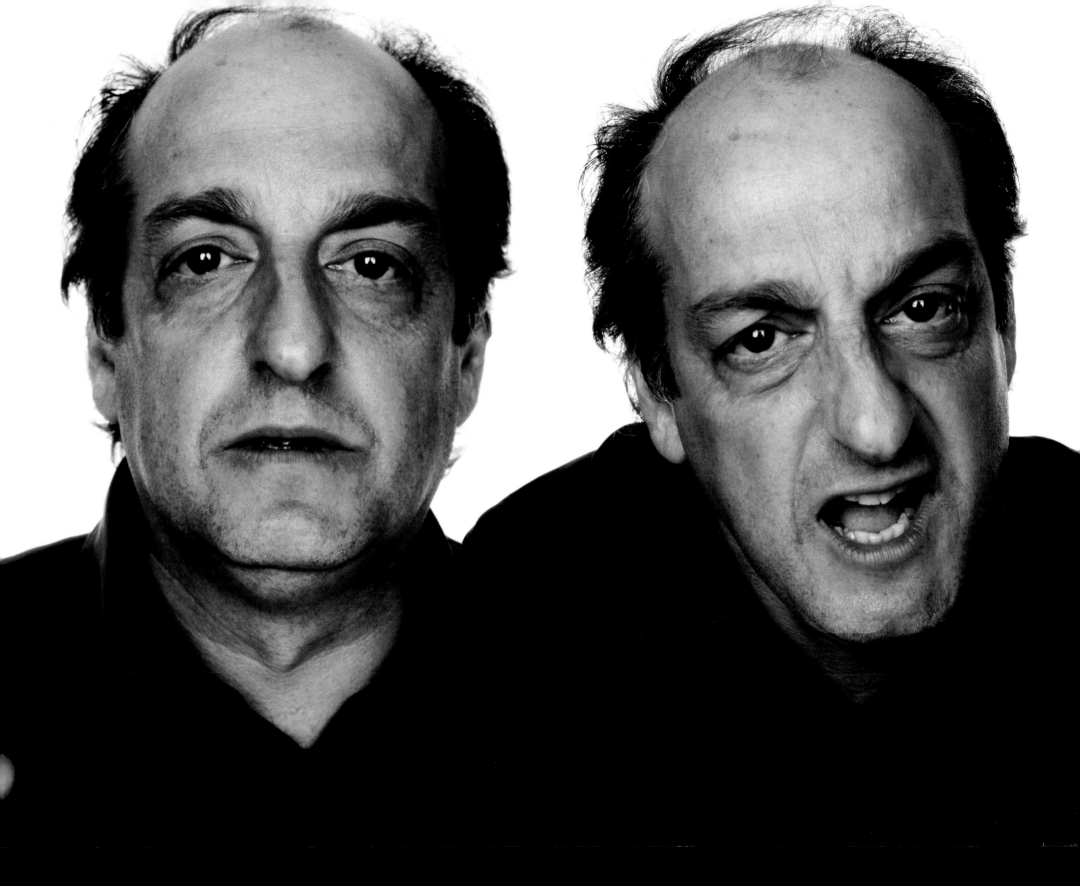

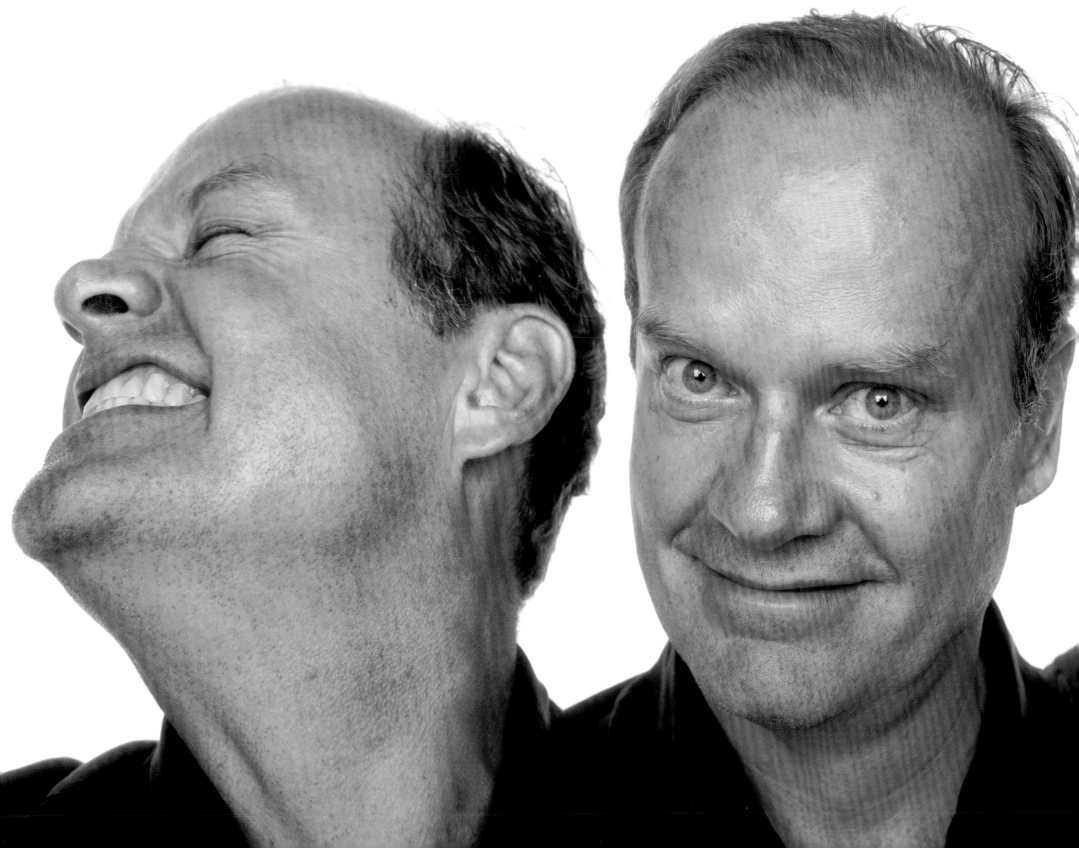

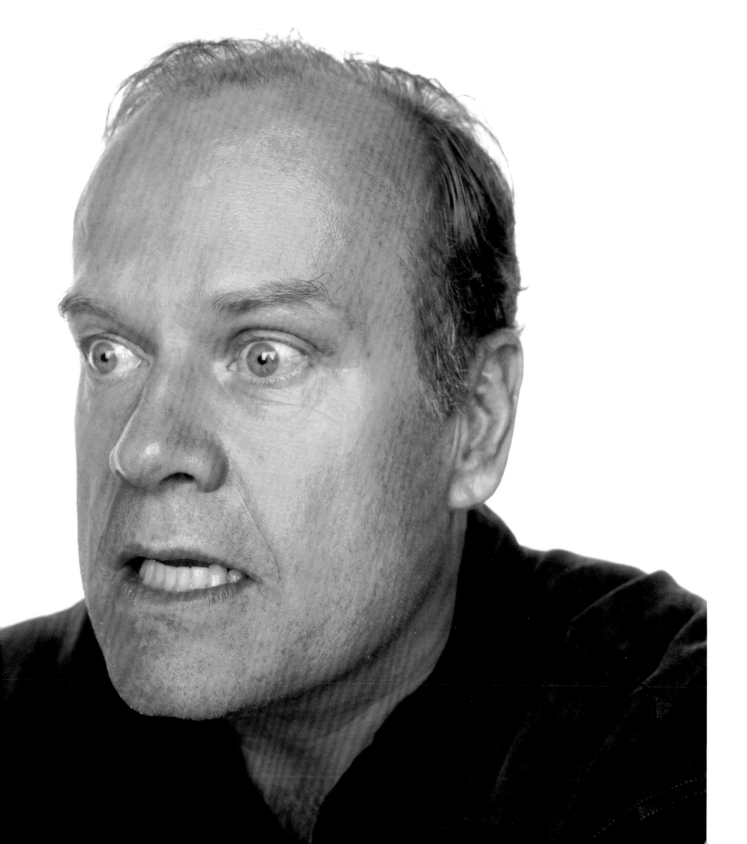

KELSEY GRAMMER

1. You are…a CFO under
indictment for looting
your company's pension plan,
with your high-priced lawyer
at your side,
hearing "not guilty!"

2. …a CPA at a strip joint.

3. …a doting grandfather
suddenly discovering that your
four-year-old granddaughter
is no longer on
the park swing where
you saw her just moments ago.

The actor's responsibility in any rehearsal process is to be an advocate for the character. He's the only one who's really the expert on the character at that point. You defend the character's choices, the director defends the whole shape of the piece, and you carve out something that's a shared vision.

Actors' Notes

SYDNEY POLLACK

It's not the actor's job to adjust to me; it's my job to adjust to the actor. The actors don't get paid to accommodate me; I'm supposed to be able to psychologically accommodate their needs. I have only one job, which is to get the best possible performance in the most truthful way from that actor. Most of the films I've made have been character driven, and the films stand or fall on the basis of the relationships of the characters. I need to get rid of tension, distraction, scattered focus. I need to make the way as easy as possible for them to go in the direction I need them to go. I need to recognize what the moment is when I see it; I need to be open enough to see a way I hadn't thought of that's emerging, that's better than the way I thought of. Given that, if I cast the picture correctly, a lot of what I have to do is to get rid of what's in the way of the actor. The performance is in there, in the person.

I got pushed, bamboozled, forced, into playing a role in a film I was directing called *Tootsie*. And that opened the floodgate. Then Woody Allen came after me, and at that point, it was more curiosity – I acted in order to spy on other directors. I got a chance to watch Stanley Kubrick, I got a chance to watch Woody Allen. I've worked with great directors. You're curious when you never see how it's done. You don't know if you're doing it right.

ROBERT LOGGIA

Stella Adler didn't want you to be a one-trick pony. She wanted you to have a kind of neutral zone that you were in, as neutral as possible, so that you could go left, right, up, or down with a character. And you worked from the material. In other words, you didn't do Chekhov the way you would do Strindberg. You didn't do Strindberg the way you would perform O'Neill. You are a chameleon and you change. I'm in my sixth decade as an actor and I attribute the longevity to that, because I'm not a one-trick pony. I'm a character actor. And Marlon Brando was also under the same influence with Stella and worshiped Stella. And so did Bobby De Niro.

With Strasberg you came first. You dominated the material. It's your character. It's what you want to do with it. You act out of yourself. It's a whole different thing.

ERIC ROBERTS

Film acting needs to be very close to the level and tone of how we communicate in real life. Film camera work and editing give the audience a very close look at each character; you can't bombard the viewer with too much.

Theater is a different kind of feeling. You learn the piece from beginning to end. You experience the adrenaline of opening, and then get really comfortable with the routine, and you feel very responsible, being watched live in a group of people you care about. Of all mediums, you can feel when you're "on."

DAVID PAYMER

I think the character of Malloy in *Line of Fire* is just trying to protect his family. He's got a sort of dysfunctional relationship with his wife, but his family is also the group of men who work for him. One of my acting teachers told me once, "You never judge your villain. You play your villain like a hero." In the pilot for *Line of Fire*, someone sells crack to my nephew and there's a scene on the dock where I whack him over the head with a crowbar and push him in the river. If someone did something to someone I loved – that could drive me to murder. I'm not a physical man – I don't go around getting in bar fights – but I don't think it's that foreign when you think of danger being done to those you love. And that's an emotional exercise, the kind of preparation you would do in the few minutes before the scene is shot – it's not a pleasant place to go, but I would think about what I would do if something horrible happened to someone I love. I certainly have felt wronged at different times in my life for different reasons, some career, some personal. And I would write in my script notes – often it's just a word or two that reminds me of situations where I really thought that I was wronged and angry. And before we shoot the scene, I might walk away from the crew or from the other cast and just take myself back to that situation and put myself in that emotional place, and those feelings are there like a cauldron that's sort of percolating. And as the scene builds, I would call on those emotions – they're tools for me to use in the scene.

Good acting is a spontaneous experience that is captured by the camera, and when you're working with good actors you are listening with all your senses to what is coming at you from your fellow actor. And maybe in one take that guy on the dock didn't make me as angry because he was pleading for his life. Perhaps in another take he sneered at me and kind of shook his head in a way that really got me more incensed. So you're open to the stimuli that are coming at you. And I think most good actors will work that way, will keep things open so it's not set.

KATHY BAKER

I decided to be an actor when I was five; it was a tremendous secret passion that I had that I didn't think anybody else knew. I read from an early age and I wanted to be the characters in the book. I wanted to be in the theater. I wanted to be the grande dame of the American stage. I acted in every play in high-school. They called me the drama queen. It was my huge passion.

KELSEY GRAMMER

A new English teacher came to school when we were in eleventh grade and he asked me to do a play. I stood up for the first curtain call I'd ever taken after a play and fell in love with the audience, fell in love with the applause, and said, "This I can do." I auditioned about a hundred times. Broadway, Off-Broadway, regional theater, summer stock. I was as depressed and as disconsolate as I could have been, but I thought I had to hang on. To survive in the industry, you have to have a resilient ego.

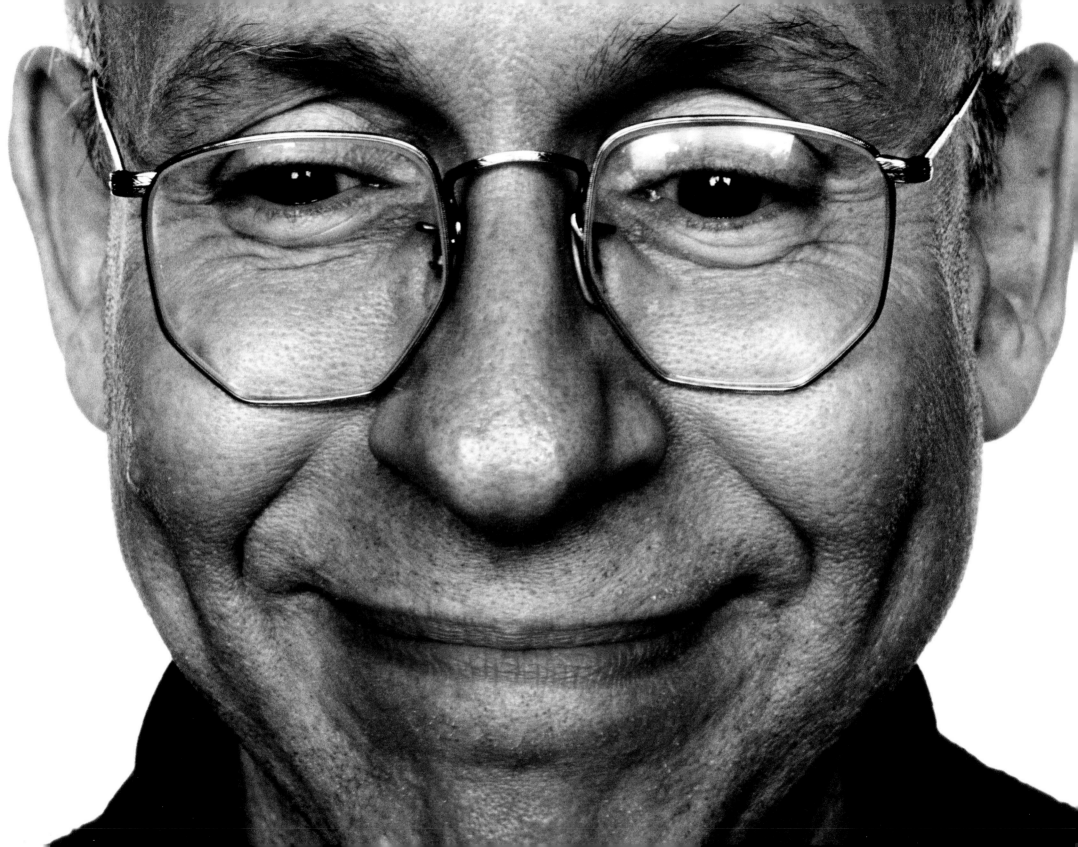

Biographies

F. MURRAY ABRAHAM: born 10/24/39 in Pittsburgh, PA. Attended the University of Texas at El Paso. Film (55 titles): *Finding Forrester, The Name of the Rose, Amadeus* (Oscar, Golden Globe), *Mighty Aphrodite, An Innocent Man, Scarface, Bonfire of the Vanities*. Television series and movies (17 titles): *Dead Man's Walk, Journey to the Center of the Earth, Dream West*. Theater: NYC: *Macbeth, King Lear, Oedipus Rex, Othello, Twelfth Night, A Midsummer Night's Dream, Uncle Vanya, The Seagull;* Broadway: *The Ritz, Triumph of Love, Bad Habits, Teibele and Her Deamon, Legend;* regional: *Cyrano de Bergerac.*

JASON ALEXANDER: born 9/23/59 in Newark, NJ. Attended Boston University. Film (50 titles): *Pretty Woman, Love! Valor! Compassion!, Shallow Hal*. Television series and movies (31 titles): *Seinfeld, Bye Bye Birdie, Cinderella, The Man Who Saved Christmas*. Theater: *Jerome Robbins' Broadway* (Tony), *Broadway Bound* (original cast).

BRUCE ALTMAN: born in the Bronx, NY. Received M.F.A. from the Yale School of Drama. Film (26 titles): *Matchstick Men, L.I.E., To Gillian on Her 37th Birthday, Glengarry Glen Ross, Rookie of the Year, Changing Lanes, Cop Land, Regarding Henry*. Television series and movies (20 titles): *The Sopranos, Law & Order, Ed, White Mile, Nothing Sacred*. Theater: over 50 productions.

DYLAN BAKER: born 10/07/59 in Syracuse, NY. Attended the College of William and Mary and the Yale School of Drama. Film (32 titles): *Spider-Man 2, Road to Perdition, Head of State, Thirteen Days, Happiness, Changing Lanes, The Cell, Disclosure*. Television series and movies (15 titles): *The Pitts, Benjamin Franklin, The Laramie Project, Murder One, Feds*. Theater: *La Bête* (Tony nomination), *Not about Heroes* (Obie), *Tartuffe, Eastern Standard, Homebody/Kabul.*

KATHY BAKER: born 6/8/50 in Midland, TX. Received B.A. in French from the University of California, Berkeley. Film (24 titles): *Cold Mountain, The Right Stuff, Edward Scissorhands, Clean and Sober, The Cider House Rules.*

Television series and movies (17 titles): *Picket Fences* (3 Emmys & 1 additional nomination; 1 Golden Globe & 2 additional nominations), *Boston Public* (Emmy nomination), *Door to Door* (Emmy nomination), *Touched by an Angel* (Emmy nomination). Theater: *Fool for Love* (original production; Obie).

BOB BALABAN: born 8/16/45 in Chicago, IL. Received B.A. in English from New York University. Film (51 titles): as actor: *Marie & Bruce, A Mighty Wind, Best in Show, Gosford Park, The Mexican, Waiting for Guffman, Close Encounters of the Third Kind, Altered States, Absence of Malice, Midnight Cowboy;* as producer: *Gosford Park* (BAFTA award, Oscar nomination), *The Last Good Time;* as director: *The Last Good Time*. Television series and movies (16 titles): *Friends, The West Wing, Seinfeld*. Theater: as director: *The Exonerated* (Outer Critics Circle, Lucille Lortel, & Drama Desk awards).

P. J. BARRY: born in Coventry, RI. Film: *Family Man, For the Love of the Game, The House on Carroll Street*. Television series and movies: *Law & Order*. Theater: Broadway: as playwright: *The Octette Bridge Club;* Off-Broadway: *A Distance from Calcutta, Down by the Ocean, After the Dancing in Jericho;* regional: *Bad Axe, Jump the Train at Riverpoint;* as actor: *The Little Foxes, House of Blue Leaves, Filthy Rich.*

JAMES BOOTH: born 12/19/29 in Croyden, England. Attended Municipal College and Royal Academy of Dramatic Art. Film (40 titles): *Zulu, The Bliss of Mrs. Blossom, The Secret of My Success, Jazz Boat*. Television series and movies (13 titles): *Twin Peaks, The Lady and the Highwayman, Hotline*. Theater: multiple roles at the Old Vic Theater and the Royal Shakespeare Theater; London: *King Lear, 'Afore Night Come, The Entertainer, The Inspector General, A Thousand Clowns, Fings Ain't What They Used to Be;* London and Broadway: *Travesties.*

PHILIP BOSCO: born 9/26/30 in Jersey City, NJ. Received B.A. from the Catholic University of America. Film (34 titles): *Wonder Boys, The Money Pit,*

Trading Places, Children of a Lesser God, Working Girl. Television series and movies (24 titles): *Read between the Lines* (Emmy), *Hoboken, The Return of Elliott Ness, Janek, Law & Order.* Theater: Broadway: *Copenhagen, Moon over Buffalo* (Tony nomination), *Lend Me a Tenor* (Tony), *The Rape of the Belt* (Tony nomination), *You Never Can Tell* (Tony nomination); Obie award for lifetime achievement.

ELLEN BURSTYN: born 12/7/32 in Detroit, MI. Received three honorary doctorates, served as president of Actor's Equity Association and as artistic director of the Actors' Studio. Film (37 titles): *The Last Picture Show* (Oscar & Golden Globe nominations), *The Exorcist* (Oscar & Golden Globe nominations), *Alice Doesn't Live Here Anymore* (Oscar, Golden Globe nomination), *Same Time, Next Year* (Oscar nomination, Golden Globe), *Resurrection* (Oscar & Golden Globe nominations), *Requiem for a Dream* (Oscar & Golden Globe nominations). Television series and movies (33 titles): *The People vs. Jean Harris* (Emmy & Golden Globe nominations), *Pack of Lies* (Emmy nomination), *That's Life.* Theater: Broadway: *Same Time, Next Year* (Tony, Drama Desk, Outer Critics Circle awards), *Shirley Valentine;* Off-Broadway: *Long Day's Journey into Night, The Trip to Bountiful.*

KATE BURTON: born 9/10/57 in Geneva, Switzerland. Received B.A. from Brown University and M.F.A from the Yale School of Drama. Film (27 titles): *Unfaithful, The Ice Storm, Swimfan, Celebrity, The First Wives Club.* Television series and movies (15 titles): *Empire Falls, Law & Order, The West Wing, 100 Centre Street, The Practice, Notes for My Daughter* (Emmy). Theater: Broadway: *The Elephant Man* (Tony nomination), *Hedda Gabler* (Tony nomination), *Some Americans Abroad* (Drama Desk award nomination).

DAVID CARRADINE: born 12/8/36 in Hollywood, CA. Attended San Francisco State College. Film (103 titles): as actor: *Kill Bill, The Long Riders, Bound for Glory, The Serpent's Egg;* as director: *Americana* (Cannes Peoples' Prize: Directors' Fortnight). Television series and movies

(41 titles): *Kung Fu* (Emmy nomination), *Shane, North and South* (Golden Globe nomination), *Gaugin, The Savage, Family Law.* Theater: Broadway: *The Royal Hunt of the Sun, The Deputy.*

CHEVY CHASE: born 10/8/43 in New York City. Received B.A. from Bard College. Film (39 titles): *Fletch, Caddyshack, Seems Like Old Times, Foul Play* (Golden Globe nomination), *National Lampoon's Vacation, National Lampoon's European Vacation, National Lampoon's Christmas Vacation, The Three Amigos, Funny Farm, Memoirs of an Invisible Man, Cops & Robbersons, Man of the House, Vegas Vacation, Snow Day.* Television series and movies (42 titles): *Saturday Night Live* (Emmy, supporting actor and writer, and additional nominations).

DON CHEADLE: born 11/29/64 in Kansas City, MO. Received B.A. from Cal Arts. Film (28 titles): *Devil in a Blue Dress, Traffic, Ocean's Eleven, Boogie Nights, Out of Sight.* Television series and movies (11 titles): *The Rat Pack* (Golden Globe, Emmy nomination), *Things behind the Sun* (Emmy nomination), *A Lesson before Dying* (Emmy nomination), *Picket Fences, The Golden Palace, ER* (Emmy nomination). Theater: *Top Dog Underdog, Leon, Lena and Lenz, The Grapes of Wrath, Liquid Skin, Cymbeline.*

PATRICK CRANSHAW: born 6/17/19 in Oklahoma. Film (35 titles): *Everyone Says I Love You, Best in Show, The Hudsucker Proxy, Bonnie and Clyde, Old School, Nothing to Lose.* Television series and movies: *After MASH, ER, The Bob Newhart Show, Alice.* Theater: *Arsenic and Old Lace, Mister Roberts, Li'l Abner, The Bad Seed.*

JAMES CROMWELL: born 1/27/40 in Los Angeles, CA. Film (38 titles): *Babe* (Oscar), *The Green Mile, Snow Falling on Cedars, The Sum of All Fears, The People vs. Larry Flynt, L.A. Confidential.* Television series and movies (37 titles): *Angels in America, Citizen Baines, The Magnificent Ambersons, Six Feet Under* (Emmy nomination), *RKO 281* (Emmy nomination), *ER* (Emmy

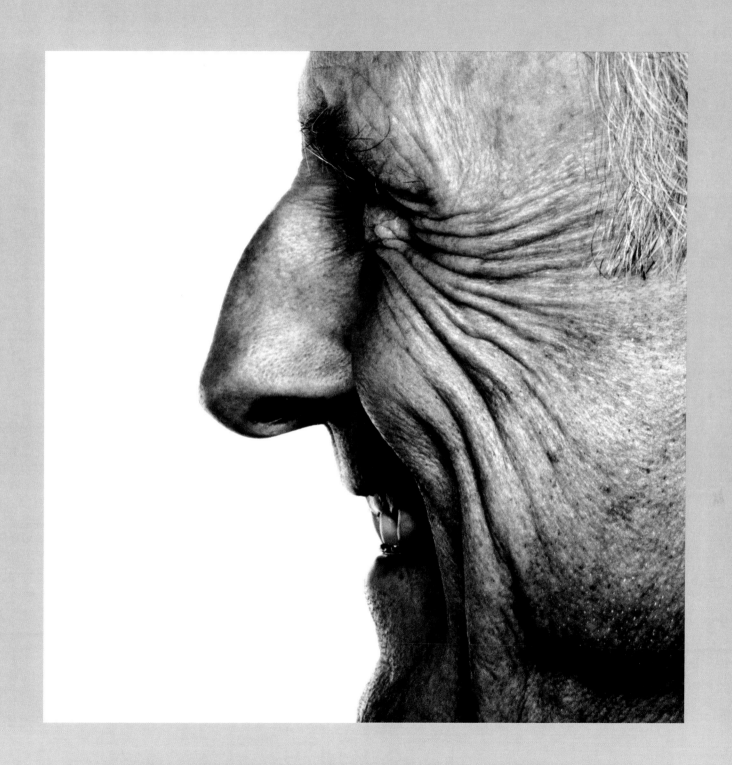

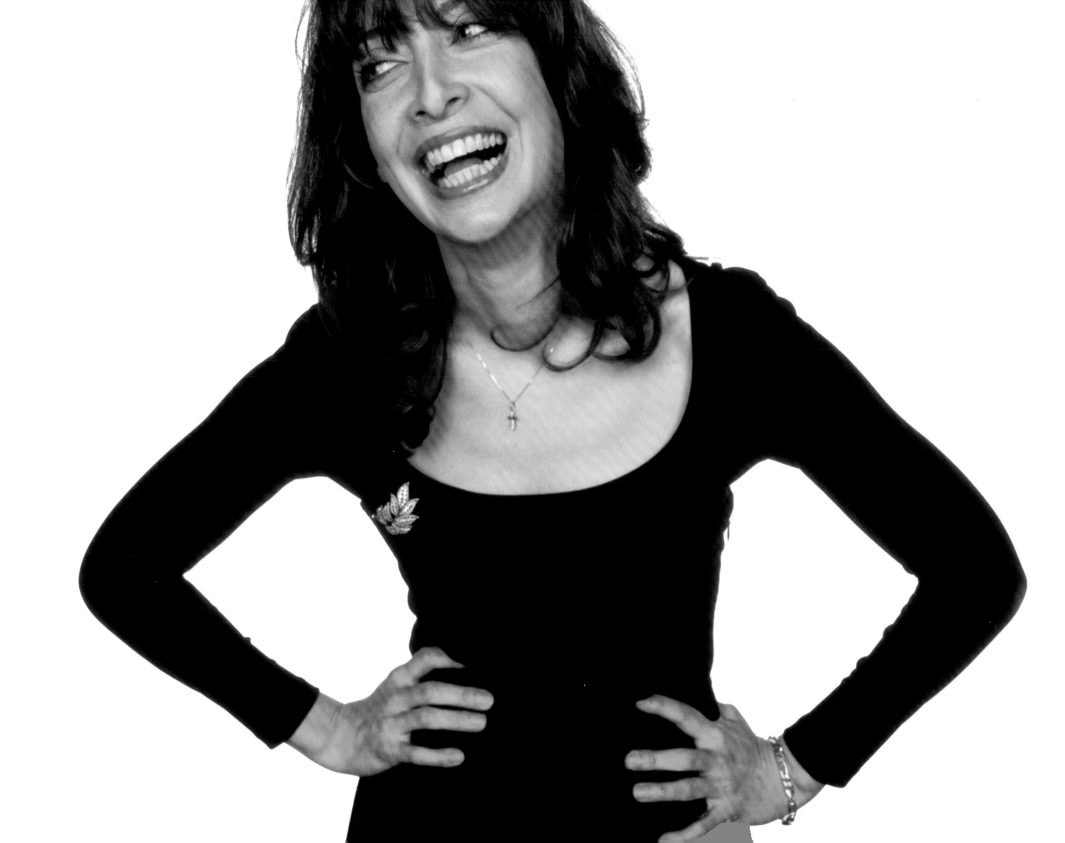

nomination), *Picket Fences, Six Feet Under*. Theater: *Hamlet, The Iceman Cometh, Devil's Disciple, All's Well That Ends Well, Beckett, Othello*.

HUME CRONYN: born 7/18/11, died 6/15/03. Film (41 titles): *The Pelican Brief, *batteries not included, Cocoon, The Parallax View, The World According to Garp, The Postman Always Rings Twice, The Seventh Cross* (Oscar nomination). Television series and movies (21 titles): *To Dance with the White Dog* (Emmy), *Broadway Bound* (Emmy, Golden Globe nomination), *Age-Old Friends* (Emmy). Theater: *Hamlet* (Tony), *The Gin Game, A Delicate Balance, The Petition*, first recipient (with Jessica Tandy) of Tony award for lifetime achievement.

ALAN CUMMING: 1/27/65 in Perthshire, Scotland. Received B.A. in dramatic studies from the Royal Scottish Academy of Music and Drama. Film (35 titles): *X2: X-Men United, The Anniversary Party, Titus, Eyes Wide Shut, Emma, Circle of Friends*. Television series and movies (12 titles): *Out on the Edge, Saturday Night Live, Annie, God, the Devil and Bob, The High Life, Bernard and the Genie*. Theater: *Design for Living, Cabaret* (Tony, Drama Desk award), *Hamlet, La Bête, Accidental Death of an Anarchist, The Conquest of the South Pole*.

MICHAEL CUMPSTY: born 2/26/60 in Wakefield, Yorkshire, England. Received B.A. in English and M.F.A. in theater from the University of North Carolina at Chapel Hill. Film: *The Ice Storm, State of Grace, Fatal Instinct*. Television series and movies: *L.A. Law, Star Trek: Voyager*. Theater: Broadway: *Enchanted April, 42nd Street, Copenhagen, Electra, The Heiress, La Bête, Timon of Athens*; Off-Broadway: *The Art of Success, Man and Superman, All's Well That Ends Well, The Winter's Tale* (also with the Royal Shakespeare Company), *Romeo and Juliet, Hamlet*.

BRUCE DAVISON: born 6/28/46 in Philadelphia, PA. Film (51 titles): *X-Men, The King Is Alive, Six Degrees of Separation, The Crucible, Short Cuts,*

Longtime Companion (won numerous awards including Golden Globe, Oscar nomination). Television series and movies (44 titles): *Touched by an Angel* (Emmy nomination), *Law & Order: SVU, The Practice, Chicago Hope, Seinfeld*. Theater: Broadway: *The Elephant Man, King Lear, The Glass Menagerie, The Cocktail Hour, Richard III;* Off-Broadway: *How I Learned to Drive, Streamers, The Normal Heart*.

PETER DONAT: born 1/20/28 in Canada. Film (28 titles): *The Deep End, The Game, School Ties, The Babe, The China Syndrome, Tucker, The Godfather 2*. Television series and movies (29 titles): *Murder, She Wrote, The X-Files, Flamingo Road, Dieppe*. Theater (89 titles): *Cyrano de Bergerac, Equus, Man and Superman, King Lear, The Merchant of Venice, No Man's Land, Don Carlos*.

MARTIN DONOVAN: born 8/19/57 in Los Angeles, CA. Film (31 titles): *Insomnia, Saved, The United States of Leland, The Opposite of Sex, The Portrait of a Lady, Living Out Loud, Amateur, Simple Men, Trust*. Television series and movies (15 titles): *Traffic, RFK, The Great Gatsby, When Trumpets Fade, Pasadena, Wonderland*.

ILLEANA DOUGLAS: born 7/25/65 in Massachusetts. Studied at the Neighborhood Playhouse School of Theater. Film (40 titles): *Ghost World, Stir of Echoes, Happy, Texas, Message in a Bottle, Grace of My Heart, To Die For*. Television series and movies: *Illeanarama, Six Feet Under* (Emmy nomination), *Action, The Drew Carey Show, The Larry Sanders Show, Seinfeld*. Theater: *Surviving Grace, The Moment When, Black Eagles*.

FRAN DRESCHER: born 9/30/57 in Flushing, Queens, NY. Film (23 titles): *American Hot Wax, Saturday Night Fever, This Is Spinal Tap, The Big Picture, Cadillac Man, Beautician and the Beast, Jack*. Television series and movies (12 titles): as creator, producer, actor: *The Nanny* (2 Emmy & 2 Golden Globe nominations); as actor: *Good Morning, Miami, Beautiful Girl*.

RICHARD DREYFUSS: born 10/29/47 in Brooklyn, NY. Film (47 titles): *Mr. Holland's Opus* (Oscar & Golden Globe nominations), *The Goodbye Girl* (Oscar), *American Graffiti, Jaws, Close Encounters of the Third Kind, Down and Out in Beverly Hills, Stakeout, What about Bob?.* Television series and movies (16 titles): *Lansky, The Education of Max Bickford, Coast to Coast, The Day Reagan Was Shot.* Theater: Broadway: *Death and the Maiden, Sly Fox, Three Hotels;* London (West End): *Prisoner of Second Avenue.* Radio: *Devil's Disciple, An American General.*

CHARLES DURNING: born in Highland Falls, NY. Film (88 titles): *Home for the Holidays, Tootsie, Dick Tracy, Dog Day Afternoon, The Best Little Whorehouse in Texas* (Oscar nomination), *To Be or Not to Be* (Oscar nomination), *The Muppet Movie.* Television series and movies (57 titles): *Queen of the Stardust Ballroom* (Emmy nomination), *Captains and the Kings* (Emmy nomination), *Attica* (Emmy nomination), *Evening Shade, The Kennedys of Massachusetts* (Golden Globe). Theater: Broadway: *Cat on a Hot Tin Roof* (Tony, Drama Desk award), *That Championship Season* (Drama Desk award), *Inherit the Wind, Knock, Knock, The Au Pair Man, In the Boom Boom Room.*

CHARLES S. DUTTON: born 1/30/51 in Baltimore, MD. Attended Towson State University in Maryland and the Yale School of Drama. Films (over 35 titles): as actor, director: *Against the Ropes;* as actor: *Secret Window, Gothika, Cookie's Fortune, Mimic, Cry, the Beloved Country, Get on the Bus, Alien 3, A Time to Kill, A Low Down Dirty Shame.* Television series and movies (over 30 titles): as actor, executive producer: *Roc;* as actor: *The Practice* (Emmy), *Without a Trace* (Emmy), *Oz* (Emmy nomination), *The Piano Lesson* (Golden Globe & Emmy nominations); as director: *The Corner* (Emmy), *First Time Felon.* Theater: *Ma Rainey's Black Bottom* (original cast – Drama Desk award & Tony nomination), *The Piano Lesson* (original cast – Tony nomination).

GIANCARLO ESPOSITO: born 4/26/59 in Denmark. Film (50 titles): *Fresh, Do the Right Thing, Night on Earth, Ali, The Usual Suspects.* Television series and movies (18 titles): *Homicide: Life on the Street, The $treet, Law & Order, Girls Club.* Theater: *Sacrilege, Trafficking in Broken Hearts, Distant Fires* (Obie), *Zooman and the Sign* (Obie).

EDIE FALCO: born 7/5/63 in Brooklyn, NY. Received B.F.A. from SUNY Purchase. Film (over 25 titles): *Sunshine State* (L.A. Film Critics award), *Cost of Living, Laws of Gravity, A Price Above Rubies, Cop Land, Hurricane, The Funeral, Bullets over Broadway, Trust, The Unbelievable Truth, Judy Berlin.* Television series and movies: *The Sopranos* (3 Emmys, 2 Golden Globes, & 2 Screen Actors Guild awards). Theater: Broadway: *Frankie and Johnny in the Claire de Lune, Sideman* (Theater World award); London: *The Vagina Monologues.*

PETER FALK: born 9/16/27 in New York City. Attended Hamilton College and received B.A. from the New School for Social Research, M.A. in public administration from Syracuse University. Film (50 titles): *Lakeboat, Wings of Desire, The In-Laws, A Woman Under the Influence, Murder Incorporated* (Oscar nomination), *A Pocket Full of Miracles* (Oscar nomination). Television series and movies (88 titles): *The Law and Mr. Jones* (Emmy nomination), *The Price of Tomatoes* (Emmy), *The Trials of O'Brien, Columbo* (4 Emmys). Theater: *Defiled, The Prisoner of Second Avenue* (Tony), *Murder by Death, The Cheap Detective, The Sunshine Boys, Glengarry Glen Ross, Mr. Peter's Connections.*

MIGUEL FERRER: born 2/7/55 in Santa Monica, CA. Film (28 titles): *Sunshine State, Traffic, RoboCop, Where's Marlowe, The Harvest.* Television series and movies (32 titles): *Crossing Jordan, Twin Peaks, The Stand, Drug Wars: The Camarena Story, Lateline.*

JOHN FINN: born 9/30/52 in New York City. Film (24 titles): *Catch Me if You Can, The Human Stain, Analyze That, Glory, True Crime, The Pelican Brief, The Pope of Greenwich Village.* Television series and movies (23 titles): *Cold Case, Without a Trace, NYPD Blue, The X-Files, Brooklyn South, EZ Streets.*

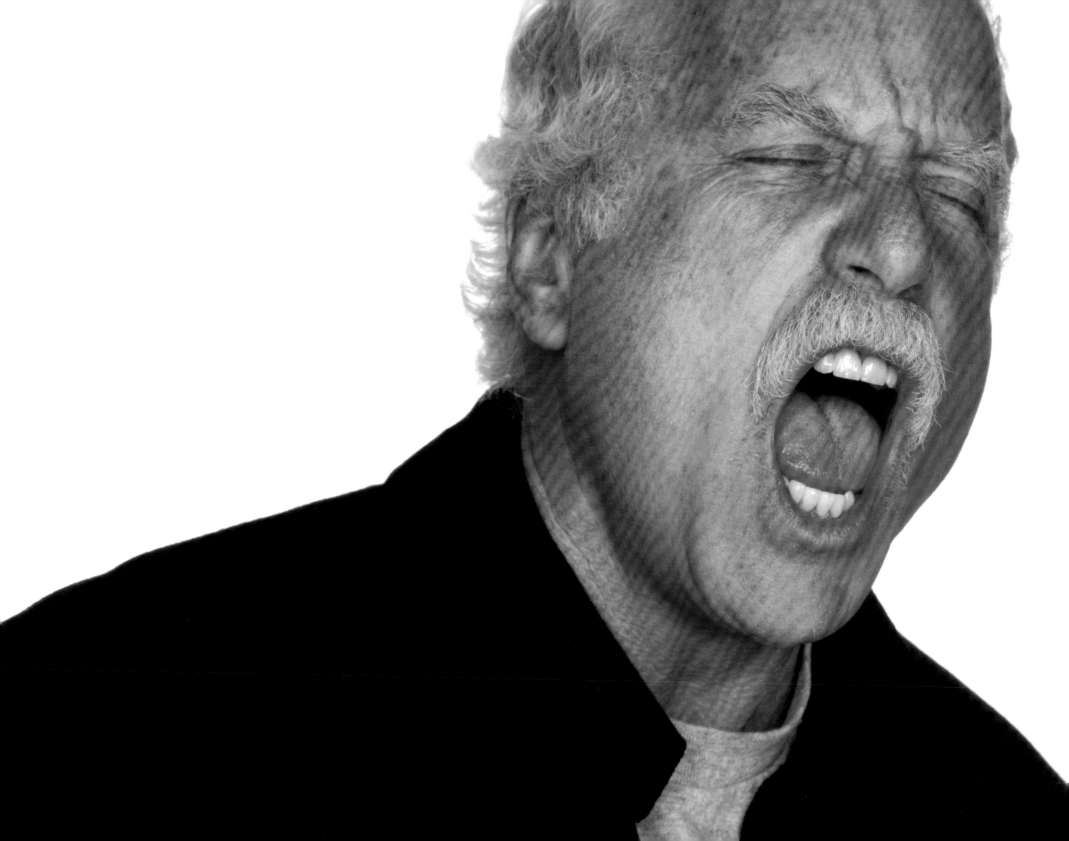

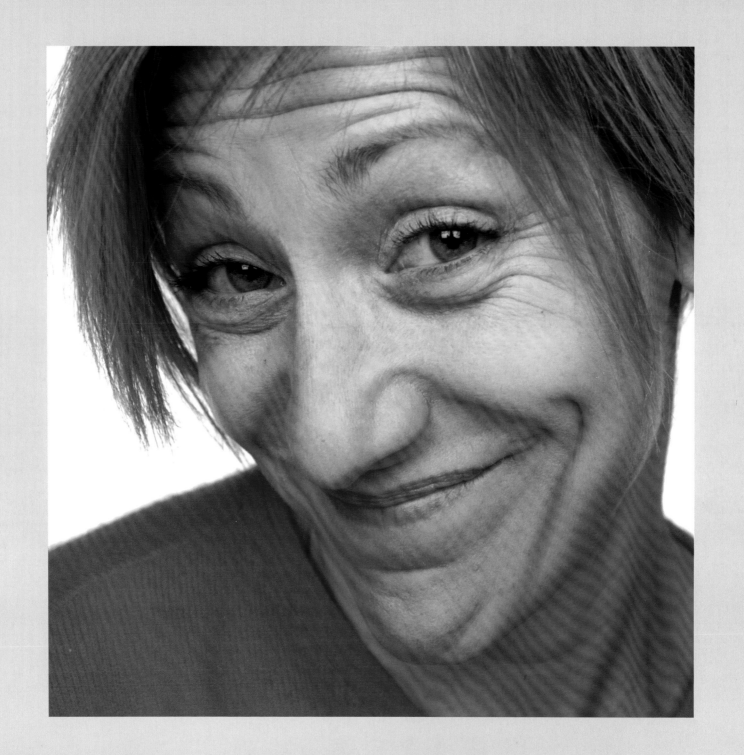

Theater: national tour: *Biloxi Blues;* Off-Broadway: *Remembrance, The Last of the Knucklemen, Mr. Bloom and the Cyclops;* regional: *Glengarry Glen Ross, Ourselves Alone, The Sweet Life.*

ANTHONY FRANCIOSA: born 10/25/28 in New York City. Film (37 titles): *City Hall, A Hatful of Rain* (Oscar nomination), *Career* (Golden Globe), *Rio Conches* (Golden Globe nomination), *A Face in the Crowd.* Television series and movies (20 titles): *Finder of Lost Loves, Matt Helm, Stagecoach, The Black Widow, The Deadly Hunt.* Theater: Broadway: *End as a Man, Wedding Breakfast, A Hatful of Rain* (Tony nomination); *Love Letters, Grand Hotel.*

SCOTT GLENN: born 1/24/41 in Pittsburgh, PA. Film (46 titles): *The Shipping News, Courage under Fire, Absolute Power, Urban Cowboy, The Right Stuff, Backdraft, Training Day, Vertical Limit, Personal Best, Silence of the Lambs, Carla's Song, Tall Tales, Silverado, The Hunt for Red October.* Television series and movies (15 titles): *A Painted House, The Seventh Stream, Homeland Security, Past Tense.* Theater: Broadway: *Burn This, Killer Joe.*

DANNY GLOVER: born 7/22/46 in San Francisco, CA. Received B.A. in economics from San Francisco State University. Film (48 titles): *The Royal Tenenbaums, Lethal Weapon* series, *Grand Canyon, To Sleep with Anger, Beloved, The Color Purple.* Television series and movies (25 titles): as actor and

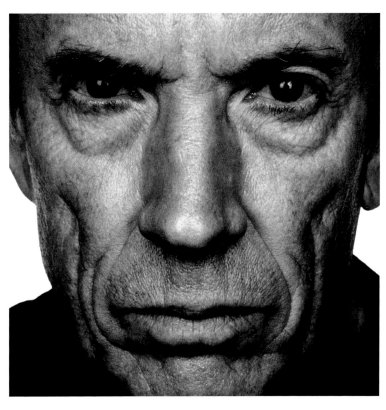

executive producer: *The Henry Lee Project, Good Fences, Freedom Song* (Emmy nomination), *Buffalo Soldiers;* as actor: *Lonesome Dove* (Emmy nomination). Theater: *Macbeth, Master Harold and the Boys, Island, Sizwe Banzi Is Dead.*

ELLIOTT GOULD: born 8/29/38 in Brooklyn, NY. Started as a chorus boy in the theater in New York City. Film (over 100 titles): *MASH* (Golden Globe nomination), *Ocean's Eleven, Nashville, Bob & Carol & Ted & Alice* (Oscar nomination), *A Bridge Too Far, Getting Straight, Little Murders, The Silent Partner, California Split, The Long Goodbye, The Touch.* Television series and movies (25 titles): *Sessions, Once Upon a Mattress, The Rules of Marriage, Friends,* six-time host of *Saturday Night Live.* Theater: Broadway: *I Can Get It for You Wholesale, Irma La Douce, Say, Darling, Little Murders, Drat! The Cat!.*

KELSEY GRAMMER: born 2/21/55 in the Virgin Islands. Attended the Juilliard School. Film (19 titles): *15 Minutes, Toy Story 2.* Television series and movies (20 titles): *Frasier* (3 Emmys, 5 Emmy nominations, 2 Golden Globes), *Cheers* (2 Emmy nominations), *Wings* (Emmy nomination), *Benedict Arnold, The Pentagon Wars, Mr. St. Nick, Another World.* Theater: Broadway: *Macbeth, Othello;* Off-Broadway: *Plenty, Sunday in the Park with George, Quartermaine's Terms.*

STEVE GUTTENBERG: born 8/24/58 in Brooklyn, NY. Film (34 titles): *Diner, Cocoon, 3 Men and a Baby, The Boys from Brazil, Police Academy,*

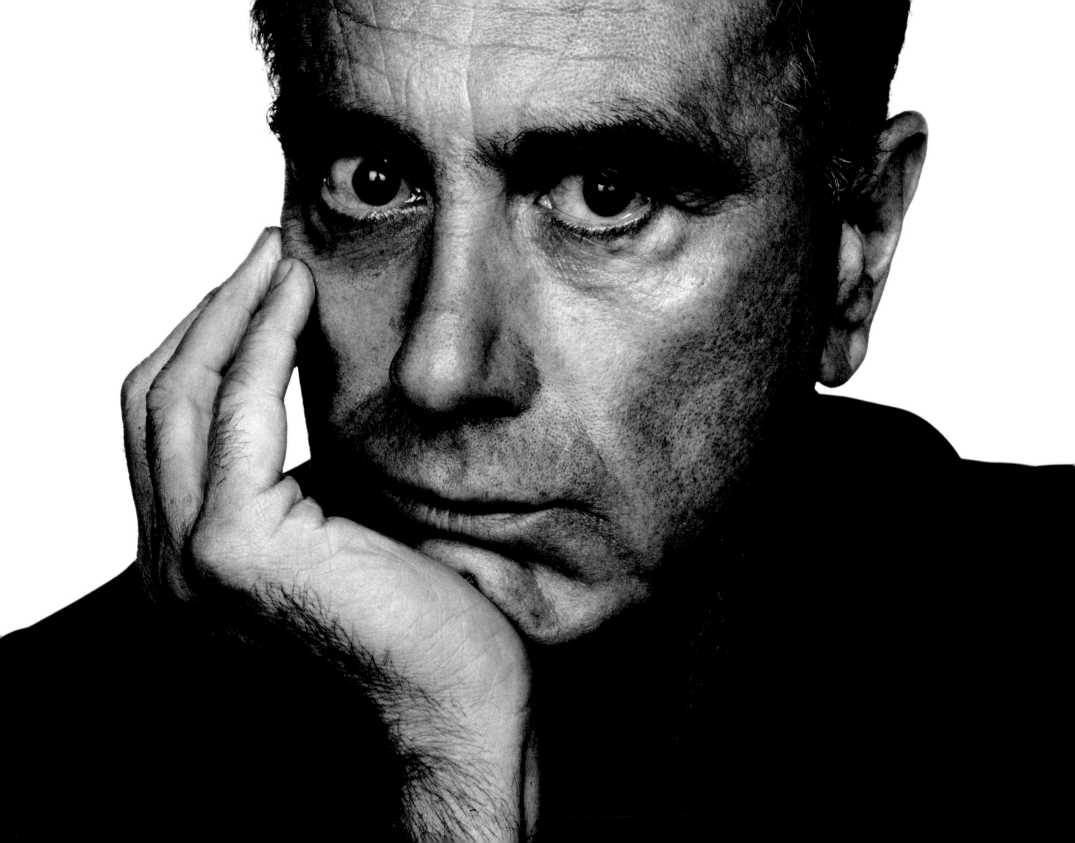

It Takes 2, Short Circuit, P.S. Your Cat Is Dead. Television series and movies: *Tower of Terror, To Race with the Wind, Something for Joey, The Day After, Miracle on Ice.* Theater: Broadway: *Prelude to a Kiss; Furthest from the Sun.*

BEN HAMMER: born 12/8/25 in Brooklyn, NY. Film (14 titles): *Zabriskie Point, Sleepers, Crazy People, The Jagged Edge, The Beastmaster.* Television (10 titles): *The Execution of Private Slovik, The Winds of War, Law & Order.* Theater: Broadway: *The Great Sebastians, The Diary of Anne Frank* (original production), *Mother Courage, The Tenth Man, Broadway Bound, Royal Hunt of the Sun;* Off-Broadway: *Meshugah, The Golem, More Stately Mansions, Slavs.*

ROSEMARY HARRIS: born 9/19/30 in Ashby, Suffolk, England. Film (17 titles): *Spider-Man, Spider-Man 2, Sunshine, Tom & Viv* (Oscar nomination), *Crossing Delancey, The Boys from Brazil.* Television series and movies (17 titles): *Holocaust* (Golden Globe, Emmy nomination), *Notorious Woman* (Emmy, Golden Globe nomination), *The Royal Family, Uncle Vanya, Web of Belonging.* Theater: *Waiting in the Wings* (Tony nomination), *A Delicate Balance* (Tony nomination), *Inspector Calls, Hay Fever* (Tony nomination), *Heartbreak House* (Tony nomination), *Pack of Lies* (Tony nomination), *The Royal Family* (Tony nomination), *Old Times* (Tony nomination), *The Lion in Winter* (Tony), *The Climate of Eden* (Theater World award).

DENNIS HAYSBERT: born in San Mateo, CA. Films (22 titles): *Far from Heaven, Love & Basketball, Absolute Power, Love Field, Heat, Waiting to Exhale, The Thirteenth Floor, Navy SEALS, Suture.* Television series and movies (15 titles): *24* (Golden Globe nomination), *Now and Again, Lou Grant.*

GLENNE HEADLY: born in New London, CT. Graduated with honors in drama from the New York High-School of Performing Arts, received B.A. in American literature and art history from the American College of Switzerland. Film (30 titles): *Dick Tracy, Dirty Rotten Scoundrels, Mortal Thoughts, Breakfast of Champions, Around the Bend.* Television series and movies: *My Own*

Country, Lonesome Dove (Emmy nomination), *Bastard Out of Carolina* (Emmy nomination), *Pronto.* Theater: Broadway: *Arms and the Man;* Off-Broadway: *Aunt Dan & Lemon, Balm in Gilead, Curse of the Starving Class, Mother Courage.*

DAN HEDAYA: born 7/24/40 in Brooklyn, NY. Received B.A. in English literature from Tufts University. Film (55 titles): *Mulholland Drive, A Life Less Ordinary, The First Wives Club, Clueless, To Die For, Blood Simple.* Television series and movies (27 titles): *Cheers, Hill Street Blues, NYPD Blue, Law & Order, The Second Civil War, The Garden of Redemption.* Theater: *The Basic Training of Pavlo Hummel, Conjuring an Event, Museum, Survivors.*

BUCK HENRY: born 12/9/30 in New York City. Film (42 titles): as actor: *Taking Off, The Man Who Fell to Earth, Breakfast of Champions, Old Boyfriends, Eating Raoul, The Player, Grumpy Old Men, Short Cuts;* as screenwriter: *The Graduate* (Oscar & Golden Globe nominations), *The Owl and the Pussycat, Catch-22, What's Up, Doc, To Die For;* as codirector: *Heaven Can Wait* (Oscar nomination). Television series and movies: as writer and performer: *The Gary Moore Show, The Steve Allen Show, That Was the Week That Was;* as cocreator and writer: *Get Smart* (Emmy). Theater: Broadway: *Art, Mornings at Seven;* Off-Broadway: *Three Viewings, Kingfish, The Premise* (Obie).

EDWARD HERRMANN: born 7/21/43 in Washington, D.C. Received B.A. from Bucknell University, Fulbright scholar to London Academy of Music and Dramatic Art. Film (40 titles): *Intolerable Cruelty, The Cat's Meow, Overboard, The Great Gatsby, Reds.* Television series and movies (38 titles): *The Practice* (Emmy), *James Dean, Eleanor & Franklin* (Emmy nomination), *Oz, Gilmore Girls, St. Elsewhere* (Emmy nomination). Theater: *Uncle Vanya, The Deep Blue Sea, Mrs. Warren's Profession* (Tony), *Plenty.*

JUDD HIRSCH: born 3/15/35 in New York City. Received B.A. in physics from City College. Film (11 titles): *A Beautiful Mind, Ordinary People*

(Oscar nomination), *Independence Day, Running on Empty, Without a Trace.* Television series and movies (24 titles): *Taxi* (2 Emmys), *Dear John* (Golden Globe), *Delvecchio, The Law.* Theater: Broadway: *Conversations with My Father* (Tony), *I'm Not Rappaport* (Tony), *Tally's Folly* (Tony nomination), *Art, Chapter Two, Knock, Knock* (Drama Desk award); regional: *Death of a Salesman.*

HAL HOLBROOK: born 2/17/25 in Cleveland, OH. Received B.A. in theater from Denison University. Film (40 titles): *The Majestic, Men of Honor, Wall Street, The Firm, All the President's Men, Midway, Magnum Force.* Television series and movies (54 titles): *The Senator* (Emmy), *Mark Twain Tonight!* (Emmy nomination), *The Pueblo* (2 Emmys), *Sandberg's Lincoln* (Emmy), *Designing Women, Evening Shade.* Theater (29 titles): *Broadway: The Glass Menagerie, Man of La Mancha, Mark Twain Tonight!* (Tony, Drama Critics Circle award), *I Never Sang for My Father, An American Daughter.*

MARIANNE JEAN-BAPTISTE: born in England. Studied at the Royal Academy of Dramatic Art. Film (14 titles): *Secrets and Lies* (Oscar, Golden Globe, & British Academy award nominations), *The Cell, 28 Days, The 24 Hour Woman, Mr. Jealousy, Spy Game.* Television series and movies: *Without a Trace, Silent Hearts, The Murder of Stephen Lawrence, The Man, The Wedding.* Theater: Royal National Theater: *The Way of the World, Measure for Measure;* Paris: *Le Costume.*

JAMES EARL JONES: born 1/17/31 in Arkabutla, MS. Film (69 titles): *Field of Dreams, Great White Hope* (Oscar nomination, Golden Globe), *Patriot Games, Clear and Present Danger, Matewan, Cry, the Beloved Country, Dr. Strangelove,* voice of Darth Vader and Mufasa in *The Lion King.* Television series and movies (56 titles): *Homicide: Life on the Street, Frasier* (Emmy nomination), *Gabriel's Fire* (Emmy), *Heat Wave* (Emmy), *Pros & Cons* (Golden Globe nomination), *Under One Roof* (Emmy nomination), *Picket Fences* (Emmy nomination), *Claudine* (Golden Globe nomination).

ROBERT KLEIN: born in the Bronx, NY. Received B.A. from Alfred University and attended the Yale School of Drama. Film (32 titles): *How to Lose a Guy in 10 Days, The Owl and the Pussycat, One Fine Day, Primary Colors, Two Weeks Notice, People I Know.* Television series and movies (13 titles): *The Stones, Sisters,* seven one-man shows for HBO, *Comedy Tonight.* Theater: *They're Playing Our Song* (Tony nomination), *The Sisters Rosenzweig* (Obie, Outer Critics Circle award).

MARTIN LANDAU: born 6/20/31 in Brooklyn, NY. Studied fine art at the Pratt Institute and with Lee Strasberg at the Actors Studio. Film (75 titles): *Ed Wood* (Oscar, Golden Globe), *Crimes and Misdemeanors* (Oscar nomination, Golden Globe), *Tucker* (Oscar nomination), *North by Northwest, Ed TV, The X-Files: The Movie.* Television series and movies (29 titles): *Mission: Impossible* (3 Emmy nominations, Golden Globe), *Space 1999.* Theater: Broadway: *Goat Song, Stalag 17, First Love, The Penguin, Middle of the Night.*

MELISSA LEO: born 9/14/60 in New York City. Attended SUNY Purchase. Film (17 titles): *Hide and Seek, 21 Grams, Confess, Last Summer in the Hamptons, Ballad of Little Jo, Immaculate Conception, A Time of Destiny.* Television series and movies (11 titles): *Homicide: Life on the Street, Scarlett, The Young Riders.* Theater: *The Vagina Monologues, How I Learned to Drive, A Touch of the Poet, Out of Gas on Lovers Leap, Will Mr. Meriwether Return from Memphis.*

MICHAEL LERNER: born 6/22/41 in Brooklyn, NY. Studied theater and English at the University of California, Berkeley; Fulbright scholar to the London Academy of Music and Dramatic Art. Film (54 titles): *Barton Fink* (Oscar nomination), *Godzilla, Elf, The Candidate, The Postman Always Rings Twice, Eight Men Out, The Road to Wellville, Radioland Murders.* Television series and movies (39 titles): *Ruby & Oswald, The Missiles of October, This Year's Blond, Clueless.* Theater: two years in repertory at ACT, San Francisco; *Mislansky/Zelinsky, Hurly Burly, Up for Grabs.*

TED LEVINE: born 5/29/57 in Bellaire, OH. Attended Marlboro College in Vermont. Film (25 titles): *Silence of the Lambs, Georgia, Heat, Birth, Flubber.* Television series and movies (20 titles): *Monk, Wonderland, From the Earth to the Moon, Crime Story.* Theater: Chicago: *Buried Child, Moby Dick, El Salvador.*

DELROY LINDO: born 11/18/52 in London, England. Studied at the American Conservatory Theater in San Francisco. Film (31 titles): *Malcolm X, Crooklyn, Clockers, Get Shorty, Ransom, Romeo Must Die, Gone in 60 Seconds, The Cider House Rules, Heist.* Television series and movies (6 titles): *Soul of the Game, Glory and Honor, Strange Justice* (Peabody award), *Profoundly Normal.* Theater: Broadway: *Master Harold and the Boys, Joe Turner's Come and Gone* (Tony & Drama Desk award nominations).

CHRISTOPHER LLOYD: born 10/22/38 in Stamford, CT. Studied at the Neighborhood Playhouse School of Theater. Film (64 titles): *Back to the Future series, The Addams Family, One Flew over the Cuckoo's Nest, Things to Do in Denver When You're Dead, Who Framed Roger Rabbit, The Dream Team, Twenty Bucks.* Television series and movies (31 titles): *Taxi* (2 Emmys), *Road to Avonlea* (Emmy). Theater: Broadway: *Mornings at Seven, Happy End; Kaspar* (Obie, Drama Desk award), *Waiting for Godot, In the Boom Boom Room, Macbeth.*

ROBERT LOGGIA: born 1/3/30 in Staten Island, NY. Received B.J. from the University of Missouri; lifetime member of the Actors Studio. Film

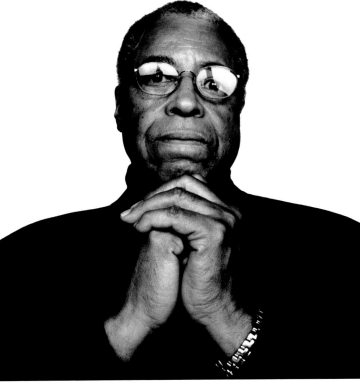

(59 titles): *Scarface, Prizzi's Honor, Jagged Edge* (Oscar nomination), *Big.* Television series and movies (53 titles): *The Sopranos, Queens Supreme, El Fego Baca, T.H.E. Cat, Mancuso, FBI, Joan of Arc.* Theater: *The Man with the Golden Arm, 3 Sisters, In the Boom Boom Room, Toys in the Attic.*

DONAL LOGUE: born 2/27/66 in Ottawa, Canada. Received B.A. with honors in history from Harvard University. Film (50 titles): *The Tao of Steve, Confidence, The Patriot, Blade.* Television series and movies (11 titles): *Grounded for Life, A Bright Shining Lie, Northern Exposure, And the Band Played On, ER, The Practice.*

JOE MANTEGNA: born 11/13/47 in Chicago, IL. Film (61 titles): *Searching for Bobby Fischer, Things Change, Suspect, House of Games, Homicide, The Godfather 3, Compromising Positions, Alice.* Television series and movies (26 titles): *The Last Don* (Emmy nomination), *The Simpsons, The Rat Pack* (Golden Globe & Emmy nominations), *Joan of Arcadia, Bleacher Bums* (Emmy). Theater: *Glengarry Glen Ross* (Tony), *Bleacher Bums, Working.*

MARK MARGOLIS: born in 1939 in Philadelphia, PA. Studied with Stella Adler; member of the Actors Studio. Film (52 titles): *Requiem for a Dream, The Thomas Crown Affair, Jakob the Liar, Pi, Ace Ventura: Pet Detective, 1492: Conquest of Paradise, Scarface.* Television series and movies (20 titles): *Oz, Now & Again, The Equalizer, The Kitchen.* Theater: Broadway: *Infidel Caesar, The World of Sholom Aleichem;* Off-Broadway: *Balm in Gilead, My Uncle Sam, Second Avenue Rag.*

MARLEE MATLIN: born in Morton Grove, IL. Films (11 titles): *Children of a Lesser God* (Oscar, Golden Globe), *Walker, The Man in the Golden Mask, The Linguini Incident, The Player, Hear No Evil, It's My Party, Freak City*. Television series and movies (10 titles): *Bridge to Silence, Reasonable Doubts* (2 Golden Globe nominations), *Picket Fences* (Emmy nomination), *Seinfeld* (Emmy nomination), *Against Her Will: The Carrie Buck Story, The Practice* (Emmy nomination), *The West Wing, Law & Order: SVU*. Theater: *The Wizard of Oz, Children of a Lesser God*.

JOHN C. McGINLEY: born 8/3/59 in New York City. Received B.A. and M.F.A. from New York University. Film (65 titles): *Identity, Seven, The Rock, Platoon, Any Given Sunday, Office Space, Nothing to Lose, Get Carter, Wall Street*. Television series and movies (12 titles): *Scrubs, Intensity, The Jack Bull, The Pentagon Wars*. Theater: *Danny and the Deep Blue Sea, The Ballad of Soapy Smith, Talk Radio*; Broadway: *Requiem for a Heavyweight*.

LARRY MILLER: born 10/15/53 in New York City. Received B.A. from Amherst College, studied with Milton Katselas. Film (37 titles): as actor: *Pretty Woman, Nutty Professor 1, Nutty Professor 2, 10 Things I Hate about You, The Princess Diaries, Waiting for Guffman, Best in Show, A Mighty Wind*; as actor, writer: *Pros & Cons*. Television series and movies: *Law & Order, Seinfeld, The Tonight Show, The Late Show with David Letterman*. Theater: Broadway: *The Dinner Party*.

HOLMES OSBORNE: born in Kansas City, MO. Received B.S. in language arts from the University of Kansas, M.A. in theater from the University of Missouri, Kansas City. Film (20 titles): *That Thing You Do!, Affliction, The Quiet American, Donnie Darko, Identity*. Television series and movies (35 titles): *From the Earth to the Moon, Truman, Seven Days, Frasier, The West Wing, The X-Files, ER, The Practice*. Theater: regional (12 seasons): *Long Day's Journey into Night, Nicholas Nickleby* (12 different roles), *The Glass Menagerie, Much Ado about Nothing*.

DAVID PAYMER: born 8/30/54 in Oceanside, NY. Received B.A. in theater and psychology from the University of Michigan. Film (over 40 titles): *State and Main, Get Shorty, Quiz Show, Nixon, Searching for Bobby Fischer, Mr. Saturday Night* (Oscar & Golden Globe nominations). Television series and movies (over 30 titles): *Line of Fire* (ABC series lead), *HBO's Crime of the Century* (Golden Globe nomination), *The Larry Sanders Show*. Theater: Broadway: *Grease*.

MARK PELLEGRINO: born 4/9/65 in Pasadena, CA. Film (34 titles): *National Treasure, Twisted, Mulholland Drive, Murder of Crows, The Big Lebowski*. Television series and movies: *NYPD Blue, The Beast*.

AUSTIN PENDLETON: born in Warren, OH. Attended Yale University. Film (65 titles): *A Beautiful Mind, Finding Nemo, Amistad, The Mirror Has Two Faces, Guarding Tess, My Cousin Vinny*. Theater: Broadway: *The Diary of Anne Frank, Grand Hotel, Fiddler on the Roof, Hail Scrawdyke, Doubles*; Off-Broadway: *Educating Rita, Oh Dad, Poor Dad, The Last Sweet Days of Isaac, Hamlet, Richard III, Uncle Vanya*.

ROSIE PEREZ: born in Brooklyn, NY. Film (15 titles): *Fearless* (Oscar & Golden Globe nominations), *Do the Right Thing, Night on Earth, It Could Happen to You, Human Nature, White Men Can't Jump, Riding in Cars with Boys*. Television series and movies: as choreographer: *In Living Color* (Emmy nomination). Theater: Broadway: *Frankie and Johnnie in the Clair de Lune*; Off-Broadway: *The Vagina Monologues, References to Salvador Dali Make Me Hot, A Midsummer Night's Dream*.

MARTHA PLIMPTON: born 11/16/70. Film (31 titles): *200 Cigarettes, Pecker, Beautiful Girls, Parenthood, The Mosquito Coast*. Television series and movies: *The Defenders, ER, Law & Order: SVU* (Emmy nomination). Theater: *Boston Marriage*.

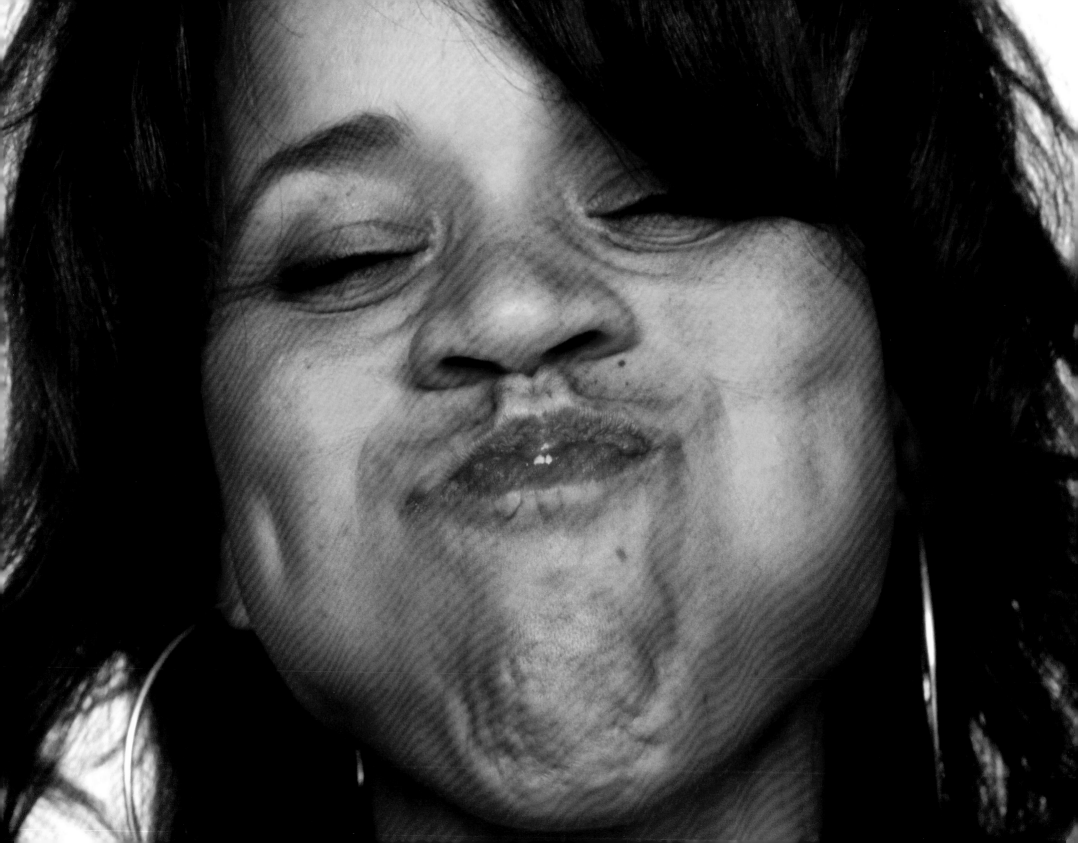

AMANDA PLUMMER: born 3/23/57 in New York City. Films (47 titles): *Pulp Fiction, So I Married an Axe Murderer, The Fisher King, Needful Things, The Million Dollar Hotel, My Life without Me.* Television series and movies (15 titles): *The Outer Limits* (Emmy), *Miss Rose White* (Emmy, Golden Globe nomination), *L.A. Law* (Emmy nomination), *The Dollmaker.* Theater: *Pygmalion* (Tony nomination), *Agnes of God* (Tony), *A Taste of Honey* (Tony nomination).

JON POLITO: born 12/29/50 in Philadelphia, PA. Received B.A. from Villanova University. Film (48 titles): *Miller's Crossing, The Man Who Wasn't There, Barton Fink, The Crow, The Freshman.* Television series and movies (28 titles): *Crime Story, Homicide: Life on the Street, Chronicle.* Theater: *The Curse of an Aching Heart, Death of a Salesman, Other People's Money;* performances with Dodger Theater Company and the BAM Theater Company 1979–80 (Obie).

SYDNEY POLLACK: born 7/1/34 in Lafayette, IN. Studied theater at New York's Neighborhood Playhouse. Film (51 titles): as actor: *Husbands and Wives, Tootsie, The Player, Eyes Wide Shut;* as producer: *Cold Mountain, The Quiet American, Iris, The Talented Mr. Ripley, Sliding Doors, Presumed Innocent, The Fabulous Baker Boys, Sense and Sensibility;* as director: *They Shoot Horses, Don't They?* (Oscar nomination), *The Way We Were, Tootsie* (Oscar nomination), *Out of Africa* (2 Oscars). Television series and movies (20 titles): as actor: *Mad about You, Will and Grace, Just Shoot Me.*

KEVIN POLLAK: born 10/30/57 in San Francisco, CA. Performed stand-up comedy since the age of twenty. Film (51 titles): *Willow, Avalon, A Few Good Men, The Usual Suspects* (National Board of Review best ensemble cast award), *Grumpy Old Men, Indian Summer, Grumpier Old Men, She's All That, Casino, Deterrence, The Whole Nine Yards, Seven Times Lucky, The Whole Ten Yards, Hostage.* Television series and movies (13 titles): 2 HBO stand-up comedy specials, *The Underworld, From the Earth to the Moon.*

ROBERT PROSKY: born 12/13/30 in Philadelphia, PA. Received B.A. in economics from Temple University. Film (35 titles): *Death to Smoochy, Dead Man Walking, The Chamber, Mrs. Doubtfire, Broadcast News.* Television series and movies (20 titles): *Veronica's Closet, Cheers, Into Thin Air, Hill Street Blues, The Practice.* Theater (200 titles): Broadway: *A View from the Bridge, Glengarry Glen Ross* (Tony nomination), *Death of a Salesman, A Walk in the Woods* (Tony nomination).

BILL PULLMAN: born 12/17/53 in Hornell, NY. Received M.F.A. in directing from the University of Massachusetts at Amherst. Film (43 titles): *Independence Day, Zero Effect, Igby Goes Down, Lucky Numbers, Lost Highway, The Last Seduction, While You Were Sleeping, The Accidental Tourist, Sleepless in Seattle, Wyatt Earp.* Television series and movies: as actor, director: *The Virginian.* Theater: Broadway: *The Goat* (Tony).

AIDAN QUINN: born 3/8/59 in Chicago, IL. Studied at the Piven Theater Workshop in Chicago, IL. Film (34 titles): *At Play in the Fields of the Lord, This Is My Father, The Assignment, Legends of the Fall, Avalon, Song for a Raggy Boy.* Television series and movies (13 titles): *All My Sons, An Early Frost, The Two of Us.* Theater: *The Exonerated, Hamlet, A Lie of the Mind* (original cast), *A Streetcar Named Desire, Irish Hebrew Lesson.*

JAMES REBHORN: born 9/1/48 in Philadelphia, PA. Received B.A. from Wittenberg University, M.F.A. from Columbia University. Film (44 titles): *The Talented Mr. Ripley, Cold Mountain, Far from Heaven, Scotland, PA, Meet the Parents, The Game, Independence Day.* Television series and movies (29 titles): *Law & Order, From the Earth to the Moon, The Practice, Third Watch, Reversible Errors.* Theater: *The Man Who Had All the Luck, Dinner at Eight.*

JOHN RHYS-DAVIES: born in Wiltshire, England. Received B.A. from the University of East Anglia and studied at the Royal Academy of Dramatic Art. Film: *Lord of the Rings, Raiders of the Lost Ark, The Great White*

Hype, Indiana Jones and the Last Crusade, The Living Daylights. Television series and movies: *Helen of Troy, Star Trek Voyager, War & Remembrance, Shogun* (Emmy nomination), *The Untouchables, Great Expectations, Sliders.* Theater: *The Misanthrope, Hedda Gabler, It Happened in Venice, How the Other Half Lives, Royal Hunt of the Sun.*

NATASHA RICHARDSON: born 5/11/63 in London, England. Film: *Patty Hearst, The Handmaid's Tale, The Comfort of Strangers, Widow's Peak, Nell, The Parent Trap, Asylum.* Television series and movies: *Ghosts, Hostages, Zelda, Suddenly, Last Summer, Haven.* Theater: *The Seagull, High Society, Anna Christie* (Outer Critics Circle & Theater World awards, Tony & Drama award nominations), *Cabaret* (Tony, Outer Critics Circle, Drama League, & Drama Desk awards), *Closer, Lady from the Sea.*

RON RIFKIN: born 10/31/39 in New York City. Film (27 titles): *The Sum of All Fears, Boiler Room, The Substance of Fire, The Negotiator, L.A. Confidential, I'm Not Rappaport, Husbands and Wives.* Television series and movies (35 titles): *Alias, ER, Leaving L.A., Flowers for Algernon, The Winds of War.* Theater: Broadway: *Cabaret* (Tony), *Month in the Country, Wrong Mountain, Broken Glass, The Goodbye People, Come Blow Your Horn; 3 Hotels* (Lucille Lortel award & Drama Desk award nomination), *The Substance of Fire* (Obie, Lucille Lortel, L.A. Dramalogue awards, Drama Desk award).

ERIC ROBERTS: born 4/18/56 in Biloxi, MS. Studied at the Royal Academy of Dramatic Art and the American Academy of Dramatic Arts. Film (76 titles): *Runaway Train* (Oscar nomination), *The Coca-Cola Kid, The Specialist, It's My Party, The Pope of Greenwich Village, King of the Gypsies* (Golden Globe nomination), *Star 80* (Golden Globe nomination). Television series and movies (34 titles): *In Cold Blood, Less Than Perfect, A Force of One.* Theater: *Burn This, The Exonerated.*

TONY ROBERTS: born 10/22/39 in New York City. Received B.A. in drama from Northwestern University. Film (22 titles): *Annie Hall, Serpico, Play It Again, Sam, Radio Days, Hannah and Her Sisters, Stardust Memories.* Television series and movies (21 titles): *Rosetti and Ryan, The Four Seasons, The Thorns, Seize the Day, The American Clock, The Carol Burnett Show.* Theater (22 titles): Broadway: *Jerome Robbins' Broadway, Victor/Victoria, How Now, Dow Jones* (Tony nomination), *Play It Again, Sam* (Tony nomination), *The Tale of the Allergist's Wife, Promises, Promises.*

RICHARD SCHIFF: born 5/27/55 in Bethesda, MD. Received B.F.A. and honorary doctorate from City College of New York. Film (40 titles): *Unchain My Heart: The Ray Charles Story, People I Know, I Am Sam, Forces of Nature, Crazy in Alabama, Living out Loud, Heaven, Dr. Dolittle, Deep Impact, The Lost World: Jurassic Park, Grace of My Heart, The Trigger Effect, City Hall, Seven.* Television series and movies (11 titles): *The West Wing* (1 Emmy & 3 Emmy nominations), *Relativity, NYPD Blue.* Theater: *The Exonerated, Urban Folk Tales, Goose and Tom Tom.*

GEORGE SEGAL: born 2/13/34 in New York City. Attended Haverford College, received B.A. from Columbia University, studied with Lee Strasberg and Uta Hagen, 2 years in U.S. Army. Films (55 titles): *King Rat, Who's Afraid of Virginia Woolf?* (Oscar & Golden Globe nominations), *The Quiller Memorandum, A Touch of Class* (Golden Globe), *The Duchess and the Dirtwater Fox.* Television series and movies (27 titles): *Just Shoot Me* (2 Golden Globe nominations), *Murphy's Law, Picture Windows: Language of the Heart, Houdini, The Endless Game.* Theater: *Art, The Iceman Cometh;* Off-Broadway: *Leave It to Jane, The Premise* (Obie).

NESTOR SERRANO: born 11/5/55 in the Bronx, NY. Film (21 titles): *The Insider, Runaway Jury, Bringing out the Dead, Showtime, City by the Sea, The Day after Tomorrow.* Television series and movies: *Moloney, The Hat Squad, Undefeated, Police Story.* Theater: Broadway: *The Tempest, Cuba and His Teddy Bear; Jesus Hopped the A Train.*

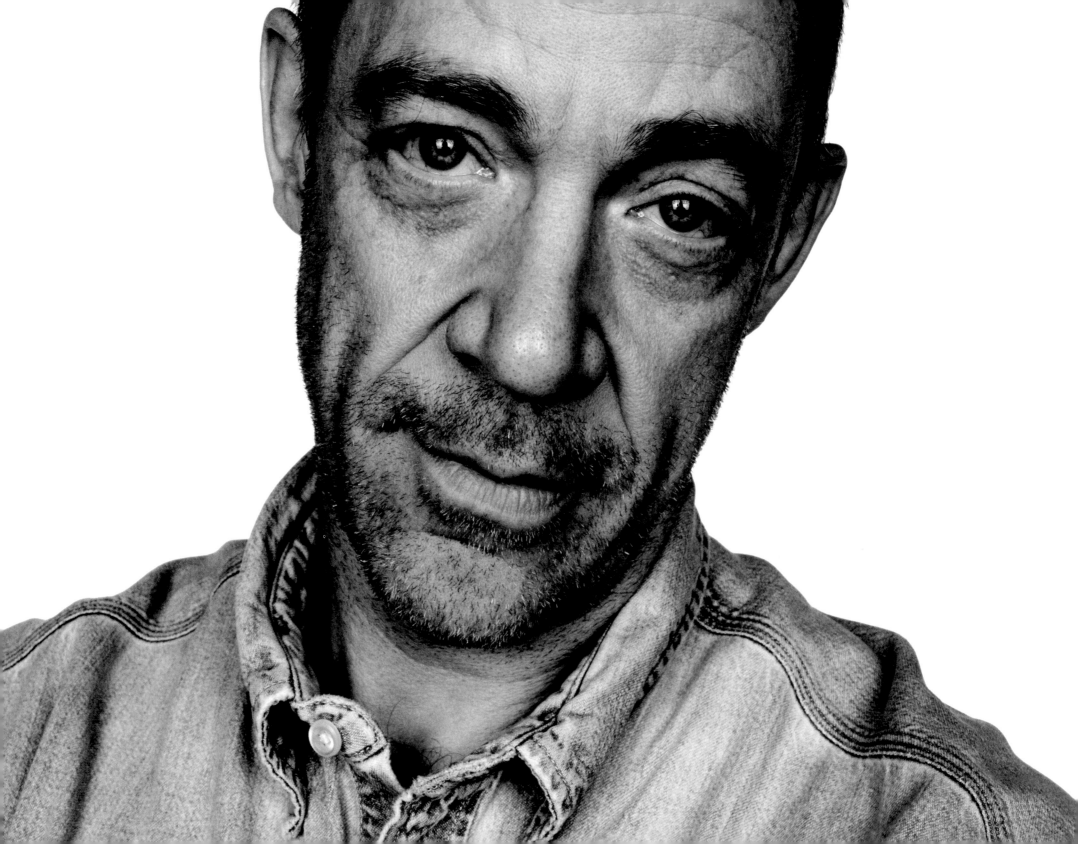

J. K. SIMMONS: born 1/9/55 in Detroit, MI. Received B.A. from the University of Montana. Film (23 titles): *The Ladykillers, Spider-Man, Spider-Man 2, The Cider House Rules*. Television series and movies: *Oz, Law & Order*. Theater: Broadway: *Guys and Dolls, Laughter on the 23rd Floor, A Few Good Men*.

TOM SKERRITT: born 8/25/33 in Detroit, MI. Film (46 titles): *Top Gun, Steel Magnolias, A River Runs through It, Contact, Alien, Tears of the Sun, MASH*. Television series and movies (37 titles): *Picket Fences* (Emmy), *Path to War, Cheers*.

BEN STEIN: born 11/25/44 in Washington, D.C. Received B.A. with honors in economics from Columbia University, J.D. from Yale Law School. Film (26 titles): as actor: *Ferris Bueller's Day Off, Planes, Trains and Automobiles, The Mask, Honeymoon in Las Vegas, Miami Rhapsody*; as writer: *The Boost*. Television series and movies (16 titles): *Charles in Charge, The Wonder Years, Win Ben Stein's Money* (Emmy), *Duckman*.

PATRICK STEWART: born 7/13/40 in Yorkshire, England. Film (33 titles): *X-Men, X2: X-Men United, Star Trek* features (*Generations, First Contact, Insurrection*, and *Nemesis*), *Jeffrey, Dune, Lady Jane, L.A. Story, Robin Hood: Men in Tights, Conspiracy Theory*. Television series and movies (30 titles): *Star Trek: The Next Generation* (SAG award nomination), *A Christmas Carol* (SAG award nomination), *Moby Dick* (Emmy & Golden Globe nominations), *King of Texas, Lion in Winter*. Theater: *The Caretaker, The Master Builder, The Ride Down Mt. Morgan, The Tempest, A Midsummer Night's Dream, A Christmas Carol* (Drama Desk award, Olivier award), *Othello* (Helen Hayes nomination), *Hedda Gabler, Who's Afraid of Virginia Woolf?* (London Fringe award); honorary associate artist of the Royal Shakespeare Company since 1967.

ERIC STOLTZ: born 9/30/61 in Los Angeles, CA. Film (53 titles): *The House of Mirth, Little Women, Pulp Fiction, The Waterdance, Some Kind of Wonderful, Mask* (Golden Globe nomination). Television series and movies (25 titles): *Out of Order, Once and Again, Inside, Mad about You*. Theater: *The Glass Menagerie, The Importance of Being Ernest, Three Sisters, Our Town* (Tony nomination).

DANIEL SUNJATA: born in Evanston, IL. Received B.F.A. in acting from the University of Southwestern Louisiana, M.F.A. in acting from Tisch School of the Arts. Film: *Noel, Bad Company, Feast of All Saints, Brother to Brother*. Television series and movies: *D.C., Rescue Me, Law & Order*. Theater: Broadway: *Take Me Out* (Tony, Drama Desk, Lucille Lortel awards, Theater World award nomination), *Twelfth Night*; Off-Broadway and regional: *Camino Real, Henry VIII, Othello*.

STEPHEN TOBOLOWSKY: born 5/30/51 in Dallas, TX. Received B.A. from Southern Methodist University. Film (67 titles): *Mississippi Burning, Groundhog Day, Single White Female, Sneakers, Thelma & Louise, Memento, The Insider*. Television series and movies (over 100 titles). Theater: *Mornings at Seven* (Tony nomination).

ROBERT VAUGHN: born 11/22/32 in New York City. Received Ph.D. from the University of Southern California. Film (76 titles): *The Young Philadelphians* (Oscar nomination), *Bullitt, The Magnificent Seven, The Towering Inferno, Superman III, BASEketball*. Television series and movies (52 titles): *The Man from U.N.C.L.E.* (Golden Globe nomination), *Washington: Behind Closed Doors* (Emmy), *Backstairs at the White House* (Emmy nomination), *FDR, The Blue and the Gray*. Theater: *Hamlet, Inherit the Wind, The Exonerated*.

M. EMMET WALSH: born 3/22/35 in Ogdensburg, NY. Received B.A. from Clarkson College, attended the American Academy of Dramatic Arts. Film (100 titles): *Blade Runner, Blood Simple, My Best Friend's Wedding, Straight Time, Clean and Sober, Ordinary People, The Jerk*. Television series and movies (over 100 titles): *The Mind of the Married Man, The Lottery, Home*

Improvement, The Abduction of Kari Swenson, Murder Ordained, Murder Ordained 2. Theater: Broadway: *That Championship Season, Does the Tiger Wear a Necktie.*

FRED WARD: born 12/30/42 in San Diego, CA. Studied at the Herbert Berghoff Studio in New York City, with David Alexander in Los Angeles, and Jerzy Grotowsky. Film (50 titles): *The Player, The Right Stuff, Short Cuts* (Golden Globe for best ensemble cast), *Henry & June, Silkwood, Tremors, Remo Williams: The Adventure Begins, Sweet Home Alabama.* Television series and movies (15 titles): *10.5, Black Iris, Coast to Coast, ...First Do No Harm, Cartesius, The Power of Cosima.* Theater (12 titles): *Simpatico.*

PETER WELLER: born 6/24/47 in Stevens Point, WI; raised in Texas and Europe. Received B.A. from the University of North Texas, studied at the American Academy of Dramatic Arts, with Uta Hagen at H.B. Studio, entered the Actors Studio under aegis of Elia Kazan, received M.A. in Renaissance art history from Syracuse University in Florence, Italy. Film (30 titles): as actor: *Just Tell Me What You Want, Shoot the Moon, Naked Lunch, Beyond the Clouds, Cat Chaser, RoboCop, Mighty Aphrodite, The New Age, The Adventures of Buckaroo Banzai;* as director: *Partners* (Oscar nomination). Television series and movies (22 titles): as actor: *Dusk before Fireworks;* as director: *Gold Coast, Homicide: Life on the Street, Michael Hayes, Odyssey V.* Theater: *Sticks and Bones, Streamers, The Woods, Serenading Louie.*

FRED WILLARD: born 9/18/39 in Cleveland, OH. Film (44 titles): *Best in Show* (American Comedy award), *Waiting for Guffman, A Mighty Wind, This Is Spinal Tap, American Wedding, The Wedding Planner.* Television series and movies (32 titles): *A Minute with Stan Hooper, Teamo Supremo, Everybody Loves Raymond* (Emmy nomination), *Fernwood 2 Night, Roseanne.*

HENRY WINKLER: born 10/30/45 in New York, NY. Received B.A. in drama and child psychology from Emerson College, M.F.A. from the Yale School of Drama. Film (20 titles): as actor: *Holes, The Waterboy, Scream, Night Shift* (Golden Globe nomination), *The Lords of Flatbush;* as director: *Memories of Me, Cop and a Half.* Television series and movies (50 titles): as actor: *The Practice* (Emmy nomination), *Happy Days* (2 Golden Globes, 3 Emmy nominations), *Laverne & Shirley;* as executive producer: *MacGyver, Hollywood Squares, Sightings, So Weird.* Theater: Broadway: *The Dinner Party* (Outer Critics Circle award for best ensemble cast). Creator of: *Hank Zipzer; The World's Greatest Underachiever.*

MICHAEL YORK: born 3/27/42 in Fulmer, Buckinghamshire, England. Received B.A. from Oxford University and trained at the National Theater. Film (64 titles): *The Taming of the Shrew, Romeo and Juliet, Jesus of Nazareth, Cabaret, Something for Everyone, The Three Musketeers, Logan's Run, The Island of Dr. Moreau, Murder on the Orient Express, Fedora, Austin Powers* series. Television series and movies (44 titles): *The Forsyte Saga, Great Expectations, Space, The Heat of the Day, The Lot, Curb Your Enthusiasm.* Theater: *Someone Who'll Watch over Me, Bent, The Little Prince, The Crucible, Outcry.*

HARRIS YULIN: born 11/5/37 in Los Angeles, CA. Film (43 titles): *Clear and Present Danger, Scarface, End of the Road, Candy Mountain.* Television series and movies (32 titles): *24, Mr. Sterling.* Theater: Broadway: *Hedda Gabler, The Price, The Diary of Anne Frank, The Visit, A Lesson from Aloes, Watch on the Rhine;* Off-Broadway: *Raindance, Arts and Leisure, Don Juan in Hell* (also producer and director), *Hamlet, Approaching Zanzibar, King John, Mrs. Warren's Profession;* as director: *This Lime Tree Bower, Baba Goya, Winterplay, Prisoner's Song, As You Like It, The Front Page.*

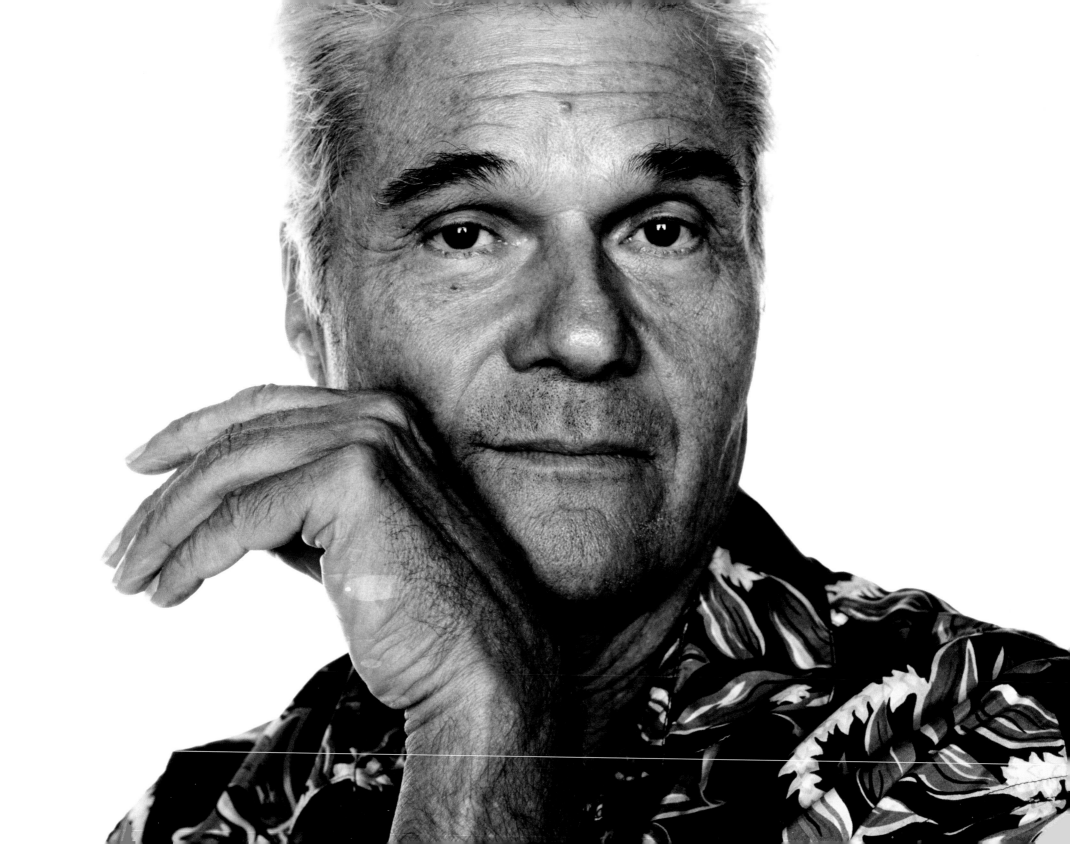

Ensembles

INTRODUCTION

Martin Landau, Rosemary Harris, Henry Winkler
Edie Falco, Chevy Chase, Kathy Baker
Dennis Haysbert, Fran Drescher, Patrick Stewart

COMEDY Martin Landau

Bruce Altman, Ellen Burstyn, Charles S. Dutton, Natasha Richardson
Amanda Plummer, Dan Hedaya, Robert Prosky, F. Murray Abraham
Michael Lerner, Dennis Haysbert, John Rhys-Davies, Rosemary Harris
Ron Rifkin, Patrick Cranshaw, Eric Roberts, Robert Klein

James Cromwell, Kelsey Grammer, Larry Miller, Fran Drescher
Elliott Gould, Giancarlo Esposito, Kate Burton, Danny Glover
Alan Cumming, Peter Falk, Don Cheadle, George Segal
Marlee Matlin, Delroy Lindo, Kathy Baker, Chevy Chase

FEAR Edward Herrmann

Robert Klein, Rosemary Harris
Marlee Matlin, Jason Alexander

Chevy Chase, Natasha Richardson, Dylan Baker
Melissa Leo, Delroy Lindo, Illeana Douglas
Bruce Davison, Ellen Burstyn, Peter Donat

OVER-THE-TOP Kelsey Grammer

James Earl Jones, Peter Falk, Illeana Douglas, Holmes Osborne
Ben Hammer, Marianne Jean-Baptiste, Dan Hedaya, Danny Glover
Bruce Altman, John Finn, Peter Weller, Chevy Chase
Tom Skerritt, Donal Logue, James Booth, Stephen Tobolowsky

James Cromwell, Kathy Baker
Michael Lerner, Richard Schiff

SUSPICION M. Emmet Walsh

Fred Ward, Edie Falco, Stephen Tobolowsky
Robert Loggia, Peter Falk, Illeana Douglas
Fred Willard, Kate Burton, Judd Hirsch

Nestor Serrano, Amanda Plummer, Michael Lerner, Elliott Gould
Philip Bosco, Sydney Pollack, Rosemary Harris, John Rhys-Davies
Glenne Headly, Scott Glenn, Richard Schiff, Richard Dreyfuss
Joe Mantegna, Danny Glover, Dan Hedaya, Marlee Matlin

ANGER Ted Levine

Don Cheadle, Ben Stein, Elliott Gould, Michael York
Buck Henry, Michael Cumpsty, Aidan Quinn, Kelsey Grammer
Robert Klein, Alan Cumming, Ellen Burstyn, Jon Polito
Rosie Perez, Mark Pellegrino, Jason Alexander, Danny Glover

Fred Willard, Illeana Douglas, F. Murray Abraham, Fred Ward
Marianne Jean-Baptiste, Steve Guttenberg, Nestor Serrano, P. J. Barry
Dylan Baker, Daniel Sunjata, Edward Herrmann, Ben Hammer
Scott Glenn, Austin Pendleton, Mark Margolis, John Rhys-Davies

FLIRTATION Alan Cumming

Jason Alexander, Rosemary Harris, Delroy Lindo, Glenne Headly
Tony Roberts, Judd Hirsch, Joe Mantegna, Marlee Matlin
Buck Henry, James Earl Jones, Richard Dreyfuss, Michael Lerner
Don Cheadle, James Rebhorn, Illeana Douglas, Kathy Baker

Rosie Perez, Charles S. Dutton, Edward Herrmann, Natasha Richardson
Kelsey Grammer, Sydney Pollack, Edie Falco, Elliott Gould
Bruce Altman, Marianne Jean-Baptiste, John C. McGinley, Ellen Burstyn
Aidan Quinn, George Segal, Fran Drescher, P. J. Barry

TRAGEDY Delroy Lindo

Glenne Headly, Robert Klein, Kate Burton
Martin Landau, Richard Dreyfuss, David Carradine
Natasha Richardson, Michael York, Kathy Baker

Jason Alexander, James Earl Jones, Bill Pullman, Illeana Douglas
Rosemary Harris, Don Cheadle, Scott Glenn, Ben Hammer
Steve Guttenberg, James Rebhorn, Danny Glover, Hume Cronyn
Edward Herrmann, Eric Roberts, Anthony Franciosa, David Paymer

BIOGRAPHY PORTRAITS *(in order of appearance)*

Bob Balaban, James Cromwell, Illeana Douglas,
Richard Dreyfuss, Edie Falco, Scott Glenn,
Dan Hedaya, James Earl Jones, Rosie Perez,
J. K. Simmons, Fred Willard

FRONT JACKET

Edie Falco, Don Cheadle, Robert Klein, Rosie Perez, and Kelsey Grammer

BACK JACKET

Elliott Gould, Fran Drescher, Richard Dreyfuss, Charles S. Dutton,
and David Carradine

Index of Photographs

following page: DAVID CARRADINE

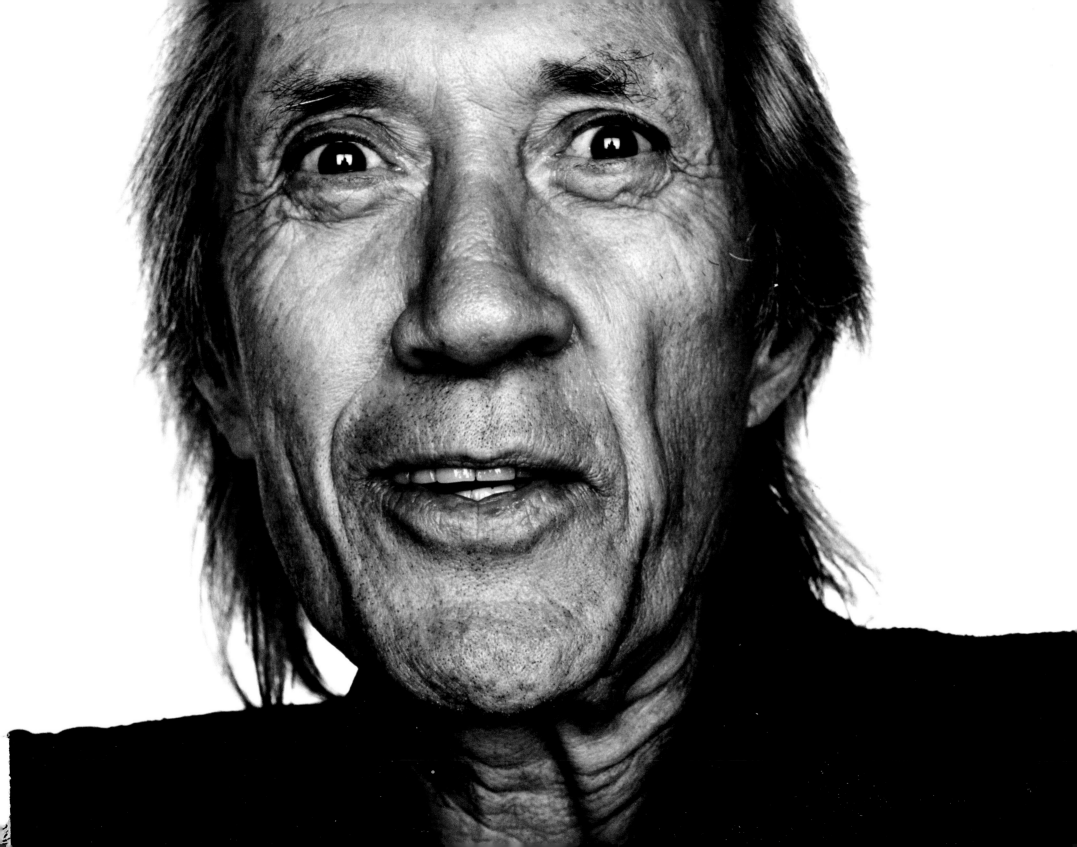

Acknowledgments

Producer: Molly Nee
Senior photo assistant: Ben Law-Viljoen
Additional photo assistants: Carlin Sundell, Virginie Blachere
Script consultant: Owen Edwards
Design consultant: Jean Orlebeke
Post-production: Diego Alvarez, Aaron Epstein, Geoff Green
Layout: Allison Malcolm Carroll
Documentation and archiving: McKenna Lebens, Monique Reddington
Intern: Brian Offidani

We appreciate all the support provided by the following companies and individuals.
Hasselblad: Lars Papilla, Goran Bernhoff, Allan Zimmerman, Bob Finucane, Richard Schleuning, Paul Claeson
Chimera: Eileen Healy, studio lighting banks
Leaf: Jan Lederman, Mark Resonico, Amit Shvatz, Michal Adar, Cliff Hausner, Kevin Stubbs, Rick Adsed, Pat Buono
Balcar: Kevin Balli, president of Balcar; David Serdimet, director of Balcar US
Kodak Professional: David Swift, Jonathan Cummings, Scott DiSabato, Sharon Tczap

The fine artwork of Howard Schatz is represented by the following galleries:

Staley Wise Gallery, New York, New York
Apex Fine Art, Los Angeles, California
Robert Klein Gallery, Boston, Massachusetts
Photography West Gallery, Carmel, California
Gallery M, Denver, Colorado
Photo Eye Gallery, Santa Fe, New Mexico
Benham Gallery, Seattle, Washington
PhotoClassics, Munich, Germany

You can view the work of Howard Schatz at www.howardschatz.com

Our inimitable agent, John Campbell, has championed our work tirelessly
and found us a wonderful home with Bulfinch Press.

We want also to extend our appreciation to Jill Cohen, the publisher of Bulfinch Press,
and to Michael Sand, our editor, for his attention and enthusiasm for *In Character*.

We are grateful to have had the cooperation of the following agents, publicists, managers, and assistants who made it possible for us to work with this distinguished group of actors.

Leslie Allen-Rice, Leslie Allen-Rice Management; Esailama Artry-Diouf, Carrie Productions; Laurie Berwick, Hofflund-Polone; Rachelle Brehm, Guttman Associates; Don Buchwald, Don Buchwald & Associates; Bill Butler, The Gersh Agency; Marion Campbell, The Gersh Agency; Adena Chawke, Innovative Artists; Jessica Cohen, Bragman/Nyman/Cafarelli; Sam Cohn, ICM; Michael Cutler, Douglas Management; Donna Daniels, Donna Daniels PR; Lori Dewaal, Lori Dewaal & Associates; Ro Diamond, SDB Partners; Peg Donegan, Framework Entertainment; Steve Dontanville, William Morris Agency; Daniel Doty, InnerAct Entertainment; Ari Emanuel, Endeavor Talent; Marc Epstein, Personal Management; Phyllis Fioretti, Feury/Grant Entertainment; Brian Friedman, The Conversation Company; Lisa Gallant, ICM; Michael Garnett, Leverage; David Geisinger; Bob Gersh, The Gersh Agency; Ellie Goldberg, Kerin-Goldberg; Dick Guttman, Guttman Associates; J. J. Harris, One Entertainment; Scott Hart; Scott Henderson, William Morris Agency; Karl Hofheinz, The Gage Group; Jeff Hunter, William Morris Agency; Stephen Huvane, PMK/HBH; Nancy Iannois, Nancy Iannois PR; Jack Jason; Catherine Jeffery, I/D PR; Nikki Joel, ICM; Jill Kaplan, LMRK; Robbie Kass, Robbie Kass Management; Charles King, William Morris Agency; Lisa King, Northern Exposure Agency; Annika Kispersky, Stan Rosenfeld & Associates; Elise Konialian, Untitled Entertainment; Gabrielle Krengel, Metropolitan Talent Agency; Landmark Artists Management; Ginger Lawrence, The House of Representatives; Michael Levine, Levine Management; Liberman & Zerman; Joe Libonati, I/D PR; David Lillard, IFA Talent; Lisa Loosemore, Viking Entertainment; Steve Lovett, Lovett Management; Beverly Magid, The Gersh Agency; Brian Mann, ICM; Gayle Max, Blue Max Management; Carrie McClue, PLPR; Judith Moss, Paradigm; David Nesmith, PMK/HBH; Jason Newman, Untitled Entertainment; Susan Patricola, Patricola PR; Johnnie Planco, Parseghian/Planco Management; Mark Redanty, Bauman, Redanty & Shaul; Elaine Rich; Rory Rosegarten; Stan Rosenfield, Stan Rosenfield & Associates; Jeff Ross, Jeff Ross Management; Jon Rubinstein, MG Management; Heidi Schaeffer, PMK/HBH; Jeri Scott Management; Jim Selman, Rogers & Cowan; David Seltzer, Management 360; Craig Shapiro, Innovative Artists; Risa Shapiro, ICM; Susan Smith, Susan Smith & Associates; Cynthia Snyder, Cynthia Snyder PR; Alan Somers, Pure Arts Entertainment; Spivak Entertainment; Louisa Spring, Spring Management; Peter Strain, Peter Strain & Associates; Ina Treciokas, I/D PR; Bill Treusch, Treusch/Erickson Associates; Ron West, Thruline Entertainment; Keri Wilson, Mirage

following page: FRAN DRESCHER

263

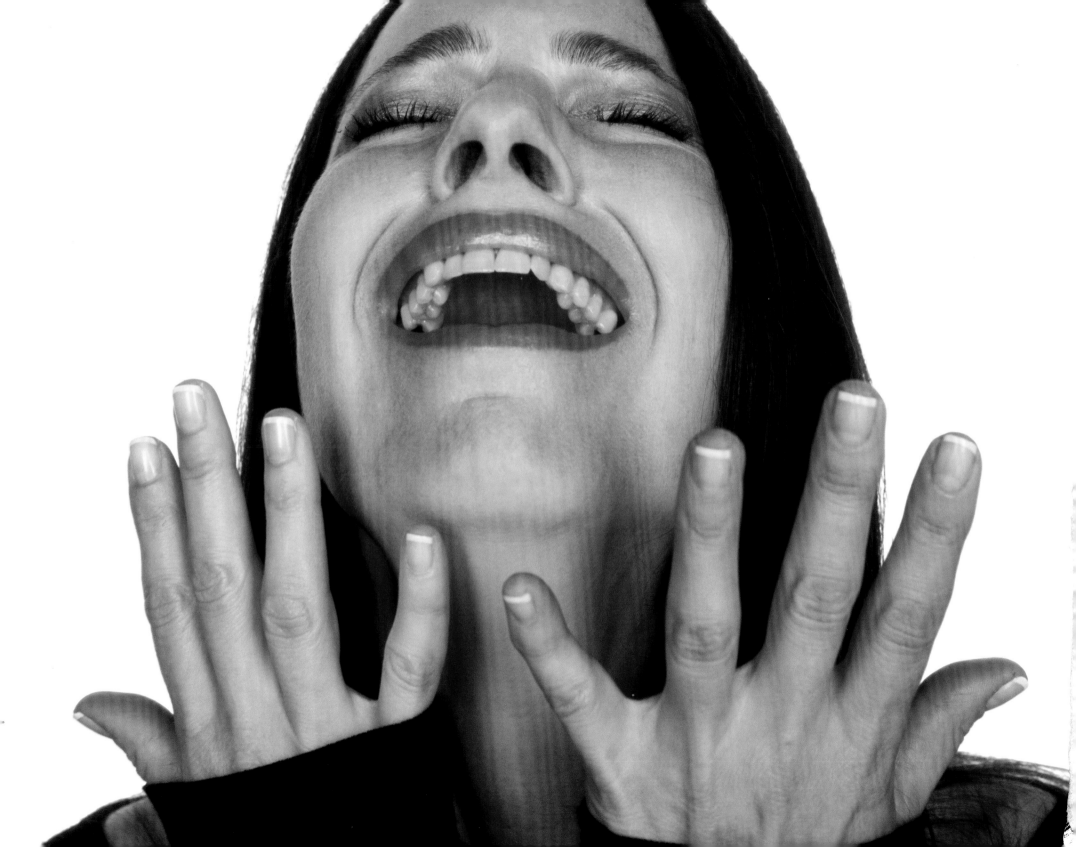